Edition **DETAIL** Green Books

Sustainable building services

Principles
Systems
Concepts

Bernhard Lenz
Jürgen Schreiber
Thomas Stark

Imprint

Project management:
Jakob Schoof, Dipl.-Ing.

Editorial work:
Jana Rackwitz, Dipl.-Ing.
Jakob Schoof, Dipl.-Ing.

Editorial assistants:
Marion Dondelinger, Dipl.-Ing.
Judith Faltermeier, Dipl.-Ing. Architect
Verena Schmidt

Illustrations:
Ralph Donhauser, Dipl.-Ing.
Bettina Großhardt,
Elisabeth Krammer, Dipl.-Ing.

Translations:
Sharon Heidenreich, Dipl.-Ing. (FH)

English proofreading:
Roderick O'Donovan, B. Arch.
Paul Smyth, MEng

Cover design:
Cornelia Hellstern, Dipl.-Ing.

DTP & layout:
Roswitha Siegler, Simone Soesters

Reproduction:
ludwig:media, Zell am See

Printing and binding:
Kösel GmbH & Co. KG, Altusried-Krugzell
1st edition 2011

Institut für internationale
Architektur-Dokumentation GmbH & Co. KG
Hackerbrücke 6, D-80335 München
Tel.: +49/89/38 16 20-0
Fax.: +49/89/39 86 70
www.detail.de

© 2011 Institut für internationale
Architektur-Dokumentation GmbH & Co. KG, Munich
A specialist book from Redaktion DETAIL

ISBN: 978-3-920034-49-2

Contents

In the maintenance of building operations, buildings in Germany are responsible for approximately 50 % of total energy consumption and give rise to 40 % of all the greenhouse emissions. For the future planning of buildings, it is therefore fundamental to optimise the building envelope in terms of energy usage as well as to provide an energy supply that is based on the decentralised utilisation of renewable energies. The very ambitious modified EU Directive on the Energy Performance of Buildings already demands so-called "zero-energy buildings" for the year 2020: From this date onwards, new builds have to generate the energy they consume from renewable sources on site.

In this context, buildings are no longer consumers that simply need to be optimised. Only if the buildings themselves become part of the energy generating system, is it going to be possible to meet the targets of sustainable development in the construction industry. Ideally, seen over a year, a building should generate as much renewable energy as it requires. In a global context, it can then be considered as "carbon neutral". In the long term, this requirement will also extend to existing buildings, even if measures to increase energy efficiency are currently paramount.

Architects and engineers have to face this great challenge together. The aim is to achieve the highest level of comfort, profitability and quality of design with minimum use of energy and resources. The development of sustainable energy concepts will continue to become increasingly important in future. However, it is not sufficient to consider just the utili-

sation phase of the building alone. The boundaries of accountability are gradually being broadened to incorporate all energy and material flows for construction and also for potential removal. Furthermore, the range of the relevant criteria is being extended beyond energy and material matters in order to establish a comprehensive basis to evaluate planning alternatives.

Despite all efforts to adopt a holistic approach, the topic energy will presumably be the centre of attention over the next few years due to concerns regarding resources and climate. Buildings are being conceived as long-term goods with the operation phase dominating within the life cycle assessment.

In the face of the consumption statistics mentioned earlier and the worldwide ambition, in the longer term, to meet the global energy supply from renewable sources, the construction sector is inevitably entrusted with a great deal of responsibility. Buildings, especially, offer considerable savings potential and numerous possibilities to provide a decentralised, regenerative energy supply. A variety of technologies are already at the planners' disposal today. Some of these are well-established and also viable, while others are still under development or not yet competitive from an economic point of view.

The information concerning technical and conceptual possibilities is of great significance in this context. The building engineering systems for energy-efficient building compiled in this book are intended as a guideline. The aim is to provide a systematic basis for the devel-

opment of energy concepts and the communication thereof.

The main aim of this book is to inform architects about this topic and enable them to plan schemes in a constructive interdisciplinary way. Early collaboration between architects and consultants is fundamental for ambitious technical concepts. It will only be possible to achieve sustainable solutions if architecture and building services are carefully coordinated. For this interaction, it is essential that architects, too, are aware of the most relevant aspects of energy-efficient building services. Apart from concise technical details, the focus of this book is therefore especially on the clear and informative description of individual subjects. The contents can either be approached from the individual energy aspects (heating, cooling, lighting, ventilation, electric power supply) or from the presentation of completed projects, something that architects are well-accustomed to.

Since the application of technology always has to be considered in conjunction with comfort and the well-being of the user, this topic is offered as an introduction in the first chapter "Architecture and building services". The following chapter "Building services in the energy concept" explains how the individual technologies can contribute towards the overall energy concept. The presentation is based on the so-called "10 steps to an energy-efficient building", a systematic approach, which discusses the energy-relevant issues, heating, cooling, lighting, ventilation and electricity.

The chapter "Building services systems" presents all relevant technologies and their technical details according to the different types of energy. Examples of completed technical systems are included in the chapter "Technical concepts". Solutions for buildings of differing scale and function are presented in a uniform style, thus enabling the reader to easily compare the range of projects. These contents are supplemented by the important topics "Optimising existing buildings" and "Optimising building operations". Having been slightly neglected up until now, both topics are gaining increasing significance in practise due to the more stringent requirements regarding energy efficiency.

We hope this book will be a helpful tool and look forward to it making a real contribution in terms of integrated planning.

Bernhard Lenz
Jürgen Schreiber
Thomas Stark

Historical development of building services engineering

A look at the historical development of architecture reveals that technical concepts to optimise the use of energy have long played an important role. In early Greek and Egyptian architecture structures were oriented to the course of the sun. The complex hypocaust constructions invented by the Romans provided central heating for rooms, while the integration of animal accommodation in residential buildings made use of the warmth of the animals for heating purposes. These are just a few examples within this context. However, the idea to use technical devices to make buildings increasingly independent of their natural surroundings – which nowadays is taken for granted – originates from around the 18th century.

Surprisingly, one of the first documents concerning this topic stems from a German vicar who wrote an essay on "Calculation of the heat demand in buildings" in 1720. Following the foundation of the Association of German Engineers (Verein Deutscher Ingenieure – VDI) in 1856, the physicist Schinz – also German – went into greater depth performing calculations to determine the heat demand of buildings. The results led to the introduction of the concept "Heat loss due to transmission and ventilation". On the basis of numerous practical studies towards the end of the 19th century, Hermann Rietschel eventually established the basis for today's calculation of heat demand in buildings and compiled the first text and reference book for heating engineers. In the meantime, architects had started to show an interest in the topic and in 1926 the German professor of architecture,

Richard Schachner, published the first comprehensive book for building specialists on building services engineering. Three years later, the knowledge gained became documented in the newly published DIN 4701 "Regulations for calculating the heat demand of buildings and the boiler and radiator sizes of heating systems", which still functions as a basis today. At this early stage, the 47-page document already included climate tables from the Prussian Meteorological Institute, information concerning natural air exchange due to lack of airtightness in windows and doors as well as a list of k values (today U values) of various building components.

Then, in 1940, the subject achieved a considerable breakthrough in the education of architects when "Technical installations" was made a mandatory subject in the foundation courses of architectural faculties. Due to the increasing industrialisation in the building industry and numerous technical innovations in building materials, construction and system engineering, buildings in the more industrialised countries have, for several decades now, featured highly sophisticated systems for room conditioning, that are independent of exterior conditions. However, it is especially these systems that have led to a rising energy demand in the operation of buildings.

In the 20th century, high energy consumption sparked further motivation to consider thermal protection, although at first exclusively for cost-saving reasons. Books specialising in building physics and building services engineering published in the 60s and 70s still did not make any ecologically based suggestions for reducing energy consumption.

The ecological motivation to optimise the

use of energy in buildings, which we are familiar with today, did not materialise until the end of the 20th century. Since the introduction of the energy saving directive in 2002, the scope of accounting has been extended to include the demand for primary energies. What is more, in non-residential buildings, not only the energy consumed by space heating and hot-water production is considered, but also the cost of ventilation, cooling and illumination. The result is that all services within a building which require energy, except for user-specific consumption, are recorded during the useful period of a building. Although, nowadays the focus is increasingly on the use of renewable energies rather than the technical systems that supply the services to buildings. [1]

The zero-energy standard as a new challenge

At the end of 2009, the European Union passed an amended version of the directive concerning the energy performance of buildings (EPBD) [2]. According to this, as of 31 December 2020, all EU member states must ensure that all newly constructed buildings produce as much energy as they themselves consume. Public buildings will have to meet an earlier deadline of 2018. This means that member states should already be developing national plans to increase the number of "net-zero energy buildings". According to the agreed directive, a net-zero energy building is defined as a building "in which, as a result of the building's very high level of energy efficiency, the overall annual primary energy consumption does not exceed the energy production from renewable energy sources on site" (Fig. 1.2). Applying these standards to buildings in

urban environments will represent a further challenge. Towns take up only two per cent of the earth's surface offering slightly more than 50 % of the world's population a home today. However, they are responsible for approximately 75 % of the world's energy consumption and approximately 80 % of the CO_2 output. The world population continues to grow and with it the size of towns – even in some parts of Europe where, in recent times, the concentration has been on the phenomenon of a shrinking and aging society. It is highly possible that by 2050 as much as 75 % of the world population will be living in towns.

Thermal comfort and building services

In Europe, we spend almost our entire life inside. High quality interior space is therefore an important part of our wellbeing and something to be valued and preserved. Measures to improve energy consumption should not be taken to the detriment of comfort. Quite the opposite, comfort should be maintained at today's level or even improved further. This is the only way to achieve a sustainable development of buildings and the related technical services. Comprehensive planning and careful coordination with the user are fundamental for a building to meet these requirements. The comfort criteria, as specified in the respective standards (VDI 4706, DIN EN 15251, DIN EN ISO 7730), are an integral part of this process. The first requirement for an acceptable thermal room climate is that a person feels thermally neutral (i.e. that they do not know whether they might prefer a higher or lower ambient temperature). The feeling of warmth is influenced by the type of activity, the heat insulation of the clothing, the air temperature, the average radiation temperature, the air velocity and the air humidity (Fig. 1.3 and 1.9–1.11, p. 11).
The energy consumption of buildings depends strongly on criteria relating to the design, the indoor climate (temperature, ventilation and lighting) and the

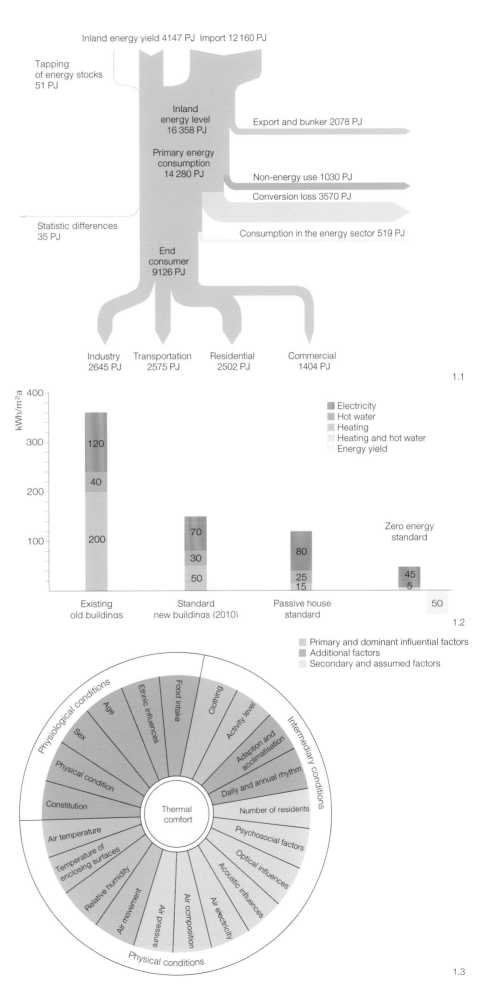

1.1 Energy flow diagram for Germany (from 2008), values in petajoule (1 PJ = 278 mil. kWh)
1.2 Average primary energy consumption in different buildings ranging from old buildings to zero-energy buildings
1.3 Factors influencing thermal comfort in building interiors

9

Category	Description
I	High level of expectations; recommended for rooms used by very sensitive and fragile people or people with special needs, e.g. people with disabilities, sick people, very young children and old people
II	Normal level of expectations; recommended for new and refurbished buildings
III	Acceptable, moderate level of expectations; can be used for existing buildings
IV	Values below the categories mentioned above; this category should only be applied for a limited period

1.4

Criteria for the room climate	Category of the building	Design criteria
Thermal conditions in winter	II	20°C–24°C
Thermal conditions in summer	III	22°C–27°C
Air quality index, CO_2	II	500 ppm higher than outside air
Ventilation rate	II	1 l/sm^2
Lighting		$E_m > 500$ lx; UGR[1] < 19; 80 < R_a[2]
Acoustics		Noise, inside < 35 dB (A) Noise, outside < 55 dB (A)

[1] UGR = United Glare Rating
[2] R_a = Colour Rendering Index

1.5

Source	Pollutants
Building materials and furnishings	Formaldehyde, volatile organic compounds (VOC), low-volatile or particle-bound organic compounds (SVOC/POM) such as biocides, plasticizers, flame retardants
Fibres (textile fibres, mineral fibres)	Pollutants in old buildings such as asbestos, pentachlorphenol (PCP), tar oil components (naphtalene, PAHs), polychlorinated biphenyls (PCB)
Damp materials	Mould fungi, bacteria, VOC
Residents, metabolism products	Carbon dioxide (CO_2), water vapour, body odour/VOC, bacteria
Cooking	Particles, water vapour, odour/VOC
Cooking and heating with gas (gas cooker, instantaneous water heater with pilot flame)	NO_x, CO (as well as CO_2 and water vapour)
Bathroom/toilet (showers, baths, personal hygiene)	Water vapour, VOC, fragrance
Household goods, hobbies	VOC, fragrance, SVOC, biocides, formaldehyde
Candles	Fine dust (PM_{10}), VOC, SVOC
Smoking	Fine dust (PM_{10}), particle-bound PAHs, NO_x, CO, formaldehyde, benzene, VOC, SVOC
Outside air	Fine dust (PM_{10}), particle-bound polycyclic aromatic hydrocarbons (PAHs, diesel exhaust particulates), nitrogen oxides (NO_x), carbon monoxide (CO), ozone (O_3), benzene and other volatile organic compounds (VOC), mould fungi, pollen
Subsoil (ground)	Radon

1.6

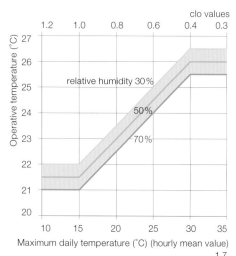

1.7

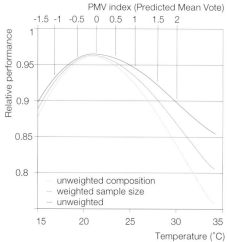

1.8

operation of the building (including all of its systems). The indoor climate also affects the health, productivity and comfort of its occupants. The costs to an employer, the owner of a building or society of resolving problems connected with a poor indoor climate are often higher than the energy costs for the particular building. It goes without saying that the quality of the indoor climate also has an effect on the overall performance of people at work or in education. Furthermore, people residing or working in uncomfortable ambient climates tend to take their own remedial measures, which very often have a negative effect on the energy consumption.

There is no sense in making an energy declaration without defining the indoor climate objective. It is therefore necessary to determine criteria for the indoor climate which can then be used for planning the layout, calculations in respect of energy use, as well as performance and operational matters (Fig. 1.5). Figure 1.7 presents the recommended operative temperatures (mean value of the air temperature and the temperature of the enclosing surfaces) in heating and cooling situations. The operative temperature levels relate to the mean maximum daily temperature of the outside air (hourly average values). Users have to be able to adapt their clothing to suit the operative temperatures. The values presented apply to usual resistance values of clothing ranging between 0.3 and 1.0 clo (clothing, see Fig. 1.9). The levels refer to rooms which allow adjustments of the thermal resistance value of clothing within this range. If adjustments to clothing are not possible or permitted, the thermal resistance values (clo values) given apply for the operative temperatures. For typical thermal resistance values of clothing see ISO 7730.

Ventilation, air quality and emissions
Draughts are a particularly frequent cause of discomfort in ventilated and air-conditioned rooms. Air pollution in the interior of buildings is dependent on a number of factors. Apart from pollution caused by residents, the pollution and emissions from building materials also have to be considered. These have a significant impact on the quality of indoor air (Fig. 1.6). So far, there are no standard procedures for the reliable selection of low-emission building materials. For plan-

ning procedures, the following room clas-
sifications are recommended as a basis
of calculation for the necessary flow vol-
ume of outside air:
· New or fully refurbished buildings,
 where special attention has been paid
 to the choice of materials, can be classi-
 fied as "very low emission".
· Existing buildings, which include build-
 ing materials with high emission rates or
 buildings in which test persons rate the
 air as low quality (percentage of dissat-
 isfied persons > 30 %) are classified as
 "not low emission".
· All other buildings are regarded as "low
 emission".

Natural ventilation systems are depend-
ent on exterior climate conditions (tem-
perature, wind conditions). As a rule, they
are not able to maintain constant interior
climate conditions. These disadvantages
should be defined clearly and the user
should be made aware of them during the
planning process. If mechanical ventila-
tion systems are to be used, careful atten-
tion must be paid to the location of the air
intake and the appropriate air quality. The
defined air flow volume then has to be
transported to and from the designated
rooms using appropriate technical equip-
ment.
The effect the air quality has on the pro-
ductivity and efficiency of occupants has
only recently been examined in greater
depth. Given that the combined salaries
of employees in today's office buildings
are as much as 100 times the costs of
energy and maintenance in a specified
building, an increase in productivity of as
little as 1 % should be sufficient to justify a
doubling of these operational costs or
larger investments to pay for refurbish-
ments in the building.
The relationship between, for example,
room temperature and relative productiv-
ity is presented in Figure 1.8. Depending
on the predicted mean vote (PMV) on the
thermal sensation scale, the greatest pro-
ductivity can be expected at a room tem-
perature of approximately 22 °C. A room
temperature deviation of as little as 5 K
reduces the productivity by more than
5 %. According to [3], productivity can be
increased if the thermal conditions
approach the thermal comfort zone. Poor
air quality results in increased economic
costs. These are caused by, for instance,
more frequent illnesses and a greater
number of days of sick leave, reduced

work performance levels as well as higher
costs for medical treatment.

Future developments and strategies

Against a background of global warming,
questions concerning resource-saving
energy production and efficient use of
energy as well as the introduction of a
closed-loop recycling management are
absolutely essential for mankind. At the
same time, it is necessary to minimise the
energy required to manufacture and
transport building materials as well as the
amount of waste produced during con-
struction. Architects and engineers
involved in the planning procedures have
a contribution to make in this area.
Whereas in recent years, considerable
advances have been made in terms of
energy-saving measures and the efficient
use of energies, greater effort has to be
made to reduce the level of emissions
during the construction and operational
phases of buildings. Regarding the intro-
duction of a closed-loop management
system for building materials and compo-
nents, the building industry is still almost
at the beginning. The following targets
could be defined as a basis for the total
recycling of our built environment:
· Zero energy (construction of buildings
 which, on an annual average, require no
 additional energy)
· Zero emission (construction of buildings
 which do not emit any dangerous pollut-
 ants)
· Zero waste (construction of buildings
 which are fully recyclable).

This requirement for "triple zero" and its
implementation will be the future bench-
mark in building development.

References:

[1] Usemann, Klaus: Entwicklung von Heizungs- und
 Lüftungstechnik zur Wissenschaft, Munich 1993
[2] http://ec.europa.eu/energy/efficiency/buildings/
 buildings_en.htm
[3] Seppänen, Olli; Fisk, William: Association of
 Ventilation Type with SBS Symptoms in Office
 Workers, International Journal of Indoor Air
 Quality and Climate, 2002

Clothing	clo	m²K/W
T-shirt	0.09	0.014
Shorts	0.06	0.009
Underwear with short sleeves and legs, shirt, trousers, jacket, socks, shoes	1.00	0.155
Underwear, shirt, trousers, socks and shoes	0.70	0.110
Pants, tights, blouse, long skirt, jacket, shoes	1.10	0.170
Underwear with short sleeves and legs, shirt, trousers, waistcoat, jacket, coat, socks, shoes	1.50	0.230

1.9

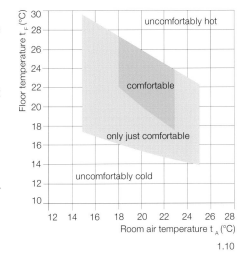

1.10

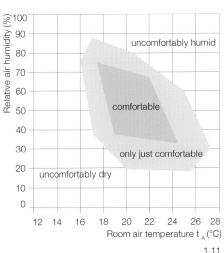

1.11

1.4 Classification of requirements concerning
 comfort in buildings according to DIN EN 15251
1.5 Requirements concerning certain comfort
 criteria according to DIN EN 15251
1.6 Airborne pollutants in building interiors and the
 most important sources
1.7 Operative temperature in building interior
 dependent on the maximum daily temperature
1.8 Relation between room temperature and
 productivity
1.9 Thermal insulation values (clo) of clothing
 according to EN ISO 7730-2005 (D)
1.10 Comfort zone dependent on floor temperature
 and room air temperature
1.11 Comfort zone dependent on room air
 temperature and relative air humidity

Energy concepts and their boundary conditions

The aim of every energy concept is to satisfy all energy-relevant services by creating a perfect interplay of all structural and technical measures. The first step is to perform a needs analysis. The energy demand of buildings is derived mainly from specific boundary conditions and requirements specified by the user. At first, it is these factors, rather than architectural parameters, which have a direct or indirect impact on the energy-relevant services (Fig. 2.3).

The mean outside temperature in Central Europe ranges between –20 °C and +40 °C. The requirements for thermal comfort specified by the user, however, call for temperatures to be maintained within a particular range. This leads to a demand for the provision of services for "heating" and possibly also for "cooling". The luminosity value also varies from almost 0 Lux at night to approximately 100 000 Lux on a sunny day. This leads to the service "lighting". Living or working in enclosed space causes a certain degree of "air consumption" due to corresponding emissions. However, in the ideal case, a constant level of high quality air is required. A systematic air exchange is needed which is achieved by means of "ventilation". If humidity levels have to lie within a certain range, the services "humidify or dehumidify" are required. The temperature level of fresh water in buildings is usually around 10 °C. In order to create acceptable conditions, especially for body hygiene, drinking water has to be heated accordingly. Finally, there will be a need to operate electrical equipment and plant. These range from circulation systems, such as escalators or lifts, to technical tools or tel-

ecommunication and household equipment, such as refrigerators and consumer electronics. In industrial premises, these demands are supplemented by process-related heating and cooling demands. Whereas the climatic boundary conditions are specific to a site and difficult to influence, there is significant scope in the requirements specified by the user. For example, the permitted maximum air temperature in summer has a significant impact on the extent of the energy service "cooling". User behaviour regarding heating, ventilation, lighting or the use of warm water affects the utilisation of energy-relevant services in the same way. For this reason, it is highly recommended that, in agreement with the users, a general analysis of the requirements is made. Deviations from the best available technical solutions make sense if the user explicitly agrees to restricted levels due to economic and/or ecological reasons (e.g. natural ventilation or purely passive cooling). Developing the energy concept at an early stage is a key element in the design of a building which is fit for the future. The procedure can be structured into an analytical part (boundary conditions), a process-oriented part (concept development) and a quantitative part (evaluation) (Fig. 2.1). In line with the form finding methods in architecture, the development and compilation of such a concept is a creative process, which cannot be standardised. This skill is one of the key qualifications of a planner. The foundation for the development of an energy concept is the determination of the boundary conditions, which can be divided into four thematic groups:

Site-specific boundary conditions
Figure 2.2 offers an overview of the most

important site-specific boundary conditions and the impact they have on the energy concept. The focus is on temperature and weather conditions as well as the local energy potential.

User-specific boundary conditions
The required energy services are the result of an analysis of the user-specific boundary conditions, which can in most cases be derived from the building's use. However, they are also influenced by the client's or the user's own ideas and expectations. The requirements regarding room temperature (e.g. living room, bedrooms and offices), summer heat protection (e.g. maximum permissible temperatures in offices) or the air quality (e.g. the air exchange rate in a classroom) are important boundary conditions in developing an energy concept.

Technical and legal boundary conditions
Guidelines laid down by building planning law and building regulations (e.g. development plan, design regulations, etc.) as well as regulations concerning energy saving measures are part of an increasingly strict technical regulatory framework. The building density, cubage, roof shape, specifications regarding materials, etc. can in part be derived from these specifications. Supplementary information concerning the technical infrastructure (e.g. district heat, gas connection, mandatory connection, etc.) and possible legal requirements according to the building's use (e.g. ventilation in concert halls) are also further influential factors.

Design-related conditions
When developing energy concepts, the potential and availability of energy from the local environment – and therefore the

interrelation between the building and its immediate surroundings – are an important boundary condition for the design. The amount of solar radiation, depending on the orientation of the building, leads to specific demands on, for example, transparent exterior wall surfaces or on sun protection devices. Finally, geometric aspects, such as plot size relative to building volume or usable floor area relative to potential solar areas, the shading by surrounding buildings and special requests put forward by the client, are all important design parameters.

Assessment

Energy concepts compiled in the early stages of planning contribute considerably towards an objective evaluation. With reasonable effort and expense, it is possible to determine and evaluate the energy demand, comfort and emission levels fairly precisely by using characteristic values and descriptions of possible measures. In terms of a comprehensive analysis, there are four significant dimensions: ecological, economic, social and architectural evaluations. The ecological evaluation reviews possible negative effects that energy utilisation and generation have on the environment. The primary evaluation parameter is the emission of CO_2 or equivalent substances (Fig. 2.5, p. 14). The assessment is performed in accordance with generally accepted methods. The Energy Performance of Buildings Directive applies for the operation of buildings.

In the context of an environmental assessment, it is also important to consider all the energy flows for the construction and deconstruction of the building. The limits of the assessment have to be defined in agreement with the user or the client. Furthermore, it is necessary to check the overall cost effectiveness of measures to optimise energy efficiency, the utilisation of renewable energy sources and the eco-efficiency of projects. It should be noted that restricting consideration to investment costs and their minimisation, which is often still commonplace, fails to meet any of these objectives. A full picture of a project's economic effectiveness can only be achieved through a combined analysis of running costs, subsidy measures and, if appropriate, proceeds from using renewable energies. The aim is to examine the costs over the entire life cycle of a build-

2.1

Boundary conditions	Influenced parameters
Annual temperature development with extreme values	Thermal quality of the building envelope
Air temperature difference day/night	Possibility of utilising passive, natural cooling (cooling potential of the night air)
Annual mean temperature	Utilisation of surface-near geothermal energy
Air humidity	Possibility of utilising adiabatic cooling
Wind velocity Wind directions	Natural ventilation Utilisation of wind power to generate energy
Amount and distribution of precipitation	Evaporative cooling via air-conditioning and ventilation plant
Nature of soil, groundwater	Building heating and cooling via ground or groundwater
Intensity of solar radiation Solar ecliptic	Passive utilisation of solar energy Heat protection in summer Energy yield through solar thermal systems Energy yield through photovoltaic systems

2.2

Requirement	Boundary condition	Service	Energy topic
Provide comfortable temperature	Outside temperature (-20 to +40 °C)	Heating and cooling	Heat
Provide comfortable light	Illuminance (0–100 000 lux)	Lighting	
Maintain air quality	Air consumption (15–130 m³/h person)	Ventilation	Cold
Provide comfortable air humidity	Air humidity (0–100 %)	Humidify and dehumidify	Air
Provide domestic hot water	Drinking water supply (approx.10 °C)	Heat drinking water	
Operate electrical equipment	Equipment efficiency	Supply electricity	Light
Provide process heat	Process efficiency	Generate process heat	
Provide process cold	Process efficiency	Generate process cold	Electricity

2.3

Energy topic	Minimise energy demand	Optimise energy supply
Heat	Retain heat	Generate heat efficiently
Cold	Avoid overheating	Dissipate heat efficiently
Air	Supply air naturally	Supply air efficiently with mechanical support
Light	Utilise daylight	Optimise artificial lighting
Electricity	Use electricity efficiently	Generate electricity in decentralised units

2.4

2.1 Schematic diagram of the procedure for compiling an energy concept
2.2 Site-specific boundary conditions and their influence on the energy concept
2.3 Requirements, boundary conditions and services for providing building systems
2.4 Action areas and components for the compilation of an energy concept

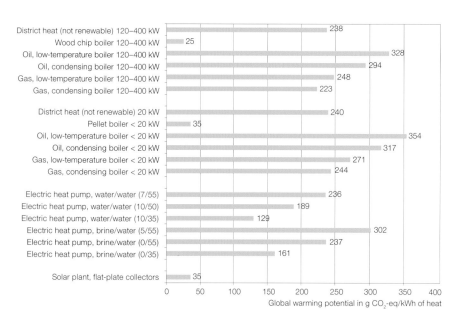

2.5

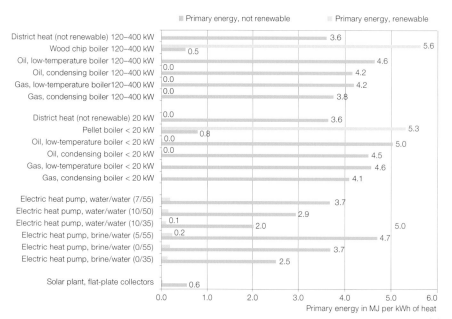

2.6

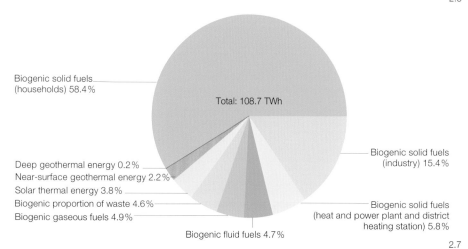

2.7

2.5 Global warming potential of heat generators
2.6 Primary energy efficiency of different heat generators
2.7 Heat provision from renewable energies in Germany (from 2009)

ing. When assessing energy concepts, it is absolutely essential to consider the effects they may have on the users of the building. User acceptance is a key requirement for the wellbeing of the user and operation in accordance with planning. Apart from thermal comfort, the visual, acoustic and olfactory features (e.g. perceived temperature, indoor air humidity and air movement) all influence the user's wellbeing. The possibility to adjust the room climate (e.g. open the windows, individually control sun and glare protection, etc.) are further significant factors affecting user satisfaction. Finally, energy concepts can have a strong impact on the appearance of buildings and rooms. They should influence architecture in a positive way and demonstrate that the built environment is willing to face the big socio-political challenges of today. The ideal goal is therefore to use the ecological, economic and social requirements of the energy concept as a catalyst for the design of high-quality and possibly innovative buildings.

Concept development: 10 steps to an energy-efficient building

The development of an energy concept includes a core of two complementary objectives (Fig. 2.1, p. 13). On the one hand, the aim is to keep the energy demand low by applying suitable structural measures. The structure, construction and materials should be coordinated during an early planning phase in a way that enables the building to offer a comfortable room climate without any substantial technical support for as long as possible. This means that components of a building should not be selected merely for their structural, functional or aesthetical characteristics, but ideally should also offer additional benefits in terms of energy use (e.g. building component activation). The challenge, apart from the utilisation of synergy effects, is to find creative solutions for conflicting objectives such as compactness versus use of daylight or transparency versus summer heat protection.

The second conceptual emphasis is on a sustainable design of the technical measures for the energy supply. To enable this, the chain from the source of energy to the desired energy service provider has to be understood and examined to see whether it is efficient and appropriate

for the future (Fig. 2.6). The surface required to generate energy has to be considered at the same early stage as the supply of suitable technical space. Once again the aim here is to create synergy effects by constantly balancing aesthetic and structural measures. If the individual aims are analysed in terms of minimisation of energy demand and optimisation of energy supply according to the five energy topics, heating, cooling, ventilation, lighting and electricity, 10 steps stand out that together form the basis for the development of an energy-efficient building (Fig. 2.8, p. 16).

All considerations concerning the energy concept should begin with the question whether and to what extent a specific energy service can be provided to the user without a loss of quality. The systematic handling of this "zero option" can lead to the discovery of simple technical solutions and new spatial experiences. It is advantageous to draw up a clearly formulated agreement about the energy-saving targets for the building in question as a basis for the development of an energy concept. Energy standards which are clearly defined in terms of their requirements, calculation methods and proof procedures can be applied as guidelines. The agreed target of a carbon-neutral building, for example, can be achieved by using renewable energies to cover the total energy demand throughout the operation phase or even the total life cycle of the building. The question concerning the extent to which energy services are to be provided by technical systems depends on the type of use and the standard of requirements. Of overriding importance, however, are the shape of the building, the building envelope and the choice of materials. There are two possible strategies to consider. The first is directed towards technological solutions that ensure perfect functionality. In this case, numerous energy systems, flaps, valves, sensors, etc., offer flexibility and the ability to adapt. They are controlled by complex software which guarantees optimal settings in response to climatic boundary conditions and user behaviour. Supported by technically-optimised building equipment, comfortable indoor conditions can be achieved in almost any building and in almost every location.

The other strategy is aimed at designing the building so that the desired conditions – possibly with minor concessions regarding the optimal result – are achieved with a minimum of technical equipment. Reflected in this are the urban arrangement as well as an energy-optimised building shape and envelope, the distribution of functions and the choice of materials. In layman's terms, these strategies are often referred to as "high-tech" and "low-tech". Since, as in most cases, neither of these theories can be realised in isolation, a balanced interplay of both strategies usually leads to the best results.

Step 1 + 2: Conserving and supplying heat efficiently

The supply of heat is one of the most important tasks in building services engineering. During heating periods, it is essential to make sure that heat does not escape and as a result is retained for as long as possible. Since, despite all efforts, there often remains a need for additional heat input, it is essential to provide an efficient way of producing, storing, distributing and transferring heat. In all of these areas, however, especially in the production of heat, there is potential to utilise renewable energies and develop a low carbon or even carbon-neutral master plan. Numerous technologies which utilise biomass, solar thermal systems or heat pumps offer a range of possibilities. As a renewable resource in energy supply, herbal biomass offers the benefit of providing a carbon-neutral cycle, since the same amount of CO_2 is discharged during combustion as is absorbed during the growth of the plants. Biomass is therefore regarded as a carbon-neutral energy source, subject to the condition that the growth and the utilisation of the cultivation are configured in a sustainable way (Fig. 2.7). Solar thermal energy which is solar radiation converted into thermal energy offers further considerable potential for the heat supply in buildings (see Building services systems, p. 29ff).

In active solar thermal energy systems, the functions solar energy absorption, conversion and storage are not exclusively taken care of by the building itself or by the building's components. Furthermore, the heat flow can be influenced significantly using automatic control technologies. The aim of most active systems for heat supply is to maximise the time separation between provision of the required heat quantity and the solar radiation. For this reason, the storage facility in combination with the automatic control device play a decisive role within the system as a whole.

There are further potential heat sources in the immediate surroundings of the building. The term "ambient heat" includes the earth's upper atmospheric layers up to a height of approximately 100 m as well as the strata close to the surface (ground, groundwater and surface water) down to a depth of approximately 200 m. Waste heat from production processes, waste water and exhaust air are further forms of ambient heat. The temperature of these heat sources is generally too low for the direct heat supply of buildings. In order to use the energy content regardless of the temperature level, the ambient heat has to be treated efficiently with the support of a technical device, a heat pump (see Building services systems, p. 24ff.).

Step 3 + 4: Avoiding overheating and dissipating heat efficiently

In cooling, the initial aim is to avoid overheating of the usable space by means of planned structural and constructional measures. If cooling is still required or requested, the same requirements and possibilities apply as for the heat supply in that, if possible, the excess heat should be removed in a carbon-neutral way. Systems that use the cooling potential of the ground and the ground water or solar energy for cooling purposes are environmentally beneficial (see Building services systems, p. 40ff.).

Most buildings, especially those in cold or temperate zones and those planned in an energy-efficient way, can be operated without active cooling. Design of the building envelope with a view to minimising the external cooling load is therefore the highest priority. However, special work processes, specific climatic boundary conditions or especially high cooling loads due to the building's function sometimes require the provision of "cold input", or, to use the physically correct term, "heat sink". Ideally, the heat load in buildings should be dissipated by means of naturally available cooling potentials or heat sinks, without an active cooling mechanism. The media air, ground and water offer ideal temperatures for this purpose. In most cases, the demand for cooling corresponds with periods of high outside temperatures. Nevertheless, there are situations during the course of the

a

b

c

d

e

2.8

2.8 10 steps for energy concepts
 1. Minimise energy demand:
 a Retain heat
 b Avoid overheating
 c Natural ventilation
 d Utilise daylight
 e Use electricity efficiently

day and the year, when the outside air can be directly integrated into the technical concept as a heat sink (e.g. night-time ventilation). In order to make use of the ground's temperature level as a heat sink, there are basically two suitable concepts: for buildings with mechanical air supply systems, the outside air can be drawn into the building through earth pipes (also ground loop) (see Building services systems, p. 61ff.). This method reduces the air temperature by several kelvin which often makes further cooling unnecessary. As an alternative to earth pipes, ground probes or mass absorbers (e.g. bored piles) can be installed into the ground as a heat sink for cooling purposes in the same way as they can be used as a heat source (see Building services systems, p. 40f.). This multiple utilisation accelerates regeneration of the ground and leads to improved efficiency of the overall system.

Active systems are required for larger cooling loads. Apart from efficient electrical refrigeration machines, which can ideally be run on regenerative power, the application of sorption-assisted systems is an interesting alternative for cooling the building. If the heat to drive the cooling process is exclusively or mainly produced by solar thermal systems, the method is referred to as direct solar cooling. If cooling loads and solar gains occur simultaneously, the cooling medium can be supplied in a carbon-neutral way and with little demand for storage.

Step 5 + 6: Natural ventilation and supplying air efficiently with mechanical support

Good air quality in buildings requires a regular air exchange related to the use of the space and the number of people occupying it. Today's construction methods produce high degrees of airtightness; an uncontrolled air exchange through joints and gaps is largely prevented. For this reason, it is necessary to plan ventilation systems carefully by using either the building envelope or technical building equipment.

In line with sustainable aspects, it is first of all necessary to strive for a large proportion of natural ventilation. Electric ventilation consumes a considerable amount of energy, on average a specific electric power output of approximately 2500 W is needed per cubic metre of air per second. However, the function and efficiency of systems for natural ventilation are

dependent on the climatic conditions of the surroundings. There are therefore considerable fluctuations in the flow volume and the air exchange rate. If a constant air exchange is requested, additional mechanical ventilation to supply fresh air and remove exhaust air is needed.

There are numerous systems using differing methods to convey and treat air. Decentralised mechanical ventilation units using the building envelope allow a constant air exchange rate without air ducts. Further advantages are the space saved by not having to install vertical or horizontal ducts, greater flexibility in the case of changes of use and higher efficiency due to an individual, demand-dependent operation. Apart from maintaining an even volume flow rate, decentralised mechanical ventilation units can eliminate further disadvantages involved in natural ventilation: if there is exposure to noise, the ventilation can be taken care of with closed, sound insulated windows and, due to the use of air filters, the quality of supply air is improved.

If the system includes air supply and exhaust air facilities, the ventilation heat loss can be reduced considerably during the heating period by integrating a heat recovery system. The installation of heating or cooling coils enables the supply air to be heated or cooled accordingly. These units can therefore also be used to provide heating and cooling.

Facade ventilation devices take in fresh air directly at the facade. The units can be integrated in raised flooring or in the ceiling area, in parapets or frames. Since the efficiency of facade ventilation equipment is limited in terms of flow volume, it is especially suitable for offices with little room depth. Furthermore, facade ventilation units can be retrofitted, for instance, within the scope of refurbishment work. Apart from taking care of the air exchange, an air-conditioning and ventilation plant can also be used to maintain temperature and humidity levels. The size of the plant is determined by the required heating or cooling capacity. Depending on the requirements, this can lead to a very high air flow volume, which affects the size of the plant and the corresponding energy consumption. For this reason, it is desirable to limit the air flow volume to a level that just satisfies hygienic standards. Surplus heating or cooling capacities that cannot be covered must

hen be satisfied by additional systems
e.g. radiators, cooling panels, etc.). In
the energy balance of well-insulated
buildings, the level of ventilation heat loss
is considerable. During the heating
period, significant amounts of heat are
lost through the exhaust air either by
opening windows for ventilation purposes
or by using installed exhaust air plants.
Energy-efficient ventilation, therefore,
requires a controlled supply and exhaust
air plant with an integrated heat
exchanger. With efficiency levels of over
90%, ventilation heat loss can be avoided
almost completely.

Step 7 + 8: Using daylight and optimising the use of artificial light

The aim of light planning is to achieve
maximum daylight autonomy by optimis-
ing the concept of the building. On the
other hand, the use of the building has to
be maintained independent of the avail-
ability of daylight.

In some cases, it is not possible or not
desired to use daylight. In this case, the
aim is to provide adequate artificial light
with minimal energy consumption. It is
important, in this context, to consider col-
our neutrality, good contrast as well as
glare-free conditions.

In order to optimise the light concept from
an energy perspective, there are gener-
ally three relevant planning aspects: light-
ing technology, lighting concept and light
automation. The choice of lighting prod-
uct has a significant impact on the elec-
tric power demand. The efficiency (lumi-
nous efficacy), measured in lumens per
watt of connected load, sometimes differs
considerably. What is more, a low lumi-
nous efficacy leads to greater heat devel-
opment which in turn affects the internal
heat load of the building.

High levels of illumination, especially in
work situations, have a positive effect on
visual acuity and productive efficiency.
However, due to the high number of full-
load hours, the installed light output has a
major impact on energy consumption. A
reduction to the minimum necessary level
not only reduces energy consumption but
also construction costs.

With regard to the type of lighting
selected, there is a major difference in the
energy consumed by direct and indirect
lighting or a combination of the two. Indi-
rect lighting has a positive effect on the
space and is often considered pleasant
since hardly any shadow is cast and

there is no glare. However, in order to
meet the desired level of illuminance, it is
necessary to install significantly higher
light output, compared to direct lighting,
which leads to a corresponding rise in
energy consumption. An optimised
design of the interior using light and/or
reflective surfaces improves the lighting
situation within the space. The proportion
of reflection or the loss of luminance due
to the light-absorbing features of the sur-
faces varies considerably according to
material and colour.

The aim of automation is primarily to
increase the user's level of comfort. In
addition, there are high saving potentials
in the power consumption of lighting due
to a reduction of full-load hours. The
degree of automation has to be deter-
mined by balancing the two target values,
energy saving and user satisfaction. An
optimised automatic control mechanism
should respond sensitively to user
requirements without being overpower-
ing. It makes sense to differentiate
between mainly common areas (e.g.
access and circulation areas, sanitary
rooms, etc.) and individually used rooms
that demand manual control (e.g. single
or shared office cubicles).

Step 9 + 10: Applying efficient equipment and generating power in decentralised plants

In physical terms, electric power is the
most valuable form of energy since it can
be converted into all other forms of
energy (mechanical power, heat, etc.).
Due to the many different fields of appli-
cation, it has become indispensable in
everyday life. This is especially true in the
operation of buildings. As a result of ris-
ing efficiency in heating services, the
electric power demand is playing an
increasingly important role. In contrast to
the thermal economy, influence over the
electricity consumption caused by the
building's users is limited. The demand
for electric power, over and above that for
artificial lighting, cooling and ventilation,
is generally determined by the user's
needs and the electrical equipment they
require. The aim here, apart from plan-
ning the building in an optimal way, is to
ensure that users install energy-efficient
equipment, wherever possible.

In the context of a future-oriented electric
power supply, which is to be generated in
decentralised plants based on renewable
energies, the planning of a building is of
crucial importance: apart from minimising

f

g

h

i

j 2.8

2.8 10 steps for energy concepts
 2. Optimise energy supply:
 f Generate heat efficiently
 g Dissipate heat efficiently
 h Supply air efficiently with mechanical support
 i Optimise artificial light
 j Generate electricity in decentralised systems

the electric power demand, every building should be examined in order to determine whether and to what extent the structure itself can be used to produce electricity. Ideally the building should be able to fully satisfy its own electric power demand. The overall aim is not to operate the building off the grid, but to achieve a neutral energy balance over the course of a year.

Photovoltaic and combined heat and power plants are well-developed systems for the decentralised generation of electric power, which are immediately linked to the planning of the building. There are further important technologies that have not yet been integrated in buildings, but may be a source of value in the future (e.g. solar thermal power generation, wind energy, waterpower, etc.). Photovoltaics offers the opportunity to generate electricity by using the building envelope without causing any mechanical wear and tear, emission or noise. Photovoltaic modules are technically-mature products and are available in various configurations. Apart from generating energy, these modules are increasingly taking on additional functions and are therefore making use of numerous synergy effects. Photovoltaic elements can be used in weather and sun protection situations as well as for visual screening or even as insulating glass modules forming the thermal envelope of a building. In pitched roofs, photovoltaic modules can be applied directly to shed water and therefore replace conventional materials such as roof tiles.

South-facing single-pitched or saw-tooth roofs are best suited for the integration of photovoltaics. The amount of solar radiation captured on vertical surfaces is less than that on inclined surfaces. However, in return, these facades have considerable energy and economic potential, especially when conventional, high-quality components, such as metal panelling or natural stone, are replaced by photovoltaic elements. Owing to their usual function of preventing direct solar radiation, shading elements are particularly suited for the integration of photovoltaic modules.

In addition to photovoltaics, the decentralised combined heat and power (CHP) generation, which combines the generation of electricity and heat in one process, is an important aspect. The generation of heat and power can either be directly integrated into the energy concept of the building or within the neighbourhood. Depending on the choice of energy medium, various technologies are available for the decentralised cogeneration of heat and power. From an ecological point of view, renewable energy sources should be favoured, for example, biomass, hydrogen, waste heat or solar radiation.

Costs and profitability

The development and implementation of an energy concept is an integral part of project planning today. Energy concepts determine potential ways to save energy and make proposals for the economic operation of a building.

A concept of systems tuned to meet the needs of the building and the application of regenerative energies are requirements to reach national and European climate protection targets as well as maintain normal standards of comfort. They should also ensure economic efficiency when operating the building. Since every building is a prototype in its own unique surroundings, it requires its own analysis in terms of energy and technical plant. Against this backdrop, the early involvement of specialist consultants will become increasingly important since they possess the detailed technical knowledge necessary to develop plans for individual concepts.

Design requirements

Alongside traditional requirements regarding the functionality and the appearance of buildings, energy issues are coming increasingly to the fore. Subject to the basic principle of viability, the total energy demand in a building (and especially the demand for fossil fuels) has to be minimised by means of structural, architectural, technical and organisational measures. While the overall economic efficiency of a project is a key factor, the level of comfort that can be achieved with a specified concept must also be borne in mind. With just a few minor adjustments, the scale of technical building facilities can be reduced and their energy efficiency increased, leading to a reduction of costs:

Compact building shapes are more energy efficient as well as economical. The orientation and inclination of the building's envelope influence the possible use of passive or active solar energy and should therefore be investigated at an early stage. The utilisation and orientation of rooms in the building should be coordinated with regard to, for example, temperature and noise. The aim is also, if possible, to make maximum use of natural light. Rooms without windows and large room depths should therefore be avoided. There is, of course, the possibility to use light channelling systems. The proportion of windows in the facade has to be balanced carefully with regard to natural daylight as well as energy loss and gain, especially the demand for cooling in summer. It is important to examine whether easily accessible, convertible or retrofittable medium channels (electric and communication facilities, water-bearing systems) can be fitted in an economically efficient way.

Energy requirements concerning construction and building services

The level of energy consumption (and therefore the operating costs) of a completed building is influenced significantly by the building design. This applies particularly to the need for cooling, the electric power demand for lighting and, if required, mechanical ventilation. The significance of the annual heat demand, which used to have a dominant role, has declined due to the improvements in building envelopes, especially in the area of non-residential buildings. In terms of energy and economic efficiency, glass facades are generally unfavourable. This applies in particular to north-facing facades, which in our region (northern Europe) should be designed in a more or less closed fashion. In contrast, large proportions of glass on the south side can make sense from an energy perspective if glass with a very low thermal transmittance value (U-value) is used. Effective shading devices can provide protection from summer heat. Concerning building ventilation, the possibilities and limits of natural ventilation should be examined. Ventilating during the cool hours at night is particularly helpful in providing an energy-efficient and economic temperature balance in summer. However, site and fire protection issues need to be considered in this case. The airtightness of the building envelope also has to be taken into account. A reduction in the electric power demand can be achieved by using efficient technical building systems.

The cost effectiveness of using renewable energies should be considered at an early stage in the design. In Germany, under the Renewable Energy Heat Act (EEWärmeG), it is mandatory to use renewable energies for the heat supply in new buildings. The Act stipulates the minimum proportions of energy demand, dependent on the technology, to be covered by renewable energies. This requirement may be waived if the building undercuts the primary energy demand of the EnEV by 15 %. This means, for example, that a new building which meets the requirements of the EnEV, due to the installation of condensing boiler technology and a solar thermal system, and which also satisfies the requirements of the EE-WärmeG, due to the installation of a solar system, is allowed to consume 15 % more primary energy than a comparable new building which has invested in efficient insulation rather than a solar system.

The efficient utilisation of renewable energy technologies is just as important as their installation. In order to save on the consumption of primary energy by using, for instance, a heat pump, the annual performance factor (APF) should be at least 3.0. Otherwise a condensing boiler would be more efficient in terms of primary energy. Hence, it is not sufficient to simply plan and install a heat pump, it also has to work efficiently, for example, in combination with a panel heating system with a low-temperature heat transfer medium. Only the quantity of heat which is generated with a APF > 3.0 can be included in the proportion of renewable energies.

Economic evaluation based on variant comparison

Variant comparisons are necessary when considering different competing technical systems since their advantages and disadvantages are unclear without a detailed investigation. This usually involves financial comparisons based upon projected energy use and annual cost balances (reflecting investment costs, operating costs, annual costs determined according to annuity procedures).

Figures 2.9 and 2.10 compare, by way of example, the investment and energy costs of four different room-conditioning concepts. The installation of an air-conditioning system was compared with a chilled ceiling (in combination with mechanical ventilation) as well as two fur-

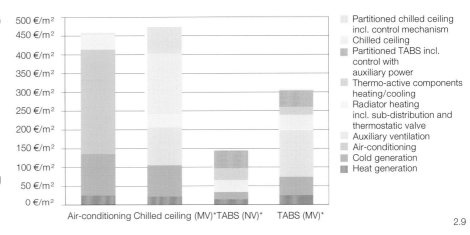

2.9

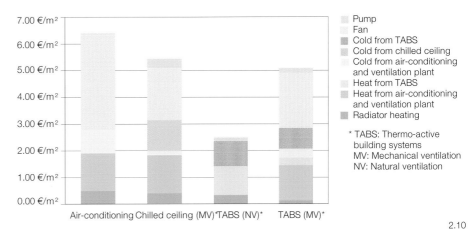

2.10

Level of demand	very high	high	mod-erate	low	very low	very high	high	mod-erate	low	very low
Room function	**specific installed capacity (W/m²$_{ERA}$)**					**specific electric energy demand (kWh/m²$_{ERA}$a)**				
Office, one to two workplaces	59	53	27	16	11	100	77	33	19	6
Open-plan office, three to six workplaces	47	41	22	13	8	100	70	33	19	6
Open-plan office, more than seven workplaces	38	32	18	11	7	100	90	48	23	13
Meeting room, conference room, seminar room	47	42	22	13	8	110	80	35	21	4
Ticket hall	20	18	11	8	6	55	49	30	16	7
Retail, department store (without refrigerated products)	25	22	13	9	7	91	78	48	33	25
Retail, department store (with refrigerated products)	27	23	14	10	7	96	82	50	35	26
Classroom	25	21	12	7	4	31	19	9	4	2
Lecture hall/theatre	45	39	21	12	7	67	47	22	13	5
Bedroom	39	35	18	11	6	160	110	51	30	8
Hotel room	26	23	12	7	4	60	54	28	16	4
Canteen	16	13	7	5	3	28	18	9	5	
Restaurant	19	17	11	8	6	81	63	35	26	15
Kitchen in non-residential building	49	43	23	14	8	190	130	65	40	18
Kitchen – Preparation, storage	31	27	14	9	5	100	70	34	21	6
Toilets and sanitary rooms in non-residential building	26	23	12	7	4	50	36		9	0.4

2.11

2.9 Investment costs for heating and air-conditioning (office and administration buildings)
MV = mechanical ventilation system
NL = natural ventilation

2.10 Annual energy costs for heating and air-conditioning (office and administration buildings)
2.11 Specific energy demand for lighting according to VDI 3807 (excerpt)

Plant component	Calculated service life[1]	Expense of repair[2]	Expense of maintenance[2]	Expense of operation[3]
1 Heating				
1.1 Benefit transfer				
1.1.1 Heating surface with ancillary equipment (valves, screw fittings, fixing device)				
Cast iron radiators	40	1	0	0
Steel radiators	35	1	0	0
Panel radiators, steel	30	1	0	0
Convectors with covering	30	2	0	0
Painting of radiators	10	0	0	0
Ceiling heating with suspended steel pipes and heat conducting plates	20	1.5	0.5	0
Warm water floor heating	30	1	0	0

[1] in years
[2] in per cent of the investment sum per year and component
[3] in hours per year. Expense for operation is added to the production of each component.

2.12

Calculation of the annuity factor in relation to interest rate and time period

$$AF = \frac{i + (1 + i)^n}{(1 + i)^n - 1}$$

whereby AF = annuity factor
i = interest rate (e.g. at 5%: i = 0.05)
n = period in years

Time (years)	Annuity factors at an interest rate of								
	2.0%	3.0%	4.0%	5.0%	6.0%	7.0%	8.0%	9.0%	10.0%
1	1.020	1.030	1.040	1.050	1.060	1.070	1.080	1.090	1.100
5	0.212	0.218	0.225	0.231	0.237	0.244	0.250	0.257	0.264
10	0.111	0.117	0.123	0.130	0.136	0.142	0.149	0.156	0.163
15	0.078	0.084	0.090	0.096	0.103	0.110	0.117	0.124	0.131
20	0.061	0.067	0.074	0.080	0.087	0.094	0.102	0.110	0.117
25	0.051	0.057	0.064	0.071	0.078	0.086	0.094	0.102	0.110
30	0.045	0.051	0.058	0.065	0.073	0.081	0.089	0.097	0.106
40	0.037	0.043	0.051	0.058	0.066	0.075	0.084	0.093	0.102
50	0.032	0.039	0.047	0.055	0.063	0.072	0.082	0.091	0.101
60	0.029	0.036	0.044	0.053	0.062	0.071	0.081	0.091	0.100
70	0.027	0.034	0.043	0.052	0.061	0.071	0.080	0.090	0.100
80	0.025	0.033	0.042	0.051	0.061	0.070	0.080	0.090	0.100
90	0.024	0.032	0.041	0.051	0.060	0.070	0.080	0.090	0.100
100	0.023	0.032	0.041	0.050	0.060	0.070	0.080	0.090	0.100

2.13

Measure	Energy-saving (kWh/m²a)	Investment (Euro/m²)	Equivalent energy price (Euro/kWh)
Insulation (roof, basement ceiling, exterior wall)	50–150	50–250	0.02–0.20
Windows	20–50	30–150	0.06–0.30
Boiler replacement	20–120	20–80	0.02–0.20
Comfort ventilation system	10–30 (max.)	20–70	0.08–0.25
Solar domestic hot water production	5–20 (max.)	35–50	0.10–0.30
Solar domestic hot water production and support for heating	10–25 (max.)	50–80	0.10–0.40
Hydraulic balancing and optimisation of heating following refurbishment	10–20	1–6	0.02–0.04

2.14

2.12 Service life and repair costs of technical installations according to VDI 2067
2.13 Annuity factors for dynamic calculations of profitability
2.14 Examples for equivalent energy prices in relation to increased energy efficiency in buildings

ther alternatives including thermo-active building components (with mechanical ventilation (MV) and natural ventilation (NV)). The calculations and cost findings refer to an office building with four storeys and a usable floor area of 1200 m², a SA/V ratio of 0.35 as well as a heavy type of construction in the climate region III. Components, which, compared to standard solutions, result in low energy costs but involve large initial investments, can only be regarded as profitable if a long operating life can be anticipated. For example, geothermal systems amortise a lot quicker if they can be used to generate heat in winter and cold in summer. Furthermore, these systems have to be combined with panel heating in order to operate efficiently.

If, for structural reasons, bored piles are required for the foundation of the building, it makes sense to use them as thermo-active components at minimal extra cost. In contrast, the high investment costs for bored piles or ground probes, which are used exclusively for energy supply purposes, cannot be justified simply on the basis of the resulting lower energy costs.

Economic evaluation – life-cycle costs
To evaluate the profitability of a construction project, the investment and operating costs need to be brought together in the same equation. They have to be regarded as a single evaluation criterion within the global evaluation. Maintenance and servicing costs can vary significantly according to the different concepts and therefore also have to be considered in the life-cycle cost analysis. A differentiated approach to cost planning is the basic requirement for every estimate of construction cost and economic assessment. Furthermore, the cost plan must be updated and detailed continuously through each service phase in accordance with the Official Scale of Fees for Services by Architects and Engineers (HOAI). It is supported by comparisons with costs in similar reference buildings, and all calculations are based on structural units, usable floor area, components and/or according to construction-based award units. The data collections of state and county authorities, architectural associations and other recognised advisory bodies can serve as a reference. The aim of the cost determination phases, cost framework, preliminary cost esti-

nate, cost calculation and price quotation according to DIN 276, is to produce comparisons of cost which correspond to the appropriate phase and the specific building. Comparable and characteristic values from data collections are evaluated and applied to the cost planning. The data must be relevant in terms of the specific nature of the building project, the agreed performance standards, construction and outfit as well as any special features in relation to the site and the way it is to be developed. Additional building costs that result, for example, from installing energy-efficient systems or using renewable energies have to be justified by the impact they have on the costs of using and operating the building. For the use-related cost categories, water supply/waste water, heating/cooling and electric energy, appropriate preset values (reference and target values) have to be taken into account and calculated according to the applicable local prices and tariffs (Fig. 2.11, p. 19). The results are brought into the economic evaluation.

In order to establish comparable cost standard values, it is necessary to determine a single reference value. Since buildings are erected for one specific purpose, represented by the main usable floor area (UFA), the value is generally referred to as $€/m^2_{UFA}$. If only the gross floor area (GFA) is known during the preliminary planning stages, the reference value $€/m^2_{GFA}$ is applied.

For the ecological and economic evaluation over the life cycle of the building, it is necessary to incorporate the useful life expectancy of the components into the evaluation. The life expectancies of a few selected components presented in Figure 2.12 are derived from past experience with these particular technical building systems.

The actual service life of the technical building systems depends mainly on the type of installation, the quality of workmanship, the actual usage, servicing and maintenance. Table values for an average life expectancy can be used as a guide for the evaluation, but the actual service life may deviate from this value. The costs for servicing and maintenance, cleaning as well as actions to maintain the value of the property are to be included in the evaluation.

The actual service life of a building cannot be predicted. However, attempts can be made to understand the tasks that will probably occur during the life cycle by studying different scenarios. These could include strategies for upkeep, renewal or conversion, forward planning to eliminate or cushion the effects of future problems in that, for example, installation of unnecessary systems is avoided.

Procedures to evaluate profitability
Static evaluation procedures assess the profitability according to a comparison of the costs and/or the proceeds of an investment without considering the time at which they occurred. The simplicity of this method makes it extremely popular in practical applications. However, static procedures are not always suitable in the real estate sector, since large single investments have to be balanced against comparatively low revenues and savings arising over extended periods. The timing differences are not reflected in a static valuation since the precise timings of incoming and outgoing payments are ignored.
A dynamic evaluation procedure is therefore preferable. The effort, especially with the support of computers, is hardly any greater and the results are more meaningful.
In contrast to static procedures, dynamic procedures take the incidence of ingoing and outgoing payments into account. One advantage of the dynamic investment appraisal is its unrestricted suitability for the absolute and relative valuation of investments. The absolute valuation determines whether the investment is justified; the relative valuation, in contrast, helps to select the best from several alternatives. The dynamic procedure brings interest and compound interest into the evaluation.
The key question when using the annuity method is the amount of regular income which can be derived from a given investment. It is especially suited for the evaluation of investments which compare a single payment at the beginning and profit or saving streams at regular intervals thereafter. This applies, for example, if an investment is made to improve the ecological quality in the course of a modernisation. In this case, the investment is a one-off expense which is off-set against regular profits at later dates – here in the form of saved energy costs.
In order to calculate the annuity, the one-off expense is spread into a series of reg-

ular payments over the life cycle. This annual amount is calculated by multiplying the one-off expense by the annuity factor. The annuity factors for given interest rates and time periods are shown in the annuity table (Fig. 2.13).

Equivalent energy price
In order to assess the benefits of measures undertaken to save energy and minimise emissions, the traditional method, the profitability assessment, has been supplemented by a cost calculation designed to show the energy saved in the particular case (equivalent energy price).
The equivalent energy price (cent per saved kWh) can either be determined according to the useful energy (heat demand) or the final energy (demand of final energy media). Since the saving of energy is expressed in kWh/year, the costs of the measures taken have to be divided equally over the life cycle or a specific utilisation period and expressed in Euro per year.
By applying the annuity factor, the expenses can be converted into the annual costs for financing the appropriate scheme, possibly also including the costs for maintenance and servicing. The period under consideration tends to be the service life of the component or the technical building system. At first, the determined equivalent energy price is totally independent of the energy medium, the tariff or the efficiency of the energy conversion. Only the current investment costs and the current interest rates are included in its calculation. However, the funds that have to be raised for each saved kWh to realise the scheme are expressed in this context. The equivalent energy price can then be compared with the costs, specific to the energy medium and the conversion of the energy selected, of supplying final or useful energy.
The scheme is advantageous when the expenses involved in saving a unit of energy (kWh) are lower than its generation or supply. Figure 2.14 presents a few examples of approximate values. These values refer to heated residential space. Schemes should, however, not only be assessed according to the equivalent energy price. In addition, the potential savings of the scheme in comparison to the initial situation should also be quoted in absolute or relative terms.

· Heating
· Cooling
· Air supply
· Power supply
· Water supply

Heating

Worldwide, but particularly in Europe, the heat supply to buildings is a focal issue. The first aim of a sustainability concept is for buildings to be constructed in such a way that comfort is achieved with minimal demand for energy. This is achieved primarily by developing an energy concept which optimises building volume, building envelope and selection of materials. In addition, the operation of buildings in most climate zones requires a heat supply capable of being regulated. The technical measures implemented in this case have a considerable impact on the user's comfort as well as the local environment. The building services involved in supplying heat in close coordination with the building envelope is seen as an integral component of the energy master plan. A distinguishing feature of an energy-efficient building envelope is that the required indoor climate conditions can be maintained throughout the year with little energy demand and without, as far as this is possible, complex supply technology. The planning is based on a detailed analysis of the climatic conditions, the building's utilisation and related matters. A building envelope optimised to reduce energy use will maximise passive measures and is therefore the basis for a future-proof energy concept.

With regard to winter comfort, the main aim is to retain as much of the building's heat as possible. Concerning the loss factors, there is a need to distinguish between transmission heat loss and ventilation heat loss. Internal heat sources (waste heat from occupants, lighting and electrical equipment) as well as the energy input through solar radiation via glazing and transparent surfaces (pas-

sive utilisation of solar radiation) are considered as heat gain factors. The features of the building envelope should contribute towards creating an even balance between loss and gain. The difference between these determines the necessary heat load, which must be supplied through building services. Since the internal heat sources are determined mainly by the building's use, the building envelope offers the greatest potential to minimise loss and maximise solar gain (Fig. 3.1).

The average thermal resistance of the heat loss surfaces can be used as the target value (or characteristic value) to evaluate the thermal efficiency of the building envelope. It gives an indication of the level of fabric heat loss which may be expected. The supply of outside air at low ambient air temperatures is a further cause of heat loss, which becomes more significant the higher the air change rate or air leakage becomes. In addition, the proportion of glass, conditional upon orientation, effects the potential for the passive utilisation of solar radiation. It follows that improvements to the building envelope's thermal characteristics in winter depend upon harmonisation of the following aims in coordination with building services engineering:

· Space optimisation and envelope geometry
· Thermal insulation of opaque components
· Thermal insulation of transparent components
· Passive utilisation of solar radiation
· Minimisation of ventilation heat loss

Heat supply systems
In order to size the heat generators and the heat distribution systems as well as

the emitting surfaces (e.g. radiators), the design heat load must be calculated. The heat load is the amount of heat which must be supplied to a building from a heating system so that the room temperature can be maintained on the coldest day of the year.

The total design heat load, which is the sum of the design heat loads of all rooms within a building, is made up of the design transmission heat load Φ_T and the design ventilation heat load Φ_V.

The design heat load Φ_{HL} for a building is calculated according to the following equation:

$$\Phi_{HL} = \Sigma\,\Phi_T + \Sigma\,\Phi_V$$

The thermal insulation of the building has the greatest impact on the level of the heat load. The better the building envelope is, the greater the impact of the ventilation heat load. For this reason, it will be necessary to install more mechanical ventilation systems in future if the aim is to reduce these ventilation losses further with the help of heat recovery systems. Due to today's generally high-quality building envelopes, the heat loss to the exterior is decreasing steadily. Conversely, the significance of internal heat loads is increasing in well-insulated buildings. The passive solar heat gain arising due to large window areas or internal loads in office buildings can already exceed the heat demand of today. The slower cooling of buildings reduces the savings potential that was achieved in former times by lowering the heating at night (reduction of the heating medium's temperature and therefore the room temperature at night). The thermal capacity of the heat generator is not only sized according to the heat load as in former

imes, but also by the need for hot water. The domestic hot water is also usually produced by the heat supply system. The heat load is the criterion which defines the basic design of the heat source and the heat distribution system. The design heat load is expressed in Watts (W) and is a commonly used term in heating technology. The term heat demand, in contrast, relates to the energy qualities of a building. Heat demand is calculated in kilowatt-hours per year (KWh/a) and, for comparison purposes, figures are shown according to 1 m² of net living or net floor area. Figure 3.2 presents an overview of the development of energy standards and their characteristic values concerning primary energies. There are no explicit limit values for the heat demand of a building since the Energy Performance of Buildings Directive not only requests the observation of minimum standards for thermal insulation but also limits the primary energy demand of a building. The latter can vary depending on which plant technology (heat generation system) is selected. To some extent, energy loss in poorly insulated buildings can be compensated for by implementing energy-efficient plant technology and vice versa. This gives an architect greater freedom when designing a building. The surface-area-to-volume ratio (SA:V), a key factor in the past, is becoming less and less important when considering energy matters in buildings today. The impact of an unfavourable building shape can be balanced by selecting intelligent plant technology.

Heat generation
The chemical energy stored in the fossil fuels, oil and gas, is converted into thermal energy in boilers with the aid of com-

bustion. Condensing boilers offer the greatest fuel efficiency since they make use of the latent heat contained in the steam of the flue gas through a condensing process. Depending on the operating conditions, the standard utilisation ratio, which is related to the net calorific value, reaches values of up to 108 %. In relation to the gross calorific value, this corresponds to 98 %. The aim today is to avoid fossil fuels in heat generation and use renewable energy mediums instead. Buffer storage tanks are important components in heat supply systems. As an addition to boilers, they are able to balance irregular heat generation. Buffer storage tanks are water tanks which are able to store water for heating purposes. The condensing boiler and the buffer storage tank can be combined to form a single unit (Fig. 3.4, p. 24).

Biomass boiler
All organic material, which is produced by plants and animals, is referred to as biomass. Apart from timber (logs, wood chip), other processed wood products (pellets) are also extremely suitable energy sources for generating heat in buildings. Biomass heating systems are carbon-neutral and technically sophisticated. They are therefore able to offer an ecologically sustainable solution for heating buildings. Wood is not only a domestic raw material, it is also a very reliable material from the point of view of supply. However, biomass heating systems do make specific demands on the building design. It is absolutely essential, at an early stage, to reach agreement with all persons involved in the planning process in order to ensure that the structural requirements (storage room, fuel delivery, etc.) are integrated into the design. Bio-

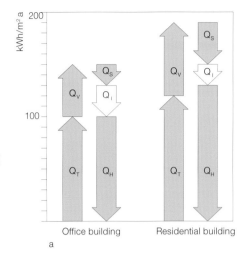

a

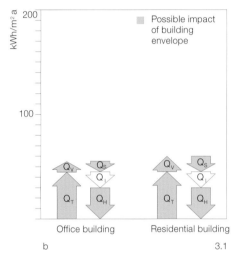

b 3.1

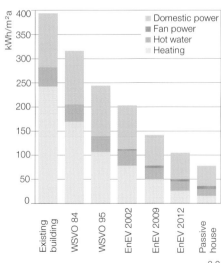

3.2

3.1 Heat gain and loss in different buildings (Q_V = ventilation heat loss, Q_T = transmission heat loss, Q_S = solar radiation, Q_H = heat demand, Q_I = internal heat sources)
 a in existing buildings
 b low-energy standard
3.2 Development of energy standards in Germany and distribution of the energy demand according to the individual consumers in buildings
3.3 Impact of the different heat sources on the planning of building services

Heat source	Heat pump required	Suitable forward-flow temperature for heat distribution	Heat storage required	Combination with heat network	Other important parameters
Near-surface geothermal energy	yes	low	no	rarely	
Ambient air	yes	low	no	no	low efficiency
Biomass combustion	no	low to high	possibly	possible	
Solar	no	low	yes	possible	additional heating required
Waste heat	depends on temperature	low to high	no	almost always	
Waste water	yes	low	no	almost always	
BTTP	no	low to high	no	almost always	
Deep geothermal energy	no	low to high	no	almost always	

3.3

3.4

3.5

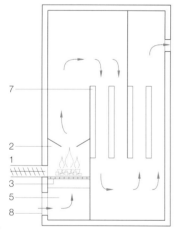

a

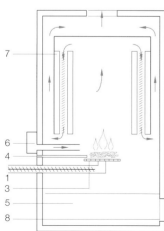

b

3.6

mass heating systems are divided into automatic and manual feed systems. Whereas manual feed systems may be suitable for smaller buildings, larger buildings should use only automatic feed systems for their heating. Pellets and wood chip represent the most common biomass for automatic heating systems in larger buildings. The boiler should be located in the immediate vicinity of the storage room since long conveyor systems are more susceptible to faults (Fig. 3.5). Today automatic biomass systems offer levels of comfort and convenience similar to those of conventional systems operated with oil or gas. Their annual fuel efficiency lies at approximately 70–75 %.

Wood-chip boiler
Wood chips are small pieces of wood (5–50 mm long) and are produced from woodland timber, leftovers from sawing or wood product processing. The quality of the wood chip depends on the raw material and the chipping process. In comparison to logs, wood chip has the advantage of being pourable and combustion can therefore be performed in a fully automatic heating system (Fig. 3.6 a). The energy content of dried wood chip (water content < 25%) is approximately 3.6 kWh / kg and therefore only slightly more than a third of the calorific value of a litre of light fuel oil.

Pellet boiler
Wood pellets are produced industrially from wood shavings and compacted sawdust. They are regular cylindrical pressed pieces with a diameter of approximately 4 to 10 mm and a length of 20 to 50 mm. Their uniform shape means that pellets can be transported from the storage vessel to the boiler automatically. The smallest systems have a capacity of approximately 2.5 kW and today offer the same level of user comfort as oil and gas boilers (Fig. 3.6 b). The compacting process reduces the wood volume considerably. The result is a homogeneous fuel with an energy content of approximately 5 kWh / kg at a density of approximately 650 kg / m³. At present, there are approximately 100,000 systems in operation in Germany (in 2010) and the market is growing. The generation of a kilowatt hour of heat costs just over four Cent which is significantly lower than comparable costs of a fuel oil or natural gas-fired heating

system (for oil approx. six Cent and for gas approx. five Cent per kilowatt hour).

Heat pumps
Heat pumps are machines which help to convert heat which is not immediately usable (anergy) into usable heat (exergy). Heat pumps and refrigeration cycles for cooling (air conditioning) both operate according to the same Carnot cycle in a counter-clockwise direction (Fig. 3.8). The heat from indirectly stored solar energy in air, water and ground, but also from heat in waste water and exhaust air can be absorbed into the cycle (Fig. 3.9). The most frequently used heat source is the outside air, which, however, also has the lowest energy density. Ground water as a heat source offers a stable, relatively high temperature throughout the year and, therefore, a favourable annual coefficient of performance. However, the use of ground water requires larger capital investments and cannot be employed everywhere. When using near-surface geothermal energy by installing bored piles or ground probes, the nature of the soil and the moisture content of the ground play an important role (Fig. 3.10). For frost protection purposes, when using this heat source, a glycol/water mixture is used as the heat transport medium in order to prevent the piping system from freezing.

Refrigerants
In heat pump processes, refrigerants are used as the working fluid for the energy transfer. Depending on the mode of application, they are selected according to the following criteria:
• The thermodynamics of the process should be adjusted to meet the needs of the application. This means that the refrigerant used must be able to evaporate at the required temperature. Condensation and evaporation take place at the pressure and temperatures appropriate to each application.
• The enthalpy of vaporisation (thermal absorption capacity) should be as high as possible.
• The optimal ratio between the cooling capacity and the driving power should be achievable.
• The refrigerant should have good thermal transfer properties.
• Furthermore, refrigerants should be non-toxic and non-combustible. They should not be harmful to the environment.

n recent years, use of refrigerants has been subject to regulation due to the effects of global warming and ozone depletion. The environmental rating of refrigerants is assessed according to the following three indicators:

• Ozone Depletion Potential (ODP), R11 equivalent:
 The percentage of chlorine in a compound indicates the degree of harm. Due to its high percentage of chlorine, R11 is the reference value to evaluate the ozone depletion potential (the ODP value of R11 is defined as 1.0).
• Global Warming Potential (GWP), CO_2 equivalent:
 The greenhouse gas, carbon dioxide (CO_2), has been defined as a reference value to evaluate the global warming potential of refrigerants. The GWP value describes the global warming potential in relation to carbon dioxide (CO_2). For example 1 kg of R22 (GWP = 1650) has the same global warming potential as 1650 kg CO_2 in the atmosphere.
• Total Equivalent Warming Impact (TEWI):
 As well as considering the leakage rate of a system and the recycling rate, the TEWI value also takes into account the CO_2 emissions which are produced by the energy demand when operating a refrigeration plant (compressor power).

Coefficient of performance
In order to assess the performance of a refrigerant cycle, the ratio of heat output to energy input must be established. This characteristic value is called coefficient of performance (COP):

$$\varepsilon_w = Q/P = (Q_0 + P)/P$$

ε_w = Coefficient of performance
Q = Useful heat
P = Compressor power

Annual performance factor
The annual performance factor (APF) determines the heat output and the energy input over a year. This value also considers the energy use of auxiliary and peripheral devices, such as circulation pumps and control systems (Fig. 3.11, p. 26).
To operate a heat pump, electric power is required, which reduces the energy efficiency of the system appreciably. The smaller the difference is between the tem-

Fuel	Calorific value	Space requirement in relation to energy content
Solid fuels		
Wood pellets	5.1 kWh/kg	0.35 m³/MWh
Wood chip	5.1 kWh/kg	0.9–1.3 m³/MWh
Logs (stacked)	5.1 kWh/kg	0.5–0.7 m³/MWh
Liquid fuels		
Rapeseed oil	10.3 kWh/kg	0.10 m³/MWh
Biodiesel	10.2 kWh/kg	0.11 m³/MWh
Ethanol	7.4 kWh/kg	0.17 m³/MWh
Extra light heating oil	11.9 kWh/kg	0.10 m³/MWh
Gaseous fuels		
Biogas	6.0 kWh/m³	166 m³/MWh
Natural gas	10.0 kWh/m³	100 m³/MWh

3.7

3.8

	Ground heat collector	Ground heat probe	Ground-water	Air	Energy piles
Availability	preferably in open space	everywhere	acc. to local availability	everywhere	in new builds
Space requirement	high	low	low	low	low
Average temperature in winter	-5 to +5°C	0 to 10°C	8 to 12°C	-25 to +15°C	-3 to +5°C
Water use subject to approval	no	almost always	always	no	no
Typical annual performance factor ß of the heat pump	4.0	4.5	4.5	3.3	–

3.9

Subsoil	Specific extraction output	
	for 1800 h	for 2400 h
Dry, light soil	10 W/m²	8 W/m²
Moist, heavy soil	20–30 W/m²	16–24 W/m²
Saturated, granular soil	40 W/m²	32 W/m²

3.10

3.4 Condensing boiler with an integrated buffer storage tank
3.5 Pellet store
3.6 Firing system for a wood energy medium
 a Wood chip boiler
 b Pellet boiler
 1 Helical conveyor
 2 Combustion chamber
 3 Burner plate
 4 Electronic ignition
 5 Ash box
 6 Fan

7 Heat exchanger
8 Inspection opening
3.7 Calorific values and space requirement for different fuels
3.8 Brine/water heat pump with ground collector
3.9 Comparison of different heat sources for heat pumps
3.10 Reference values for extracting heat with ground heat collectors according to VDI 4640 (Extraction output of ground probes see Fig. 3.69, p. 40)

	Definition	Meaning
Coefficient of performance (COP) ε	Ratio of the defined heat output to the required electric driving power at a certain point in time and at certain temperature conditions	Efficiency of the heat pump under test conditions
Annual performance factor (APF) β	Ratio per year of the supplied heat (Q) to the necessary driving power (W). Amongst other things, it is used to determine operational fluctuations.	Efficiency of the total heat pump heating system
Annual efficiency ratio	Reciprocal of the annual coefficient of performance; it defines the ratio of the driving power to the supplied heat.	Efficiency of the total heat pump system according to VDI 4650

3.11

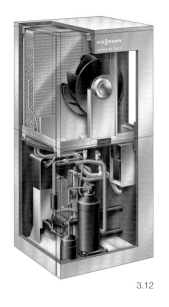

3.12

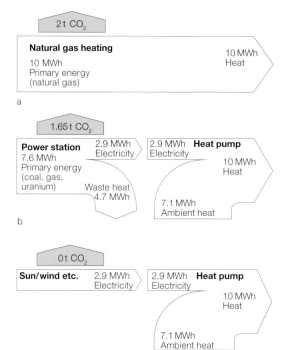

2 t CO₂

Natural gas heating
10 MWh
Primary energy
(natural gas)

10 MWh
Heat

a

1.65 t CO₂

Power station
7.6 MWh
Primary energy
(coal, gas, uranium)

2.9 MWh
Electricity

Waste heat
4.7 MWh

2.9 MWh
Electricity

Heat pump

10 MWh
Heat

7.1 MWh
Ambient heat

b

0 t CO₂

Sun/wind etc.

2.9 MWh
Electricity

2.9 MWh
Electricity

Heat pump

10 MWh
Heat

7.1 MWh
Ambient heat

c

3.13

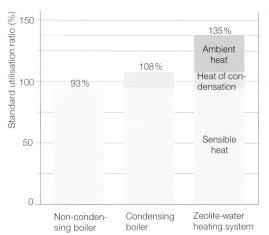

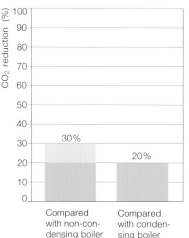

3.14

3.11 Characteristic values for heat pumps
3.12 Air/water heat pump
3.13 Exemplary energy and CO₂ balances
 a Natural gas heating with condensing technology
 b Compression heat pump operated with conventional power
 c Compression heat pump operated with regenerative power

3.14 Standard utilisation ratios of different heating systems and CO₂ reduction by using zeolite heating unit
3.15 Energy efficiency of a decentralised combined heat and power plant and separate energy generation
3.16 Combination of several BTTPs and a boiler to cover peak loads
3.17 Schematic configuration of a mini BTTP
3.18 Micro BTTP operating on vegetable oil

perature of the heat source and the temperature of the heating medium, the higher the efficiency of the heat generation system. For the heat distribution, it is therefore preferable to use panel or underfloor heating systems with heat pumps, which function well at lower temperatures. Basically, there are two different types of heat pump: the compression heat pump operates with a closed cycle where the refrigerant passes over an evaporator, a compressor, a condenser and an expansion valve. Compression heat pumps are used mostly in smaller heat pump systems. The heat transfer in an absorption heat pump is based on the physical-chemical process of a solvent cycle. However, the necessary energy input to increase the pressure and temperature is achieved by using a heat source.

Zeolite heating
Zeolite heating units are adsorption heat pumps which operate on the basis of a zeolite-water system. The difference to an absorption heat pump is that the refrigerant is accumulated on the surface of a solid. In this case, the refrigerant is an aqueous alkaline or alkaline-earth aluminosilicate with varying water content. When heated, the zeolites release water whilst maintaining their stability due to their crystalline structure and absorb other compounds and ions. When reversed, the generated heat can be used for heating purposes.
Like absorption heat pumps, these systems are powered by heat rather than electricity. However, in this case, two heat sources are needed: a gas condensing water heater, which initiates the process, and an ambient heat source. Water, which is naturally harmless, is used as the refrigerant. On average, this system can achieve an efficiency of 135 % per year (Fig. 3.14). The first heating units in operation have reached thermal outputs of 10 kW in modulating modes of operation. They are therefore suitable for heating residential buildings.

Efficiency
Heat pump heating is not necessarily significantly cheaper nor more favourable from an ecological point of view than a well-designed heating system with a boiler. The CO₂ balance improves only if renewable energy sources are used to drive the compressor (Fig. 3.13).

In most cases, the compressors in heat pumps are powered by electrical energy. In the light of today's efficiency levels of approximately 33 % in generating electric power in conventional power stations, an annual performance factor of approximately 3 is required in the heat pump process to prevent a negative energy and CO_2 balance. Otherwise it would make more sense ecologically to burn the primary energy medium directly. Assuming an increase in the future efficiency of electric power generation in power plants, it will only take a few years until heat pumps reach an annual performance factor of 2.5 and perform better than a condensing boiler fired with a fossil energy medium.

However, there are several reasons why these average annual performance factors, may often not be met:

- Over-dimensioned auxiliary drive systems (e.g. brine circulating pumps)
- Design of the heat distribution system with too high forward and return flow temperatures
- Unfavourable hydraulics in the heat distribution system which causes the heat pump to short cycle
- A poorly adjusted control system or faulty programming of the system

These facts highlight why heat pump systems are often not able to meet their economic and ecological expectations. The installation of a heat pump should therefore always be planned and carried out according to the specific needs of a project.

Combined heat and power generation
The process of creating mechanical energy (converted into electricity) and heat simultaneously in one plant is referred to as combined heat and power generation (CHP). The overall efficiency of the combined heat and power generation (the electricity and useful thermal energy produced in relation to the fuel energy used) is approximately 80–95 % and therefore considerably higher than the efficiency of a conventional power plant (Fig. 3.15). In order to achieve the same heat output and power in separate conventional power plants, approximately 50–60 % more fuel must be used than in a CHP plant. In electricity generation, the German power stations attain an average efficiency of approximately 33 %. Alongside the extraction of heat in power

plants, this process is also used in decentralised block-type thermal power stations or fuel cells. For economic reasons, it is important that all CHP plants are designed to operate for sustained periods of time. These systems are therefore especially designed to cover heat and electricity base loads. Additional supply systems to cover peak loads may be necessary.

Power stations
The extraction of heat in power stations is performed by the condensation of steam from the industrial process. This steam drives turbines which by means of a generator produce electricity. The heat is transported to the consumers via a district heating network.

Block-type thermal power stations
Block-type thermal power stations (BTTP) should preferably be situated close to where the heat consumption takes place. In this case, the generator is powered by a combustion engine (diesel motor or gas turbine) (Fig. 3.17). The engine's waste heat is used for heating purposes. The electricity yield is not affected by use of the motor's waste heat, however, for this reason, the temperature level of the waste heat should be around 70–90 °C. In recent years, there have been frequent examples of BTTP stations powered by palm oil. In order to gain and produce palm oil, large areas of rain forest in tropical countries must be cleared. It is therefore necessary to make sure that this fuel originates from a sustainable cultivation process. Furthermore, large amounts of methane are released during palm oil production, which has a much greater ozone depletion potential than carbon dioxide. In these areas biogas plants have been successfully combined with BTTP stations.

Micro CHP plants
Micro CHP plants are small combined heat and power plants, which can be installed in residential buildings (Fig. 3.18). According to the definition of the Bundesverband KWK (German CHP Association), the upper limit of electrical output is 15 kW. Apart from fuel cells, steam and Stirling engines or micro gas turbines, combustion engines are usually employed to drive the system. Most of these are fuelled with natural gas. Due to the relatively high investment

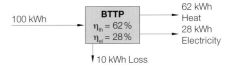

3.15

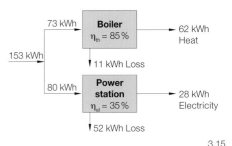

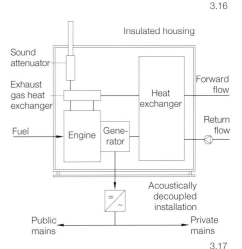

3.16

3.17

3.18

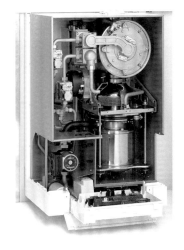

3.19

3.20

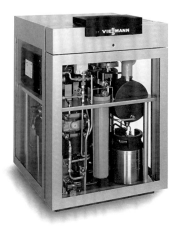

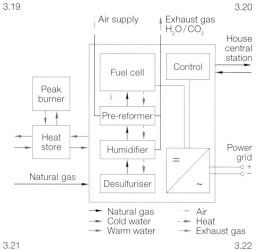

3.21

3.22

Description	Electrolyte	Mobile ion	Gas of the anode	Gas of the cath-ode	P (kW)	T (°C)	η (%)
Alkaline fuel cell (AFC)	KOH	OH⁻	H_2	O_2	10–100	< 80	60–70
Polymer electrolyte membrane fuel cell (PEMFC)	Polymer membrane	H⁺	H_2	O_2	0.1–500	60–80	35
Direct methanol fuel cell (DMFC)	Polymer membrane	H⁺	CH_3OH	O_2	< 0.001–100	90–120	40
Phosphoric acid fuel cell (PAFC)	H_3PO_4	H_3O^+	H_2	O_2	< 10000	200	38
Molten carbonate fuel cell (MCFC)	Molten alkaline carbonate	CO_3^{2-}	H_2, CH_4, coal gas	O_2	100000	650	48
Solid oxide fuel cell (SOFC)	Ceramic oxide electrolyte	O^{2-}	H_2, CH_4, coal gas	O_2 (air)	< 100000	800–1000	47

3.23

3.19 Mini BTTP with free-piston Stirling engine
3.20 Free-piston Stirling engine for mini BTTP
3.21 Home energy station with fuel cell
3.22 Schematic configuration of a fuel cell BTTP
3.23 Overview of available fuel cells
3.24 Working principle of a PEM fuel cell
3.25 Working principle of a flat-plate solar collector
3.26 Comparison of emissivity and thermal conduction
　　a Normal sheet metal
　　b Selective absorber
3.27 Solar irradiance on a collector surface according to orientation
3.28 Efficiency and application fields of different collector types in dependence of the operating temperature. The temperature difference between the outside air and the absorber is relevant.

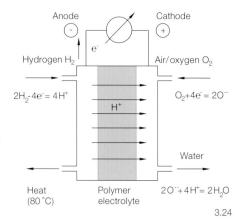

3.24

costs, the market share of these systems for residential buildings is still well below 1 %. As with all CHP systems, it is important that the plant is designed for a long service life.

Fuel cells
In a fuel cell, electric power is normally gained directly from the hydrogen energy medium in an electrochemical process. Heat is produced in the reaction of hydrogen and oxygen, which is extracted and used for heating purposes (Fig. 3.22). As in block-type thermal power stations, the extraction of heat does not affect the electricity generation and the temperature level of the waste heat should also be set at approximately 70 °C (in PEM cells). Figure 3.23 offers an overview of the different fuel cell types currently available. The polymer electrolyte membrane fuel cell (PEMFC) is the fuel cell type most frequently used in heating systems today. Its working principles are displayed in Figure 3.24. This low temperature fuel cell changes chemical energy into electric power by using hydrogen (H_2) and oxygen (O_2). A polymer membrane which is coated with a catalytic electrode serves as the electrolyte. The H_2 molecules dissociate at the anode and by releasing two electrons are each oxidised into two protons (hydrogen nucleus H⁺). These protons diffuse through the membrane. Oxygen is reduced by the electrons at the cathode, after having generated power in the electrical circuit. They then react with the protons which travelled through the electrolyte and produce water. The anode and cathode are connected to the power supply, so that the generated electricity can be used.

Without financial incentives, it does not yet make economic sense to use fuel cells to heat buildings. However, fuel cell technology is a promising concept for environmentally-friendly heating. If valuable resources are used efficiently, fuel cells will be able to make a useful contribution towards climate protection. Hydrogen can play an important role as an energy source in future energy supply systems. However, since it does not exist as a natural resource, the very energy-intensive chemical processes to produce hydrogen must be developed and optimised further. In evaluations comparing the environmental impact and efficiency of different energy choices, the impacts of hydrogen production should be con-

sidered alongside fuel transportation and efficiency.

Stirling engine

The Stirling engine is a hot air engine that keeps the gas sealed inside the engine. Apart from an external heat source (necessary for the Stirling engine to operate), usually generated by combustion, this engine works without any waste gas emission. In contrast to the Otto engine, an internal combustion engine, the Stirling engine (Fig. 3.19, 3.20) does not require any fuel, since it relies on an exchange of heat. It is of no relevance where the heat comes from. Apart from fossil fuels such as oil or gas, renewable energy sources such as solar energy, geothermal energy or waste heat from manufacturing processes can also be used.

In comparison to conventional block-type thermal power stations, the Stirling engine, used as a drive unit in smaller BTTP modules, has many advantages: due to the enclosed workings of the Stirling engine, particulate matter produced by combustion cannot enter the inside of the engine. The result is little wear and tear and long maintenance-free running periods. The servicing intervals are up to 6,000 hours. The operation costs are much lower than those of Otto gas engines. Furthermore, the amount of pollutants emitted by today's Stirling burner is approximately only one tenth of that produced by the Otto gas engine with a catalytic converter. There is very little noise and vibration associated with this engine. What is more, the efficiency is almost twice as high as that of conventional combustion engines.

Solar thermal energy

Unlike so-called passive solar energy utilisation, the active utilisation of solar thermal energy can be achieved independently from the interior of the building. With efficient storage technology, active solar systems are able to use solar energy almost independently from the actual irradiance conditions and the indoor climate. In contrast to the use of passive solar gains, the functions of active solar thermal energy systems, solar energy absorption, conversion and storage, are taken care of not by the building itself but by technical systems. In general, these systems consist of a collector, heat transfer medium, transport equipment and a heat storage facility. Automatic control

engineering is used to regulate the energy flow within these components. The aim of active heat supply systems is to achieve independence between the periods of solar radiation and the periods utilising the heat. A storage vessel in combination with automatic control is therefore an important function within the overall system (see p. 33ff.).

The basic principle of a solar thermal system is the conversion of shortwave solar radiation into long-wave thermal radiation. This process takes place when sunlight makes contact with a surface. The intensity depends on the conductivity and absorptivity of the material (Fig. 3.26). An ideal absorber has low reflection and transmission losses. At the same time, however, the absorbed thermal energy is not to be radiated but should be, as far as possible, transferred to the medium via thermal conduction. This has led to the development of selective solar absorber materials, which, for technical reasons, range from dark blue to black. Although other colours can also be used, this decreases the efficiency considerably.

In order to limit the thermal loss to the surroundings, the absorbers are usually extended to form collectors, which are insulated on the rear side facing away from the sun and provided with special solar glass with highly transparent coatings on the side facing the sun. A heat-transfer medium (usually a glycol/water mixture) flows through the collectors in order to transfer the usable heat.

Building integrated solar thermal systems

The collector which converts the solar radiation into thermal energy to generate heat is key to the systems design. On the one hand, the collector is a part of the building services, but, at the same time, if so planned, it can be a component of the building envelope. Its integration from a technical and aesthetical viewpoint is therefore a special challenge. In principle, this synergy effect of building integration also offers financial advantages. A variety of collectors are in common use and a few frequently installed types are displayed in Figure 3.29 (p. 30). In technical terms, solar thermal collectors are divided into different categories:

Open absorbers are the most simple kind of solar thermal collector. However, due to the high thermal loss, their efficiency remains very low. They are used for the

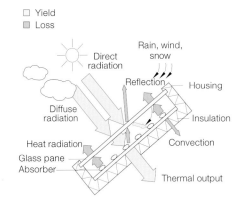

3.25

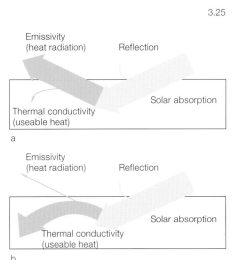

a

b

3.26

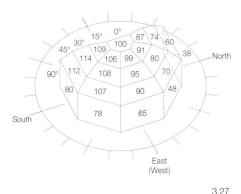

3.27

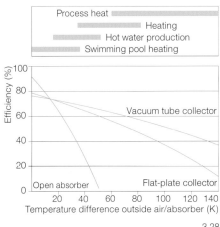

3.28

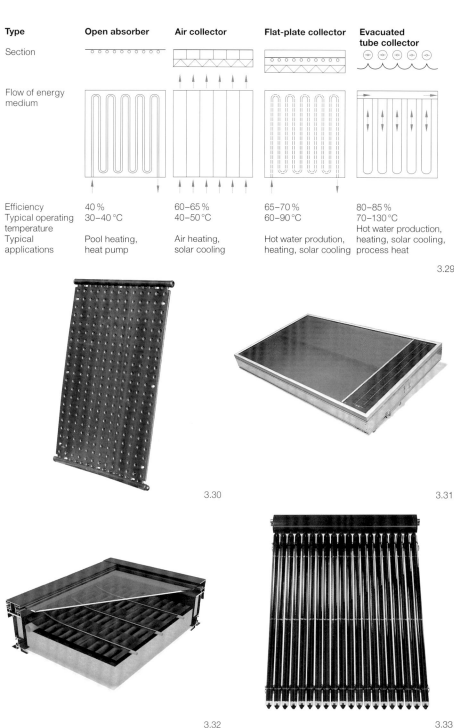

Type	Open absorber	Air collector	Flat-plate collector	Evacuated tube collector
Section				
Flow of energy medium				
Efficiency	40 %	60–65 %	65–70 %	80–85 %
Typical operating temperature	30–40 °C	40–50 °C	60–90 °C	70–130 °C
Typical applications	Pool heating, heat pump	Air heating, solar cooling	Hot water prodution, heating, solar cooling	Hot water production, heating, solar cooling, process heat

3.29

3.30

3.31

3.32

3.33

3.34

3.29 Typical types of collectors and their fields of application
3.30 Mat absorber for the solar heating of a swimming pool
3.31 Air collector with photovoltaic-powered fan
3.32 Solar thermal flat-plate collector
3.33 Evacuated tube collector
3.34 Parabolic trough collector
3.35 Flat-plate collectors as a fully-fledged roof element, residential estate in Innsbruck (A)
3.36 Facade integrated flat-plate collectors, multi-family dwelling in Bennau (CH), Grab Architekten
3.37 Evacuated tube collectors as balustrades, multi-family dwelling in Zurich (CH), Beat Kämpfen
3.38 Facade collectors in a residential building in Tübingen, Plathe, Schlierf und Sonnenmoser Architekten

solar heating of swimming pools or serve as a heat source for heat pumps (Fig. 3.30).

In flat-plate collectors, the absorber is provided with a special solar glass coating on the side facing the sun and the rear face is insulated (Fig. 3.32). With this configuration, it is fairly easy, from a structural point of view, to integrate the collectors into the building envelope. Flat plate collectors are the most commonly used type of collector for providing heat in buildings. In rare cases, the air space is filled with noble gas to minimise heat losses from convection.

As an alternative to flat-plate collectors, which heat water, solar air collectors can be used in combination with a warm-air heating system as a solar preheater (Fig. 3.31). The configuration is similar to that of flat-plate collectors. However, these collectors do not transfer the thermal energy into a fluid circuit. Instead fans draw in air which is warmed as it passes over metal fins heated by solar radiation.

In evacuated tube collectors, the flat or round absorber is located in an evacuated glass tube (Fig. 3.33, p. 30). Convective thermal losses are almost completely avoided by using this method. Depending on the type of system, mirrored surfaces can be used to concentrate solar gains in a given area. Of all solar collectors, evacuated tube collectors are the most efficient and can reach the highest operating temperatures. Many products offer the possibility to twist the individual tubes so that they can be adjusted to the solar irradiance. This way, collectors fitted either horizontally or at very steep angles, are able to work very efficiently.

By means of special lenses or mirror areas, collectors can achieve very high temperatures (> 300 °C) with high direct radiation. However, these so-called concentrating collectors are only installed for the heat supply of production processes and for the generation of solar thermal electric power (Fig. 3.34). They can really only be used effectively in areas with large proportions of direct radiation (close to the equator).

Nowadays solar thermal collectors are manufactured mainly as standard products with fixed dimensions and technical specifications. The integration of solar systems into the building envelope, however, requires individual solutions, which

currently are supplied by only a few manufacturers. Flat-plate collectors especially are ideal for creating flat surfaces and therefore highly suitable for the integration in facades and roofs. Custom-made products offer the possibility to align the formats as well as the horizontal and vertical structuring of the collector areas with the building design. The colour of the panels and the optics of the glass coating can also be selected. Collectors are usually fully prefabricated and are available in sizes of up to 30 m².

Facade integration
Flat plate collectors can be fitted to solid exterior walls as a ventilated exterior wall cladding. In this case, the collectors replace the conventional facade and, as well as generating energy, also provide weather protection. The wall make-up is not altered when collectors are mounted with rear ventilation, although thermal bridges must be avoided when installing the second leaf. Alternatively, collectors can be integrated in the wall configuration without cavity ventilation (Fig. 3.36). This construction method is desirable as the insulation of the collector can simultaneously function as the insulation of the exterior wall.
A further positive effect is that, even in the case of diffuse solar irradiance, high temperatures develop behind the absorber, which reduces heat flow to the exterior. In a similar way to structures with transparent insulation, this can result in exterior walls having no thermal loss. When collectors are integrated without cavity ventilation, it is necessary to make sure that the heat conduction from the outside to the inside in the summer months does not lead to excessive heat gains within the building. The collectors and the wall should therefore be provided with high-quality insulation. Furthermore, the entire wall configuration should be carefully assessed with regard to diffusion and condensation.
It is also possible to introduce solar thermal flat-plate collectors into a refurbishment, especially when facade rehabilitation work is being carried out in combination with composite thermal insulation systems. When mounted without cavity ventilation, the collector areas also improve the building fabric's thermal efficiency and can, therefore, replace other insulation measures. In timber stud structures without solid structural components,

it is possible for the exterior wall to be formed as a collector. The result is a highly efficient wall with a fairly slim make up. These systems provide a similar moisture and building fabric performance to non-ventilated collectors.
If a large amount of low-temperature heat is required (< 40 °C, e.g. as a heat source for heat pumps), conventional metal elements (metal roof covering or facade elements) without glass coatings can be used as thermal collectors. A fluid heat exchanger is simply fitted to the rear side of the metal element to extract heat from the warm metal areas. However, their efficiency is limited to the target temperature of approximately 40 °C (Fig. 3.45, p. 32).
Where warm-air heating systems are used, the supply air can also be preheated by means of facade-integrated solar air collectors. This can be achieved with an appropriate facade structure, for example a combination of a solid exterior wall and mounted glass elements. Alternatively, prefabricated air collectors can be installed. In principle, their structural configuration corresponds to that of water-circulating flat-plate collectors, but in this case the absorber is formed as a flat shaft structure, through which outside air flows. Their integration is similar to that of flat plate collectors, however, the vents for drawing in the air must be carefully designed (Fig. 3.31).
The integration of evacuated tube collectors in terms of construction and design is currently still of minor importance. Despite having great aesthetic potential, the possibilities concerning geometry and design are very limited due to the modular character of the tube collectors. A few projects have been realised so far including that shown in Fig. 3.37 where tube collectors are used as balustrades. The synergy effects associated with solar shading devices are also worth considering.

Roof integration
Roofs are the most common location for solar thermal systems. Collectors on flat roofs are usually placed upon supports. Evacuated tube collectors can be fitted horizontally, without a decrease of yield, if the absorbers in the tubes are adjusted according to solar irradiance (Fig. 3.44, p. 32).
In terms of construction and design, inclined roofs are especially suited to the integration of flat-plate collectors. As with

3.35

3.36

3.37

3.38

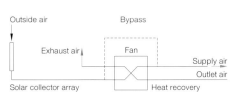

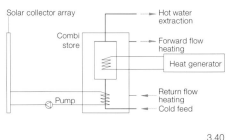

3.39 3.40

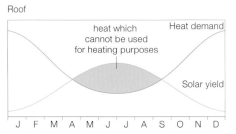

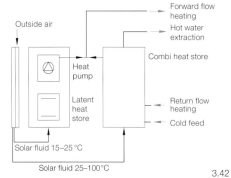

3.41 3.42

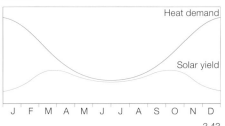

3.43

3.39 System concept: Solar air heating system
3.40 System concept: Solar back-up heater
3.41 System concept: Solar domestic hot water heating system
3.42 System concept: Solar heating with hybrid collector (water/air), latent heat store and heat pump. The heat pump uses the solar-fed latent heat store as a heat source.

3.43 Heat demand of a building during the course of a year and possible solar yields (roof/facade) in comparison. Roof integrated collectors produce a surplus of heat in the summer months, which must be removed. Facade collectors achieve a more even solar yield.
3.44 Evacuated tube collectors on a flat roof
3.45 Metal roof covering as a solar thermal absorber

3.44

3.45

the facade, they can take on the function of the roof covering and can be prefabricated as complete roof elements to cover large areas (Fig. 3.35, p. 31).
In short, similar conditions regarding technical matters and building physics apply as for integrated solar thermal facades. In terms of construction and design, it is also possible to integrate evacuated tube collectors in the roof area, for example when used as a sun protection device.

Solar thermal concepts for buildings
In Europe, solar thermal energy generated in decentralised units is usually used within a temperature range of up to 80 °C and applied mainly to heat domestic hot water and support heating systems in residential buildings. Solar pool heaters are also becoming established as an economic alternative. At present, there are pilot-projects that use solar collectors for the cooling of buildings with the help of appropriate refrigeration plant (see p. 45ff.).
So far solar thermal systems have been used mainly for the heating of domestic hot water (Fig. 3.41). The dimensions of the systems are influenced by the demand for hot water and the volume to be heated by solar energy. A typical plant size for a single-family home with four persons is a collector area of approximately 5 m² with a solar storage volume of 0.3 to 0.4 m³ and an annual percentage of solar coverage of approximately 50 to 60 %. For greater, all-year-round demand for hot water, for example in residential estates, hotels, multi-family dwellings or hospitals, plants with several hundred square metres of collectors and corresponding storage volumes are being constructed. Flat-plate collectors are employed in most cases, but tube collectors with higher efficiencies are also quite common.
If the solar heat is to be used to support the heating system, in addition to heating the domestic hot water, the size of the plant must be increased according to the desired percentage of solar coverage. Typical collector areas for a single-family home in Germany with four persons range from 10 to 20 m² with a storage volume of 0.7 to 2.0 m³. In energy-efficient buildings, this plant size would allow between 20 and 30 % of the total heat demand to be covered by solar thermal energy (Fig. 3.48, p. 34).

The buffer storage tank for the heating circuit is either added to the hot water tank, or a combined storage tank is installed (Fig. 3.40). By selecting appropriate dimensions for the collector area and the storage volume, which is ideally placed inside the thermal envelope, it is possible to achieve a one hundred per cent solar coverage of the total heat demand in single-family homes. These high efficiencies assume a low heating load thanks to a good building envelope and the use of a low temperature heating system.

Systems that combine a hybrid solar collector using air and water, a combi-storage tank, a latent heat store based on an ice/water cycle and a heat pump are relatively new on the market (Fig. 3.42). In the case of solar radiation, these systems function in the same way as conventional plants; the heated solar fluid flows directly into the combi-storage tank. In bad weather conditions, a fan draws ambient air through the collector. This process raises the temperature of the solar fluid, which then flows into the latent heat storage device, where it is then used as a heat source for the heat pump. Heat pumps applied in these kind of systems reach annual coefficients of performance between five and seven.

Local district heat supply is another important field for the application of solar thermal energy. The heating networks can be supplied with heat from solar thermal plants that are equipped with long-term heat storage facilities (Fig. 3.46, p. 34). The time lag between high levels of radiation in the summer months and heat demand in winter is to a large extent evened out by storing heat in an interseasonal heat storage tank (approx. 50% solar coverage of the total heat demand). Solar-assisted local district heating networks with interseasonal heat storage make sense in residential areas with more than about 100 dwelling units. The heat gained in the collectors is transported to the heating station via pipes and distributed directly to the buildings on demand. The surplus solar heat gained during the summer is fed into the interseasonal heat storage tank (see p. 34 f.). The thermal energy is then extracted from the storage tank during the heating period and, if required, supplied with additional heat from a central heat generator.

If the solar heat generation plant is supplemented by a biomass system, the entire heat supply of large residential areas or town quarters can be achieved entirely with a renewable heat supply. The solar collectors can either be located in one central place or distributed on the roofs and facades of buildings. In this case, in addition to the design of individual buildings, the urban design of the area to be supplied is also significant. The scale of this type of plant depends on the individual circumstances of each site such as the size of the community, specific heat demand, type of interseasonal heat store, temperature level, etc. A collector area of approximately 1.5 m² and a storage volume of approximately 3 m³ per MWh of annual heat demand can be used as reference values.

Solar thermal heat generation is ideally suited to the heating of public and private swimming pools since the main demand is in the summer months (Fig. 3.47, p. 34). These systems are relatively simple, with open absorbers normally used. Since there is no need for a buffer storage, due to the volume of water in the pool itself, it is possible to achieve a very cost effective solution. If minor temperature fluctuations are acceptable, it is generally possible to dispense with an additional heat generation system. In Central Europe, the area of the absorbers should correspond to approximately 50 to 80% of the pool area.

Efficiency and profitability
The quality of a solar collector can in part be judged by its efficiency, which is defined as the quotient of two factors: the heat flow extracted from the heat transport medium divided by the global solar radiation received on the collector. It largely depends on the temperature difference between the ambient air and the absorber. Apart from the collector efficiency, the »percentage of solar coverage« within the overall system is significant. It specifies the proportion of the building's total thermal energy demand which is covered by the useful energy gained through the solar system in per cent. The percentage is influenced by the time lag between the available solar radiation and the demand for energy, including the solar radiation which is not used and the loss through conduction and storage. Based on these conditions, it is generally accepted that the percentage of solar coverage increases with the size of the plant (absorption area and storage

capacity), whereas the area-specific efficiency of the system and therefore also the profitability declines.

Alongside the load profile and the orientation of the collectors, the efficiency of a solar plant is influenced mostly by the availability of local solar radiation. In Europe, there is considerable variation, with values between approximately 850 to 1750 kWh/m²a being achieved for horizontal surfaces. Since availability of solar radiation is time limited, comparatively large investments are required in plant for energy conversion and storage. Due to the different irradiance conditions, the solar gain of roof and facade collectors differs. In comparison to ideally oriented roof collectors, facade collectors in Europe should be approximately 20 to 25% larger in order to generate the same annual amount of energy (Fig. 3.27, p. 29). However, with regard to the utilisation of thermal solar energy, it is not the annual yield which is most important, rather the proportion of solar coverage and this, in turn, is dependent on the load profile.

If collectors are used for the generation of heat, a vertical arrangement of collectors is often more favourable, since the yield during the heating period is larger and the danger of the collector fluid overheating in the summer months is reduced (Fig. 3.43).

Emissions from solar thermal systems arise only from the manufacturing process and the provision of electric power necessary to operate pumps (auxiliary energy). Active solar thermal heating systems are a mature technology and manufactured to reach a high technological standard. Progress is reflected in the continuous improvements in the individual components and especially through optimised system design and electronic control strategies.

Storage
Storage is a fundamental component of every heating system. Storage tanks are used to improve the operating cycle of heat generators or the efficiency of the combustion process (solid fuel), to bridge periods of power cuts effecting heat pumps or as a temporary storage facility for useful energy from a passive source (solar thermal power plant).

Short-term storage
If the thermal demand cannot be pro-

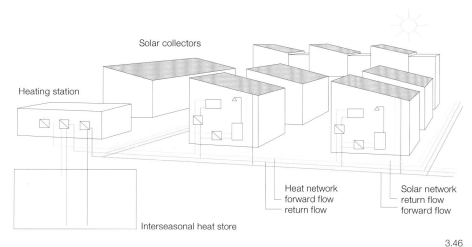

Solar collectors

Heating station

Heat network
forward flow
return flow

Solar network
return flow
forward flow

Interseasonal heat store

3.46

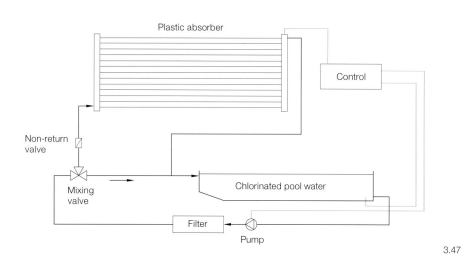

Plastic absorber

Control

Non-return
valve

Mixing
valve

Chlorinated pool water

Filter

Pump

3.47

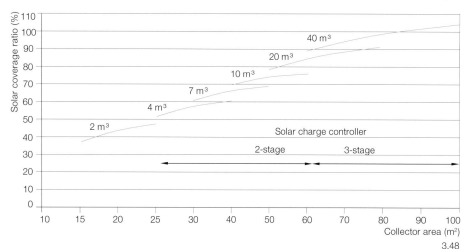

3.48

3.46 System concept for local solar heating plant
3.47 System concept for the solar heating of a
 swimming pool
3.48 Assessment of the solar coverage for a single-
 family home in relation to the collector area and
 the storage capacity (useful floor area 200 m²,
 KfW 40 insulation standard, location Munich,
 orientation of collector south/angle 45°)
3.49 Heat store mediums and their characteristic values
3.50 Typical short-term heat stores: solar water tank
 and tank-in-tank system
3.51 Configuration of different long-term heat stores
3.52 Assembly of a building-integrated long-term
 heat store in a multi-family dwelling in Bennau
 (CH), Grab Architekten
3.53 Seasonal heat store

Storage system / storage medium	Energy density / operating temperature
Sensible / water	approx. 60 kWh/m³ < 100 °C
Latent / salt hydrate paraffins	up to 120 kWh/m³ approx. 30–80 °C approx. 10–60 °C
Thermochemical / metal hydride silica gel zeolite	200–500 kWh/m³ approx. 280–500 °C approx. 40–100 °C approx. 100–300 °C

3.49

vided by a heat generator immediately and in an efficient way, it is necessary to provide a buffer storage tank (Fig. 3.50). Water has proved to be an effective storage medium. In Germany, buffer storage tanks are prescribed according to BImSchV (Federal Immission Control Act) for wood boilers with an output of more than 15 kW. The boiler can always work at nominal load, i.e. at ideal operating conditions, and is not subject to a fluctuating load.

The buffer storage tank should typically be sized to allow 25 litres storage capacity per kW of boiler output. If the tank is also intended to cover peak demands, a buffer capacity of at least 50 litres per kW of boiler output should be provided. Furthermore, the boiler output should be selected in order to allow an adequate recovery time (30 minutes to one hour) for the buffer storage as well as sufficient thermal output (new buildings according to EnEV: 35 W/m²; passive houses: 10 W/m²) in winter. Buffer storage tanks should also be planned for CHP systems. Similar to block-type thermal power stations, heat pumps should also have continuous and long operating periods at nominal output. Here too, buffer storage tanks provide the flexibility necessary to adapt to peak demands.

Latent heat stores
Today there are already more than 100 phase change materials (including paraffins and salt hydrates) which are suitable for use in latent heat stores and are able to cover the temperature range from about –40 °C to about 130 °C (Fig. 3.49). In the meantime, the PCM capsule technologies – micro and macro encapsulation – are state of the art. Building materials which use microencapsulated PCM are available in many different forms today. Examples are gypsum plaster, gypsum plasterboard as well as composite materials with PCM (see p. 51 and Optimising existing buildings, p. 127).

Long-term storage
Interseasonal heat stores, which are designed to cover the heat supply of, for example, a residential area and are fed by solar thermal plants in summer, are sized according to their own specific criteria. The individual consumers are connected to this storage facility via the local heat supply network (insulated underground piping). Systems like these are

being tested in several projects, however, the economics are still to be proven. Whereas the short-term storage of thermal energy is quite common today, the storage for longer periods is still not widely used. The high capital costs are viewed as a major obstacle. However, the costs can be reduced considerably by building thermal stores below ground (Fig. 3.51). Apart from borehole thermal energy storage systems, which access the ground close to the surface or strata in depths of 20 to 100 metres as their storage media, and steel tanks (Fig. 3.53), naturally occurring, self-contained layers of groundwater (aquifers) have also been used to store heat in recent years. Insulation is not required. Aquifer thermal stores with high temperature levels only make sense for very large storage volumes (over 100,000 m³) and are therefore only suitable for application in conjunction with power stations.

Heat distribution

In hot water systems, the diameters of the heating pipes should be dimensioned so that it is cost effective to transport heat throughout the building. Small pipe diameters have the advantage of low material costs and minimal space requirement. However, small pipe diameters cause greater pressure loss which, in turn, leads to a higher electric power demand of the circulation pump.

The choice of the temperature difference between the forward flow and return flow temperature has a significant impact on the heat output that can be transported in the system. This difference is specified for a maximum thermal output, for example 15 K for a 70/55 °C heating circuit (Fig. 3.57, p.36). The greater this temperature difference is, the more heat can be transported at the same mass flow rate. In heating engineering, standardised steel or copper pipes are predominately used to transport water. Plastic pipes are frequently applied for underfloor heating systems.

The pipe network for the heating, air-conditioning and ventilation systems is designed to distribute the water flow to the areas where heating or cooling is needed. Based on careful calculations, the pipe diameters are dimensioned so that each heating surface is supplied with the right amount of heating water. At the same time, the energy requirement of the circulation pumps should be kept at the

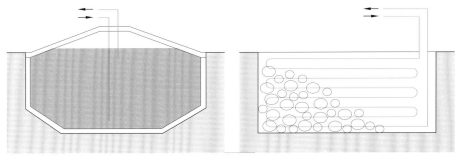

Domestic solar hot water store — Hot water, Back-up heating, Solar plant, Cold water

Tank-in-tank system — Forward flow heating, Hot water, Back-up heating, Hot water tank, Solar plant, Cold water, Return flow heating

3.50

Water-based interseasonal heat store

Pebble bed-water heat store

Borehole heat store

Aquifer heat store

3.51

3.52

3.53

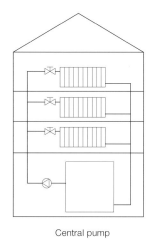

Central pump

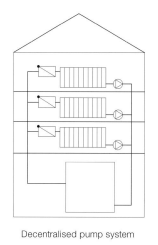

Decentralised pump system

3.54

```
                    Heat transfer systems
                   /                      \
              Radiators                Panel heating
             /    |    \              /    |    |    \
      Radiators  Flat  Convection  Underfloor  Thermo-  Ceiling  Wall
               radiators heaters    heating   active   heating  heating
                                             components
```

3.55

Summer **Winter**

+26°C +20°C

+22°C +22°C

cool heat

3.56

Heating system	Design temperatures
Radiators	70/55°C to 60/40°C
Underfloor/ wall heating	40/30°C to 35/30°C
Thermo-active components	30/28°C to 28/25°C

3.57

Floor covering

Screed

Insulation

Ceiling slab with reinforcement

Ceiling plaster

Capillary tube ceiling system Concrete core activation Floor activation Double-layer component activation

3.58

lowest level possible. In the main pipework, the flow velocity ranges between 0.3–1.5 m/s and 0.5 m/s in pipes feeding radiators or underfloor heating. The average pressure differences are 50–100 Pa/m.

Decentralised pump systems are a very recent development. In this case, small pumps are fixed to each radiator instead of thermostatic or butterfly valves and draw the heating medium directly into each radiator (Fig. 3.59). Compared to a central heating circulating pump, the advantages are shorter operation periods and lower electricity consumption under the assumption that a lot of heating networks are nowadays badly regulated and the therefore high system pressure produced in the network is throttled at the individual heating elements (Fig. 3.55). The electricity consumption of decentralised heating pumps is approximately one Watt. Energy saving is primarily based on the quality of control, minimised loss during the generation and the distribution of heat as well as the demand led distribution of heat. In comparison to heating systems, which are operated with central circulating pumps and thermostatic valves, electricity savings of as much as approximately 90% can be expected. Due to the better control, it is also possible to save up to 20% of heating energy.

Heat emission

Heating surfaces emit warmth to their environment either through convection (with air as the heat transfer medium) or by radiation. The effects of thermal conduction can be neglected in the case of radiators. Due to their consistently low temperature over a large area (e.g. underfloor heating) and the low airflow rate they create, radiation heating is, from a physiological point of view, found more pleasant than convection heating. Heating elements should ideally be placed in immediate vicinity to cold exterior surfaces in order to avoid uncomfortable situations, which can arise due to asymmetric radiation causing air movement. The heat output of radiators is not only influenced by the size, but also by the choice of the heating circuit temperature and the situation concerning the installation. In addition to thermal comfort, the wellbeing of residents also depends on their sensitivity to smell. Heating surfaces, which are operated at temperatures

igher than 50 °C, can lead to the forma-
on of unpleasant smells caused by the
carbonisation of dust. In addition to con-
siderations concerning energy matters,
this is a further reason to operate heating
surfaces at temperatures below 50 °C.

Radiators, panel heaters and convectors
Depending on the design, most of the
radiators and panel heaters installed emit
approximately 50–80 % of their heat
through radiation off the visible surfaces
(Fig. 3.60).
Depending on the design and the tem-
perature of the heater, the method of heat
transfer varies. The performance ranges
differ considerably since the heaters can
be adjusted gradually by stringing
members together or by changing the
height, length or depth of the panel to
meet the appropriate demand. Panel
heaters consist of smooth or profiled
water circulating panels with fins welded
to the rear to improve the convective heat
transfer. Due to their configuration,
convectors almost exclusively transfer
their heat through convection and do not
emit any noteworthy amount of radiant
heat (Fig. 3.61). Their application in low-
temperature heating systems is therefore
limited.

Underfloor heating
In principle, floor, ceiling and wall sur-
faces can be utilised to heat rooms via
their large surface area. In underfloor
heating, the system consists of heating
coils, panel elements or other hollow
bodies which are laid into the floor and
circulate water as their heating medium
(Fig. 3.58). These pipe systems are fixed
onto insulating boards which are mounted
onto a load-bearing substructure. Usually
the heat is transferred to the screed. Due
to the large thermal mass (floor structure),
the system's response to control is fairly
sluggish. The specific heat output of
underfloor heating systems is defined by
the temperature difference between the
maximum surface temperature (29 °C and
35 °C along the edges) and the room tem-
perature. Depending on the floor cover-
ing, up to 80 W/m^2 can be transmitted to
the room. If these systems are also to be
used for cooling, it is necessary to make
sure that the specific cooling load of
approximately 30 W/m^2 is not exceeded
since, depending on the floor covering,
this could be regarded as uncomfortable
under foot. In this case, it is advisable to

perform a precise analysis of thermal
comfort.

Wall heating
This system can either be laid in plaster
or dry-wall construction systems, usually
with a layer of insulation in the case of
solid masonry walls, and permits almost
any level of operating temperature, even
high ones, during the heating period.
Wall heating is installed primarily on the
exterior walls of a building and the heat is
emitted via radiation (Fig. 3.62). An
exception is wall heating with integrated
air ducts which transfer heat to a facing
layer by convection. The surface temper-
ature of wall heating can reach higher
values than that of underfloor heating. It
is not necessary to observe the maxi-
mum temperatures that apply to floor
heating.

Thermo-active building systems – TABS
In contrast to underfloor heating, the
plastic tubes in this system are placed
into the primary construction (concrete
floor slab) and, as a slab heating system,
contribute towards the heating of the
adjoining rooms (Fig. 3.56). The position
and arrangement of the tubes should be
coordinated with the structural engineer
at an early planning stage. By activating
the structural mass, the need for heating
can be delayed to low-load periods. The
required maximum heat output of the
heating system can therefore be reduced.
With a slab surface temperature of
approximately 30 °C, heat loads of up to
30 W/m^2 can be transmitted, which is
sufficient to heat a building today. A
combination of such heating surfaces
with fast-reacting heating elements is still,
from a technical point of view, advisable
even in well-insulated buildings. Thermo-
active building systems can also be used
for cooling purposes (see p. 49 ff.).

3.59

3.60

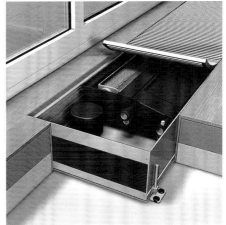
3.61

3.54 Comparison of a central and a decentralised
 pump system
3.55 Overview of the most common heat transfer
 systems
3.56 Principle of year-round utilisation of component
 activation
3.57 Typical design temperatures for heating systems
3.58 Typical constructions for the thermal activation
 of a ceiling slab
3.59 Decentralised heating pump
3.60 Vertical flat radiator
3.61 Floor-integrated convector
3.62 Panel heating to be integrated in dry wall

3.62

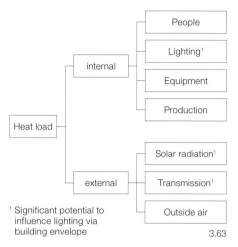

¹ Significant potential to influence lighting via building envelope

3.63

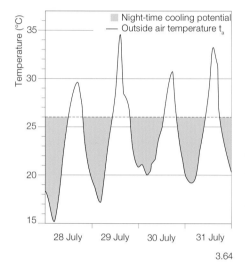

3.64

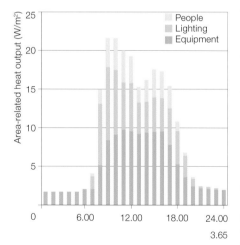

3.65

3.63 Heat loads in a building
3.64 Qualitative potential for night-time ventilation
3.65 Typical profile of internal heat loads in a building during the course of a day
3.66 Decision tree for a cooling strategy: a systematic approach can provide help in selecting the appropriate cooling system.
3.67 Possibilities available for cooling buildings
3.68 Typical features of cooling systems

Cooling

There are numerous different passive, hybrid and active technologies available to cool buildings. In most cases, it makes sense not to cool a building with a single system, but to combine a passive with either a hybrid or an active system. A passive system operates without a mechanical drive and utilises the building's structure for cooling purposes, as is the case with, for example, natural ventilation.

A hybrid system is a combination of a mechanical system and a natural process, for example a thermo-active floor slab combined with an energy pile system. Technologies like conventional compression refrigerating plants or solar-powered absorption refrigerating systems are amongst the active systems used for cooling (see p. 45 ff.). By way of example, Figure 3.66 shows the approach for selecting a suitable cooling system.

Cooling loads

The cooling load that is to be removed is the result of the thermal requirements, the internal and external heat loads, which in turn are dependent on the microclimatic conditions of the site and the type of construction (e.g. the thermal quality of the building envelope) (Fig. 3.63).

Heat loads are differentiated according to convective and radiant heat loads. Convective loads lead to a direct increase of room air temperature whereas radiant loads increase the temperature of surfaces. With regard to internal gains, it is generally assumed that the ratio is approximately 55% convective to 45% radiant heat.

Ideally the heat loads are not extracted immediately but stored temporarily. The condition for temporary storage is that the building has a sufficiently large thermal storage capacity. In order to avoid overheating in the building structure, the thermal mass must be able to discharge its thermal load once within a 24-hour cycle. This can, for example, be performed during the night hours (Fig. 3.64).

Because it is mainly the day-time heat loads that are of interest, heat loads are not stated in Watt, but in Watt hours per square metre and day (Wh/m²d). The internal heat gains in residential buildings are around 120 Wh/m²d. For office buildings, internal gains of approximately 15 W/m² are assumed during working

hours and approximately 2 W/m² outside working hours (Fig. 3.65).

Generally only the thermal gains are considered when calculating the heat loads. Latent gains and losses, which occur due to vaporisation and breathing, are not usually taken into consideration. However, latent loads must be taken into account when systems are used that operate on the basis of evaporative cooling since they influence the system's performance considerably.

Before deciding on a cooling system, the building should be optimised in order to reduce the cooling loads as much as possible. Furthermore, the availability of existing heat sinks should be looked into and, based on this, the ideal cooling strategy can be selected.

If the same level of thermal comfort is to be maintained in the building interior throughout the year, there are approximately 50 to 200 cooling hours a year in residential buildings located in Central Europe. In administrative buildings, dependent on the heat load, approximately 1000 cooling hours per year are to be expected.

Cooling systems

Air, water or brine can be used to cool a building. Alongside air-conditioning units, other systems, such as induction units, air recirculating cooling units, downflow coolers, cooling ceilings or thermo-active building components, can be considered (Fig. 3.68).

• The application of induction units requires the installation of an air duct and a cold water network. In this system, the supply air is preconditioned in a central plant and then fed to the decentralised cooling coil via ductwork. The cooling coil is connected to a cold water network so that the supply air is cooled even further as it flows into the room. The induction effect causes room temperature air to be drawn into the system, which results in a flow of cooled mixed air leaving the induction unit.

• Recirculating cooling units also require the installation of a cold water network; an air duct system is not needed. In principle, this system consists of a cold water-circulating fan convector. Aided by the fan, the room temperature air is forced past the convector and cooled. In comparison to induction units, there are no ducts for supply air.

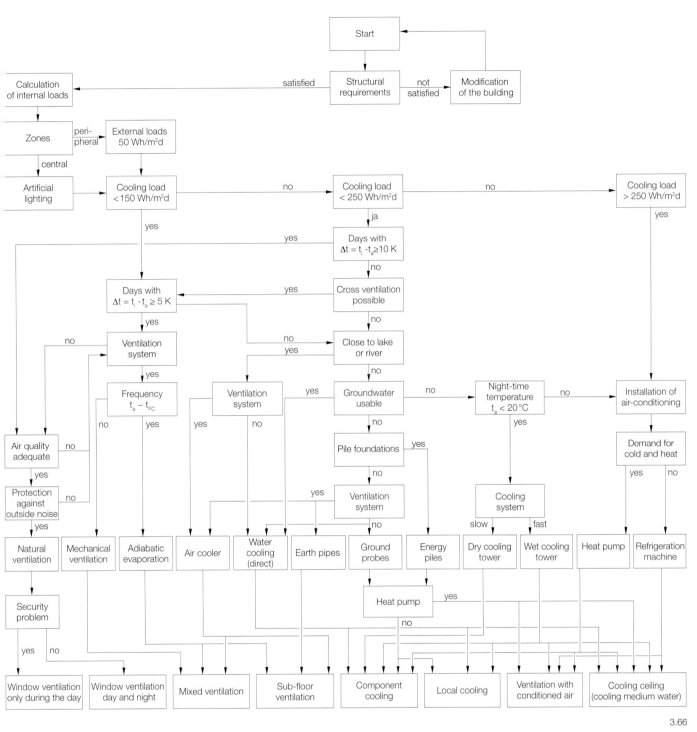

3.66

	Cooling capacity (W/m²)	Forward flow temperature (°C)	Controll-ability	Cold output	Passive/regenera-tive cold	Notes
Cooling ceiling	80–120	10–18	very good	radiation	+	dew-point regulation
Thermo-active ceiling	~50	16–20	low	radiation	++	no suspended ceilings
Floor cooling	20–30	16–20	low	radiation	++	risk of discomfort
Downflow cooler	60–100	6–10	good	convection	-	condensation drainage might be necessary
Induction unit	60–100	6–10	good	convection	-	condensation drainage might be necessary
Recirculating cooler	80–120	6–10	very good	convection	--	condensation drainage might be necessary
Air-conditioning plant	80–120	6–10	good	convection	--	large amount of installation work

3.67

3.68

- Downflow coolers are usually installed behind panelling. In this system, a cold water circulating convector is fitted close to the ceiling so that the airflow is directed downwards. An additional fan can increase convection and lead to better results. In practice, this system is comparable to a recirculating cooling unit.
- Cooled ceilings circulate water throughout a system of panels. Cooling panels can, for example, be suspended from the ceiling in a sail-like arrangement. Energy is exchanged via radiation.
- Thermo-active building components generally include water pipes (see p. 49f.), which are either embedded in the floor slab or retrofitted underneath the slab.

Energy piles and ground probes
These building components are closed-loop systems which make use of the temperature of the ground water or the ground itself. In comparison to ground loops, which are installed at a depth of between two and four metres, probe systems reach down to a depth of 100 metres or more. When it comes to vertical systems, there is

a difference between ground probes and energy piles. This source is also referred to as near-surface geothermal energy. Pile foundations are generally used when the bearing capacity of the top ground is limited. They are therefore necessary from a building construction point of view and reach down to a depth of approximately 20 to 25 metres. The difference between the construction of an energy pile and a normal foundation pile is merely that pipes are installed into the reinforcement cages of the piles, which circulate water once the building has been completed (Fig. 3.73).This method thermally activates the reinforced concrete pile. In summer, heat is dissipated via the soil; in winter, heat is absorbed. In contrast to energy piles, ground probes are not necessary building components from a statics point of view and can therefore be retrofitted. They are usually installed to provide heat to operate a heat pump in winter or to provide a heat sink for the cooling of buildings in summer.

Construction and function
The installation of ground probes is similar to that of pile foundations, in that it is

necessary to drill a borehole into the ground. A ground probe consists of twin tubes which are connected at the lowest point; they function as the forward and return flow of the system (Fig. 3.72). In addition, a ground probe is equipped with a third pipe which is used to fill the borehole. The difference to energy piles is that the borehole is not filled with concrete but usually with a bentonite-water cement-mixture. Depending on the desired application, shorter ground probes are used if cooling is the primary function, whereas longer ones are necessary for heating purposes. The installation depth of a ground probe is approximately 75 to 150 metres. As in the case of energy piles, water is pumped through a probe system, the result being that ground probes and energy piles are both efficient thermal exchangers between the ground and the building services. The pipes which are installed in the ground probes or energy piles are routed to a distribution unit inside the building which in turn is connected to the heat exchanger of the air handling unit, the heat pump or the surfaces selected for component cooling.

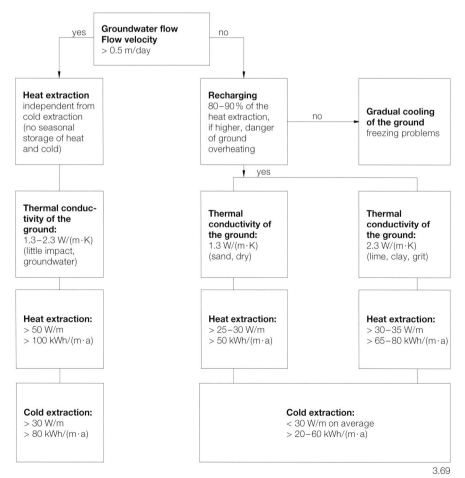

3.69

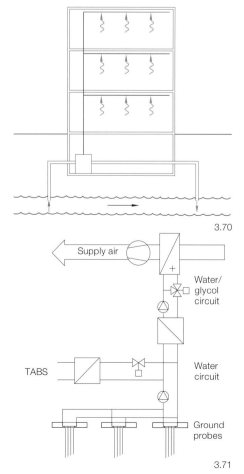

3.70

3.71

Planning and operation

If several energy piles or ground probes are installed in the subsoil, careful attention should be paid to the direction of the ground water flow and the distance between the individual systems. Interaction between the piles or probes must be avoided. The minimum distance between the ground probes or energy piles should be approximately 10% of the depth.

The temperature of the ground, down to depths of approximately 15 m, fluctuates according to the air temperature and is also influenced by long-term snow coverage. At lower depths, the temperature is more or less stable. At a depth of approximately 10 m, the ground temperature is approximately 1–2 K above the average annual temperature. With increasing depth, the temperature rises; the increase is approximately 2.5–4 K per 100 m depth.

The flow velocity of groundwater is usually only a few centimetres a day, so that the ground can be used as an interseasonal heat store, which is loaded and unloaded during the course of a year. If the groundwater flow velocity exceeds approximately 0.5 m per day, the ground constantly regenerates. In this case, there is no seasonal loading and unloading of the system's surrounding soil.

Ideally the system is not operated with brine, but simply with water. Apart from the advantage concerning possible leakages, water has the advantage of achieving a higher heat transfer rate and can function with a lower pumping capacity for the same volume flow. Systems that are to be combined with heat pumps should, as a rule, be operated with a glycol/water cycle.

Field of application

Ground probes and energy piles can generally be used in combination with different applications. It is, for example, possible to connect thermo-active building components or cooling ceilings. There is also the possibility to discharge waste heat from appliances into the ground. In the ideal situation, ventilation and cooling are combined (Fig. 3.71). This form of combination has the advantage that the air exchange rate for the building ventilation can be reduced to a hygienically satisfactory level and the heat can be removed effectively by using cooled building components.

System performance

In winter, the systems are used to extract the energy stored during the cooling period. In order to maintain the efficiency of the system, the energy must be loaded and unloaded in alternating cycles throughout a year. An even annual energy balance is needed to avoid overheating or freezing of the ground. Usually the system is designed for cooling applications so that approximately 10–20% less heat is fed into the system in summer than is extracted in winter. The heat extraction is also limited in the case of energy piles in order to avoid freezing of components functioning primarily as the building foundation. As a general rule, the ground functions as an enormous interseasonal heat store, which is loaded and unloaded annually – heat is supplied in summer, discharged in winter. Since only the natural storage capacity of the ground is being used, no structural measures are required. Warming of the subsoil by the building located above should be prevented as much as possible, as this might otherwise decrease the cooling efficiency.

The efficiency of ground probes is generally dependent on the ground characteristics. In contrast to ground with good thermal conductivity, the source temperature in ground with bad thermal conductivity rises much quicker during the course of the heat input. Depending on the heat input, however, even if heat input and output are balanced, seasonal increases in the source temperature can arise. In order to cover long-lasting peak loads that may occur due to short heat waves, the probe length must be determined in a way that will prevent excessive seasonal increases. The average cold extraction efficiency is approximately 20–30 W/m of probe length (Fig. 3.69).

Cooling with groundwater

In groundwater cooling, the low temperature of the groundwater is used to cool the building. The system consists of an extraction well and an infiltration well (Fig. 3.74). According to the water resources act, the utilisation of groundwater in Germany requires official approval.

Construction and design

In order to utilise groundwater, a pumping well is installed to extract water from the ground which is then fed through a heat exchanger. The warm return flow from a

3.72

3.73

3.74

3.69 Approximate dimensions for energy piles and ground probes
3.70 Building cooling via ground or surface water. Groundwater can be extracted with a pumping well and reintroduced into the ground at a different place with an infiltration well.
3.71 Schematic diagram for integrating ground probes into the building services system. A glycol/water mixture is used in frost danger zones (ventilated side).
3.72 Probehead with a double U tube
3.73 Reinforcement cage of an energy pile with plastic tubing connected in the longitudinal axis for cooling the building.
3.74 View into an extraction well

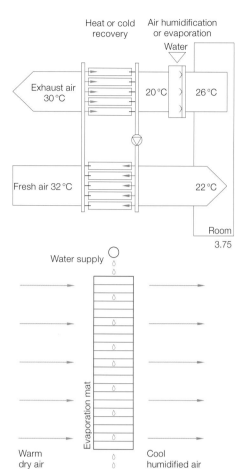

Heat or cold recovery / Air humidification or evaporation

Water

Exhaust air 30°C — 20°C / 26°C

Fresh air 32°C — 22°C

Room

3.75

Water supply

Evaporation mat

Warm dry air / Cool humidified air

3.76

3.77

3.75 Indirect adiabatic cooling (evaporative cooling) via air-conditioning and ventilation plant
3.76 Cooling and simultaneous humidifying of warm air by means of an evaporation mat
3.77 Evaporation mat made of cellulose fibre
3.78 Schematic diagram of an open-circulating radiant cooling system
3.79 Release of water through the human body in relation to physical activity. The moisture content of the air is a decisive factor when applying an adiabatic evaporative cooling system.
(1 met = 58.15 W/m² body surface)
3.80 Unglazed metal roof collectors can also be used for the reverse operation. They can dissipate heat to the ambient air during the night.
3.81 Exemplary development of cooling load and cooling performance in a test building. The cooling is performed via radiation, convection and evaporative cooling. A roof area measuring 75 m² was provided for the cooling process.

cold water supply or warm supply air is channelled through the heat exchanger in the opposite direction. During the process of absorbing heat, the temperature of the groundwater is increased by approximately three degrees before it is finally returned to the ground via an infiltration well.

Planning and operation
The extraction well should reach down to approximately 5 m below the actual groundwater level. In relation to the flow of groundwater, the infiltration well must be positioned downstream from the extraction well (Fig. 3.71, p. 40). If the direction of flow is unknown, the minimum distance between both wells should be around 15 m. As a rule, the geological conditions and the chemical composition of the groundwater should be known. In the case of large proportions of divalent iron ions, careful attention must be paid to ensure that groundwater in the installation systems does not come into contact with oxygen as this could lead to a precipitation of ferric hydroxide. This could give rise to clogging within the water-circulation systems. Reduced performance or failure of the cooling system could be the result. Care should be taken to ensure that the level of the water extraction is always clearly below the groundwater table.

Fields of application
Cooling with groundwater can, for example, be used in combination with a mechanical ventilation system. Centralised cooling is possible by passing supply or recirculated air through a heat exchanger at the same time as having a counterflow of cool groundwater. The conditioned air is then distributed throughout the building via ductwork. Alternatively the cold groundwater can also be fed through a heat exchanger which has a closed-loop water cycle flowing in the opposite direction. The water, which has been cooled by the groundwater, is then distributed in the building via the forward flow of the cold water network. The cold water flows through a heat exchanger in the parts of the building which require cooling. The heat exchanger could, for example, be a fan convector, which cools the room air in a recirculation process.
A cold water network has the advantage that the installation of the distribution sys-

tem is more straightforward. This system is very suitable if simply cooling rather than ventilation is required.

Performance range
The system performance is sensitive to the volume of extracted water and the prevailing ground water temperature. The latter depends on the time of year and the location but is usually in the range of 8 to 12°C.

Evaporative cooling (adiabatic cooling)
Adiabatic cooling occurs when water evaporates in a medium that is not saturated by water vapour. Since the energy that is required for the evaporation of the water is extracted from the surrounding medium, its temperature is automatically reduced. The principle of cooling is based on the fact that a comparatively large amount of energy is required to convert a small amount of water into water vapour and therefore change the physical state of water. This process is generally referred to as adiabatic or evaporative cooling.

Construction and function
Generally, a distinction is drawn between direct and indirect systems in evaporative cooling. In the case of direct evaporative cooling, the evaporation of water takes place directly in the volume flow of the cooling air (Fig. 3.75). In the case of indirect systems, the exhaust air is cooled adiabatically and then channelled through a heat exchanger, which has supply air flowing in the opposite direction. In this process, the volume of cold exhaust air absorbs the thermal energy from the supply air, which leads to a cooling down of the supply air. In indirect evaporative cooling, an increase of the relative, not the absolute, humidity occurs within the supply air volume. In the case of direct evaporative cooling, both humidity values increase.
Evaporation mats (Fig. 3.76 and 3.77) or air washing systems are suitable devices for the humidification of air. The use of rainwater is ideal as process water. It can be collected in rainwater tanks and provided to the adiabatic cooling system on demand.

Planning and operation
Since the operation of the system is influenced by the condition of the air, it is not possible to guarantee a maximum

acceptable supply air temperature. If maximum supply air temperatures are to be maintained, even in unfavourable weather conditions, it makes sense to combine the system with a compression cooling machine installed downstream. If the thermal loads are not to be discharged exclusively via the ventilation system, a combination of adiabatic cooling and thermo-active building components could be a practical solution.

Fields of application
In Central Europe, direct humidification of the supply air is not normally necessary as the relative humidity in the supply air would increase too much. Since a high relative humidity prevents the human body from cooling quickly due to the evaporation of perspiration, high air humidity is often regarded as uncomfortable. It is therefore more appropriate in Central Europe to cool the volume flow of exhaust air adiabatically. Evaporative cooling systems can be used in hot dry regions. However, due to the water consumption, it is necessary to examine whether an alternative system might be more appropriate.
Whether or not the utilisation of adiabatic cooling can be integrated in the concept of building services generally depends on the condition of the outside air and the exhaust air requiring humidification. The application is especially practical when the temperature of the exhaust air, which is to be humidified, is high and, at the same time, the relative humidity is low. The humidity values of exhaust air are subject to the building's use and vary according to the number of persons occupying the building and their activities. One person performing activities in a seated position (approximately 1.2 met) dissipates almost 100 g of water per hour as a result of perspiration. This release of moisture rises with an increase in activity (Fig. 3.79).

Performance range
At outside air temperatures of up to 30°C, it is possible to achieve air supply temperatures of approximately 22°C in average office applications without adding additional cooling technology. The efficiency of an evaporative cooling device depends particularly on the available air temperatures and the humidity as well as the efficiency of the heat transfer medium. In order to achieve high performance, the fans require a high level of efficiency, the recooling rate of the heat transfer medium needs to be high and the energy consumption of the air humidifier should be kept low. The highest specific cooling output that can be achieved is approximately 3 W/m³/h. In indirect systems, the water consumption in relation to the heat transfer medium can be as much as 2.5 kg per kWh of usable cooling energy.

Radiant cooling
The principle of radiant cooling is based on the fact that the sky temperature (radiant temperature of the atmosphere) is often below the outside air temperature on clear nights. It is therefore possible to achieve cooling below the level of the outside air temperature by means of radiation. Radiant cooling can be implemented either as an open or closed hydraulic system. The two variants differ in the way they recool.

Construction and function
Radiant cooling generally consists of cooling panels, one or more primary circuits, a secondary circuit, a water storage tank and a recooling system. The primary circuit is a closed-loop cold water circuit which consists of a forward and return flow. The primary circuit flows through the cooling surfaces as well as the heat exchanger, which integrates the secondary circuit in counterflow direction. It generally makes sense to divide a building into zones with different primary circuits so that there is flexibility in reacting to the different cooling loads. The secondary circuit is connected to a rainwater cistern with a forward and return flow (Fig. 3.78). In order to cool a building, the warm room air passes over a cooled surface, which could, for example, be a recirculating cooler or a cooling ceiling. Due to this process, the room heat can be discharged to the primary and secondary circuits via the cooling surfaces and then finally to the water in the rainwater cistern. The cistern water is a cold store, which gradually heats up during the course of a day. To prevent the cistern water from heating up too much, it must be recooled in cycles. In open systems, this is achieved, for example, by pumping the cistern water up onto the roof of the building at night where it is distributed across the surface. This method, causes the heat to dissipate by means of convection, evaporation and radiation. Due to the

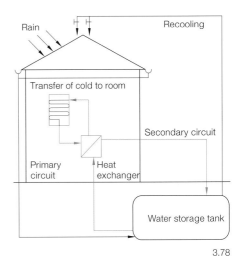
3.78

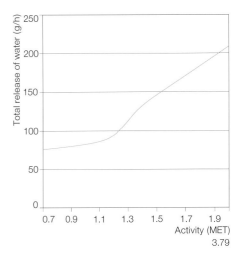
3.79

3.80

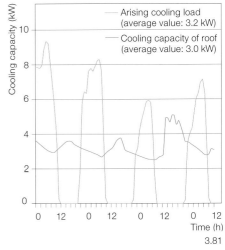
3.81

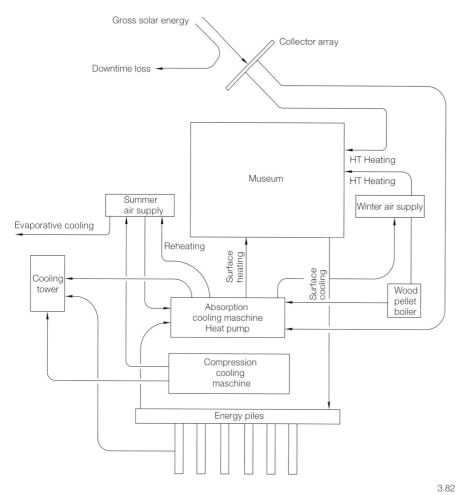

3.82

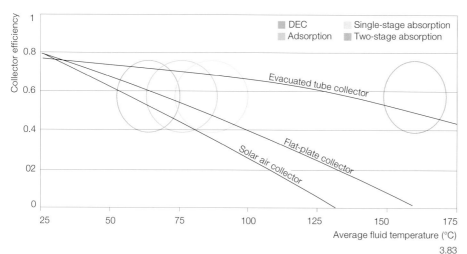

3.83

Technology	Absorption		Adsorption	DEC
	Single-stage	Two-stage		
Refrigerant	water	water	water	–
Sorbent	lithium bromide	lithium bromide	silica gel	silica gel or lithium chloride
Cooling agent	water	water	water	
Low temperature range	6–20°C	6–20°C	6–20°C	16–20°C
High temperature range	75–100°C	140–170°C	65–95°C	55–100°C
Range of cooling capacity per unit	15–20500 kW	170–23300 kW	70–350 kW	6–300 kW
COP	0.6–0.7	1.1–1.4	0.6–0.7	0.5–1.0

3.84

heat dissipation via radiation, the minimum water temperature that can be reached is below the dew point. The cooled water is then guided back to the cistern. In closed systems, closed collectors are responsible for the recooling (Fig. 3.80, p. 43).

Planning and operation
The nighttime recooling is put into operation as soon as the outside temperature drops below a defined level. Because part of the cooling water evaporates in an open recooling system, the water level sinks. This loss of water is ideally replenished during the next rainfall. There is no loss of water in a closed system.

Fields of application
Open systems can only be used in regions where there is sufficient water, for example in Central Europe. However, the cloudy weather conditions often experienced in Central Europe reduce the theoretical system efficiency.
If frequent cloudiness is expected, due to the mesoclimatic conditions, the system can be used to recool machines and technical equipment which can make use of recooling temperatures above 20°C. Primarily rainwater should be used as the cooling agent.
The recooling provided by metal roof collectors in closed systems is not as efficient as an open cooling system due to the lack of evaporative cooling. However, it does have the advantage of not consuming any water. Closed systems are therefore more suitable for hot dry regions. Since these areas are seldom very cloudy, a relatively constant system efficiency can be assumed.
As well as water, frost-resistant glycol mixtures are also suitable for the secondary circuit in closed systems. With these liquids, it is also possible to make use of the radiative cooling at temperatures below zero. Despite the same volume of liquid, the amount of energy consumed by the pumps is greater when using glycol due to the different viscosity. The thermal exchange rate is also reduced.

Performance range
The efficiency of the system is directly associated with the attainable temperature of the return flow and the necessary temperature of the cooling water. The higher the cooling water temperature can

be selected, the more efficient the system becomes. Since a large proportion of the total energy demand is used to operate the pumps, it is important to make sure that these work efficiently.

The size of the system depends on the maximum admissible increase of room air temperature. With the implementation of an open prototype, a maximum specific cooling output of approximately 50–150 W was achieved during the cooling period. This represents a daily specific cooling output of approximately 40 W per square metre of roof area. For a situation with an average cooling load of approximately 3.2 kW and an available roof area of 75 m², an almost even energy balance was achieved (Fig. 3.81, p. 43). The measured coefficient of performance (COP) of the system is around 14 to 24 and therefore much higher than the efficiency level of a highly efficient compression cooling plant.

Absorption and adsorption cooling systems
Sorption cooling systems can be used for solar cooling. They operate at extreme negative pressure so that the refrigerant, water, can evaporate at a fairly low temperature in a closed circuit (Fig. 3.85). The energy required for the evaporation of the refrigerant is absorbed from the return flow of the cooling supply network. The result is the availability of cold water in the forward flow of the network.

Construction and function
In order to maintain the evaporation process within a sorption cooling machine, the vapour produced during the evaporation of the refrigerant must be discharged continually. This is achieved through sorption.
Since the absorbability of the sorbents is limited, a continual discharge of water vapour can be guaranteed only if the sorbents are desorbed once the sorption process has been completed. The process of sorption and desorption takes place in cycles, which means that some of the sorbents are absorbing water vapour at the same time as others are releasing water vapour. The water vapour produced during the desorption process is condensed and reintroduced into the evaporation process (Fig. 3.90, p. 46). Solar thermal energy or waste heat from a block-type thermal power station, for instance, could be used for the desorption process of the sorbents.

In absorption and adsorption systems, a distinction is made between single-stage and two-stage systems. Single-stage systems can be operated at low temperatures, however, they are not as efficient as two-stage systems (Fig. 3.83). Either liquid or solid materials are used as sorbents. Absorption systems operate with liquid sorbents, adsorption machines with solid ones. Systems using liquid sorbents have the advantage that the desorbed sorption agent can be stored temporarily. Due to the possibility of using a temporary storage facility, periods with low energy yield can simply be bridged. The cooling capacity is not reduced during this period; it is also not necessary to switch to an additional conventional cooling system based on compression.

Planning and operation
The required driving temperature for a single-stage system is approximately 75–100 °C, that of two-stage systems approximately 140–170 °C (Fig. 3.84). High-temperature waste heat is therefore required to operate the two-stage system. Alternatively a high-efficiency collector plant, such as parabolic trough collectors with a uniaxial tracking system, can be integrated to cover the demand. However, these collectors are not suitable for use in Central Europe, since the proportion of direct radiance in relation to the total global radiation is not sufficiently high in these latitudes.
In general, the collector area required to drive the system is strongly dependent on the microclimatic site conditions and systems already installed have shown that these can vary considerably. In good conditions, a specific collector area of approximately 2.5 m²/kW is required for single-stage absorption cooling machines and approximately 3.4 m²/kW for adsorption cooling machines (Fig. 3.88, p. 46).

Fields of application
In comparison to compression cooling plants, the application of absorption and adsorption cooling systems makes sense from a primary energy point of view, if a minimum amount of the required thermal energy is provided by solar energy or available waste heat. According to comparable systems, single-stage systems require minimum coverage ratios between around 50 and 75 %.

3.85

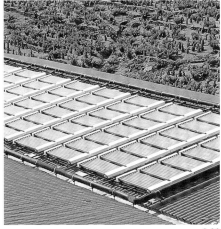

3.86

3.87

3.82 Cooling concept for the Ritter museum in Waldenbuch, architect: Max Dudler. The arrows show the direction of each heat flow. Part of the cooling is provided by a solar-powered absorption cooling machine.
3.83 Sorption cooling machines are operated at different temperatures in accordance with their design. If they are powered by solar energy, different collector systems are required.
3.84 Overview of solar thermal cooling procedures
3.85 Absorption cooling plant
3.86 Tube collectors used to power a sorption cooling plant on the roof of a wine cellar in the south of France.
3.87 Tube collectors used to power a sorption cooling plant; Ritter museum in Waldenbuch, architect: Max Dudler

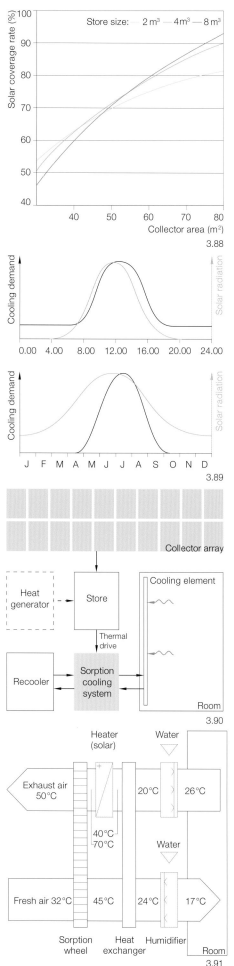

3.88

3.89

Collector array

Heat generator — Store — Cooling element

Thermal drive

Recooler — Sorption cooling system — Room

3.90

Heater (solar) — Water

Exhaust air 50°C — 20°C — 26°C

40°C / 70°C — Water

Fresh air 32°C — 45°C — 24°C — 17°C

Sorption wheel — Heat exchanger — Humidifier — Room

3.91

Whether the integration of a sorption cooling machine into the concept of building services makes sense depends not only on the microclimatic site conditions but especially on the amount and configuration of the thermal loads which need to be discharged. These systems are, for example, suitable to provide cold water for an air-conditioning system (Fig. 3.90).

Due to the changing meteorological conditions, it can generally be said that systems which rely solely on solar radiation cannot offer one hundred per cent coverage of the required cooling output. For this reason, it can be expected that the standards of thermal comfort will not be met for a number of hours during the year. The number and distribution of the predicted high-temperature hours can only be determined approximately by using simulations. In order to cover this uncertainty of supply resulting from changing meteorological conditions, the cooling system can be supplied with a back-up system, for instance, a small compressor cooling plant (Fig. 3.82, p. 44).

Particularly in the case of plants with low coefficients of performance, it is in no way sensible, from a primary energy point of view, to compensate for the lack of solar thermal energy by using a fossil fuel. In hot and dry regions and temperatures above approximately 32°C, sorption cooling plants require an evaporative cooling tower or something similar for recooling. The application of a cooling tower in these regions should be examined carefully regarding the consumption of water resources. Sorption cooling machines can be used in hot humid areas as long as the issue concerning recooling is resolved.

Performance range

Cold water temperatures ranging from approximately 6–20°C can be achieved with one and two-stage sorption cooling machines. The range of cooling capacity that can be attained with absorption or adsorption cooling plants depends on the size of the plant. The coefficient of performance (COP), which in this case means the relation of heat input to cold output, for one-stage absorption systems and adsorption devices is approximately 0.6–0.7, for two-stage absorption machines approximately 1.1–1.4 (Fig. 3.84, p. 44).

Sorption-assisted air-conditioning (desiccant and evaporative cooling, DEC)

This technology, in a similar way to sorption cooling machines, involves a cooling system which can be powered by solar thermal energy. The difference is that cold air is produced. A sorption-assisted air-conditioning plant is integrated into the building services concept in a similar way to an air-conditioning system and operates with a supply and exhaust air system. The energy to power the system is either heat gained from solar collectors or waste heat from a combined process (e.g. a block-type thermal power station). As in the case of sorption cooling systems, the substances used as sorbents or refrigerants should not have an ozone depletion potential (ODP). The cold air is produced in an adiabatic evaporative cooling process. Merely the fans and pumps are powered by electrical energy (Fig. 3.93).

Construction and function

In contrast to direct or indirect adiabatic evaporative cooling systems, these systems operate with an upstream dehumidification (desorption) of the supply air. The dehumidification is achieved through sorption. Liquid (absorption) or solid (adsoprtion) sorbents can be used as sorption agents.

In systems with solid sorbents, the outside air is dehumidified as it flows through a sorption rotor placed within the volume flow of the supply and exhaust air (Fig. 3.91). Then the supply air is channelled through an integrated heat exchanger where it meets exhaust air flowing in the opposite direction. Before entering the heat exchanger, the exhaust air is humidified, which has the effect of cooling it adiabatically. The result is that the supply air is precooled by the exhaust air in the heat exchanger. The dehumidified and precooled supply air is finally cooled further by humidification in a conditioning unit.

In order to guarantee a continuous dehumidification of the supply air before entering the heat exchanger, the sorption rotor must be dehumidified (desorbed) at the same time. This is performed by heating the exhaust air after the cooling process and guiding it past the humidified sorbent. The thermal energy required to heat the exhaust air and, therefore, carry out the desorption of the sorbent can, for example, be supplied by solar collectors.

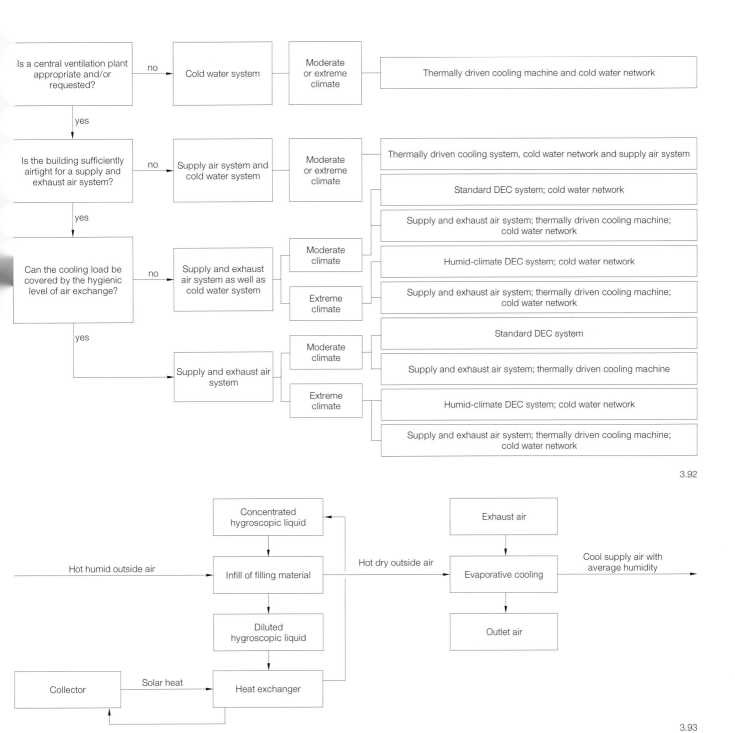

3.92

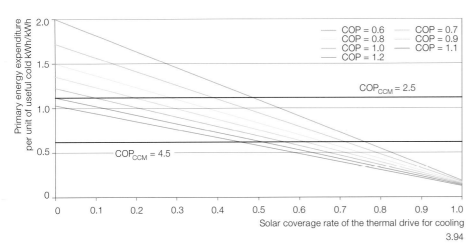

3.93

3.88 Dimensions of a solar 15 kW absorption cooling machine (example for a 20 MWh/a demand of cooling energy)
3.89 Temporal conformity of solar radiation and cooling demand from external loads
3.90 Schematic diagram of solar thermal cooling with a sorption cooling system
3.91 Sorption-assisted air-conditioning with sorption wheel (DEC)
3.92 Decision tree for the selection of a thermally driven cooling system
3.93 Treatment of supply air in a sorption-assisted air-conditioning system (DEC)
3.94 Primary energy expenditure required for the generation of cold by a solar-powered cooling machine in relation to the solar coverage rate. The primary energy expenditure values of a compression cooling machine are applied as reference values (COP CCM).

3.94

Planning and operation

If the adiabatic humidification is operated with untreated drinking water, a continuous elutriation of the system is required. Elutriation is necessary to prevent the mineral and salt content in the flow of process water rising steadily due to the evaporating water. Depending on the plant configuration, small amounts of biocide might have to be added to prevent the growth of Legionella in the humidification units.

Fields of application

A sufficient supply of thermal energy is required for a sensible integration of this system. Depending on the sorbent used, a temperature of between approximately 65 and 95 °C is needed for the desorption of the sorbing agent. To generate the energy required for the desorption process, a specific collector area, subject to the location, of approximately 8.2 m² is required for an air volume flow of 1000 m³/h.

To achieve an advantage with regard to the use of primary energies over compression cooling systems, depending on the system, approximately 55–75 % of the required thermal energy should be provided in the form of solar energy or waste heat (Fig. 3.94, p. 47).

Apart from the microclimatic site conditions, the quantity and quality of the loads that are to be removed as well as the air tightness of the building are important factors influencing the choice and dimensions of the system (Fig. 3.92, p. 47). Due

3.95 Schematic diagram of a closed-loop desorption and evaporation-assisted air-conditioning system
 1 Outside air
 2 Supply air inside
 3 Exhaust air inside
 4 Exhaust air
 5 Cold air flow
 6 Desorption flow
 7 Forward flow hot water
 8 Condensate drainage
 9 Return flow hot water
 10 Countercurrent heat exchanger
 11 Sorption cylinder
 12 Solar collectors
 13 Heat exchanger and condenser
 14 Fans
3.96 Detail view of a sorption rotor which removes moisture from the outside air. The following adiabatic cooling process is therefore much more efficient.
3.97 Thermal activation is possible in normal flat slabs or special constructions, such as so-called bubble ceilings.
3.98 To thermally activate the floor slab, water-bearing plastic tubes are embedded on the neutral axis of the concrete floor slab.

to the permanent consumption of water, sorption-assisted air-conditioning systems are in no circumstances suitable for hot dry regions. If the system is to be installed in hot humid regions, the system configuration must be adjusted slightly by integrating an additional cooling unit, for example a compression cooling device.

Performance range

The coefficient of performance (COP) of a sorption-assisted air-conditioning unit is approximately 0.5–1.0. A cold output of approximately 0.5–1.0 kW can therefore be achieved with 1 kW of thermal energy. Cooling capacities of approximately 5 to 6 kW can be reached with an air volume flow of 1000 m³/h.

Closed desorption and evaporation-assisted air-conditioning

Solar thermal energy or waste heat can be used to drive this new innovative system. The technology belongs to the group of solar cooling and air-conditioning systems. Electrical energy is required only for the transportation of air and water, for fans and pumps. The technology has been developed especially for hot dry regions.

Construction and function

The system consists basically of two closed loop air circuits, a new kind of sorption or desorption component, two heat exchangers, a condenser, a solar collection array and water as the refrigerant. Within the system, the refrigerant appears partly as water vapour and partly as water in its fluid form. During a work cycle, the refrigerant undergoes a phase change from fluid to vapour.

In a first step, the hot dry outside air is fed through a heat exchanger where it meets exhaust air in counterflow from the building interior. In this first step, the supply air is warmed and preconditioned. Then the preconditioned air is channelled through another heat exchanger which has a closed loop of cooling air moving in the opposite direction. In this second cooling process, the supply air meets its desired temperature. In order to produce the volume flow of cooling air, the air volume is dehumidified through sorption and cooled by an outside air heat exchanger within a cycle. Finally the cooling air is humidified adiabatically causing the temperature to drop further.

The dehumidification is achieved by an innovative, patented moisture exchange

process. It transfers the moisture to a second similarly closed loop air volume flow. In this second cycle, the moisture absorbed from the first air volume flow is regained by supplying heat (e.g. solar energy). The released water vapour is then removed by condensation and reintroduced to the system.

In contrast to sorption cooling plants, which are operated at extreme negative pressure, this system can be operated in normal conditions.

Planning and operation

The system is integrated into the building services concept in a similar way to conventional air-conditioning systems. By cooling the hot outside air, the relative humidity of the supply air is increased so that humidification is generally not required before entering the building interior. Integrating an additional humidification unit into the system may be necessary only in locations with climate conditions where the relative humidity of the supply air is permanently below 30 %. Ductwork is necessary for the distribution of the supply air and the extraction of the exhaust air. To guarantee high solar thermal yield, the integration and orientation of solar collectors should be considered at an early phase of the design or refurbishment planning.

Furthermore, it is important to make sure that the outside air heat exchangers are correctly positioned. They should not be placed in direct sunlight. The supply air should be drawn in from a shaded area and not directly above a sun-exposed surface.

Fields of application

Both sorption-assisted air-conditioning systems (see p. 46) and sorption cooling machines (see p. 45) can be operated with thermal energy, such as solar energy. When the outside air temperatures are high, sorption cooling machines require recooling with water spray systems. Their use in hot dry regions would, therefore, lead to high water consumption. Sorption-assisted conditioning systems consume water. For this reason, the use of both of these technologies should be avoided in hot dry regions if the aim is to plan a sustainable building.

In contrast, the new innovative closed loop desorption and evaporation-assisted air-conditioning system depends only on an adequate supply of solar radiation

r waste heat; water is generally not
equired. This system is therefore ideal for
ot dry regions, for example in the Persian
Gulf countries.

Performance range
This technology can produce cold air. At
outside air temperatures of around 40 °C
and a relative humidity of 12 %, it is possi-
ble to achieve a supply air temperature of
approximately 25 °C and a relative air
humidity of 30 %. At the same exterior air
conditions, an assumed exhaust air tem-
perature of 29 °C and a relative humidity
of around 35 %, it is possible to remove a
heat load of approximately 14 kJ with the
exchange of a kilogram of air.

**Heat dissipation via thermo-active building
systems (TABS)**
This method is a panel cooling system in
which the heat dissipation is separated
from the ventilation. It uses the mass of
the building, for example the floor slabs,
to store heat loads temporarily. The
stored loads are not removed immedi-
ately but extracted later. This method
prevents extreme temperature fluctuation
in the building interior. The thermo-active
building components can be used to cool
the building during the cooling period
and heat the building during the heating
period.

Construction and function
In contrast to underfloor heating, the
water circulating tubes in thermo-active
building components are embedded in
the structural component itself along with
the reinforcement (Fig. 3.98). Alterna-
tively, the tubes can be laid in the bonded
concrete screed. The tube registers can
either be integrated in normal flat slabs or
in special constructions, like, for example,
so-called bubble deck ceilings
(Fig. 3.97).
Water circulates within the cooling circuit
causing the complete ceiling to function
as a large-scale heat exchanger. The
heat absorbed by the thermo-active
building components is transferred to the
water circulating within the cooling circuit
and removed with the flow. The heated
water is guided to a recooling unit where
it is cooled back to its original tempera-
ture and then transported back to the
same space (Fig. 3.99, p. 50). Ideally the
recooling is performed with natural heat
sinks, for example ground probes.
Generally, the thermo-active building

components are pooled so that one build-
ing is divided into several zones and
therefore different cooling circuits. The
aim of this zoning is the ability to react to
different internal and external loads (e.g.
due to different levels of solar gains) with
appropriate component temperatures. If
the zoning is performed according to
internal as well as external loads, the
zones should be arranged in a way that
allows sufficient flexibility for future refur-
bishments. In buildings without zones,
there is a danger of undercooling in
rooms with low heat loads.
In order to avoid obstruction of heat
transmission, thermo-active building
components should not be encased
and suspended ceilings should not be
used. This means that if acoustic fittings
are required, alternative positions
should be considered early in the plan-
ning stage.

Planning and operation
The system can be operated in addition
to a ventilation plant or natural ventilation.
Due to the high mass, which is either
heated or cooled, a rapid change of room
temperature is not possible. If the room
temperature is to be controlled locally
and if certain upper or lower temperature
limits are to be observed, it is necessary
to install an additional cooling or heating
system. In this case, it makes sense to
use either a heat pump or link up to a dis-
trict heating network. Building compo-
nents are usually activated in summer as
well as winter in order to provide the
building with a basic temperature. In this
case, it is supplemented by an air-condi-
tioning system. In order to limit the
required cooling output, the system
should only be operated during working
hours and the thermo-active building
components should only be unloaded
outside working hours. In this operation
mode, the cooling capacity must not be
provided for both systems at the same
time since this reduces the maximum
necessary cooling output. Sufficient stor-
age mass is the precondition for opera-
tion at separate times.
Due to the large overall mass, the thermo-
active building components only heat up
very slowly during the course of a day
(Fig. 3.100). If there is an exceptionally
large proportion of convective load,
due to the building's use, the result may
be an above-average increase of room air
temperature. In this case, the system

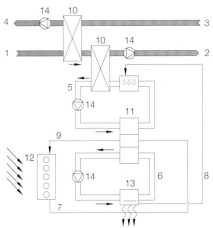

3.95

3.96

3.97

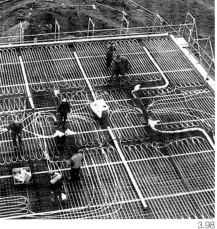

3.98

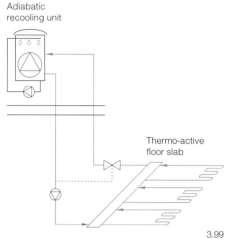

Adiabatic
recooling unit

Thermo-active
floor slab

3.99

Without air-conditioning: T_{Room} $T_{Ceiling surface}$
With night-time ventilation, 4 times, with concrete core activation: T_{Room} $T_{Ceiling surface}$
$T_{Outside air}$

3.100

should be combined with an air-conditioning plant.

The forward flow temperatures within a TABS are determined according to individual demand. The lower the necessary cooling and the building's energy consumption is, the higher the forward flow temperature can be in summer and the lower it can be in winter. As a rule, the thermo-active building components are connected to low-temperature systems since the flow temperatures differ only slightly from the room temperatures. The minimum water temperature within an activated building component is approximately 18 °C. Too low a temperature would lead to a drop below the dew-point temperature of the indoor air leading to the development of condensation on the ceiling face. At a room temperature of 26 °C and a relative air humidity of 50 %, the dew-point temperature is approximately 15 °C.

With regard to recooling, if this is to be provided by outside air (cooling tower), in contrast to recooling via the ground, there is no heat source for heating the building

in winter. When using an evaporative cooling tower, the expected water consumption must be taken into account.

Fields of application
Temperature-controlled building components are frequently combined with, for example, energy piles or ground probes. Providing that the system is placed below the frost line, the circuit can be operated with water. In contrast to brine, water has advantages with regard to the transmission of heat and the required pump capacity. If frost protection cannot be fully guaranteed, the fluid circuit in the building is operated with water and the circuit of the heat sink or heat source outside the building with brine. In this case, the different circuits are linked by a heat exchanger.

The principle of thermo-active building components is not limited to new buildings; it can also be used in refurbishments. In this case, capillary tube mats are fixed to the underside of the existing floor slab and then plastered (see Optimisation of existing buildings, p. 120f.).

Performance range
Due to the slight temperature difference between the building components and the air temperature, the system can make use of its self regulating effects. If the room temperature drops below that of the floor slab in summer, the slab is no longer able to absorb heat and the cooling component then works as a radiant heating element. The reverse situation occurs in winter. If the room temperature rises in winter, for example due to solar irradiance, the temperature of the ceiling slab falls below that of the room with the effect that heat can no longer be transmitted to the room. The excess heating or cooling capacity is, in both cases, distributed evenly throughout the building.

If the system has been planned accurately, it can be assumed that each kW of electrical energy, which is invested for pumps, allows more than 10 kW of heat to be dissipated from the building. Internal heat loads should be under 30 W/m². External loads should be minimised by an appropriate standard of insulation and by providing transparent building compo-

3.99 Schematic diagram of a thermo-active building system (TABS) with adiabatic recooling
3.100 Comparable simulations of room and surface temperatures according to different cooling strategies. A wet cooling tower performed the recooling for the concrete core activation.
3.101 Temperature development and quantity of stored heat in the case of sensible and latent heat storage
3.102 24-hour development of the cooling energy consumption in a large office building with and without ice storage
3.103 Cooling ceiling system with PCM
3.104 Construction of a large ice storage
3.105 Ice storage in the office tower One Bryant Park, New York (USA), architects: Cook + Fox
3.106 Heat exchanger fins of an ice storage system

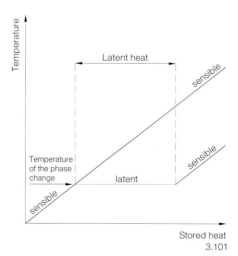

3.101

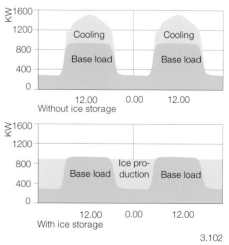

3.102

ents with shading devices. The station-
ry cooling capacity is approximately
0–50 W/m². At a temperature difference
f 5K, approximately 6–10 W/m²K of heat
an be transferred to the building compo-
ents (Fig. 3.100).

CM cooling systems
Efficient heat dissipation can also be
achieved using a combination of capillary
ube mats and a facade ventilation sys-
em with a PCM storage. The capillary
ube mat system can either be retrofitted
o a light suspended ceiling structure or
mounted on the underside of the ceiling
slab and plastered (Fig. 3.103).
Heat produced in the building interior is,
n this case, absorbed by the ceiling and
removed via the capillary tube system
and transferred to the facade ventilation
system. However, the heat produced dur-
ing the day is not immediately dissipated
to the exterior but stored in the facade
ventilation system. This is where phase
change materials (PCM) come into action.
They are integrated in the facade ventila-
tion system and change their physical
state when heat is supplied. Paraffin, for
example, liquefies when it absorbs heat.
As a result of changing its physical state,
the PCM becomes a latent heat store,
which means that the thermal energy is
stored without the material itself heating
up (Fig. 3.101). Due to the phase change,
the heat transporting medium, water,
cools down in the capillary tube mats
enabling heat to be extracted from the
room.
Because the heat is only stored and not
decomposed in the PCM, it must be
dissipated at a later stage. This is usu-
ally performed during the night when the
outside temperatures tend to be a lot
lower. A second water circuit, which
connects the heat store with a facade
integrated heat transfer medium, dissi-
pates the heat at night into the cold night
air. A particular advantage of this system
is the time delayed heat dissipation utilis-
ing the low night temperatures without
any need to open windows or ventilation
flaps, thus avoiding potential security
problems.

Ice storage
If only electrical compression cooling
plants can be used due to a high cooling
demand, the possibility of integrating an
ice storage into the overall concept
should be considered (Fig. 3.104–106).

The cold storage is operated by loading
the ice storage via the cooling system at
night and removing the cold thermal
energy during the day. Ice storage sys-
tems make particular sense if extreme
fluctuations in the cooling demand of a
building arise during the course of a day.
Since cooling plants must be dimen-
sioned to meet peak loads, plants with
large demand fluctuations should operate
for long periods with low utilisation rates.
If systems are not operated within the
range of their nominal output, increased
quantities of energy are consumed. An
ice storage system can balance these
fluctuations and increase the efficiency of
the system significantly (Fig. 3.102).
Apart from optimising the cooling plant,
the system can be dimensioned a lot
smaller. The main advantage of an ice
storage system is the reduction of the
daily peak electricity loads. For power
supply companies this means a more
optimal use of the electricity grid. Apart
from the higher energy efficiency of the
plant, the user has the economic benefit
of being able to use the off-peak tariff
valid during the night.
In contrast to a cold water storage sys-
tem, ice storage is not only able to store
sensible but also latent energy. This
means that an ice store can achieve a
much higher storage density than a water
store.
The integration of an ice storage facility
corresponds to that of a warm water stor-
age system. The dimensions of an ice
storage facility are comparably small,
since only the maximum cooling output
for one day is stored at one time. The
cold storage is carried out by forming ice
with a proportion of the storage water. If
temperatures for the storage are selected
below 0 °C, saline solutions can also be
used.

3.103

3.104

3.105

3.106

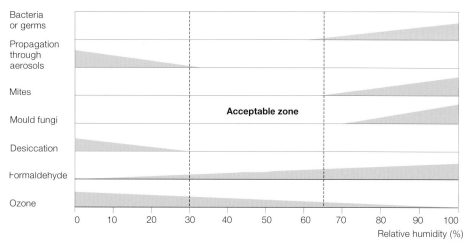

3.107

Air supply

In addition to supplying oxygen, the principal aims of building ventilation are to remove pollutants and smells from rooms inside the building. In this context, particular reference has to be made to CO_2, ozone, formaldehyde, emissions from building and interior finishing materials and body odour compounds from the occupants of the building, for example propionic, caprylic and butyric acid. A person in sedentary occupation dissipates 0.0047 l/s CO_2. For physiological reasons, the Pettenkofer limit of 0.1 vol % or 1000 ppm (parts per million) is usually recommended as the maximum CO_2 concentration (Fig. 3.112). The CO_2 concentration of the outside air is approximately 300–400 ppm. In offices, the concentrations frequently range between 600 and 800 ppm, which is clearly too high, while in classrooms levels can exceed 1500 ppm. An excessive CO_2 concentration leads to tiredness, a dry throat, lack of concentration and headaches.

In contrast to older buildings, in newer properties moisture dissipation from the interior should also be considered. Older buildings used not to be draught proof. They were traditionally heated with wood burners, which generated negative pressure in the interior and, as a result, cool relatively dry fresh air was drawn in through the building's gaps. The risk of condensation building up in the construction or the rooms inside was to all intents and purposes eliminated. Moisture arising in the air was constantly extracted along with the flue gases. New buildings, which are equipped with extremely airtight building envelopes and therefore ensure minimal ventilation heat loss, should also be ventilated to avoid excessive humidity values in the buildings' interiors. Excessively high values can lead to mould infection and occupants feeling uncomfortable. The limiting value for an unclothed person to sense high humidity is approximately 14.3 g of water per kilogram of air according to VDI 2089. In normal situations, when a person is clothed, the absolute humidity must be kept below 11.5 g of water per kilogram of air. The relative air humidity should be between 30 and 65 %. Apart from criteria concerning comfort, the relative air humidity also affects the emission of pollutants from materials and the growth of bacteria and fungi. Very high air humidity values

Category	Description
IDA 1	high room air quality
IDA 2	medium room air quality
IDA 3	moderate room air quality
IDA 4	low room air quality

3.108

Category	CO_2 content above the content in the outdoor air (ppm)	
	normal range	standard value
IDA 1	≤ 400	350
IDA 2	400–600	500
IDA 3	600–1000	800
IDA 4	> 1000	1200

3.109

Category	Non-smoker m³/(h x person)	Smoker m³/(h x person)
IDA 1	72	144
IDA 2	45	90
IDA 3	29	58
IDA 4	18	36

3.110

Month	Shock ventilation[1] (duration in min.)
December to February	4–6
March and November	8–10
April and October	12–15
May and September	16–18
June to August	25–30

[1] Frequency: at least 3 to 4 times a day

3.111

3.107 Comfort zones according to Lazzarin: in order to ensure perfect room air quality at all times, the relative humidity should range between approximately 30–65 %.
3.108 Categories for room air quality (IDA) according to DIN EN 13779
3.109 Recommended values for the CO_2 content in building interiors according to DIN EN 13779
3.110 Volume of outside air per person according to DIN EN 13779
3.111 Window ventilation required to maintain hygienically necessary air exchange rate

3.112 Air quality and CO_2 concentration in a room with different levels of air exchange (according to Pettenkofer)
3.113 Pollutant load in building interior with natural ventilation without filter as well as mechanical ventilation with filter (Example: Acropolis Museum in Athens; exemplary diagram for sulphur dioxide)
3.114 Utilisation of wind energy for building ventilation
3.115 Facade-integrated solar chimney for building ventilation

increase the growth of germs, relatively low humidity values lead to higher ozone concentrations (Fig. 3.107).
Window ventilation, especially in the winter months, leads to very unsatisfactory results. On the one hand, the minimum ventilation periods can hardly be met and, on the other hand, the ventilation heat loss from opening the window for the necessary period is very high (Fig. 3.111). Furthermore, the intensity of window ventilation is dependent on the physical driving force, which means that different weather conditions have a significant impact on the quantity of fresh air.
As a rule, the air volume flow should be limited to the hygienically necessary air exchange. Ideally, thermal loads should not be removed by increasing the air exchange rate. In order to reduce the air exchange rate, particularly during the heating period to a practical 30 m^3/h per person, it is essential to use special low-emission products. If the activities within a building are not limited to low-intensity activities, such as sedentary work, but also, for example, cooking which leads to higher humidity values, the air exchange frequency must be increased correspondingly.
When dimensioning the ventilation plant, it is important to pay attention to the required room air quality. The room air quality is divided into four categories (IDA 1–4) according to DIN EN 13779 (Fig. 3.108).
The required quality can either be defined directly according to the CO_2 concentration and the amount of certain pollutants or indirectly by using the outside air volume flow per person or per square metre (Fig. 3.109–110). According to DIN, a supply of approximately 30 m^3/h per person to a room with normal air conditions is capable of achieving only "medium" room air quality. A high room air quality, according to DIN, requires an air exchange rate of 36–54 m^3/h. However, for energy conservation reasons, an air exchange rate of only 30 m^3/h per person is usually applied.
According to DIN EN 13779, the quality of supplied outside air is divided into three categories (IDA 1–3). Since filters cannot be used in natural ventilation systems, they should ideally be used only when the outside air quality is high (Fig. 3.113). If mechanical ventilation systems are to be installed, the class of the installed filter must be determined

according to the relation between the classification of the available outside air quality and the desired classification of the indoor air quality. It should also be noted that the class of filter selected has a decisive impact on the pressure loss within the ductwork. Significant pressure loss must be compensated for by higher fan power and therefore directly influences the energy efficiency of the ventilation system. A mechanical or forced system can only work efficiently if there are low pressure losses within the ductwork or within the building.

Natural ventilation – updraught
Natural ventilation systems borrow from nature in numerous ways. The underground burrows of the prairie dogs, for example, or the mounds of termites above the ground are naturally ventilated to prevent their homes from overheating. Natural ventilation systems require openings within the building envelope to exploit naturally occurring pressure differences. These pressure differences can arise either due to different temperatures between the inside and the outside space or due to wind pressure. Aspects particularly worth considering are the shape and size of the openings as well as their position in relation to each other. It follows that the shape and appearance of the building should be coordinated with the ventilation system. In principle, systems that operate with wind pressure require smaller dimensions than systems based on updraught (Fig. 3.114 and 3.115).
The simplest form of ventilation is window opening. Its effectiveness is influenced especially by the height of the window or the height difference between two openings and the cross-sectional areas of the openings. In the case of window ventilation, the depth of the room to be ventilated should not exceed 2.5 times the room height, as otherwise the ventilation of the space furthest away from the opening can no longer be guaranteed. If cross ventilation is used, the maximum room depth should not exceed five times the room height. Where window ventilation is selected, the window should be equipped with a device which automatically interrupts the waterflow of the radiator.

Utilising updraught systems
The use of updraught requires the provision of elevated atria or solar chimneys.

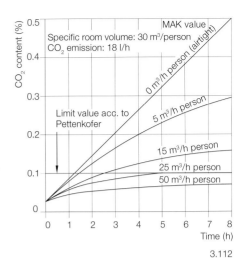

3.112

— Concentration in building interior
 air-conditioning system with filter
 Concentration in building interior
 natural ventilation
 Concentration in outside space

3.113

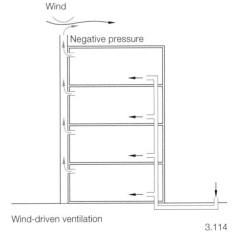

Wind-driven ventilation

3.114

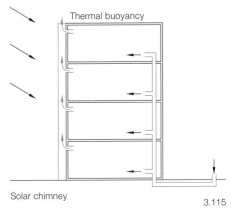

Solar chimney

3.115

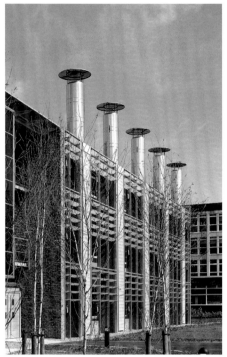

3.116

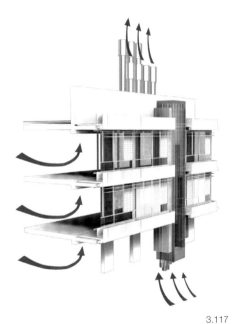

3.117

3.116 Utilisation of wind energy for building
ventilation, office building of BRE in
Hertfordshire (GB), Feilden Clegg Architects
3.117 Ventilation system in a residential building in
Paris (F), Barthélémy & Griňo Architectes/
Bernhard Lenz. Surplus heat produced by
collectors during the day is stored in a buffer
and channelled into the solar chimney in a
controlled way so that it can also be utilised for
ventilation purposes during the night.
3.118 Residential building in Watford (GB) with a
wind catcher, Sheppard Robson Architects
a Wind catcher and pholtovoltaic plant
b Section
3.119 School in Ladakh (IND), Arup Associates
a Solar-powered ventilation shaft
b Section

Their effectiveness derives from the fact
that air pressure decreases linearly with
increasing height at constant temperature
and that warm air has a lower density
than cold air. If the temperature differ-
ence is sufficient, thermal buoyancy
occurs which can be exploited for ventila-
tion purposes.

A solar chimney generally consists of a
vertical shaft, which is situated either
above or next to the ventilated zones.
The efficiency of a solar chimney can be
increased if it is either fully or partially
glazed (Fig. 3.116).

Occasionally active heating systems
based on waste heat or surplus solar
energy are integrated at the top of the
chimney (Fig. 3.117). They are especially
suitable where a significant excess of
solar thermal energy is produced during
the day. The surplus energy can be
stored and guided to the solar chimney
via the heating system at night. The chim-
ney is then also available for ventilation
purposes at night.

Planning and operation
To achieve the best results, the supply air
inlet should be placed at the lowest pos-
sible position of the building and the
exhaust air outlet at the highest. The tem-
perature difference between the exhaust
air and the outside air should be as large
as possible; the flow resistance, which
leads to pressure loss, should be as low
as possible.

Because the thermal buoyancy changes
in accordance with the temperature differ-
ence and the height of the shaft, varying
pressure differences can arise in the indi-
vidual storeys if several levels are con-
nected to one buoyancy area. To guaran-
tee minimum ventilation of the uppermost
floor, it must be located well below the
highest point of the ventilation shaft or the
atrium roof. The air outlets can be dimen-
sioned slightly smaller on the lower levels
in order to counter-balance the varying
pressure differences.

When investigating the necessary pres-
sure differences, it is most important to
consider the extreme seasonal fluctua-
tions. In summer nights and during the
winter months, the pressure differences
are usually sufficiently high due to the
large temperature differences between
the exhaust air and the outside air. Spring
and autumn, however, can cause prob-
lems. Temperature differences of only a
few Kelvin do not lead to sufficiently high

pressure differences and only very high
ventilation shafts could theoretically
improve the situation.

As an alternative, it is possible to achieve
an adequate pressure difference by
heating the volume flow of exhaust air
with waste heat thereby making it much
warmer than the outside air. In terms
of energy efficiency, the combustion of
fossil fuels for this purpose must be
avoided. Possible means for heating the
exhaust air include use-related thermal
loads, for example server waste heat. The
heating process should not affect the
thermal conditions of the rooms located
nearby.

It is absolutely essential to consider the
installation of weather and temperature
controlled apertures during the planning
process since these often require expen-
sive measurement and control equip-
ment.

A considerable advantage of natural ven-
tilation is that no energy is required to
power the air movement during the oper-
ation and that very little maintenance
work is involved. The main disadvantage
is the dependence on the mesoclimatic
site factors.

Application
Urban, highly polluted locations often
prove to be very difficult. In contrast to a
building with air-conditioning, in these
locations natural ventilation, especially
during the day, can lead to higher pollut-
ant loads (without CO_2) in the interior. Fil-
ters, similar to those used in air-condition-
ing systems, cannot normally be applied
in naturally ventilated buildings because
the pressure drop caused is higher than
the negative pressure produced by the
system.

In contrast to buildings with a mechanical
ventilation system, maximum tempera-
tures cannot be guaranteed in naturally
ventilated buildings. However, it is gener-
ally the case that occupants of mechani-
cally ventilated buildings are far more
sensitive to deviations from the perfect
room temperature than users of naturally
ventilated buildings. The reason for this
phenomenon is that the occupants have
had to adapt to the air temperature fluctu-
ations.

Performance
The thermal buoyancy results from the
different densities of two air volumes and
the possible height that the air mass can

se. Because warm air has a lower density than cold, it is lighter. The relative humidity has only a small impact on the thermal buoyancy. However, at the same temperature, damp air is lighter than dry air. Despite the same air volume flow, the air flow rate decreases at extremely low air pressure, which is the reason why less energy can be transported.

The thermal buoyancy can be calculated by multiplying the available height that the air may rise and the density difference between the outside air and the air in the vertical shaft. Assuming that the solar chimney has a height of h = 10 m, the temperature of the exhaust air is increased to 60 °C due to solar irradiance and the outside temperature is $t_{OA} = 30\,°C$, the following pressure difference can be determined:

$$\Delta P_{therm} = h \cdot g \cdot (\rho_A - \rho_I)$$
$$= 10\ m \cdot 9.81\ m/s^2 \cdot$$
$$(1.059\ kg/m^3 - 1.164\ kg/m^3)$$
$$= -10.3\ Pa$$

ρ_A = Density of outside air (kg/m³)
ρ_I = Density of exhaust air (kg/m³)
g = Gravity (m/s²)
h = Height of rising exhaust air (m)

Thermal buoyancy, however, only takes place if the pressure loss of the in-flowing air is below the buoyant force produced by the vertical shaft. In order to achieve an effective buoyant force, large temperature differences or tall chimneys are needed. It is theoretically possible to produce these differences by using excess heat, which is, for example, not needed in summer, to boost the system performance by channelling it into the flow of exhaust air.

The performance can also be increased by using available wind pressure and taking advantage of the Venturi effect. The Venturi effect states that the velocity of a fluid (e.g. air) flowing through a tube increases if its section is reduced. This phenomenon can be used for ventilation purposes in buildings.

Natural ventilation – wind

If wind blows perpendicular to a building, a positive pressure zone is created on the windward side and a negative pressure zone on the leeward side as well as on the side walls. This effect can either be used for cross ventilation or cross-corner ventilation purposes. The resistance to

the approaching wind flow is specified as wind pressure coefficient and can only be determined by CFD simulations (Computational Fluid Dynamics) or wind tunnel tests. The same applies for the determination of the distribution of pressure fields, which, depending on the geometry of the building, can be extremely complex. As a rule, the distribution of pressure and tension zones caused by the wind flow around buildings is not balanced. It is, therefore, difficult to ensure even ventilation with the same amount of supply and exhaust air. For instance, an orthogonal wind flow produces an increase of positive pressure at the bottom of the building on the windward facade and an increase of negative pressure in the upper area of the leeward facade.

In order to make effective use of wind pressure, special structural elements are advantageous, for example windcatchers that have for a long time been used in the Middle East.

Construction and function

In its most basic form, a windcatcher consists of a simple shaft, which has one or several openings in the upper section. If the windcatcher is used merely as a supply duct, it only has to be provided with one opening on the side facing the prevailing wind direction. If an additional exhaust air outlet is to be provided, it should be placed on the leeward side of the tower. The main function of a windcatcher is to cool the supply air.

When channelled through the windcatcher, the supply air, which in comparison to the building material of the windcatcher only has a very low heat storage capacity, dissipates energy to the cooler mass of the building and cools down. The process of the outside air cooling down as it enters the structure leads to an increase of air density, which makes the air sink and thus draw in more outside air. The degree of convection achieved in the windcatcher depends especially on the height of the tower, since with increasing height there is greater exposure to the structural mass and more thermal energy can be transferred to the structure. Furthermore, the period of contact between the air mass and the cool surface of the windcatcher at the same air velocity is longer, the higher the tower is. The natural wind pressure supports the resulting downwind leading to higher air velocities.

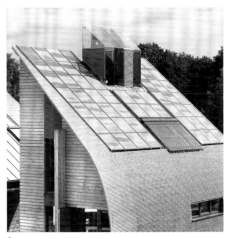
a

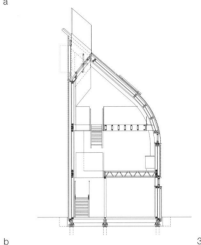
b
3.118

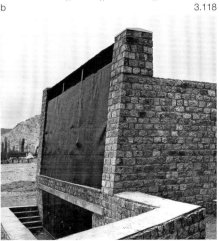
a

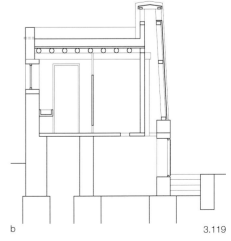
b
3.119

55

Planning and operation

A windcatcher should generally be made of a material with a high thermal mass and sufficient thickness to ensure that the necessary level of cooling is achieved continuously throughout the day. If the storage capacity of the material is inadequate, the reversal effect could occur in the evening. In this case the windcatcher dissipates unwanted heat into the cooler evening air and works in a similar way to a solar chimney. In systems that work with downwind and updraught, in sections arranged one behind the other, the heat transmission between the supply and exhaust air ducts must be minimised. Within a windcatcher, the downwind results generally from a mix of temperature induced convective airdrop and available wind pressure. Contemporary variants of windcatchers planned and built in climates without extreme temperature differences during the day, only make use of wind pressure and can therefore be made of construction materials with low thermal mass (Fig. 3.118, p. 55).

Since the utilisation of the wind takes place close to the ground, the topography of the site has a significant impact on the function and efficiency of a windcatcher. A built-up environment usually has a reducing effect on the wind velocity and can lead to wind shear.

Application

The use of a windcatcher requires a high daily temperature amplitude, as found in hot-dry regions. In particular, the low night-time temperatures are extremely important, since the thermal unloading of the storage mass, that was charged during the day, is the condition for the operation of this ventilation system. Prevailing wind directions, characteristic of most hot-dry regions, are also a clear advantage. The operation of a windcatcher is therefore extremely dependent on the mesoclimatic site factors. It is important to note that the pressure differences generated by wind are usually a lot higher than the pressure differences induced by updraught. The utilisation of wind can therefore not only increase the buoyancy generated by updraught but also reduce it and possibly also lead to a reversal of the flow direction.

Performance

Apart from downwinds, which are caused by cooldowns, the wind velocity influences the performance of a windcatcher. Tall or free-standing buildings can therefore make far greater use of the wind pressure than low ones.

The expected air velocity at the height of the air inlet can be determined approximately. Assuming that the air velocity at a height of ten metres is 5.5 m/s, that the windcatcher is twelve metres tall and located within the surface topography of a small town, the following wind velocities can be estimated:

$$V_{Cat} = V_{10} \cdot \ln(z_2/z_0) / \ln(z_{ref}/z_0)$$
$$= 5.5 \text{ m/s} \cdot \ln(12 \text{ m}/0.4) / \ln(10/0.4)$$
$$\approx 5.8 \text{ m/s}$$

V_{Cat} = Wind velocity at the height of the windcatcher
V_{10} = Reference velocity of the wind
z_{ref} = Reference height of the wind velocity
z_0 = Roughness of the topography
z_2 = Height of the air inlet

The wind pressure acting on a building or a ventilation aperture is generally directly dependent upon the pressure coefficient, the air density and the wind velocity. The maximum pressure expected to act on the air inlet can be estimated according to the specific wind velocity and the air density which can be derived from the air temperature:

$$P_w = C_{pL} \cdot [(\rho_L \cdot U_o^2)/2]$$
$$= 1.0 \cdot [(1.165 \text{ kg/m}^3 \cdot 5.8 \text{ m/s}^2)/2]$$
$$\approx 19.6 \text{ Pa}$$

P_w = Wind pressure
C_{PL} = Pressure coefficient
ρ_L = Air density
U_o = Wind velocity

At an assumed air temperature of 30 °C and a specific air velocity of 5.8 m/s, with a windcatcher, it is possible to achieve a maximum positive pressure of approximately 20 Pa. In comparison, a standard air filter (grade F 5) fitted inside a ventilation system can lead to a pressure drop of at least 100 Pa. For this reason, if a windcatcher is to be used efficiently for the building ventilation, it is very important to minimise pressure loss.

The cooling capacity of a windcatcher can be increased if it is combined with a direct adiabatic evaporation system. However, direct adiabatic cooling (see p. 42) can only be used in hot-dry regions.

Mechanical ventilation systems

In contrast to natural ventilation, these systems have the advantage that they can easily be provided with a control mechanism, they can be used with filters and recover heat. However, unlike in natural ventilation systems, these mechanical systems require energy to operate the fans (Fig. 3.121).

In mechanical ventilation systems, it is necessary to distinguish between central and local systems. In central systems, there is also a differentiation between exhaust air systems and air supply and exhaust systems (Fig. 3.120). Central systems require ductwork (Fig. 3.123). Local air supply and exhaust systems are integrated in an exterior wall and do not require any kind of ductwork.

Air exhaust systems

Air exhaust systems require ductwork simply to discharge the exhaust air. The supply air is introduced to the building interior in a local fashion via openings cut into the exterior wall specifically for this purpose (Fig. 3.125, p. 58).

It is necessary to make sure, when positioning the wall penetrations, that the supply air is drawn into the building interior immediately above a heat source to prevent draughts occurring in winter. It therefore makes sense to locate the wall penetration immediately above a radiator. The air inlet should be equipped with an automatic volume flow limiter so that, even at high wind pressure, only the required air volume enters the room. For reasons concerning energy efficiency, the air inlets should close at night in buildings that are used only during the day. Automatic systems are available for this purpose.

Waste air valves should be located close to smell and moisture zones. In kitchens, the extraction system should not be placed directly above the stove due to the formation of grease. It makes sense to equip the extraction hood with a regenerable grease filter. A booster switch is extremely useful for extraction units located in areas with high moisture levels, such as bathrooms.

As a rule, it does not make sense from an energy perspective to discharge exhaust air to the exterior without extracting the heat. Concepts which make provision for use of the heat contained in the exhaust

air should take precedence over systems purely for extraction.

Exhaust systems in combination with heat pumps
If the building services concept includes the operation of a heat pump, it is appropriate to use the waste heat as a heat source for the operation of the heat pump. By using a heat exchanger, a proportion of the energy contained in the waste air is extracted and increased to a higher level of energy by a heat pump. The energy can either be used to heat the building or for the domestic hot-water production. Since the formation of ice must be avoided on the heat pump's evaporator coil, the temperature of the exhaust air should not be reduced any further than approximately 5 °C.

Air supply and exhaust systems without ductwork
These systems consist of a heat exchanger and a small fan which is integrated into a penetration in the exterior wall. To operate local ventilation units with heat recovery, at least one unit should be installed into the exterior wall of each room requiring ventilation (Fig. 3.124). The ventilation is based on the principle of cross ventilation. This means that half of the units are removing exhaust air from the building interior for a period of about one minute, at the same time as the other units are drawing in fresh outside air. This procedure alternates, so that all rooms take turns in either being supplied with fresh air or having their exhaust air removed. The heat exchangers integrated in the local units, regain part of the heat contained in the exhaust air and use it to preheat the supply air. The ventilation system is controlled so that the ventilating fans operate in an even push-pull mode. To integrate this kind of system, a wall opening measuring approximately 20 × 20 cm must be provided.

Air supply and exhaust systems with ductwork
In contrast to a system which is intended purely for the removal of exhaust air, in this case the fresh air is drawn in at a central location and channelled through a heat exchanger which has the exhaust air volume flow moving in a counterflow direction (Figs. 3.123 and 3.127). During the heating period, a large proportion of the energy contained in the exhaust air

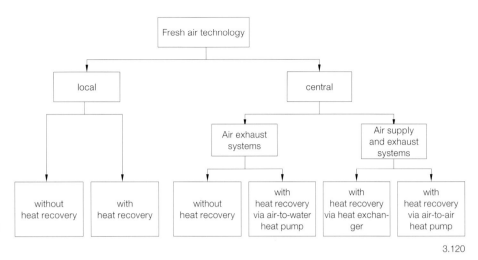

3.120

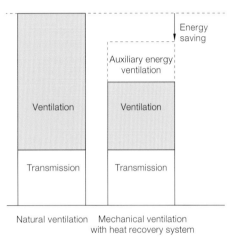

3.121

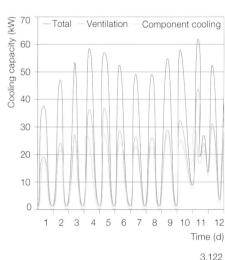

3.122

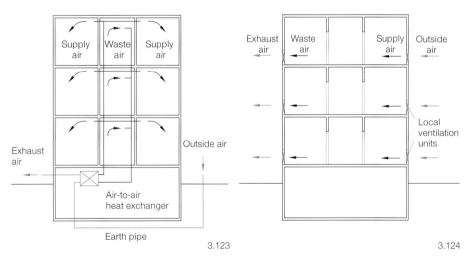

3.123 3.124

3.120 Overview of central and local ventilation systems. The systems differ according to the extent of installation work and the level of efficiency.
3.121 Potential savings through heat recovery in residential buildings
3.122 Combined dissipation of cooling loads from buildings via component activation and ventilation
3.123 Controlled air supply and air exhaust in residential building with ductwork in summer.
3.124 Cross ventilation using a local supply and exhaust air system without ductwork in summer

3.125

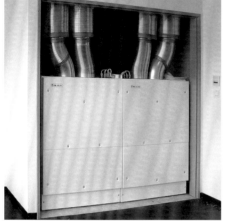

3.126

3.127

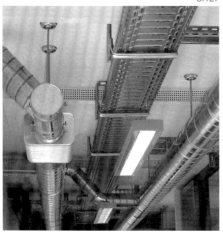

3.128

can be transferred to the cold supply air. In summer, the outside air can be cooled down in the same way. If the outside temperatures are too low, the supply air may have to be heated further. It can be omitted if the temperature of the supply air is increased to at least 17 °C by the exhaust air.

Generally, it is important to balance the air volume flow of the supply and exhaust air in order to avoid inefficiencies or, in the worst case, structural damage. If the supply air volume flow is greater than that of the exhaust air, the inside of the building will be subject to positive air pressure and air exfiltration. In this situation, air is dissipated to the exterior through leakage points. In the worst case, this can lead to condensation and structural damage. If the supply air volume flow is lower than that of the exhaust air, an infiltration of outside air will occur. In addition to the controlled air supply, outside air is then drawn in through the leakage points in the building envelope. Problems concerning building physics are not to be expected, however, there is no opportunity to condition the infiltrated air. In the worst case, draughts may occur. Units that are equipped with a mass balance system, do not have to be adjusted and do not lead to differences in the volume flows.

Twice the amount of ductwork is required to channel the supply and exhaust air, with the result that these systems require significantly more construction space. In places where the supply air and exhaust air ducts cross, it is particularly important to ensure that sufficient construction height is provided to accommodate both ducts (Fig. 3.128). It goes without saying that the ductwork should be kept as short as possible in order to minimise pressure loss.

Air supply and exhaust systems in combination with heat pumps
As an alternative to systems that transfer heat directly from the volume flow of exhaust air to the supply air, a heat pump can be used to extract heat from the exhaust air (Fig. 3.134). In contrast to a heat exchanger, the temperature of the supply air that can be achieved by a heat pump is clearly greater than the temperature level that can be achieved by a heat exchanger. This kind of system can also be used as a warm-air heating system. Alternatively, post heating of the supply

air can be provided by a heating coil that is either connected to the heating system or operated electrically.

The post heating of supply air causes difficulties in rooms that have a high demand for fresh air but, at the same time, low demand for heat, for instance in bedrooms. In order to avoid this problem, it is necessary to split the air supply duct before the heat coil, so that rooms with low heat demand can be supplied with cooler air and rooms with high heat demand can be supplied with warmer air. A disadvantage in this case is the greater cost and effort involved in installation.

If a building is to be heated exclusively via a ventilation system, the building envelope must be built according to passive house standards regarding both insulation and air tightness. A passive house may not exceed an annual heat requirement of 15 kWh/m²a. The actual heat demand may be above 15 kWh/m²a, however, the excess demand must be covered by internal and external heat gains. The annual primary energy demand including domestic power may not exceed 120 kWh/m²a.

Planning and operation of ventilation plants
Ideally, office buildings are divided into different ventilation zones. It should be possible for operation of the ventilation plant to reflect the office hours, so that the air supply can be adjusted according to the varying size of the workforce during flexitime and core working hours as well as closed periods. In this case, the plant is controlled by the central building control system. It is not necessary to arrange zones in residential buildings.

In general, care should be taken to maintain a low volume flow and consequently also low pressure loss within the ventilation system. The pressure loss increases with the square of the volume flow and the power consumption of the fan with the third power of the volume flow. The recommended flow velocity is about 2–3 m/s. Large duct cross sections have the effect of reducing the pressure loss and the flow velocity.

When planning the infrastructure of the building services, the air ductwork should be given priority since circuitous routing of the air ducts, in contrast to that for heating and water pipework, can have detrimental effects. Air ductwork should generally be taken through heated areas

of the building. In Germany, VDI 3803 provides guidance on the dimensioning of air ductwork (Figs. 3.130 and 3.131). For an energy-efficient operation, it is vital to reduce the pressure loss, which can be caused by duct fittings, such as sound attenuators or complicated bypass situations. Furthermore, flood vents and air inlets should also ensure low flow resistance. Flood vents required between the individual zones should be designed in such a way that they cannot be closed.

If there are no special requirements concerning sound protection in residential buildings, non-visible flood vents can be used simply by raising the height of the door lintel to create a gap between the lintel and the door lining. By shaping the reveal accordingly, the space is connected to the two adjoining rooms and therefore functions as a flow duct between both rooms. In office buildings, flood vents should generally be equipped with sound protection devices. Figure 3.132 provides guidance on the dimensioning of flood vents. If the vents are not correctly dimensioned, the effect of the ventilation may be limited and ventilation heat loss might occur due to forced air infiltration or exfiltration.

In order to avoid sound transmission between individual rooms via the ductwork, sound attenuators must be fitted in the ductwork between the rooms. Round or flat sound attenuators are preferable to insertable sound attenuators, which should be avoided as far as possible since they cause significant pressure loss. To reduce pressure loss, single flow-resistant elements, such as sound attenuators, should not be placed immediately behind duct elbows (Fig. 3.128).

To prevent the ductwork from becoming soiled, the supply air and exhaust air stacks should be equipped with filters. The choice of filter is directly related to the energy efficiency of the system. A fine filter prevents the ductwork from becoming soiled, however, it increases the flow resistance which leads to greater energy consumption by the fan and therefore higher costs. In order to minimise the pressure drop caused by the filters, it is necessary to inspect them regularly and replace any coated filters as soon as possible. Therefore easy accessibility of the inspection flaps should be considered during planning.

When selecting the fans, their energy effi-

Type	Cross flow heat exchanger	Counter-flow heat exchanger	Closed loop heat exchanger	Rotary heat exchanger with and without hygroscopic storage mass
System				
Heat recovery	up to 60%	up to 90%	up to 50%	up to 80%
Moisture regain	no moisture exchange	no moisture exchange	no moisture exchange	up to 70%

3.129

Duct section calculation

$$A = \frac{V_h}{w \cdot 3600}$$

A = Duct section (m² =10000 cm²)
w = Air velocity in duct (m/s)
V_h = Air volume flow (air volume) (m³/h)

$$A = \frac{d^2 \cdot \pi}{4}$$

$$A = l \cdot w$$

3.130

Volume flow (m³/h)	Required diameter (mm)
40	60
50	70
60	80
70	90
80	100
90	105
100	110
120	120
140	130
160	140
180	150
200	155
220	165

3.131

Required volume flow (m³/h)	Required section (cm²)	Required gap width (mm) for a length of 1 m
20	56	6
30	83	8
40	111	11
50	139	14
60	167	17
70	194	19
80	222	22

3.132

Air velocity in ducts

Low-pressure plants	Air velocity (m/s) Comfort plants	Industrial plants
Outside air	2–3	4–6
Main ducts	4–8	8–12
Branch ducts	3–5	5–8
Exhaust/recirculation air louver	2–3	3–4

3.133

1 Fan
2 Air condenser
3 Vaporiser
4 Compressor
5 Booster heater
6 Water condenser
7 Coil (heat exchanger)
8 Outlet air
9 Exhaust air
10 Outside air
11 Supply air
12 Air heat exchanger

3.134

3.125 Opening in exterior wall for local ventilation system
3.126 Local ventilation system in an office building built according to passive house standards
3.127 Supply and exhaust air system with cross-flow heat exchanger
3.128 Exposed air ducts with integrated sound attenuator
3.129 Principles of heat recovery in ventilation plants
3.130 Approximate calculations of duct sections according to VDI 3803
3.131 Required diameters of air ducts (for max. air velocity c_{max}=3.0 m/s)
3.132 Cross-sectional area of flood vents in dependence of required air volume flow
3.133 Maximum air velocities in ducts
3.134 Compact ventilation unit for residential building with heat recovery, an integrated air-source heat pump and a water storage tank

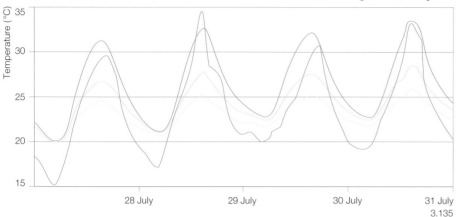

— Outside air temperature t_a
— Storage mass 200 kg/m²
— Storage mass 500 kg/m²
— Storage mass 1000 kg/m²

3.135

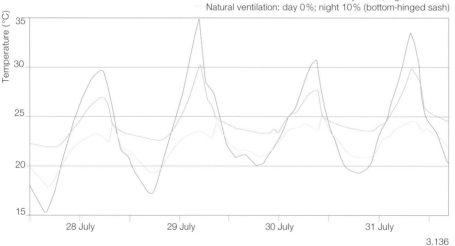

— Outside temperature t_a
— Natural ventilation: day 100%; nightNacht 0%
— Natural ventilation: day 0%; night 10% (bottom-hinged sash)

3.136

3.135 Exemplary presentation of a room with an air change rate of two during the day and four at night. It proves that the thermal storage mass has a considerable influence on the heat rise in a room.
3.136 Simulation of night-time ventilation in a building with a large storage mass. The night-time ventilation leads to results similar to those that

can be obtained with ventilation via a mechanical plant with an air exchange rate of approximately 6.
3.137 Night-time ventilation vents in a school in Frankfurt/Main built according to passive house standards, 4a Architekten
a Exterior view
b Detail view from the inside

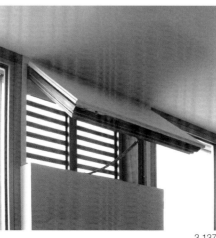

a
b

3.137

ciency is an important aspect. Ideally fans with highly efficient EC motors should be installed.

Application
It generally makes sense to install a ventilation plant if the building envelope is well-insulated and airtight. If the building envelope is of a high quality, the greatest loss of energy is caused by ventilation heat loss. A controlled supply of fresh air and extraction of exhaust air can reduce this loss significantly. Primarily, application of the different ventilation systems should be viewed in the light of the desired annual heat requirement and suitability for integration into the overall building services concept.

Performance
Looking at an exhaust system for a four-person household, it is appropriate to assume a required air volume flow of approximately 120 m³/h. In the case of a highly efficient exhaust system with an assumed power consumption of 0.15 W/m³/h, the fan would have an energy consumption of 118 kWh in a winter with an assumed heating period of 6550 hours. The advantage of using primary energy can only be established once the building residents' behaviour in relation to natural ventilation is known. When operating an air exhaust system with a heat pump, an exhaust air volume flow of 120 m³/h and a possible cool-down of the exhaust air to 5 °C, a capacity of approximately 650 W is available for other purposes. If the heat pump's coefficient of performance (COP) is assumed to be 3.0, a capacity of almost 2 kW is then available.
The efficiency of air supply and exhaust systems without ductwork is especially dependent on the power consumption of the fan and the heat recovery factor of the heat exchanger. The pressure loss also has to be considered when selecting the system, as this is a further aspect that influences the efficiency.
The energy demand of air supply and exhaust systems with ductwork is directly related to the installed filters, sound attenuators, the ductwork and the central plant utilised. Assuming that the electrical energy demand of a perfectly dimensioned plant is only approximately 0.4 W/m³/h, the power consumption of the system is almost 50 W at a volume flow of 120 m³/h.

Night-time ventilation

Night-time ventilation can be used as the sole method for cooling a building if the internal and external heat gains are low. Sufficient thermal mass is a prerequisite (Fig. 3.135). Floor slabs that function as thermal storage mass should remain uncladded. Any acoustic fittings that are required should already be considered during the planning phase.

Construction and function

A perfectly designed ventilation concept should, as far as possible, function without fans. If this is not the case, the expenses for the auxiliary energy required to power the fans must be taken into account. To guarantee good ventilation and maximum heat dissipation without fans, the ventilation openings must be adequately dimensioned. It is generally possible to increase the air exchange rate with fans to well above the air exchange rate achieved through natural ventilation. However, if the fans are operated economically, the air exchange rate that can be achieved with fans is no higher than $n = 4 \, h^{-1}$ and, therefore, clearly below the air exchange rates which can be reached with natural ventilation and ideally dimensioned ventilation openings.

Planning and operation

If the building is planned so that it is cooled exclusively by night-time ventilation, the ventilation concept should be flexible enough to cater for future changes and refurbishments. Furthermore, it makes sense to have a large amount of thermal mass which is distributed evenly throughout the space, as this contributes towards the thermal mixing of the incoming air. Not only the floor areas, but also the ceiling areas should make contact with the air to discharge the accumulated heat.

If fans are used in the ventilation concept, it has to be considered that the use of an air intake fan leads to an increase of approximately 1 K in the temperature of the supply air. For this reason, air intake fans should not be operated until the predetermined minimum temperature difference between the outside and inside air has been reached. The definition of this temperature difference is particularly dependent on the minimum coefficient of performance achieved by the system. As an alternative to operating fans, the cooling performance of the ventilation

system can be improved by combining it with an exhaust air shaft (see p. 53f.), which is based on thermal buoyancy. Since a temperature difference occurs between the outside air and the exhaust air, the dissipated heat, especially in clear summer nights, can be used to increase the thermal buoyancy and, through this, the efficiency of the ventilation system.

If a building equipped with a controlled supply and exhaust air system is to be cooled at night by natural ventilation, the cool outside air should clearly not be channelled through the heat exchanger, since this process would heat the supplied air. In this case, the ventilation system should be planned with a bypass, which can be used to draw the cool outside air into the building in summer nights. A further advantage of the bypass is a lower pressure drop due to the fact that the heat exchanger is circumvented.

Application

The investment costs for a night-time ventilation system are clearly below those of an air-conditioning plant. Maximum room temperatures and prescribed cooling loads cannot be guaranteed. However, a night-time ventilation system can contribute considerably towards cooling the building in spring and autumn. During hot periods, especially in the case of high night-time temperatures, this ventilation system can support the heat sink of a building in only a very limited way.

If ventilation is carried out by opening windows or vents, differing wind conditions surrounding the building may lead to different degrees of cooling and possibly also undercooling of certain rooms in the building interior. It is theoretically possible to integrate control mechanisms, such as mechanically controlled vents, however, this is usually not a very economical solution unless, for example, smoke extraction vents are in any event required.

Performance

Night-time ventilation is particularly appropriate for Central Europe where only low heat loads of, at the most, approximately 150 Wh/m²d occur (Fig. 3.137). To use night-time ventilation to dissipate the heat absorbed by the building mass during the day, the outside air temperature should be at least 5 K below the inside room temperature for at least five to six

hours (Fig. 3.136). As the summer night-time temperatures in Central Europe usually fall below 20 °C, it is likely to achieve a heat sink in the interior rooms. At higher altitudes, where the night-time temperature falls below 16 °C, greater heat loads, as high as approximately 250 Wh/m²d, can be dissipated.

Earth pipes

These systems are also referred to as earth-to-air heat exchangers and can be used to draw in air to a central unit. Earth pipes are primarily used to precondition supply air during the cooling period. A prerequisite for operating an earth-to-air heat exchanger is the installation of a ventilation plant. Since earth pipes cannot limit maximum temperatures, their application presupposes that it is acceptable for the room air temperature to rise on hot days.

Construction and function

An earth pipe is a heat exchanger which cools the supply air by drawing outside air in through the pipes and dissipating the heat to the surrounding ground. The earth pipe with its surrounding ground functions as a temporary heat store, which means that it should be able to regenerate periodically in order to remain in good working order. In winter it can also be used to preheat the supply air as the ground temperature, in contrast to the situation in the summer months, is clearly above the outside temperature (Fig. 3.139, p. 62). The earth pipes or the collective ducts are connected to the building's ventilation system. The earth pipes are either placed in the ground next to the building, beneath a foundation slab or between isolated footings. If the earth pipe is placed below the building, the basement rooms should not be heated. Earth pipes are generally only used up to an air volume of approximately 20 000 m³/h. If larger air volumes are required, so called thermal labyrinths are used. These are, in effect, large concrete ducts, which have a correspondingly much larger heat transfer surface and are usually laid below the building. Since the thermal labyrinth is not placed in the ground but integrated within the building, sufficient time to regenerate should be considered.

Because the saving of energy alone does not justify the considerable construction costs, synergies should be found for the

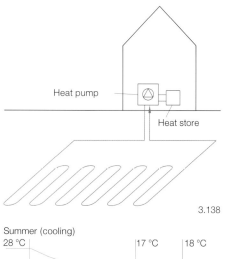

3.138

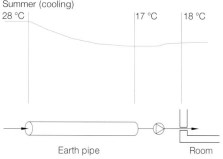

Summer (cooling)
28 °C 17 °C 18 °C

Earth pipe Room

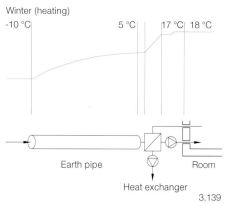

Winter (heating)
-10 °C 5 °C 17 °C 18 °C

Earth pipe Room

Heat exchanger

3.139

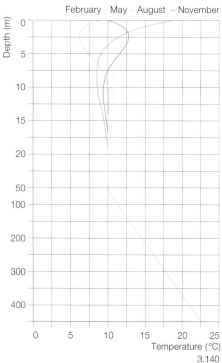

3.140

implementation of this system, for example, the necessary excavation of a foundation pit.

Planning and operation
The size of an earth pipe system depends on the required air volume flow and the possible area required for its installation. The typical diameter of an earth pipe is approximately 20 cm. Larger diameters are usually used only in the case of office buildings and then they are predominately designed as accessible air supply galleries. The distance to be maintained between the laid pipes depends upon the pipe diameter and the nature of the soil. However, to avoid thermal interference between the individual pipes, the distance apart should not be less than one metre. In the case of office buildings, the depth of the pipes should be around two to three meters. Depending on the time of the year and the geographical location, the ground temperature in Germany at this depth ranges between 6 and 15 °C (Fig. 3.140). If the earth-to-air heat exchanger is placed close to the basement wall, heat could flow from the building's basement to the earth pipe. This effect leads to a slightly improved performance of the earth pipe, although it does not lead to an energy gain. The ground temperatures in the soil surrounding the building are usually only slightly higher than the temperature of the undisturbed ground.
The earth pipe should be dimensioned so that there are no significant fluctuations within the system during the course of the day and the temperature in the earth pipe barely rises. The specific duct surface area required for the heat transfer should be selected in accordance with the air volume flow. To avoid high pressure loss and associated high energy consumption by the fans, a low air velocity of approximately 2 m/s should be ensured. In Germany, the necessary surface required for the heat exchange is approximately 0.04 m²/m³/h (Fig. 3.141).
Normally, the earth pipe system is operated only during the day. The ground can then regenerate its thermal capacity at night. It is possible to control the regeneration period via the outside temperature. If, for example, the outside temperature falls below 19 °C, the ventilation can be continued by drawing the

supply air into the building via a bypass. The thermal regeneration of the earth pipe takes place during this period as the heat previously absorbed is dissipated to the surrounding ground. If the building has a building services control system, it is also possible to control the fresh air supply by setting a defined temperature difference between the outside and inside air temperature.
In order to remove condensation, the system has to be installed with a one to two percent gradient in the opposite direction to the air flow. Furthermore, the installation of a condensation drain is required. If the earth pipe is placed in groundwater, the system should be waterproof.
With careful planning, the growth of bacteria and fungi can be avoided within the earth pipe system. To keep the system clean, a G 4 or higher class filter should be fitted to prevent dirt from entering the pipe system. If the earth pipe is used in regions where considerable amounts of radon diffuse from the ground, care should be taken to ensure that there is sufficient distance between the air inlet and the ground.

Application
Ideal mesoclimatic site factors are fundamental for the efficient usage of an earth-to-air heat exchanger. Generally, the application of earth pipes does not depend upon the region. However, the cooling capacity of an earth pipe is inversely related to the average annual temperature and, in cooler regions, there is only a small demand for cooling (Fig. 3.142). If the outside temperature is 45 °C and the ground temperature is 28 °C, as is the case in Dubai, an earth pipe would have to be about 400 m long to cool the supply air down to 28 °C. On the one hand, this kind of installation would lead to a high cooling capacity, but on the other hand the extreme length of the duct would cause considerable pressure loss and therefore also a very high energy consumption to operate the fans. In contrast, Central European sites, like, for example, Frankfurt am Main, are ideal for the use of earth pipes.
A building cannot be cooled effectively with a hygienic air exchange rate and typical heat load of over 120 Wh/m²d. However, it is still useful to reduce the temperature peaks. In order to dissipate

3.141

ypical heat loads, earth pipes are usu-
ally combined with another cooling
system. In this case, the earth pipe is
used to draw in outside air without
simultaneously adding further heat load
to the interior. The cooling loads of the
building interior can, for example, be
dissipated via thermo-active cooling
systems.

If a controlled ventilation system with
an efficient heat recovery system is to
be installed, the capacity of the earth
pipe in winter is reduced so much
that it can simply be regarded as a frost
protector for the heat exchanger during
the heating period. There are hardly
any advantages in terms of energy
saving.

Performance

The reduction or increase of the supply
air temperature is not in proportion to
the length of the ground-to-air heat
exchanger. For this reason, it is neces-
sary to balance the changes in the sup-
ply air temperature with the pressure
loss resulting from the length of the
earth pipe. The gain is largely depend-
ent on the prevailing outside tempera-
tures. An earth pipe can deliver high
performance in both summer and winter.
Depending on the location, well
designed earth pipes can, on very hot
days, reduce the temperature of the
supply air by approximately 10 K (out-
side air temperature > 30 °C). During
the heating period, a heat rise of up to
20 °C can be expected.

In spring and autumn, with outside tem-
peratures of around 12 °C to 18 °C, the
earth pipe is normally not used since the
supply air neither has to be heated nor
cooled (Fig. 3.143). The operation of an
earth-to-air heat exchanger would lead
first of all to the passive cooling of the
supply air by the earth pipe and then
having to heat it actively by the heating
plant. The same applies for the reverse
situation. The use of a bypass is there-
fore especially important during spring
and autumn. Due to this period without
any air conditioning, the amount of
energy that can be provided by the
earth pipe is modest when viewed over
the year as a whole.

The energy consumption for the trans-
portation of the supply air should be
around 0.2 W/m³/h. It is possible to con-
vey an air volume of approximately 250
m³/h with a pipe diameter of 20 cm.

	Annual mean temp. (°C)	Average cooling capacity in relation to the outside temperature (°C)				Average operation time (h) in relation to the outside temperature (°C)			
		15±0.5	20±0.5	25±0.5	30±0.5	15	20	25	30
Rome	14.5	2.2	2.4	5.1	8.2	142	3,8	153	75
Marseilles	14.3	1.9	2.4	5.0	7.8	170	392	201	59
Madrid	13.9	2.2	2.3	5.3	8.3	173	393	164	60
Milan	12.3	2.8	3.0	6.0	9.2	201	324	164	62
Locarno	11.1	2.7	3.9	6.8	9.9	223	299	143	11
Paris	10.9	2.2	4.2	7.4	10.3	359	344	65	1
London	10.5	2.0	5.0	8.3	–	493	198	47	0
Geneva	10.0	2.5	4.7	7.5	10.7	266	226	99	25
Bonn	9.7	1.9	5.2	7.9	11.3	376	240	58	1
Zurich	9.0	2.4	5.3	8.3	11.2	383	194	62	7
Hamburg	8.5	2.5	5.8	8.9	12.6	398	161	47	1
Innsbruck	8.2	2.8	5.9	8.8	11.7	386	187	42	8
Copenhagen	7.7	3.0	6.1	9.6	–	449	142	24	0

3.142

3.143

3.138 Schematic diagram of a building's cooling
system including an earth pipe and a heat
pump
3.139 Temperature development of the supply air
when cooled or heated by earth pipes
3.140 Exemplary development of the ground
temperature at different times of the year
3.141 Diameter of earth pipes according to the
required air velocity and air volume flow
3.142 Cooling capacities of an earth pipe at different
annual mean temperatures and locations (pipe

diameter: 0.3 m, installation depth: 2.5 m, pipe
length: 30 m). The cooling capacity describes
the temperature difference which can be
achieved after cooling the outside air in an
earth pipe in relation to the outside air
temperature.
3.143 Annual utilisation period of the earth pipe in
relation to the outside temperature. The earth
pipe is not usually used at temperatures
between 12 – 18 °C as it is not necessary to
cool or heat the supply air in this case.

3.144

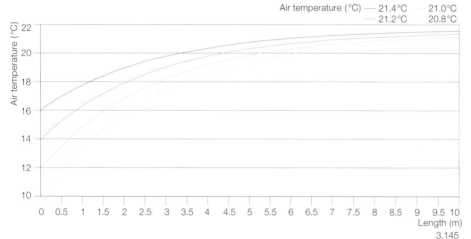

Air temperature (°C) — 21.4°C — 21.0°C
— 21.2°C — 20.8°C

3.145

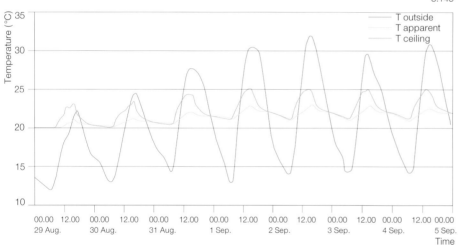

3.146

Mixed ventilation, tangential

Mixed ventilation, radial

Sub-floor ventilation

Facade ventilation with
centralised extraction system

Facade ventilation with
decentralised extraction system

Displacement ventilation

3.147

Ventilated thermo-active building systems (TABS)

A ventilated system is a special type of thermo-active building system. In contrast to conventional thermo-active systems with water pipes laid in the concrete floor slabs, this system integrates air ducts into the floor slabs (Fig. 3.144). Unlike in water-conveying TABS, the functions of heating, cooling and building ventilation are, in this case, combined in one system. The air exchange is used to remove moisture and to thermally condition the building.

Construction and function

In contrast to conventional ventilation systems, the supply air is first channelled through the floor slab before it is then introduced into the rooms. The outside air is channelled through an air-conditioning and ventilation plant and conditioned according to the supply air temperature and the humidity level. Because the heat exchange rate of concrete ceilings is around 90%, the outside air does not usually have to be reheated in winter but can be introduced directly to the building. Air is not recirculated. The temperature of the supply air approaches the ceiling temperature asymptotically when flowing through the slab-integrated ducts (Fig. 3.145).

Planning and operation

The position and arrangement of the pipes should be determined with the structural engineer in good time. As a rule, the aluminium cooling or heating tubes are embedded on the neutral axis of the ceiling slab. To improve their heat transfer properties, the tubes are ribbed on the inside. The diameter of the tubes is 60 or 80 mm. In contrast to conventional ventilation systems, the ceiling-integrated tube system allows the storey height to be reduced. It is possible to clean and inspect the ribbed tubes in accordance with VDI 6022.

Application

In winter it is easy to make use of internal and external heat gains arising in the building simply by transferring them to the cold air supply. Given an outside air temperature of 10°C, a floor slab temperature of 22°C and a ventilation tube length of ten metres, in a standard office building it can be assumed that the temperature of the supply air will increase to

approximately 21 °C before it flows into the interior of the building. Since the supply air in summer also absorbs energy via the floor slab, but a temperature rise should be avoided, the warm outside air has to be cooled down to approximately 12 °C before entering the thermo-active building system (Fig. 3.146). At cooling loads of around 40 to 60 W/m², it is not usually necessary to provide an additional building cooling system.

Performance

In contrast to water-bearing TABS, air-conveying TABS do not require any pumps. If the building needs night-time cooling, the length of time in which fans are required to operate is longer than the operation periods of fans in buildings with a combination of ventilation and water-bearing TABS.
The heat transfer of the embedded tubes is approximately 20–30 W/m²K. A rate of two air changes per hour requires an air supply of around 6 m³/h m².

Ventilation systems

A perfect ventilation strategy does not only contribute towards improving the thermal comfort, it can also influence the energy consumption of a building. Ventilation systems do not only differ according to the extent of installation work and cost, but also according to the achievable quality of ventilation. According to the various airflow patterns, there is a distinction between sub-floor ventilation, mixed ventilation and displacement ventilation (Fig. 3.147).

Sub-floor ventilation

Sub-floor ventilation systems are usually used in office buildings and are able to provide very good air quality inside the rooms.
In this case, supply air is introduced into the room at floor level at a slightly lower temperature than the room air. The air velocity is generally below 0.2 m/s so that large air ducts are required to transport the air. Due to the low air velocity and the comparatively cool supply air, a fresh air pool is created within the room. After having been heated by occupants and internal heat sources, the air rises and is finally extracted at ceiling level (Fig. 3.149). Due to the very low air velocity, there are very few draughts. The air inlets are usually made of either

3.148

a non-woven material or perforated sheet metal. The supply air is best distributed by using raised flooring (Fig. 3.148). As the temperature of the supply air is only approximately 2 K below the room air temperature, a sub-floor ventilation system can only achieve a cooling output of 20 W/m². It is not possible to use this system to heat the room. With the supply air being only slightly cooler than the room air, due to the character of the system, sub-floor ventilation systems can be disadvantageous from an energy point of view if large cooling loads need removing from the interior.

Mixed ventilation

In contrast to sub-floor ventilation systems, the supply air in mixed ventilation systems is introduced into the room at high speed (usually by jet or twist outlets). Due to the high velocity, the supply air quickly mixes with the room air (induction method). For this reason, only small inlets are required, for example, in the ceiling area, which generally calls for less elabo-rate installation work. Due to the intensive mixing of room and supply air, the temperature of the supply air can be well above or below the room temperature. This airflow system can therefore also meet a proportion of the heating or cooling loads. However, as a rule, water-bearing cooling or heating systems should be given precedence, since air has a very low storage capacity. Mixed ventilation systems are used when a high air exchange is required or part of the heat load is to be removed via the ventilation. The controlled supply and discharge of air in single family homes is also a mixed ventilation system.

3.149

Displacement ventilation

A displacement ventilation system guarantees room air with an extremely high degree of purity. The air is introduced into the room via large enclosing surfaces (e.g. the ceiling) and then extracted on the opposite side of the room. Due to the large-scale and clearly defined surfaces, a laminar flow is established without turbulences, which is able to extract impurities very successfully. Because of the very large air inlet and outlet surfaces, the installation work involved is considerable. Displacement ventilation systems are therefore usually only used in special situations (e.g. laboratories or clean rooms).

3.144 Air-conveying thermo-active building systems (TABS). The supply air pipes are embedded in the neutral zone of the concrete floor slab.
3.145 Increase of supply air temperature through TABS in relation to the outside air temperature and the pipe length.
3.146 Air temperature changes in relation to the outside temperature and using TABS (design data: air volume flow 7.5 m/hm, air inlet temperature 12 °C, total maximum cooling load 60 W/m)
3.147 Airflow patterns of mechanical ventilation systems in office rooms
3.148 Supply air outlets in raised flooring system (without pedestals and panelling)
3.149 Air extraction at suspended ceiling level

Power supply

The world-wide electricity industry is undergoing an incredible change. In striving for sustainable development, the Europeans, in particular, are promoting the development of decentralised renewable energy production. In addition to its previous function of distributing power from central power stations, the mains grid has now had to take on a new management task. It will, in future, have increased responsibility for coordinating the balance between supply and demand.

In this context, building planning fulfils an important function: especially in non-residential buildings, the electricity demand for functions such as lighting, ventilation and cooling is of greater significance than the heat demand. The fact is that the electricity demand in energy-efficient buildings cannot be reduced by built-in measures in the same way as the heating or cooling demand. Alongside minimising the demand for electric power, it is, for this reason, necessary to examine whether and to what extent the building itself can become a power generator within the electricity industry. In contrast to the numerous possibilities for heat generation, from a building planning point of view, the opportunities to produce electricity from a renewable source are limited basically to decentralised combined heat and power generation and photovoltaics. This underlines the special importance of solar technology in future energy concepts for buildings: architecture without photovoltaics will become an exception in the long-term.

Electricity supply
Today, electricity is still predominantly generated in conventional power stations by burning or using fossil fuels (coal, uranium, natural gas). The power stations are generally located outside the residential and commercial areas that are supplied. As a consequence the electricity is transmitted over great distances. In order to minimise heat loss and keep conductor sizes as small as possible, transmission is performed at high voltage and therefore low current.

The anticipated use (electric power) is a key factor in defining the voltage range of the current supply. The connected load is the sum of all the power (in kW) required by all of the connected electrical appliances and installations. The power demand of a consumer's installation is the sum of all the electric power consumed at the same time. Ideally all the appliances and electrical installations should be known so that the planning of the electrical cables and lines can be based on optimal conditions.

Alternatively the assessment can be performed according to areas. The power demand is then calculated by summing up the installed power, the connected load and a utilisation factor (between 0 and 1). This factor takes account of the fact that the power consuming appliances are never all switched on at the same time. When defining the power demand, a certain reserve margin should also be considered.

Significance of electricity in architecture – design aspects

Major consumers are supplied via a high-voltage network (10–20 kV), and large properties, such as hospitals or large office buildings, via medium-high voltage. With the help of transformers, which are usually installed in the building by the owner, the electricity is stepped down to a service voltage of 230/400 Volt (Fig. 3.151). The heat that is produced in this process must be considered when planning the arrangement of the transformers. If the transformer station is located in the basement, it should be placed next to an exterior wall where the heat can be removed naturally via light wells. In buildings with a connected load of up to 100 kW, it is more economical for them to be supplied via a low-voltage connection. In this case the electricity supply company is responsible for transforming the voltage.

Installation systems
The main task of the electrical installation system is to provide the electrical energy safely to the consumers at any place within the building with the help of a suitably branched wiring system. The traditional electrical installation system also served, to a certain degree, to control procedures within a building, for example by closing (switching on a power consumer) or interrupting (switching off) the electric circuit. With the increase of technologies and appliances in a building, the demand for cables and wires, and hence also the fire risk, has risen in buildings (Fig. 3.152). For this reason, a different principle is followed today: the idea of transmitting energy and information in separate lines has led to the introduction of so-called bus systems. Standard systems that are well known and used today include KNX (successor of EIB ((European Installations Bus)), LON (Local Operating Network) and BACnet (Data Communication Protocol for Building Automation and Control Network).

In all of these systems, all consumers (= actuators) and controlling device (= sensors) are combined to a single copper conductor (Fig. 3.153). This installation bus transmits all the information to control appliances within a building. There are also systems which transfer data via fibre optic cables (e.g. glass fibre). Optical data transfer is far superior to electrical when it comes to resistance to interference, the reach and the rate of transmission. However, to transfer data via fibre optic cables, the electrical signal must be converted into an optical signal. At the receiver, it then has to be converted back into an electrical signal. This process leads to high investment costs and is the reason why fibre optic technol-

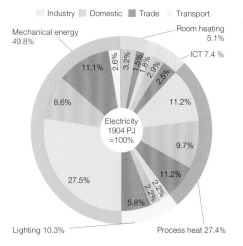

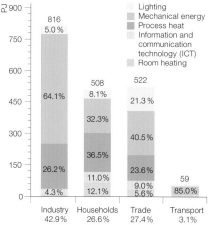

3.150

...gy has so far only been applied in large plants.

The electrical installation today is a fundamental and integral part of all building technology, however, particularly for building automation. Without bus systems, it would be difficult to respond to the growing demands for greater comfort (remote and intelligent control systems), security (motion and fire detectors) and energy or cost saving measures. Information and telecommunication components (telecommunications, data networks, internet and broadcasting systems) are supplied from a central connection point via a star-shaped network (Fig. 3.154). Structured building networks planned according to the EN 50173 standard offer a high degree of flexibility regarding the future use of space. It makes sense, when planning the communication infrastructure in buildings, to consider the installation of suitable cables and provisional conduits. Anticipatory measures help to avoid follow-on costs for retrofitting cables at later dates to meet the needs of future users.

Electricity consumers, their significance and saving potentials

Household appliances, (computers, washing machines, televisions) are categorised in the EU according to their energy efficiency (classes A–G). However, these appliances do not only consume electricity during operation, but also when in standby mode. The standby electricity loss in Germany alone adds up to approximately 22 billion kWh. If today, for example, a colour laser printer with a power consumption of 50 Watt is kept in standby mode for a whole year, it consumes approximately 438 kWh of electricity. At an average electricity price of 0.2 €/kWh, this adds up to costs of approximately 88 €.

As of 2010, household appliances, depending on the design, are allowed to consume only 1 – 2 Watts when in standby mode. Due to the reduced power input, the heat load decreases, resulting in lower cooling demand. This leads to a further reduction of the operating costs in buildings, as even those with complex installations have less need for cooling in the summer months.

Whereas the household appliances in residential buildings are responsible for approximately 70 % of the power consumption and the heating and lighting

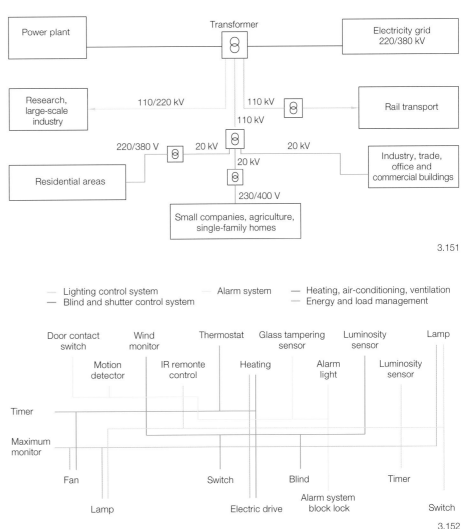

3.151

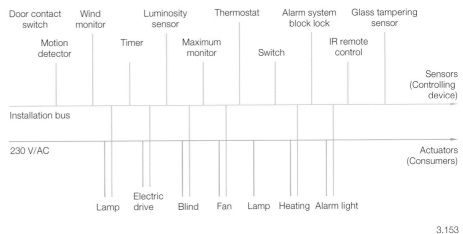

3.152

3.153

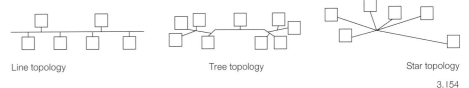

Line topology Tree topology Star topology

3.154

3.150 Electricity consumption in Germany 2007, categorised according to power consumption and application
3.151 Power distribution and supply voltages
according to consumers
3.152 Conventional electrical installation system
3.153 Electrical installation with bus system
3.154 Possible installation structures for bus systems

Category	P_{SFP} (W·m^{-3}·s)
SFP 1	< 500
SFP 2	500–750
SFP 3	750–1250
SFP 4	1250–2000
SFP 5	2000–3000
SFP 6	3000–4500
SFP 7	> 4500

3.155

Category	Description
IDA – C1	Continuous operation
IDA – C2	Manual control system The system is subject to manual control.
IDA – C3	Time-based control system The plant is operated according to a predetermined time schedule.
IDA – C4	Presence-dependent control system The plant is operated according to the presence of persons (light switches, infrared sensors, etc.).
IDA – C5	Demand-dependent control system (number of persons) The plant is operated according to the number of persons present in the room concerned.
IDA – C6	Demand-dependent control system (gas sensors) The plant is operated by sensors that measure room air parameters or predetermined criteria (e.g. CO_2 or mixed-gas sensors, VOC sensors). The applied parameters have to be adapted to the type of activities performed in the room concerned.

3.156

Expression Symbol	Description Relation	Unit Abbreviation
Luminoux flux Φ	power of light	lumen (lm)
Luminous efficacy $\eta = \Phi/P$	luminous flux / electric power	lumen / watt (lm / W)
Light output $Q = \Phi \cdot t$	luminous flux · time	lumen hour (lm·h)
Luminous intensity $I = \Phi/\omega$	luminous flux / radiation angle	candela (cd)
Illuminance E	luminous flux / area	lux (lx = lm / m²)
Luminance L	luminous intensity / area	candela /m² (cd /m²)
Degree of reflection	reflection of light	(%)

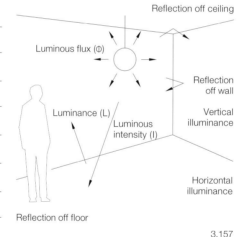

3.157

3.155 Classification of the specific fan power demand according to DIN EN 13779
3.156 Control types for air-conditioning and ventilation plants according to DIN EN 13779
3.157 Characteristic values of lighting technology including their equivalent units
3.158 LED office lighting in the Unilever Head-quarters in Hamburg, Behnisch Architekten

a

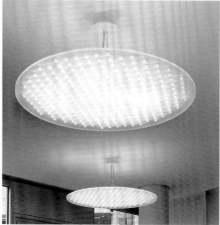

b

3.158

68

installations for approximately 30 %, the balance of the power consumption in office buildings varies considerably, depending on the type of air-conditioning system and the building services systems. In this case, the largest consumers of electricity are the refrigeration machines or heat pumps, the mechanical ventilation system and the lighting.

Energy-efficient power systems
A tried and tested way of saving energy is the application of frequency converters (FC) to control the rotational speed of HVAC plants. If systems that generate a volume flow (circulation pumps, fans, compressors) are applied without speed control, the flow of the corresponding medium must be throttled by using valves or flaps when the plant is not operated in accordance with the design load (maximum load). However, by throttling the flow, the energy already invested to power the system is wasted. By using energy-optimised engines and speed-controlled plant, the power input to the components can be reduced.

Mechanical ventilation systems
The air flow in mechanical ventilation systems is performed by fans powered by electric motors. The target value of the specific fan power (SFP) gives an indication of the expected level of power demand for all supply air and extract air fans in a building. The value should be determined at an early planning stage so that the service output demand and therefore the energy consumption required for the airflow can be assessed and the effects this has on the design process can be considered.

$$SFP = P_{sf} + P_{ef}/q_{max}$$

where:
· SFP = Required specific fan power demand (in Ws/m³)
· P_{sf} = Total fan power of the supply air fans at design air flow rate (in W)
· P_{ef} = Total fan power of the extract air fans at design air flow rate (in W)
· q_{max} = Design airflow rate through the building. This value should correspond with the extracted airflow rate (in m³/s).

The SFP value is dependent on the pressure loss in the ductwork, on the efficiency of the fan and the design of the motor. Also note that leakages in the

uctwork can increase the SFP value. In order to minimise the energy consumption of the fans, the pressure loss in the plant components should be kept as low as possible. This means that the dimensions of the air ducts should not be too small and the airflow velocity in the ducts should not be too high. Fittings mounted inside the ductwork or in the ventilation unit increase the pressure loss, which must be compensated for by the fan and increases power consumption. Economic assessments of heat recovery measures, such as installing additional heat exchangers into the system, must consider the higher electricity costs. For energy-saving reasons, the SFP categories 2–4 should be taken as the target values for the individual fans in accordance with the design concept (Fig. 3.155).

Since electricity costs are directly related to the operating periods of the fans, the control system of the air-conditioning units has a major impact on the costs. Figure 3.156 indicates the different control setting possibilities for an air-conditioning and ventilation plant designed to provide a predetermined level of indoor air quality (IDA). A demand-dependent control system should generally be favoured (e.g. CO_2 sensor or a presence monitor). The classes IDA C5 and C6 have potential for further energy savings as the air volume flow can be altered (variable air volume regulator).

Illumination
The electricity consumption of lighting plant contributes considerably towards the energy consumption of buildings. When designing a building, it is important to make sure that sufficient daylight is provided. In this regard, there is great potential for energy savings in the building's geometry (room depths) and the facade construction, which should be carefully considered. Apart from the basic planning parameters that should always be observed (illuminance, glare, contrast, colour rendering properties) to attain optical comfort, aspects affecting energy use should also be taken into account.

The efficiency of a light source is defined as the luminous efficacy (quotient of luminous flux to power) (Fig. 3.157). When developing the lighting concept, it is necessary to make sure that the indirect lighting, which undoubtedly has a more pleasant feel, is not unduly emphasised. The power consumption is higher than that for direct lighting offering the same illuminance. The reason for this is that indirect lighting requires a higher luminous flux to compensate for the light that is absorbed by wall or ceiling surfaces. It is therefore important to make sure that the corresponding surfaces are sufficiently reflective.

Lighting products
In general, the following lighting products (light bulbs) are used, as appropriate, in light fittings throughout buildings:
- Up until recently incandescent light bulbs were widely used due to their warm light colour and good colour rendering properties. However, due to their low luminous efficacy and related high energy consumption, as well as their short life expectancy, the production of these bulbs is being reduced.
- The halogen lamp is a special kind of incandescent light bulb. These are usually operated with a transformer as low-voltage halogen lamps.
- Fluorescent lamps are usually used as tubes with differing lengths, efficiencies and light colours. These lighting products can achieve high luminous efficacy with low energy consumption.
- Compact fluorescent lamps are especially small fluorescent lamps. Compared to other fluorescent lamps, the tube where the gas is discharged is a lot smaller and is curved or folded several times so that the bulb can fit into small light fittings.
- Energy saving lamps are compact fluorescent lamps with an integrated ballast and an Edison screw (screw base), which allows them to replace incandescent light bulbs. The ballast is necessary in gas-discharge lamps and fluorescent lamps to limit the flow of current.

The advantage of energy saving lamps is their high luminous efficacy of approximately 60 lm/W. Incandescent light bulbs have a luminous efficacy of only 12 to 15 lm/W and therefore convert less than 2 % of the current into light. At the same luminosity, an energy saving light requires around 80 % less electric power and the life expectancy is about 5 to 15 times greater than that of a normal incandescent light bulb. Their life expectancy fluctuates, depending on the quality, between 3,000 and 15,000 hours.

Fluorescent tubes develop less heat at the same light output as incandescent lamps. If a light fitting has a power limit, more light can be emitted if an energy saving lamp is used.

The main disadvantage of many energy saving lamps is their temperature-dependent luminosity. They do not reach their full light output until after a warm-up phase of approximately 1 – 2 minutes. For this reason, it does not make sense to use these lighting products in light fittings that are only turned on for short periods of time or that are controlled by motion detectors.

Light-emitting diodes (LED) have a relatively low light intensity and have up until now been used mainly in display illumination. However, improvements in the luminous efficacy (up to 20 lumens per watt can be achieved today), appropriate control systems and very efficient optical systems for an exact distribution of light, mean that LEDs can now also be used for general lighting purposes.

Despite current higher investment costs, LEDs can lead to good economic results in certain situations due to their long life expectancy, limited maintenance requirement and hence low operating costs. White LEDs have not been very popular with lighting designers up until recently because of the cold light that they emit. However, recently developed LEDs can achieve a colour temperature of 3200 Kelvin and therefore allow the application of LEDs with warm-white light, the light colour almost corresponding to that of a halogen lamp. These LEDs are already available in modules with different shapes and light colours.

Lighting control
Apart from increasing user comfort, automated lighting control systems have great energy savings potential. Lighting control systems with motion detectors are ideal for rooms that are used only occasionally for short periods. By integrating a daylight-dependent lighting control system, certain light fixtures or groups of light fixtures can be switched on and off according to a defined light level. Furthermore the light output of individual light fixtures can be adjusted gradually to meet the desired levels of illuminance.

Transportation systems
In normal circumstances, cable lifts consume approximately 30 % less energy

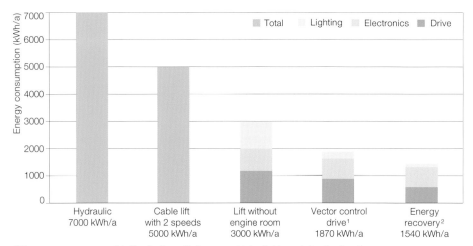

¹⁾ No energy recovery, cabin illumination with fluorescent tube lights and standby function
²⁾ In addition: Cabin illumination with LEDs, standby function for illumination, ventilation and drive

3.159

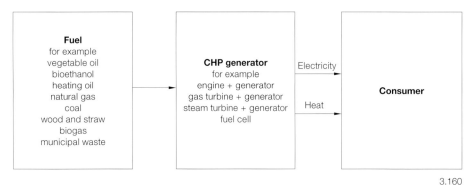

3.160

		Otto engine	Diesel engine	Stirling engine	Fuel cell
Electric power	(kW)	1–5000	5–20000	1–40	1–250
Overall efficiency	(%)	up to 90	up to 90	up to 85	up to 90
Electrical efficiency	(%)	25–42	28–44	10–30	30–47
Power to heat ratio		0.4–1.1	0.5–1.1	0.4	0.3–0.7
Partial load performance		good	good	not so good	very good
Current state of technology		established	established	small series	pilot plants
Fuels applied		biogas, natural gas	vegetable oil, diesel oil	solar, wood	hydrogen, gas

3.161

CO₂ equivalent chart (g/kWh):
- Brown coal power plant
- Bituminous coal power plant
- Brown coal CHP plant
- Bituminous coal CHP plant
- Natural gas COSAG¹ power plant
- Natural gas BTTP 5 kW
- Natural gas BTTP 500 kW
- Natural gas COSAG¹ CHP plant 50 MW
- Photovoltaics
- Hydroelectric power plant
- Biogas BTTP 500 kW

Legend: Systems without CHP · CHP systems
¹ COSAG: Combined steam and gas power plants

3.162

than hydraulic lifts. The drive is just one of several electrical components influencing the lift's energy consumption. The lighting and the motors to open and close the doors are further power consumers. By using new drive technology, it is possible today to regain a percentage of the energy generated by the loaded, descending lift. The saving potential can be as much as 20 % of the lift's total energy consumption. However, the lift lighting is responsible for about 40 % of the lift's energy consumption (Fig. 3.159). For this reason, energy-efficient, long-life fluorescent tubes or LED lamps should be used instead of halogen lamps. LED spotlights last up to ten times as long and consume up to 80 % less energy than traditional halogen light bulbs.

Electricity is also consumed for lighting and ventilation when the lift is not moving. Energy-efficient control systems are able to monitor the utilisation as well as put all systems into a sleep mode when the lift is not being used.

Combined heat and power

The term combined heat and power (CHP) refers to the simultaneous generation of useful heat and electricity with the aid of a technical system (Fig. 3.160). This principle was developed from the generation of electric power. Large amounts of waste heat are inevitably emitted in the mechanical transition process from water vapour to electrical energy. For reasons of logistics, large power stations are rarely able to use this waste heat. It sometimes even has a negative impact on the environment (increased temperature in rivers etc.), since additional cooling is required when it is discharged. It only makes sense to feed the heat into a district heating network if the distance between the power plant and the supply area is just a few kilometres. An alternative, which is currently being explored, is to generate the electric power in decentralised stations close to the consumers. In this way the electricity and the heat produced can be directly integrated into the energy concept of the building or its neighbourhood. Electricity which is not required is simply fed into the grid; if additional power is required, it is drawn from the grid.

CHP technologies
Based on the different technologies, there

a variety of fuels that can be used for
the decentralised combined heat and
power generation. In the context of sus-
tainability, renewable energy sources,
such as biomass, hydrogen, waste heat
or solar radiation, should be favoured for
running the system.

Electricity from biomass: Engine systems
To generate heat and power in a CHP
plant with biomass, power-generating
systems are used with an engine-oper-
ated generator. In this case, the engine is
a slightly modified version of those used
in the automobile industry, which oper-
ates within an acoustic enclosure. The
heat produced in the process is inte-
grated into the heating circuit via a heat
exchanger (see p. 27, Fig. 3.17). These
devices are called block-type thermal
power stations and can be integrated into
the building's energy concept as a stand-
ard component (Fig. 3.163).
The classification is undertaken accord-
ing to performance specifications. While a
BTTP has a thermal and power output,
the specification is generally based on
the power output. Systems with low power
output ($< 50\,kW_{el}$) are referred to as mini
BTTPs.
Engine systems are by far the most com-
mon form of decentralised cogeneration
of heat and power. Otto, diesel as well as
gas powered engines are commonly
used for driving the system. If using bio-
mass as engine fuel, vegetable oils
(especially rapeseed and soja oil) have
proven successful. If biogas is available,
the use of an appropriate gas engine
would also be possible.

Electricity from hydrogen: Fuel cells
In the future, alongside engine-powered
systems, fuel cells will become more sig-
nificant in combined heat and power gen-
eration. Fuel cells produce electricity from
hydrogen fuel in an electrochemical pro-
cess. In the case of a decentralised appli-
cation, the useful heat that is emitted can
be integrated into the heating circuit in
the same way as in a block-type thermal
power station. Hydrogen is required to
operate the fuel cell, which, in the case of
a sustainable development, should be
produced and stored by renewable ener-
gies. Since the necessary infrastructure is
not yet available, fuel cells tend to be
operated with hydrogen gained from nat-
ural gas. The supply chain for hydrogen
production, storage and application is

subject to very high loss factors of up to
50%, which need to be considered in the
overall balance. Although fuel cell heating
systems operate well with partial loads,
so far only a few prototypes with low out-
put ($< 100\,kW_{el}$) are in operation. A rollout
for residential buildings is expected over
the next few years.

Electricity from waste heat/solar energy
A further possibility with regard to decen-
tralised combined heat and power gener-
ation is the Stirling engine, which is able
to convert heat directly into electricity
(Fig. 3.164). Due to the possibility of sup-
plying the Stirling system with an external
heat source, it can be combined with
other forms of heat generators. In the
case of a renewable cogeneration of heat
and power, biomass heating systems with
wood pellets or wood chip can be used.
When combined with a Stirling engine,
the waste heat produced is used to gen-
erate electricity. There are already some
small compact systems on the market
with low power output that can, for exam-
ple, be fitted in single-family homes (see
p. 28, Fig. 3.19).

*Combined cooling, heating and power
(CCHP)*
A combined heat and power generator
that is supplemented by a machine able
to produce cold from waste heat during
the cooling period is referred to as a com-
bined cooling, heating and power gener-
ator (Fig. 3.165).
In this case, conventional sorption refrig-
eration machines, like the ones applied
for solar cooling, are used (see p. 45ff.).
Due to the additional heat consumption in
the summer months, this block-type ther-
mal power plant also operates in months
when no heating is required.

Energy concept with CHP
Systems for combined heat and power
generation can be integrated into the
energy concept of a building as a stand-
ard component. In this context, a differen-
tiation must be made according to the pri-
mary function of the system: in principle,
a CHP generator can be integrated either
in a power or heat-based system depend-
ing on which function is considered most
important and used for dimensioning the
system. In order to increase the overall
efficiency, the system selected is often
based on the heat demand. In this case,
surplus electricity is fed into the grid. If

3.163

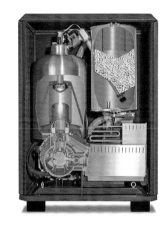

3.164

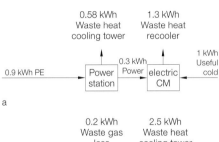

a

b

CM: Cooling machine
BTTP: Block-type thermal power station

3.165

3.159 Average power consumption by lifts. Basis for
calculation:
Lift speed 1.0 m/s (in hydraulic lift: 0.63 m/s),
nominal load (8 persons) 630 kg and 200 000
trips/year
3.160 Functional principle of a combined heat and
power system
3.161 Common systems for the cogeneration of heat
and power
3.162 CO_2 emissions from electric power generating
systems
3.163 Standardised module (CHHP) for cogeneration
of heat and power in building application
3.164 Compact Stirling engine powered by wood
pellets for a single-family home
3.165 Comparison of decentralised combined heat,
cold and power plant and conventional cooling
a Energy flow in the case of electric cooling
b Energy flow in the case of thermal cooling
with BTTP and sorption cooling machine

Primary energy	Final energy			Useful energy
320 kWh	289 kWh	BTTP	η_{th} = 52 %	150 kWh heat
			η_{el} = 35 %	100 kWh electricity
184 kWh	167 kWh	Boiler	η_{th} = 90 %	150 kWh heat
260 kWh		Germany's energy mix PF[1] = 2.6		100 kWh electricity

[1] PF = Primary energy factor

Comparison method		Credit method	
Primary energy boiler	184 kWh	BTTP	320 kWh
+ primary energy power plant	+ 260 kWh	– credit for electricity	– 260 kWh
Separate generation	444 kWh	BTTP (heat)	60 kWh
– primary energy BTTP	– 320 kWh	– boiler (heat)	– 184 kWh
Savings	124 kWh (= **28 %**)	**Savings**	124 kWh (= **67 %**)

3.166

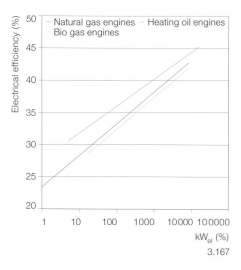

3.167

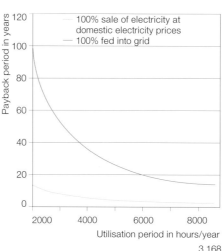

3.168

Tilt angle of module surface (°)	Useful solar area (%)	Specific irradiance (%)	Useful irradiance (%)
0	100	100	100
10	75	106	80
20	61	111	68
30	53	113	60
40	48	113	54

3.169

3.166 Savings by means of decentralised CHP system presented on behalf of a natural gas-powered BTTP
3.167 Efficiency values of BTTPs with different performance figures and different power systems
3.168 Payback periods for BTTPs in Germany, dependent on annual utilisation period
3.169 Comparison of tilt angles for mounting photovoltaic modules on flat roof

3.170 Possible multiple functions of building integrated photovoltaic plant
3.171 Exemplary loss of output due to shading of single solar cells in thin-film and crystalline modules
3.172 Facade integrated thin-film photovoltaic elements, residential and commercial building in Munich, a+p Architekten
3.173 Semi-transparent PV facade, office building, Tobias Grau in Rellingen, BRT Architekten

the generation of electricity is regarded as the prime focus, the heat produced as a by-product cannot normally be used as an energy supply.

Efficiency
The efficiency of a CHP system is calculated as the ratio of the energy fuel used and the total amount of energy produced (heat and electricity). In terms of heat, a BTTP has, in comparison to a boiler system, an efficiency ratio of approximately 50 %. However, since electrical energy is produced at the same time with an efficiency of about 25–40 % (Fig. 3.167), the overall efficiency that is attained is around 80–90 %. In order to add up the different forms of energy, the assessment must be based on the primary energy (Fig. 3.166).
Apart from the overall efficiency, the so-called power to heat ratio is an important parameter in the cogeneration of heat and power. The value indicates the percentage of electrical energy generated per kilowatt hour of heat output. A typical value for decentralised BTTPs is 0.5, which means that 0.5 kWh of electricity is generated in addition to each kilowatt hour of heat.

Profitability
Compared with a purely heat generating system, the combined heat and power system has the advantage that, in addition to generating heat, it produces electricity »for free« at the same time, and this has an impact on the financial return. The economic analysis of a BTTP compares the costs associated with capital (investment costs and interest on capital) with the value of the energy generated. In non-productive periods, the system still has to be financed, although it is not producing income. In terms of financial efficiency, it is therefore important that plants for the decentralised cogeneration of heat and power largely operate at full capacity throughout the year. The capacity is determined according to the operating time or the full-load hours of the BTTP. Depending on the mode of operation, it is determined on the basis of the power or heat demand.
From an ecological point of view, a heating bias is advantageous in that all of the generated heat is used, thus optimising the overall efficiency of the system. A good utilisation rate can be achieved if there is an even demand for

eat throughout the year. This especially applies to hospitals and nursing homes with a high demand for domestic hot water. In most cases, the same approach leads to using the output of the BTTP (or several systems) to cover only a proportion of the heat load and supplementing it by a second heat generator for the heating period. In this way economically attractive systems can reach annual operating times of over 4000 hours (Fig. 3.168).

Providing the conditions are favourable, the additional electricity generation makes it possible to either partially or fully amortise the investment costs over the technical life expectancy of the system. From an economic viewpoint, the decentralised cogeneration of heat and power is, therefore, worth considering. BTTPs can also be used as stand-by generators, creating an interesting synergy due to the savings in terms of investment costs.

Photovoltaics

Photovoltaic technology is a method of generating electrical energy without mechanical wear and tear, emissions or noise. The technology works independently of the building and is therefore also used in power plants spread over large areas of land. Since the early 80s, photovoltaic elements have also been integrated in buildings. In this application, apart from being used to generate energy, they can also fulfil additional functions, such as weather and sun protection or visual screening. As an insulated glass module, they can also be used to provide thermal insulation. In these functions, the modules are not only part of the building services system, but also part of the building envelope and therefore significant from a design perspective (Fig. 3.170).

Energy concept with photovoltaics
Solar building components place demands on the building design concerning inclination, orientation and shading. These conditions all have an impact on the energy efficiency of the system. In principle, all structural surfaces can be used for photovoltaics. However, in contrast to the use of solar thermal energy, even partial shading of the solar cells can reduce the energy yield considerably. This applies especially to crystalline modules (Fig. 3.171). For this reason, it is

essential to plan non-shaded, correctly oriented arrays. A detailed site and building analysis is fundamental for the planning of photovoltaics.

South-facing, single-pitched or saw-tooth roofs are most suitable. On flat roofs, the modules can be placed on supports, similar to the arrangement found in photovoltaic power plants. The supports allow the modules to be oriented perfectly and thereby achieve high efficiency. Due to the angle of incidence of solar radiation in Europe, the photovoltaic elements must be widely spaced to prevent the modules from casting shadows on each other. This requirement reduces the effective energy yield of an available roof area by approximately 50%. The modules can also be arranged so that they cover the whole roof area with very low tilt angles or even horizontally. In this case, the efficiency of the modules is reduced, but the overall energy yield in relation to the gross roof area is maximised (Fig. 3.169).

Facade surfaces also have potential for the active utilisation of solar energy. The radiation on vertical surfaces in Central Europe is approximately 30% lower than on inclined surfaces, however, in return, the photovoltaic elements are able to offer a considerable energy and economic saving potential by replacing high-quality facade elements (e.g. metal panelling, natural stone). The fact that they are used as design elements and also take on additional functions, including the generation of electrical energy, justifies their use in facades (Fig. 3.172).

Photovoltaic modules are very suitable for the integration in solar shading devices since, in this function, they are subject to direct solar radiation. This applies to both fixed and movable elements in which the solar modules replace opaque or partially transparent materials, such as metal panels or printed glass.

Photovoltaic modules can also be used directly as integrated shading elements (Fig. 3.173). By selecting the percentage of active cells, it is possible to influence the transparency of the building component. In this case, it is necessary to consider the high level of thermal radiation on the inside which arises due to the heat development within the solar cells. Even at low levels of transparency, it is possible to achieve very good results (reducing the G-value to 0.1) plus high shading effects, while, at the same time, utilising daylight.

Requirements concerning the building envelope	Impact of active solar energy utilisation
Thermal separation	o
Weather protection	+
Visual screening	+
Sun protection	+
Glare protection	o
Noise protection	o
Security	o
Daylight untilisation	–
Visual links	–
Design	+
Passive solar energy utilisation	–

o neutral + symbiotic – competitive

3.170

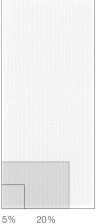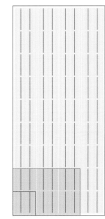

5% 20% 50% 100%

3.171

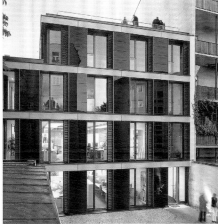

3.172

3.173

Solar cells

Solar cells are the basis of every photo-voltaic array. They are divided into different categories according to their structure and the materials used (Fig. 3.174).

Most of the solar cells used today are made of silicon (Si). There is a fundamental difference between crystalline cells and thin-film cells.

In the manufacture of crystalline modules, depending on the process, either single crystals or clusters of crystals are created. The cells are then referred to as monocrystalline or multicrystalline respectively.

The thin-film technology with solar cells made of amorphous silicon was developed in the 1970s. In this case, the substrate of glass, metal or plastic is coated directly with the silicon material. This production process offers high savings potential in terms of material and energy. Recently, other semiconductor materials are being used, such as cadmium telluride (CdTe) or copper indium selenide (CIS). In the thin-film technology, the size and shape of the cells can be chosen in accordance with the substrate's dimensions and the desired electrical properties. The planner therefore has great scope for creativity in the design.

Crystalline solar cells will continue to play a dominant role due to available production capacities. However, the thin-film technology will become increasingly important since the lower quantity of materials used offers the possibility of significant cost savings.

Photovoltaic modules

An assembly of several solar cells to achieve higher performance figures is called a photovoltaic module. The modules are predominantly used in laminated glass and can be installed accordingly (Fig. 3.175).

If the modules are to be integrated into an architectural concept, there are three different categories: standard modules that are mass produced are the most widely used. The technical parameters are fixed and they are relatively inexpensive. Most module manufacturers produce standard modules measuring approximately 0.5 to 1.5 m² with fixed dimensions and performance values stated in terms of maximum energy yield per area.

In addition, some manufacturers offer special modules tailored to individual requirements. For an additional charge of up to 100%, numerous parameters, such as dimensions, formats, colours, transparency, glass quality, insulation values, etc. can be specified to meet the demands of the building. For technological reasons, the maximum dimensions of a photovoltaic module with crystalline solar cells are currently limited to approximately 6 m². Nowadays, thin-film modules can be coated onto solid materials smaller than about 1 m². Together with further modules, they can be assembled to form larger units. Other modules, such as solar roof tiles, solar membranes, etc. are also available for special applications.

Inverters

The purpose of an inverter is to convert the direct current produced by photovoltaic modules into mains-compliant alternating current. The size, type and arrangement of the photovoltaic array influences the choice of inverter system. Central inverters, which connect all modules to a single device, are only used if the modules are not shaded and all face in exactly the same direction. Modular inverter systems are commonly used in buildings if smaller units are connected to form subsystems. The typical rated capacity for modular inverters is three to six kilowatts, which corresponds to a module area of approximately 30 to 60 m² Larger plants may therefore require several inverters. The site of installation and the necessary space with access for maintenance work must be considered whilst planning the system. Whether the plant is connected to the public grid, is fundamental for the design and scaling of the plant (Fig. 3.176).

There is a difference between standalone systems, which have to guarantee an autonomous power supply throughout the year, and grid-connected systems, which have an additional electricity supply from the national grid. In order to guarantee the supply in standalone systems, a storage facility is needed for the fluctuating energy yield. The photovoltaic system may also have to be supplemented by a further energy supplier. If a grid connection is available, there is no need to store the surplus energy. The excess is simply fed into the grid and reimbursed; if electricity is needed, it is drawn off the grid.

Performance

A fundamental criterion of a solar cell is its energy conversion efficiency. The value defines the percentage of solar energy absorbed by the solar cells and converted into electrical current. It is dependent on the material as well as the cell structure (Fig. 3.177).

In the field of research, the maximum efficiency currently achieved is around 35–40%. In Germany, the annual irradiance on a horizontal surface is on average 1100 kWh/m², in Southern Europe up to 1600 kWh/m². The maximum energy from solar radiation measured is approximately 2500 kWh/m² (e.g. in the Sahara Desert). Standard solar cells can convert

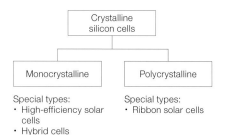

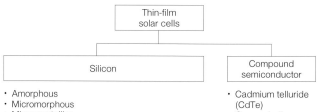

Crystalline silicon cells			Thin-film solar cells			Nano solar cells	
Monocrystalline		Polycrystalline	Silicon		Compound semiconductor	(In)organic semiconductor	

Crystalline silicon cells

Monocrystalline
Special types:
· High-efficiency solar cells
· Hybrid cells

Polycrystalline
Special types:
· Ribbon solar cells

· Wafer technology: Round to square single elements
· Wafer thickness 0.2 mm, side lengths 10–15.6 cm
· Market share of approx. 90%, established technology

Thin-film solar cells

Silicon
· Amorphous
· Micromorphous
· Microcrystalline

Compound semiconductor
· Cadmium telluride (CdTe)
· Copper indium gallium diselenide/ copper indium disulfide (CIS)

· Vacuum technology, galvanic: Usually large area coating
· Coating thickness 0.5–5 µm, width of cell strips 0.5–17 mm
· Market share of approx. 10%, upward trend

Nano solar cells

(In)organic semiconductor
Organic:
· Colour solar cells
· Plastic solar cells
Inorganic:
· CIS

· Printing process
· Nano structure
· Pilote stage

3.174

approximately 8% (amorphous silicon) to 17% (monocrystalline silicon) of the solar energy into electrical energy. Since solar cells are always integrated in modules, the module conversion efficiency is very important. Apart from being dependent on the cell technology, the value also depends on the fill factor of solar cells and is on average around ten to twelve per cent.

The maximum power output of a photovoltaic array under standard test conditions is defined as peak performance and measured in peak watts (W_p). Standard test conditions are defined as optimal irradiance of 1000 W/m^2 and a module temperature of 25 °C. The peak performance is based on measurements taken in these optimal conditions. If the irradiance is, for example, 1000 W per square metre and the conversion efficiency is ten per cent, the peak performance is 100 W. The achievable annual energy yield is measured in kilowatt hours per square metre per year (kWh/m^2a). It is, of course, dependent on the solar irradiance that strikes the module surface and is therefore strongly influenced by the location as well as the orientation of the modules (Fig. 3.178, p. 76).

The maximum annual yield achievable in Germany requires the modules to face south and a tilt angle of approximately 35°. The yield on a vertical south-facing facade is approximately only 70% of this value. Nevertheless, if a lower yield is acceptable, greater deviations from the ideal position are possible. Furthermore, the yield is dependent on the quality of the photovoltaic array, which is expressed in the performance ratio, a value independent of site conditions. The ratio of the actual yield to the theoretical yield indicates the performance of the system and lies above 70% in high-quality systems.

The amount of shading also has a large impact on the system performance. Due to the serial connection of solar cells and modules, even partial shading will generally cause a disproportionate reduction in yield. Furthermore, the conversion of the energy by inverters is subject to loss (5 to 15%) and the efficiency is dependent on the temperature of the solar cells. A high temperature also leads to reduced efficiency and if the modules are assembled without rear ventilation, the yield decreases by a further five to ten per cent.

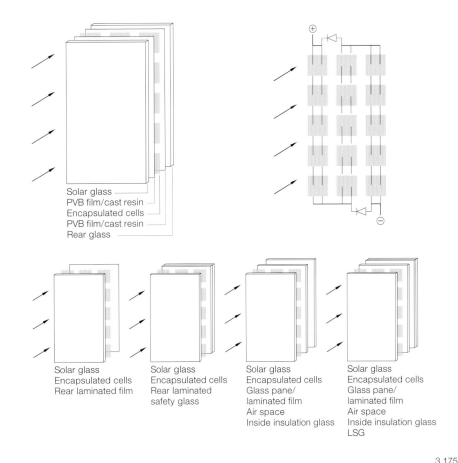

Solar glass
PVB film/cast resin
Encapsulated cells
PVB film/cast resin
Rear glass

Solar glass
Encapsulated cells
Rear laminated film

Solar glass
Encapsulated cells
Rear laminated
safety glass

Solar glass
Encapsulated cells
Glass pane/
laminated film
Air space
Inside insulation glass

Solar glass
Encapsulated cells
Glass pane/
laminated film
Air space
Inside insulation glass
LSG

3.175

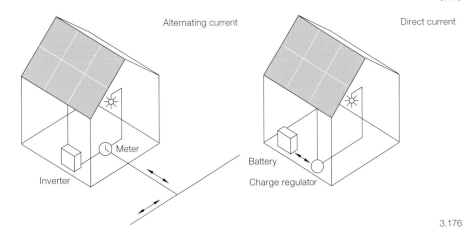

Alternating current

Direct current

Meter
Inverter

Battery
Charge regulator

3.176

3.174 Types of common solar cells on the market
3.175 Typical layer configuration (from outside to inside) of a building-integrated photovoltaic module
3.176 Different inverter systems: grid-connected and standalone system
3.177 Efficiency, area requirement and temperature behaviour of different solar cells

Cell type	Maximum cell efficiency (laboratory) (%)	Module efficiency (commercial) (%)	Output per m^2 of module area (W_p)	Area requirement for 1 kW$_p$ (m^2)	Loss of output due to increased temperature (%/°C)
Monocrystalline, standard	21.6	12–16	120–160	6.5–9	0.4–0.5
high-efficiency cell	24.7	16–20	160–200	5–6.5	0.3–0.4
hybrid HIT cells	20.2	16–17	160–170	6–6.5	0.33
Polycrystalline	20.3	11.5–15	115–150	7–9	0.4–0.5
Silicon, amorphous	13.2	5–7	50–70	15–21	0.1–0.2
microcrystalline	15.2	5–7	50–70	15–21	0.5–0.7
micromorph	13.0	7–9	70–90	11–14	0.3–0.4
CIS, standard (selenide)	20.0	8–11	80–110	9–13	0.3–0.4
sulphur	13.1	6–7	60–70	15–17	0.3
nano solar cells	14.0	8–10	80–100	10–13	
CdTe	16.5	6–11	60–110	9–17	0.2–0.3

3.177

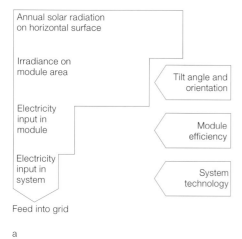

Annual solar radiation
on horizontal surface

Irradiance on
module area

Tilt angle and
orientation

Electricity
input in
module

Module
efficiency

Electricity
input in
system

System
technology

Feed into grid

a

Solar cell technology	Solar power output (kWh/m²_{module area} a)		
	Oslo	Berlin	Thessaloniki
Crystalline monocrystalline polycrystalline	90–100	95–110	125–140
Thin film CIS CdTe	60–75	65–80	90–110
Thin film amorphous silicon	35–55	40–60	55–80
Translucent modules	Reduction according to transparency		

b

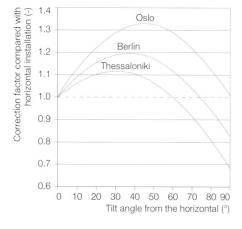

c 3.178

3.178 Approximate determination of photovoltaic
 plant dimensions
 a Loss factors
 b Solar power yield in the case of horizontal
 arrangement
 c Correction factor for tilted arrangement
3.179 Profitability assessment of building-integrated
 photovoltaic systems
3.180 Possibilities to store electricity and typical
 characteristic values

Depending on the cell typology and the fill factor, the specific yield of correctly oriented systems without shading in Central Europe is approximately 40 kWh/m²a for semi-transparent thin-film modules and up to 130 kWh/m²a for monocrystalline cells with a maximum fill factor.

Profitability
The investment costs of photovoltaics integrated into buildings are frequently compared with those for alternative materials, such as glass, metal panels, stone slabs or roof tiles. If these materials can be replaced by photovoltaic modules, not only the initial investment costs for the solar modules themselves must be considered, but also the additional costs compared to alternative materials, less the cost savings for energy or income from energy sales. It is interesting to consider the time it takes for the additional costs and the values placed on the energy yield to balance out. The initial investment costs for photovoltaic systems are related to the power output and determined per kilowatt peak. In 2010, in Europe, a standard system including the necessary technology and assembly, cost on average approximately 3000 €/kW$_p$.

In order to convert these prices to the unit area, square metre, commonly used in the building industry, the specific area requirement per kW$_p$ should be applied for evaluation purposes. Depending on the type of solar cell and the fill factor, an area of approximately 8 m² is required per kW$_p$ in the case of crystalline solar modules and up to 20 m² in the case of translucent thin-film modules. Based on these facts, the investment costs for a standard system vary between 150 and 375 €/m² but can exceed this. The profitability depends on these costs and the energy yield, which varies according to orientation, tilt angle, rear ventilation and shading. Approximately one to two per cent of the investment costs are allocated for servicing, maintenance and provisions. Apart from investment costs and the costs for repaying any related loans, it is important whether the electricity generated replaces the supply costs for conventional electricity off the grid or whether the electricity is sold on. In numerous countries (Germany; Renewable Energy Sources Act (EEG)), there are funding programmes which commit the energy supply companies to pay a fixed feed-in

tariff for solar-generated power, which is distinctly higher than the current electricity price. These favourable terms are locked in by legally binding agreements with guaranteed durations, in the case of Germany it is 20 years, so that, from an economic point of view, there is a high degree of investment security. With these reliable profits, it is possible to amortise the extra costs of a photovoltaic system during the operating period (Fig. 3.179). The feed-in tariff according to the Renewable Energy Sources Act is fixed uniformly and reduced at regular intervals. This reflects the price and market development in the photovoltaic sector. The aim of the act is for the guaranteed tariff to enable repayment of the investment costs within the contract term of 20 years, assuming normal operating conditions. If savings of the specific investment costs can be achieved through the additional benefits of integrating photovoltaics into the building envelope, the profitability improves accordingly. Furthermore, in Germany the operator of a solar power plant can obtain a license as a business from the tax office and can therefore set off VAT expenditure against received VAT. In this case, the choice of solar cell type (crystalline or thin-film) is generally of minor importance, since the investment costs for photovoltaics are related to the power output, and the yield is more or less comparable at the same output and situation concerning the installation. The fitting of complex, bespoke modules is often a financial disadvantage in comparison to simple free-standing photovoltaic systems. Integrating solar cells into the building envelope has a positive impact on building costs, especially if standard photovoltaic products and simple systems can match the function and quality of higher cost materials. Almost every type of building has great potential to generate electricity provided that solar technology is incorporated into the planning from the very beginning.

Decentralised electricity storage
In countries with a well-developed electricity supply network, it is usually not necessary to store the power that has been generated. The aim is not to operate more buildings off the grid. It is far more to develop an interconnected grid, which leads to greater flexibility in generating electricity and improved security of supply. However, in some cases it does

make sense to store electricity for a longer period. Especially if the varying demand for electricity requires a buffer storage facility due to an increase in the use of renewable energy systems. In regions without an electricity supply network, the provision of a storage facility for the continuous supply of power is a prerequisite. This especially applies to power generation from solar radiation or wind energy. There are several ways to store electricity (Fig. 3.180):

Condensers
Electricity can be stored directly in condensers in a very efficient way. However, the storage density that can be achieved is not very high. Condensers are frequently used in electronic components. Alternatively, there is the possibility to store electricity indirectly by converting it into another form of energy. This allows large amounts of energy to be stored over long periods. Electricity storage can be achieved by using one of the following devices:

Accumulator
For this storage facility, which is also referred to as »battery«, a chemical conversion is required before the storage can take place. Most widely used are accumulators and these operate with a variety of substances. Whereas efficient substances are used in the automobile industry or in the construction of electric cars (e.g. lithium ion batteries), lead-acid batteries are mainly used in buildings without access to the grid. These batteries offer a high degree of reliability and are cost effective. However, the short life expectancy and the waste disposal issues are, from an ecological viewpoint, unsatisfactory.

Flywheel
Another way to store electricity is to convert it into kinetic energy. In this case, the so-called flywheel storage system is an interesting option. The electrical energy sets a magnetically supported mass into rotation. Due to the extremely high speed of the gyrator (> 50,000 rotations per minute) and the almost frictionless bearing of the rotor, kinetic energy can be stored over long periods of time. By reducing the speed of the flywheel, electrical energy is released using a dynamo.

Compressed air
Alternatively electricity can be stored by using a compressed air storage facility. This system uses the electrical energy to compress air within an enclosed space. The compressed air can be converted back into electricity by releasing the air. This process is easy to perform, inexpensive and low maintenance. The efficiency, however, is fairly low (approx. 50 %), since the heat generated in the compression process can usually not be used.

Hydrogen
Hydrogen, as an energy medium, has the potential to assume an important role in energy storage. The process of electrolysis, makes it possible to produce hydrogen from water by using electrical energy. The fuel cell can transform stored electrical energy back into useful energy. However, hydrogen requires careful handling when being stored due to its chemical and physical characteristics (highly explosive in conjunction with air). The challenge therefore is to identify suitable storage possibilities for hydrogen as well as develop an all-embracing concept (hydrogen cycle).

Investment costs of complete photovoltaic system
−
Costs for saved components and their assembly
⇩
Extra costs for photovoltaics
⇩
Annual capital costs (annuity)
+
Annual operating costs (maintenance and upkeep)
⇩
Total costs of photovoltaics per annum

Annual electricity yield of photovoltaic system
⇩ ⇩
Amount of electricity used by the residents | Amount of electricity fed into the grid
× ×
Electricity tariff according to EEG | Feed-in tariff according to EEG
⇩ ⇩
Total yield of photovoltaics per annum

3.179

Storage facility	Energy density (kWh/kg)	Energy density (kWh/m³)	Investment acc. to capacity (Euro/kWh)	Number of cycles (life expectancy)	Costs for storage (Euro/kWh)	Typical storage period (hours)	Efficiency (%)	Storage site e.g.
Super condensers	0.005	10	50 000	500 000	0.100	0.1	> 95	Motor vehicle, energy plant
Flywheel energy storage	0.14	1000	1500	1 000 000	0.002	0,5	85–90	Motor vehicle, energy plant
Accumulators (Pb)	0.03	100	100	500	0.200	12	60–70	Motor vehicle
Accumulators (Li)	0.12–0.19	300	150	1500	0.100	12	90	Motor vehicle
Pumped storage, 250 m depth	0.0006	0,6	150	12 000	0.013	12	70–85	Power station
Compressed-air, energy storage, 60 bar	0.03	2	27	12 000	0.002	12	approx. 72	Power station
Hydrogen cavern storage, 60 bar	33	180	27	12 000	0.002	500	27	Power station

3.180

Water supply

Less than one per cent of the world's water can be directly treated for use as drinking water; the remainder is salt water. With the growing world population and rising water consumption, the supply of rainwater from natural evaporation is no longer sufficient. Already today, more than one billion people live without access to clean drinking water. In Germany, drinking water is more tightly monitored than any other food product. The list of pollutants and pathogens is being extended continuously and threshold values are being tightened. Supplying clean drinking water has become a challenge in many regions. This especially applies to places that are not connected to a central water supply network.

Water consumption

The daily water consumption in Germany currently amounts to approximately 120l per person. Two thirds of this drinking water is used in bathrooms, for washing and flushing toilets (Fig. 3.182). Apart from the steadily rising water prices, water consumption also has an effect on the amount of energy consumed. For this reason, it is important to install taps that reduce water consumption without reducing the level of comfort.

Today, modern sanitary fittings are equipped with integrated water-saving tap flow regulators. These are, for example, tap aerators, which reduce the water jet by almost 50% (Fig. 3.181 and 3.184). Flow regulators can be fitted to almost all bathroom and kitchen taps as well as between the shower mixer and the shower hose. They function like a partially closed valve.

3.181

Electronic taps, which use a proximity or motion detector to supply water only on demand, are sensible alternatives for public bathroom facilities.

In the case of thermostatic mixing valves, the consumer extracts water at the desired temperature without wasting water before the desired temperature is reached. For this reason, thermostatic mixing valves are especially suitable for showers.

WC flushing tanks with a water content of six litres are standard today and have replaced the previous systems with a nine-litre capacity. The amount of water used for flushing can be selected with the push of an integrated button on a dual flush mechanism.

However, notwithstanding all measures to save water, it is also necessary to make sure that the volume of waste water suffices to remove all residues in the drainage system. The pipework in new builds has to be dimensioned according to these low volumes of water. When performing refurbishments with the existing drainage system retained, the flush volume should not be reduced too far. In this case, it may be necessary to apply a discharge intensifier, a device which is installed either at the bottom of the waste stack or immediately behind the toilet bowl to collect the small amounts of flushed water. Due to effect caused by siphonage, the collected volume of waste is released periodically with a surge-like flush, therefore, preventing residues from remaining in the pipework.

The economical use of water resources is also an important aim in terms of the supply of drinking water. However, by reducing consumption, the standing time of water in the supply lines increases. This often requires greater effort in maintaining water hygiene standards on behalf of the public supply network. The supply lines have to be flushed more frequently so that the consumer has access to safe drinking water at all times. The charges made by the public utilities for water line maintenance are included in the fixed charges rather than the unit costs for water consumption. Economy concerning water supply is, therefore, to a certain degree, in conflict with ecology.

Water mains connection

Domestic water usually enters the building via a public water supply network. The public water utilities work with a pres-

sure of two to ten bar. At this pressure, it is also possible to provide water to supply points on the top storeys of buildings. The water mains connection consists of a shut-off valve, a water meter and a filter with a backflow preventer. If the pressure at the connection point exceeds five bar, a pressure reducer has to be installed behind the water metering device and the filter to protect the pipework and the fittings. Depending on the quality of the water, it may be necessary to install further fittings or water treatment systems (e.g. decalcification or proportioning devices) before distributing the water to the supply points.

For economic reasons, the connection rate to the central water supply network frequently only reaches 75% in Germany's sparsely populated areas. As a consequence, there are several private individual water supply companies in Germany. The quality of their well or spring water, however, often fails to meet the required standards.

The development of a decentralised water conditioning plant, consisting of mechanical filters and chemical systems, is a fairly expensive affair. According to the latest technology, ultrafiltration plants, in particular, are very effective systems to treat drinking water. This technology enables the removal of pathogens as well as turbidity in a single process. By adding an activated carbon filter, it is also possible to remove traces of pharmaceuticals and pesticides from drinking water. The filters used in ultrafiltration plants are membrane filters with pores only measuring approximately 15 nanometers (nano = 10^{-9}). They can trap and almost completely retain microorganisms and viruses. It is not really necessary to perform any additional disinfecting measures by adding chemicals or performing UV irradiation, although this remains mandatory.

Water installations

Pipes made of plastic, metal or composite materials are used for the water distribution network.

The selection of the pipe material depends upon the quality of the supplied drinking water. Copper pipes should, for example, only be used in the case of high pH values. Chemical analyses of water and recommendations for the correct choice of material can be obtained from the water utilities. In addition, the maxi-































Water supply

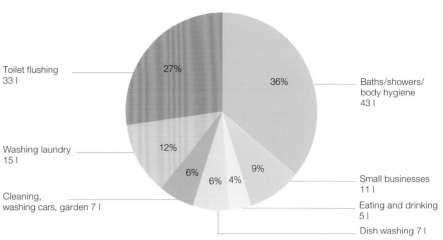

3.182

Toilet flushing 33 l — 27%
Baths/showers/body hygiene 43 l — 36%
Washing laundry 15 l — 12%
Cleaning, washing cars, garden 7 l — 6%
6%, 4%, 9%
Small businesses 11 l
Eating and drinking 5 l
Dish washing 7 l

um pressure and temperature in the pipework should be considered when selecting the material. The pipework is dimensioned according to the estimated volume flow (peak volume flow) and the pressure loss calculation (friction head loss). The inside diameter or the nominal width is relevant for the pipe diameters (nominal diameter DN).

Pressure increasing system
A pressure increasing system is a pump, which has to be installed if the pressure supplied by the public utility is not sufficient to provide the minimum level of pressure at the water outlet in the building that is the most inconvenient from a hydraulics point of view. Pressure increasing systems are therefore frequently installed in high-rise buildings. However, due to the increasing application of water meters, filters and water conditioning systems, all of which lead to greater pressure loss, pressure increasing systems are often installed in residential buildings with only a small number of storeys.
Safety valves protect the water in the pipework from contamination by preventing backflow, backsiphonage and backpressure.
The water utility is responsible for selecting the size and type of measuring device, according to the demand of the building, and for fitting the domestic water meter. The pressure loss caused by the water meter must be taken into account to ensure that the functioning of down-stream plants and fittings is not adversely affected.

Waste water
Waste water is usually discharged by means of a gravity dewatering system. Vacuum or pressure systems are an alternative to the usual gravity systems. Where such systems are used, flush toilets can be replaced by vacuum toilets similar to the ones used in airplanes, ships and trains or residential buildings in some Scandinavian countries.
By using decentralised or semi-decentralised waste water purification plants, it is possible to save costs which would otherwise be incurred by maintenance work on the sewage system.

Drainage system
Drains made of metal or plastic are applied in the drainage system. SML cast iron pipes (seamless soil pipes) and plas-

Type of building	Installation	Saving device	Normal installation
Residential building	Toilet flushing	24 l	45 l
	Washing machine	10 l	20 l
	Garden watering		0.2–0.55 l/m²
Office building	Toilet flushing	12 l	20–30 l
Schools and sports facilities	Toilet flushing	6 l	5–10 l
	Sprinkler irrigation system		0.55 l/m²

3.183

Installation[1]	Unit	without control device	with control device	Savings 1 DU	Savings 10 DU
1 Washbasin[2]					
• Volume flow	l/min	13	6	7	70
• Daily consumption	l/d	31.2	14.4	16.8	168
1 Shower[3]					
• Volume flow	l/min	19	9	10	100
• Daily consumption	l/d	87.4	41.4	46	460
Total consumption	l/d	118.6	55.8	62.8	628
Annual amount	m³/a	41.5	19.5	22.0	220
Energy consumption[4]	**kWh/a**	**1593.2**	**749.6**	**843.6**	**8436**
CO_2	**kg/a**	**525.7**	**247.4**	**278.4**	**2784**
Annual costs[5]	**€/a**	**348.7**	**164.1**	**184.6**	**1846**

Calculation parameters:
[1] 1 dwelling unit (DU) with 2 persons, 1 washbasin and 1 shower
[2] Period of washbasin use: approx. 1.2 minutes per day and person on 350 days a year
[3] Period of shower use: approx. 2.3 minutes per day and person on 350 days a year
[4] The heating of 1 m³ of water from 9°C (cold water temperature) to 42°C requires 38.38 kWh of energy, at the same time emitting approx. 12.66 kg of CO_2
[5] 1 m³ of hot water costs approx. 8.40 € (costs incl. fresh water, waste water and energy for heating the water)

3.184

Country	Water consumption per person and day (l)
Basic requirements according to WHO	50
Belgium	120
Germany	127
Netherlands	130
England	149
France	156
Sweden	197
Italy	213
Switzerland	237
Spain	270
India	25
Japan	278
USA	295
Dubai	500

3.185

3.181 Electronic washbasin tap with a reduced flow volume (6 l/min) due to the installation of an aerator
3.182 Use of drinking water in Germany: average values per person according to the water supplied to residential and small commercial buildings
3.183 Water demand for different building categories and types of installation per person and day
3.184 Potential savings of warm water in residential buildings by applying water-saving flow regulators
3.185 International comparison of water consumption per person and day (2007, without industry)

79

Type of waste water	Definition
Blackwater	Waste water from toilets and urinals, toilet flushing water containing faeces
Yellow water	Urine from separation toilets and urinals, with and without flushing water
Brown water	Blackwater without urine or yellow water
Greywater	Domestic waste water from kitchens, bathrooms (shower, bath, washbasin) and washing machines

3.186

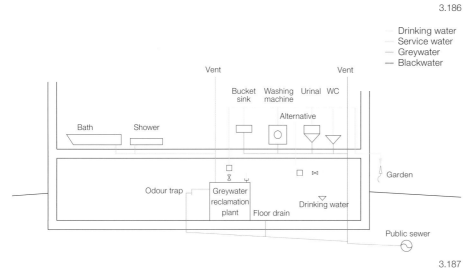

3.187

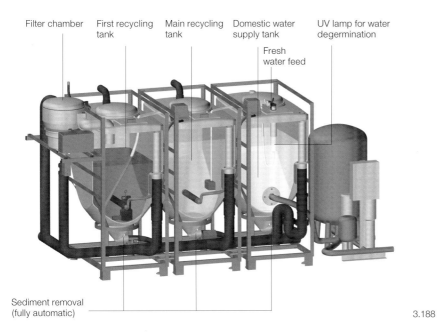

3.188

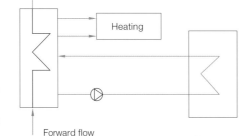

3.189

tic piping systems (high temperature pipes and sewer pipes) have become established in practical operation. Depending on fire protection or sound proofing requirements, it may be necessary to follow special technical directives The waste water is discharged horizontally to the soil stack via fixture or branch drains. Then the sewage flows down vertically, through the stack, passing one or more storeys, until it reaches the collection pipe underneath the floor slab of the lowest level. The stack is vented via the roof. The building drain channels the sewage underneath the ground slab until it meets the public sewer.

40% of the German sewer system needs to be renovated in the short to medium term. A lot of sewers are leaky, not only allowing groundwater to enter the sewer system, but also sewage to seep into the ground thereby contaminating the groundwater.

Waste water lifting systems
The installation of a waste water lifting system is required if the waste water is collected below the flood level. The responsible authority usually defines the flood level as the top level of the road at the building's tie-in point. Plumbing fixtures located below the flood level must be protected against backflow. It is also necessary to install a lifting system if the sewage cannot be removed by means of a slope or if rainwater does not seep away below the flood level.

Waste water lifting systems consist of a collection tank and pumps, which raise the waste water to above the flood level via a pressure pipe. Depending on the type of waste water, they are generally divided into systems for sewage containing faeces and those without fecal matter.

3.190

3.186 Composition of domestic waste water
3.187 Integration of a greywater reclamation system
3.188 Configuration of a greywater reclamation system
3.189 Integration of a greywater reclamation system with a heat exchanger into the domestic hot water heating system with a storage tank
3.190 Greywater reclamation system
3.191 Different ways in which water can be used in buildings

enting of drains

principle, all soil stacks in Germany ave to be led through the roof. The vents emove the sewage gas and prevent pos-ve or negative pressure occurring in the ewer system. Air admittance valves tend o be used these days since they contrib-te towards simplifying the venting of the rainage system. They can be installed nto the main venting system to prevent egative pressure situations. This obvi-tes the need to penetrate the building nvelope. In particular, this means less complicated construction work and no danger of thermal bridges.

Domestic hot water systems

The heat generation system installed for heating the building is usually also intended for heating drinking water. The domestic hot water is usually stored in tanks ready for use. The different types and concepts of storage are explained in greater detail from page 32 onwards. Systems for the solar thermal generation of hot water in residential buildings are generally also economically viable in Germany without state subsidies (see Heating, p. 32ff). A single-family home with four persons usually requires a collector area of approximately 5 m² and a storage volume of 0.3 to 0.4 m³. On average, a plant this size covers around 50 to 60 % of the hot water demand.

Energy-saving hot water circulation

In order to avoid unnecessary amounts of drinking water and energy being wasted before the water flows out of the fixture at the desired temperature, domestic water circulating pumps can be applied. They convey the domestic hot water from the hot water tank to the water outlet. Depending on the requirements, there are different possibilities to control the pumps.

Most domestic water circulating pumps are controlled via timers today. The user can programme and set the timer at the pump. However, because the daily utilisation profile regarding hot water consumption is not always predictable, unnecessary amounts of hot water are frequently conveyed through the pipes. In addition to a timer, modern circulation pumps are also equipped with a thermostat, which makes sure that hot water is only circulated once it has reached a predefined temperature of, for example, 35 to 60°C. The domestic hot water circulation pumps installed today, in line with those for heating systems, are generally very efficient energy saving devices and consume no more than approximately ten watts.
A further, very simple possibility is to control the circulation pump via a push-button switch or a sensor. It can be installed close to the water outlet and activated by the user just before the hot water is required. In this case, the switch makes sure that the circulation pump is only operated if there is a true demand for domestic hot water.

Greywater reclamation systems

Greywater reclamation systems produce hygienically clear water from greywater (waste water without fecal matter). This process not only reduces the consumption of drinking water, but also the volume of sewage. This is one of the reasons why these plants will be used more frequently in future.
Domestic sewage consists of black, yellow, brown and greywater (Fig. 3.186). Waste water from kitchens is not usually treated by greywater reclamation plants due to the greater effort and expense involved in the removal of food waste and grease. However, waste water without fecal matter from baths, showers and

wash basins can be used (Fig. 3.187). The average daily production of greywater in residential buildings is approximately 40 l per person, which is sufficient to cover the demand for water to flush toilets. Due to this double usage, the domestic water consumption and the amount of sewage are each reduced by approximately 30 %. The use of waste water from washing machines or rainwater really only makes sense if the building owner has a high demand for service water.
Through the filtration and polishing processes that are part of the water treatment procedure in a greywater reclamation system, approximately 30 % of the greywater is removed and may not be reused in the building. The remaining 70 % of the greywater can be reused as service water. At an average daily greywater production of 40 l per person in a residential building, approximately 30 l can be recovered per person and day and used as toilet flushing water. The amount of service water required in residential buildings is usually below the possible amount of greywater. Depending on the building's use, the amount of greywater varies considerably in non-residential buildings and has to be evaluated in each individual case.
Greywater can be transformed into service water using a variety of methods and depends on the system manufacturer. Generally, a mechanical process is used initially, followed by a physical process, or by applying a biological treatment process. If this were not the case, the ingredients and pathogenic germs in the greywater would soon lead to strong unpleasant odours when kept in storage containers for extended periods. Even though there are no legal requirements in Germany concerning the quality of

Water flow	Treatment	Applications	Further use
Rainwater	Simple filtration (gravel bed)	Irrigation	Groundwater replenishment
	Filtration	Cooling (technical resource)	–
		Shower, washing machine	Greywater
		Toilet flushing	Yellow and blackwater
	Biological purification	Water supply	–
Greywater	Sterilisation	Washing machine	Greywater
		Toilet flushing	Yellow and blackwater
	Filtration, biological purification	Irrigation	Groundwater replenishment
	Biological purification	Water supply	–
Yellow water	Sterilisation by means of storage and drying	Fertilizer production	–
	Storage	Raw material for the chemical industry	–
Blackwater	Anaerobic digestion	Biogas production	Production of humus and fertiliser
Kitchen and organic waste	Composting	Production of humus and fertiliser	

3.191

	Drinking water	Waste water	Rainwater
Average rates in Germany (€/m³)	1.81	2.05	0.88

3.192

	Water yield	Water treatment	Storage and pressure maintenance	Transport and distribution
Depreciation terms and return				
Subsidisation and allowances to cover building costs				
Activation methods concerning investments and maintenance expenditures				
Current demand and consumer structure	▒			
Development of the demand and consumer structure	▒			
Urbanity				▒
Population density				▒
Size and structure of the supply area			▒	
Development of the size, structure and density within the supply area			▒	
Water availability	▒			
Origin and quality of the resource	▒			
Conveyance conditions	▒			
External procurement of water	▒			
Topography in the supply area			▒	
Ground conditions			▒	

▒ Natural geographical conditions
▒ Population demography and density, consumer structure and size of the supply area
Investment criteria and financing modalities for capital costs

3.193

Calculation of the rainwater yield for rainwater use in buildings
The following formula has proved adequate for an approximate estimation of the average annual rainwater yield which can then be used to determine the storage tank capacity:
rainwater yield = roof area x annual rainfall x runoff coefficient x filter efficiency

Roof area:	The roof area is the projected area of the roof including all overhangs in m².
Annual rainfall:	Climate maps can be referred to to determine the average annual rainfall in mm/year. More specific information can be provided by the appropriate meteorological office.
Runoff coefficient:	The runoff coefficient refers to the percentage of precipitation in relation to the total rainfall that can actually be regarded as runoff.

Projected roof area

Runoff coefficients of different roof coverings according to DIN 1989, Part 1:
Roof covering	Runoff coefficient
• Inclined hard-covered roof	0.8
• Flat roof with/without gravel	0.6/0.8
• Planted roof intensive/extensive	0.3/0.5

Filter efficiency:	Value according to manufacturer
Example calculation:	Calculation of the rainwater yield • Single family home with a 100 m²-roof area and a tiled roof covering • Mean annual rainfall = 750 mm/year • Runoff coefficient = 0.8; filter efficiency = 0.98 Rainwater yield = 100 m² × 750 mm/year × 0.8 × 0.98 × 10-3 = **59 m³/year**

3.194

service water from greywater reclamation systems, it is nevertheless necessary to notify the local health authority and inform them about the installation and the start-up of the system. In accordance with the Drinking Water Ordinance, it is obligatory to ensure strict separation between the service water and the drinking water network.

Heat recovery from greywater
Due to its advantageous temperature profile, heat can be recovered from greywater by using a heat pump. The heat thus gained can then be employed for heating purposes. If the greywater reclamation system is installed within a heated building, the radiant heat of the warm greywater can be used directly to heat the corresponding room without any extra costs and effort. It is possible to gain approximately one kilowatt hour of energy from each cubic metre of greywater and each kelvin of temperature difference. The heat gained can also be used to preheat the drinking water. The treatment of greywater is usually carried out without adding chemicals and is odourless when correctly performed.

Profitability of greywater reclamation systems
Alongside the investment and operation costs of a greywater reclamation system, important factors influencing the amortisation period of such a plant include the average amounts of greywater made available and the charges for water and sewerage (Fig. 3.192).
If the charging system assumes that waste water volumes are related to fresh water consumption, a single standard charge is levied based upon the amount of fresh water consumed.
In contrast, the split sewerage charge has two elements. On the one hand, the sewerage, which is related to the amount of consumed fresh water and, on the other hand, a rain water charge which is

3.192 Water and sewage rates in Germany
3.193 Basic structural conditions and their impact on the profitability of the domestic water supply
3.194 Calculation of the rainwater yield for the use of rainwater in buildings
3.195 Schematic diagram of a rainwater reclamation system
3.196 Water storage tank made of plastic (2×10 m³) for the rainwater reclamation plant of a multi-family dwelling
3.197 Waterless urinal

dependent on the size of the sealed area on the corresponding premises. The split method is usually applied in communities with more than 100000 inhabitants.
From today's perspective, greywater reclamation systems are feasible without subsidies only if the number of users connected to the plant exceeds approximately 50 residents. In Germany, application of this innovative technology is not yet profitable for smaller units. However, in regions where water is scarce, during periods of supply shortfall or in the case of high water charges, greywater reclamation systems may quickly prove to be economically viable.
The possibility of installing a separate greywater network in new buildings should at least be examined in future. If installed as a precautionary measure, the subsequent fitting of a greywater reclamation system would be greatly simplified should one be needed.

Rainwater harvesting systems

Approximately 50% of our daily consumption of drinking water can be replaced by rainwater. Rainwater harvesting systems collect rainwater which can be used not only for cleaning purposes, but also for watering the garden, flushing the toilet or washing clothes (Fig. 3.195). Since rainwater from streets and paved areas can be polluted, only roof surfaces should be connected to the rainwater harvesting system. Figure 3.194 contains details of how to calculate the rainwater harvesting potential. If rain is harvested from bituminous or planted roofs, the collected water could be discoloured. For this reason, it is not necessarily suitable for use in washing machines.
The rainwater is channelled off the roof and through a filter where coarse debris is removed before it reaches the cistern or rainwater tank. It is important to make sure that the filters used do not accumulate dirt and are easily accessible for cleaning.
Rainwater tanks (Fig. 3.196) are available as either plastic or concrete storage systems. They should be positioned in a shady and cool place to prevent the growth of algae and bacteria in the tank. For this reason, it is preferable for cisterns to be installed outside the building in the ground below frost penetration depth. To determine the storage capacity, it is necessary to consider the roof area and its surface properties, the approximate

annual amount of precipitation as well as the estimated water demand (Fig. 3.194). The storage tanks for rainwater harvesting systems in Germany should be dimensioned in a way that the capacity is equivalent to approximately the amount of service water needed per month (in smaller residential buildings). This means that it should be possible to store approximately 1/12 or 8.5% of the mean annual amount of rainfall/annual demand for service water, at one time. DIN 1989-1 recommends a minimum size of six per cent of the annual yield/annual requirement. The smaller value of these two operands should be selected as the reference value to dimension the tank.
The pump can either be installed in the plant room (water supply station) or in a cistern outside the building, in this case, using a submersible pump. In dry periods, the water supply is guaranteed by installing an automatic fresh water feed. The fresh water has to be fed into the storage tank via an open outlet. Similar to a greywater reclamation system, there has to be a strict separation between the drinking water and the rainwater pipes within the building. It also makes sense to

combine a rainwater harvesting system with a planted roof or with a rainwater infiltration system on the property. Corrosion-resistant plastic or stainless steel pipework should be applied.

NoMix systems and waterless urinals

In contrast to NoMix systems, waterless urinals have been used for a long time (Fig. 3.197). By draining the urine through a sealant liquid, the build up of odour is prevented. Waterless urinals do not require any water for flushing. NoMix systems are also based on a separation of urine, fecal matter and water. The first of these toilets was developed and installed in the 90s in Sweden. In the meantime, there are many different models on the market. All of them are based on the same system of separating urine and the remaining waste water, however, using a different type of water drainage system. There is a realistic market potential for these systems in the fast growing cities of the emerging and developing countries, which suffer from problems caused by water pollution. Arid regions (e.g. Australia) could also be a potential market for these waterless systems.

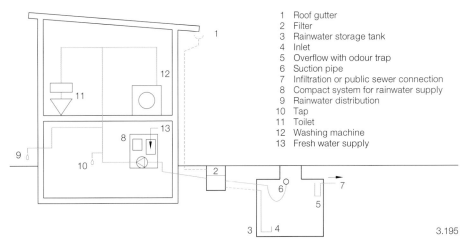

1 Roof gutter
2 Filter
3 Rainwater storage tank
4 Inlet
5 Overflow with odour trap
6 Suction pipe
7 Infiltration or public sewer connection
8 Compact system for rainwater supply
9 Rainwater distribution
10 Tap
11 Toilet
12 Washing machine
13 Fresh water supply

3.195

3.196

3.197

Current state of technology

Numerous components for sustainable building services have been proven in practice over many years. Due to their considerable relevance in relation to the conservation of resources, technologies enabling the use of renewable energies in newbuilds are gaining increasing significance. It has become apparent that some components such as heat pumps are, today, already cost effective without financial support, whereas the implementation of others, for example photovoltaics, is only economically attractive thanks to the subsidisation scheme of the Renewable Energy Sources Act (EEG). Other technologies such as solar cooling are still fairly uneconomical in Europe.

The projects in this chapter demonstrate, by way of example, how sustainable building services can be integrated into buildings of varying size and use. The focus has been on the energy-relevant topics heating, cooling, air supply and electricity.

Heating

The infrastructure of a site has a bearing on the method of heat supply in a building. If a heat network (long distance or local heat) is provided, it makes sense, from an ecological point of view, to connect. Even if the heat generation at the time of connecting is not ecologically advantageous in comparison to a decentralised heat supply, future changes to the central heat generation system (e.g. switching to biomass), due to the large number of connected buildings, may have a positive impact. If a gas grid is provided, there may also be an opportunity to utilise it in an ecological way.

In the case of the production building in Kassel (p. 110), the construction project was exploited as an opportunity to plan and construct a new biogas plant together with a local agriculturist.

The aim, in particular, is to utilise the local energy resources groundwater, the thermal properties of the ground and solar radiation. If the boundary conditions are favourable, the utilisation of these sources should be given top priority. In particular, the market for heat pumps, operated in combination with a groundwater well, ground probes or energy piles, is booming, despite the fact that these systems are often associated with increased risk due to frequently uncertain geological conditions. Solar thermal heating systems are especially popular in residential buildings. Significantly larger plant sizes, and higher solar coverage rates can be expected in the future. Solar technology, with permanently visible panels, is one of the few technologies in building services engineering which has a considerable impact on the aesthetics of the building. Its use must therefore be carefully planned. The multi-unit dwelling in Bennau (p. 90) is a perfect example of good solar design. If local energy mediums or those off the grid are not available in sufficient quantities, energy mediums consisting of solid biomass (especially wood chip or wood pellets) are a good alternative for a carbon-neutral energy supply. In future, it will be absolutely essential to consider the long-term availability of resources and the logistics concerning the energy medium's provision during the planning phase. The university building »Super C« in Aachen (p.108) is noteworthy in this respect: due to the ideal geological conditions, it is the first building to be supplied via a 2500 m-deep geothermal ground probe. The temperatures provided by using this technology, which is normally found in power plants to generate electricity, are sufficiently high to be used directly for the heat supply in the building without the addition of a heat pump.

Cooling

To date, buildings are usually cooled by means of power-operated compression cooling systems. In the context of sustainable building services, these systems can generally also be combined with photovoltaics and operated as »solar cooling«. So-called natural heat sinks, potential cooling capacities that are available without investing any energy, are an alternative or supplement to compression cooling. These are, in particular, the thermal properties of the ground, the groundwater and the cool night-time air. Almost all of the documented projects with a heat pump also use these natural heat sinks for passive cooling. In the case of ground systems, the recuperative infiltration of heat in the summer months increases the overall efficiency of the system.

Hybrid systems that utilise the cooler night-time temperatures are also fairly common (e.g. Office building in Konstanz, p. 106). Other interesting concepts use the adiabatic cooling effect, which occurs when water evaporates, in combination with a ventilation plant (e.g. Office building in Berlin, p. 104). In concepts producing surplus heat during the summer months, for example in combined heat and power plants, it is a sensible measure to add a heat-operated sorption cooling machine to form a combined heat, cooling and power plant (e.g. Production building in Kassel, p.110).

Air supply

Ensuring a supply of good quality air is of major importance for user comfort. Non-residential buildings, in particular, often have to rely on a technical solution. However, due to the increasingly airtight building envelopes, residential buildings today

so often require a ventilation system. All the projects presented in this chapter are equipped with a technical system to control the distribution of air. If planned accordingly, the heat contained in the exhaust air can be recovered. This aspect has also been considered in all of the documented projects. An earth pipe has been used in some of the schemes to preheat or recool the outside air by exploiting the fairly consistent temperature of the ground. The mountain restaurant at Klein Matterhorn (p. 116) is interesting in this context: The fresh air is drawn in through the facade, which has been planned as a solar air collector. Solar energy can also be used to support natural ventilation by means of updraught, thus reducing the need for electric fans. This is the case, for example, in the military dining and leisure facility in Donaueschingen (p. 114). Decentralised facade air handling units, as used in the office building in Konstanz (p. 106), can reduce costs and energy consumption thanks to individual control by the occupants.

Power supply

Power demand is especially important in the case of non-residential buildings. Due to lighting, air distribution and user-dependent electrical devices, consumption levels are generally high. Further increases are registered if heating and cooling are operated by electric power. In the context of an overall even balance of energy consumption, the aim is to produce the total power demand in a decentralised fashion through the building. As the grid is integrated within the concept, it is not usually necessary to store electricity on site. In most locations, wind power stations cannot be operated economically for supply to buildings, there are therefore only two systems available to generate power: decentralised combined heat and power generation (CHP) and photovoltaics. The use of CHP is currently limited to a few individual cases, like, for example, the European Investment Bank in Luxembourg (p. 100). Photovoltaic plants have been used in numerous projects. As with solar thermal systems, it is essential that the panels are properly integrated in the building envelope with regard to both function and appearance. In most of the presented projects, this approach has been taken in an exemplary fashion.

Building envelope

In combination with the building services, the energy-efficient building envelope has taken on a central role. Consequently, top priority is attached to the envelope during the building's planning phase. However, it stands to reason that energy efficiency plays only a minor role in buildings supplied mainly or totally with regenerative energies. Nevertheless, studies of these buildings show clearly that sustainable building service technologies are, not only for economic reasons, almost always combined with a correspondingly efficient building envelope.

4.1 Overview of documented projects

	Type of building	Page	Use of ground heat	Use of ground water	Heat pump	Utilisation of biomass	Combined heat and power (CHP)	Combined cooling, heat and power (CCHP)	Solar heat generation	Sorption cooling	Adiabatic cooling	DEC	Solar cooling	Photovoltaics	Solar chimney	Earth pipe	Heat recovery	Deep geothermal energy	Building component activation
Multi-unit dwelling, Liebefeld	Residential	86				■			■								■		
Passive-house housing estate, Innsbruck	Residential	88		■					■								■		
Multi-unit dwelling, Bennau	Residential	90			■				■							■	■		
Care and nursing home, Steinfeld	Special use	92	■														■		
District administration and county council, Eberswalde	Office building	94		■													■		
Office building, Cologne	Office building	96							■					■			■		
Office building, Winterthur	Office building	98															■		
European Investment Bank, Luxembourg	Office building	100					■						■						■
Office building, Vienna	Office building	102		■					■								■		■
Office building, Berlin	Office building	104									■						■		
Office building, Konstanz	Office building	106				■											■		
Institute and administration building, Aachen	Office building	108	■														■		
Production building, Kassel	Industrial	110				■	■		■					■			■		
Community centre, Ludesch	Special use	112				■			■					■			■		
Military dining and leisure facility, Donaueschingen	Special use	114													■	■	■		
Mountain restaurant, Zermatt	Special use	116							■						■	■			

Multi-unit dwelling

Liebefeld, CH 2007

Client: Halle 58 Architekten, Peter
Schürch, Bern
Architects: Halle 58 Architekten, Peter
Schürch, Bern
Energy consultant, building physics and
acoustics:
Gartenmann Engeneering, Bern
Heating and ventilation:
Riedo Clima, Bern

The three-storey residential building with
underground parking was developed
after garages were removed between an
old housing estate and solitaire buildings.
The shape of the plot determined the floor
plan, which resembles the layout of a
ship. It accommodates three stacked and
therefore equally sized apartments in tim-
ber construction. Load-bearing exterior
walls in the north and east in connection
with a central core for the mechanical
installations and a staircase, allow a loft-
like layout of the apartments. A planted
roof terrace functions as additional out-
door space for shared use.
The building envelope has been thermally
optimised and fulfils the requirements of a
passive house. All of the materials were
selected according to their environmental
compatibility; the building meets the Swiss
Minergie-P-Eco standard. A pellet heating
system with a thermal output of 7.3 kW
supplies the building with heat, which is
distributed to the rooms using a low-tem-
perature floor heating system. A solar
thermal plant measuring approximately
20 m^2 has been installed on the roof. In
connection with a storage tank in the cel-
lar with a capacity of 2240 litres, the solar
heat covers approximately 75 % of the
energy required for producing domestic
hot water. The shared washing machine in
the basement is directly connected to the
hot water network and therefore also
makes use of solar heat in summer. To
protect the living space from excessive
heat gain in summer, the protruding
south-facing balconies shade the facade.
In addition, exterior shading devices have
been fitted. The air in the apartments is
supplied and extracted mechanically by a
central air handling unit, which is placed
as a compact block on the flat roof.

📖 Detail Green 02/2009

4.2

4.3

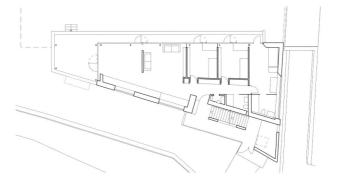

4.4

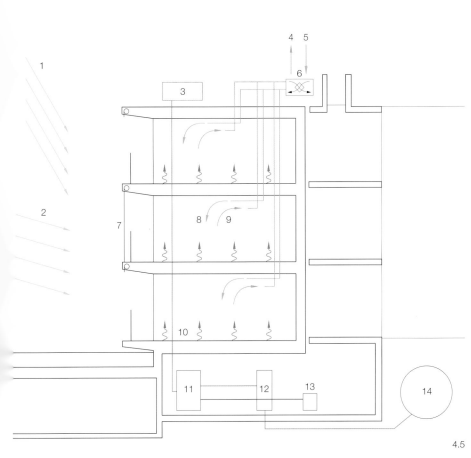

4.5

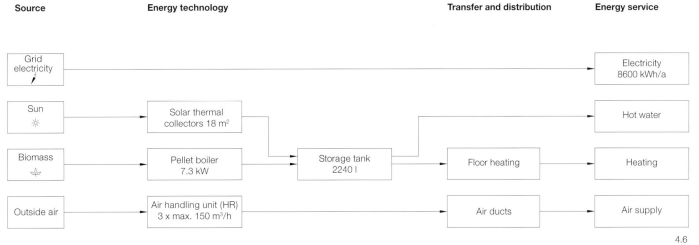

Source	Energy technology	Transfer and distribution	Energy service
Grid electricity			Electricity 8600 kWh/a
Sun	Solar thermal collectors 18 m²		Hot water
Biomass	Pellet boiler 7.3 kW	Storage tank 2240 l → Floor heating	Heating
Outside air	Air handling unit (HR) 3 x max. 150 m³/h	Air ducts	Air supply

4.6

4.7

4.8

Passive house housing estate

Innsbruck, A 2009

Client: Neue Heimat Tirol, Innsbruck
Architects:
Architekturwerkstatt dina4, Innsbruck
team k2 architects, Innsbruck
Architekturhalle Wulz-König, Telfs
Building services: Klimatherm, Zirl
Building physics: DI Fiby, Innsbruck, and
Spektrum, Bregenz
Energy consultant: Johannes Gstrein,
Karrösten

The largest passive house housing estate in Austria has been developed on the site Lodenareal in Innsbruck where the two rivers, Sill and Inn, meet. Three building complexes, each consisting of two L-shaped structures, offer space for a total of 354 apartments. The compact structures with insulation thicknesses of up to 30 cm achieve heat demand values below 10 kWh/m²a. The thermal energy is provided by a centrally located heating plant. A wood pellet burner with an efficiency of 300 kW generates approximately 80 % of the annual heat demand. The remaining heat is supplied by a gas condensing boiler. A secondary plant with a large storage tank is positioned in each of the L-shaped buildings. Apart from the local heat generated in the central heating plant, the energy from the solar thermal collectors installed on the roofs is also fed into these units. Underfloor heating systems distribute the heat in the apartments. All of the apartments grouped around one staircase form a separate air supply unit. The central air handling units are located in the corresponding basement areas. The air is drawn in through 3 m-tall inlet towers positioned in the inner courtyards. The controlled ventilation with heat recovery can be set individually at two levels in each residential unit. A groundwater well with four groundwater pumps was drilled to preheat the outside air in winter and pre-cool it in the summer months via a heat exchanger, which is fitted between the air inlet and the air handling units. Protruding balconies protect the apartments from midday heat in summer, while still allowing sunlight to penetrate into the spaces during the colder months. In addition, sun protection devices are provided that can be adjusted individually.

📖 Detail Green 01/2010

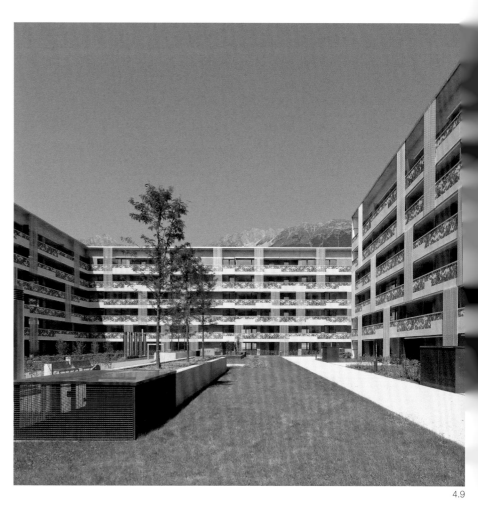

4.9

4.10

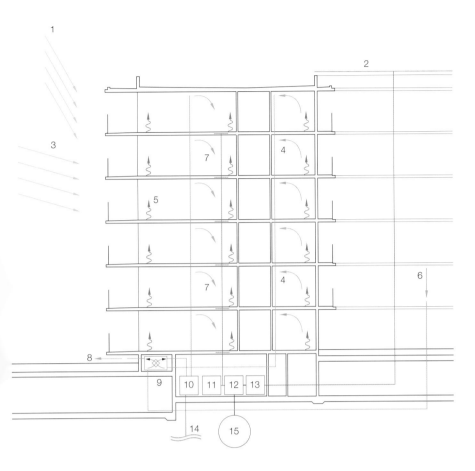

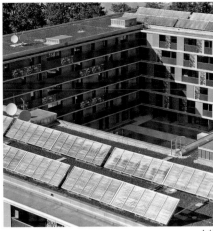

4.12

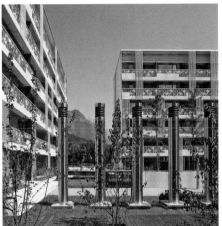

4.11 4.13

4.9 Courtyard view
4.10 Ground floor plan, scale 1:750
4.11 Section with energy and ventilation concept
 scale 1:250
 1 Summer sun
 2 Solar thermal plant
 3 Winter sun
 4 Waste air
 5 Floor heating
 6 Outside air
 7 Supply air

8 Exhaust air
9 Air handling unit with heat recovery
10 Groundwater pump
11 Condensing boiler
12 Pellet boiler
13 Storage tank
14 Drilled well
15 Pellet store
4.12 Roof view with solar thermal collectors
4.13 Air inlet towers in the courtyard
4.14 Technical concept

Source	Energy technology		Transfer and distribution	Energy service
Grid electricity				Electricity
Outside air		Air handling unit (HR) max. 3500 m³/h	Air ducts	Air supply
Ground water	Drilled well 18 m	Heat exchanger		Cooling
Biomass	Pellet boiler 300 kW		Floor heating	Heating
Sun	Solar thermal collectors 1000 m²	Storage tanks 4 x 15 000 l	Decentralised water supply system	Domestic hot water
Natural gas	Condensing boiler 326 kW			

4.14

89

Multi-unit dwelling

Bennau, CH 2009

Client:
Sanjo Immobilien, Altendorf
Architects:
grab architekten, Altendorf
Building physics:
Intep, Zurich
Energy concept:
Amena, Winterthur
Heating, ventilation and sanitary planning:
Planforum, Winterthur

The multi-unit dwelling with seven residential units, named "Kraftwerk B" by its architects, produces more energy from the sun during an average year than its inhabitants consume. The facades and roof areas comprise 40 cm thick, prefabricated insulated timber elements with an additional insulation layer of 6 to 8 cm to prevent thermal bridges. Triple glazing was used for the windows. 260 m² of photovoltaic modules, which are linked to the grid, were integrated in the 40 degree inclined south-west side of the roof. On an annual average, this area fully covers the electric power demand of the property. 150 m² of facade-integrated collectors were fitted to the south-west facade. These feed their heat into a storage tank measuring 25 m³; surplus solar energy is used to preheat the warm water of the neighbouring building. The apartments feature underfloor heating with a forward-flow temperature of 23 to 28 °C. A central air handling unit in the basement takes care of the, from a hygiene point of view, necessary air exchange. A ground loop is used to preheat the outside air; a counter-flow heat exchanger reduces the thermal loss of the waste air. In addition, the supply air is raised to 20 °C by using the return flow of the floor heating. A heat pump serves as a back-up system. It also extracts heat from the exhaust air and can not only be used to reheat the warm water but also to feed directly into the floor heating. The apartments are equipped with small wood-burning storage furnaces. Water heat accumulators integrated in the furnaces extract approximately 50 % of the heat and feed it into the towel radiators in the bathrooms as well as into the central hot water production system in the basement.

📖 Detail Green 01/2010

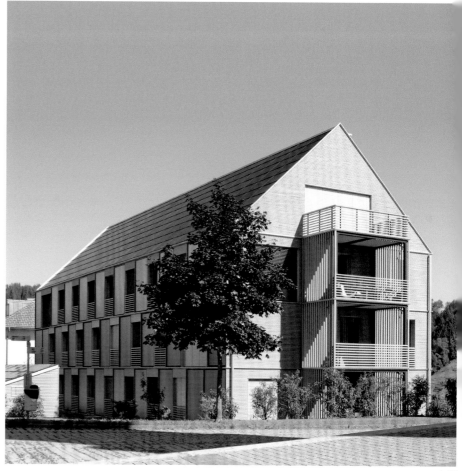

4.15

4.16

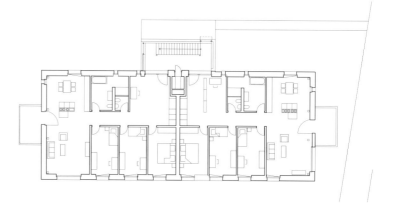

4.17

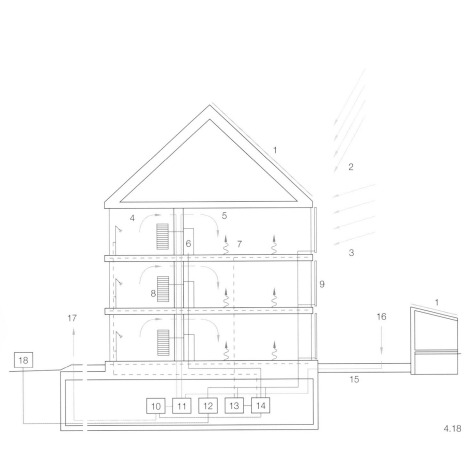

4.19

4.20

4.18

4.15 View from the south
4.16 Roof floor plan, scale 1:400
4.17 Ground floor plan, scale 1:400
4.18 Section with energy and ventilation concept, scale 1:250
 1 Photovoltaic modules
 2 Summer sun
 3 Winter sun
 4 Waste air
 5 Supply air

6 Wood burner with accumulator
7 Low-temperature floor heating
8 Towel radiator fed with hot water from wood burner
9 Facade collectors (solar thermal energy)
10 Exhaust air heat pump to reheat water
11 Air handling unit with heat recovery used for preheating supply air
12 Additional hot water storage tank for preheating water in neighbouring building

13 Main storage tank
14 Hot water storage tank
15 Ground loop for drawing in fresh air
16 Outside air
17 Exhaust air
18 Hot water boiler in neighbouring building
4.19 Installation of the roof-integrated photovoltaic array
4.20 Southwest facade with solar thermal collectors
4.21 Technical concept

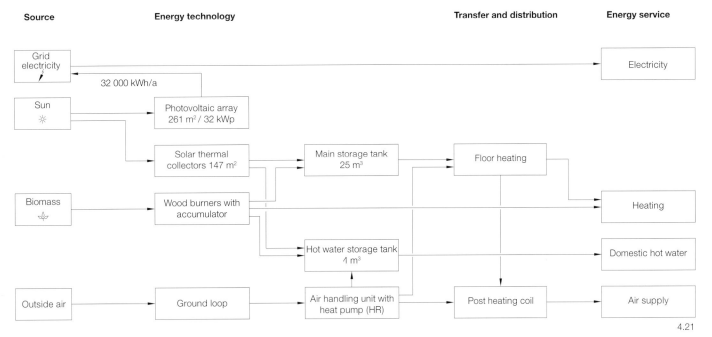

Source	Energy technology	Transfer and distribution	Energy service	
Grid electricity			Electricity	
	32 000 kWh/a			
Sun	Photovoltaic array 261 m² / 32 kWp			
	Solar thermal collectors 147 m²	Main storage tank 25 m³	Floor heating	
Biomass	Wood burners with accumulator		Heating	
		Hot water storage tank 1 m³	Domestic hot water	
Outside air	Ground loop	Air handling unit with heat pump (HR)	Post heating coil	Air supply

4.21

Care and nursing home

Steinfeld, A 2005

Client:
Sozialhilfeverband Spittal/Drau
Architect:
Dietger Wissounig, Graz
Building services:
TB Hammer, Graz
Structural design:
Kurt Pock, Gerolf Urban, Spittal /Drau

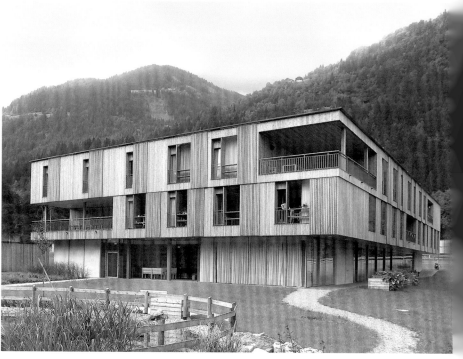

4.22

The care and nursing home is situated on a slightly inclined plot on the western out-skirts of Steinfeld, a small community in Carinthia, Austria. The service areas form a buffer zone in the northwest to screen off the busy road, whereas the rooms are oriented southeast with a view out into the green landscape. Due to the excellently insulated facade and the triple glazing, the building has a heat demand of only 15 kWh/m²a and a maximum specific heat load of only 48 W/m² at an average outside temperature of -14 °C.

A district heating system supplies the building with the necessary thermal energy, which is distributed via radiators and floor heating. A heated conservatory is placed at the building's centre. Together with a ground loop, the conservatory is used to channel outside air into and exhaust air out of the building. In winter, the supply air reaches an average temperature of approximately 20 °C thanks to preheating by the ground loop and the solar energy input from the conservatory. In summer, the ground loop cools the outside air that is drawn in. Sun shading devices above the glass roof prevent overheating of the conservatory's upper area. The residents' rooms are supplied with fresh air via individual subfloor ventilation units. These are also connected to the ground loop and a heat recovery system. The air in the rooms can also be exchanged via the atrium. The care and nursing home consumes almost half the amount of energy required by comparable newbuilds due to the use of rainwater for flushing the toilets and watering the garden, by individually controlling single heating zones according to demand and by using highly efficient lighting systems.

4.23

📖 Energie Atlas
Baumeister 05/2006
Architektur Aktuell 06/2006

4.24

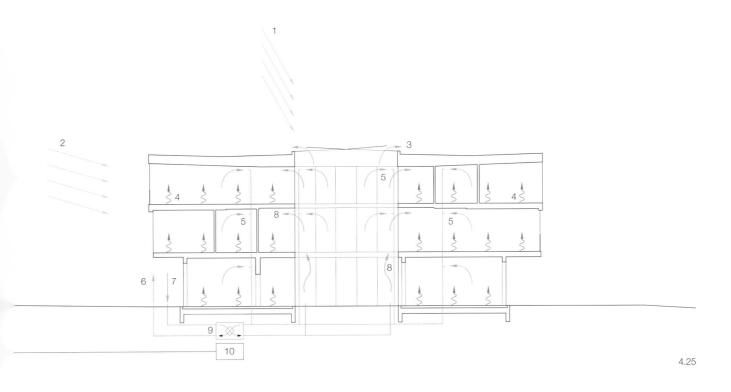

4.25

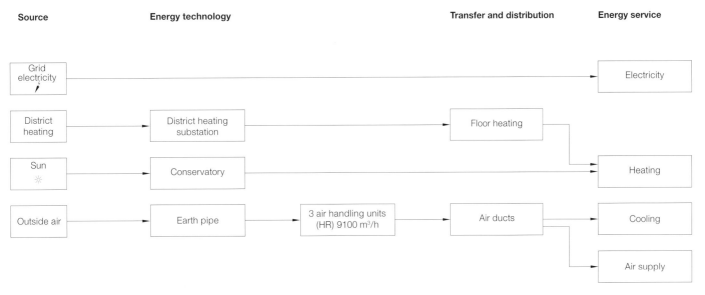

Source	Energy technology		Transfer and distribution	Energy service
Grid electricity				Electricity
District heating	District heating substation		Floor heating	
Sun ☀	Conservatory			Heating
Outside air	Earth pipe	3 air handling units (HR) 9100 m³/h	Air ducts	Cooling
				Air supply

4.26

4.27

4.22 Exterior view
4.23 First floor plan, scale 1:500
4.24 Ground floor plan, scale 1:500
4.25 Section with energy and ventilation concept
 scale 1:250
 1 Summer sun
 2 Winter sun
 3 Atrium as exhaust air outlet
 4 Floor heating
 5 Waste air
 6 Exhaust air
 7 Outside air
 8 Supply air
 9 Air handling unit with heat recovery
 10 District heating substation
4.26 Technical concept
4.27 View of the conservatory

District administration and county council

Eberswalde, D 2007

Client:
Kreisverwaltung Barnim, Eberswalde
Architects:
GAP Generalplaner, Berlin
Planning management, integral planning,
sustainability: sol.id.ar planungswerkstatt
Dr. Günter Löhnert, Berlin
Building climate concept, building
ecology: teamgmi, Vienna

The four building segments of the Paul Wunderlich House in Eberswalde incorporate a street network with a public square at its centre. It accommodates commercial space on the ground floor, a large town hall and work space for 550 staff members. The building complex was one of the first projects to be awarded the gold certificate by the German Sustainable Building Council (DGNB). Due to the geological situation, around 850 foundation piles reaching down approximately nine metres were required to ensure structural stability. 593 of these piles were thermally activated by embedding pipes into the concrete. Together with a total of ten heat pumps, they now function as a heat source for the heating system. The ventilation system distributes the warm and cool air through uninsulated pipes that are laid in the concrete floor slabs. The supply air temperature is regulated according to the outside temperature. Radiators, or in some cases floor heating, are installed to cover peak heat loads.

The ventilation system also covers the cooling loads in summer. The energy piles and the cool night-time air are directly used as passive heat sinks. In very hot periods, the heat pumps are applied in reverse operation. In order to avoid peak loads, phase change materials (PCM) have been installed in the ceilings of the meeting rooms. An air handling unit with a heat recovery system using a rotary heat exchanger supplies the building with fresh air. The supply air is fed into the rooms via the ceiling, while the waste air is removed via the central atriums. A photovoltaic array, with a total capacity of approximately 120 kW$_p$ is installed on the roof and across the south-facing facade of a multi-storey car park, which also forms part of the new complex.

Detail Green 02/2009

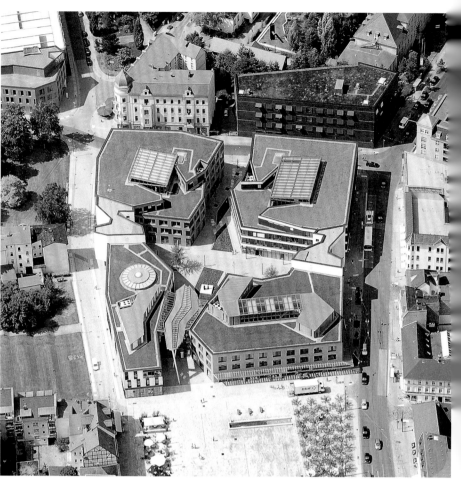

4.28

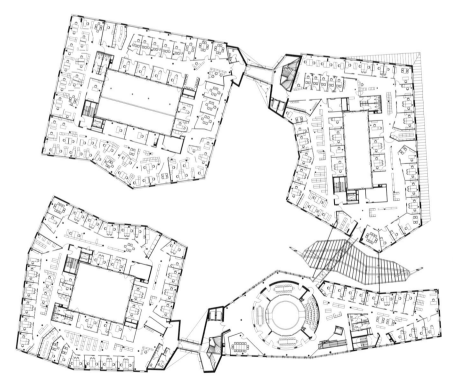

4.29

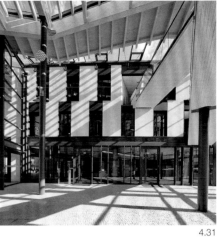

4.31

4.28 Aerial view (photomontage)
4.29 First floor plan, scale 1:1000
4.30 Section with energy and ventilation concept
 scale 1:200
 1 Summer sun
 2 Exhaust air
 3 Re-cooling plant
 4 Winter sun
 5 Outside air
 6 Air handling unit with heat recovery
 7 Discharge of waste air via atrium
 8 Supply air
 9 Waste air
 10 Night-time ventilation
 11 Storage tank
 12 Reversible heat pump (heating and cooling)
 13 Building component activation
 14 Exterior sun protection blinds
 15 Floor heating/cooling
 16 Radiator
 17 Energy piles
4.31 Entrance hall
4.32 Technical concept

4.30

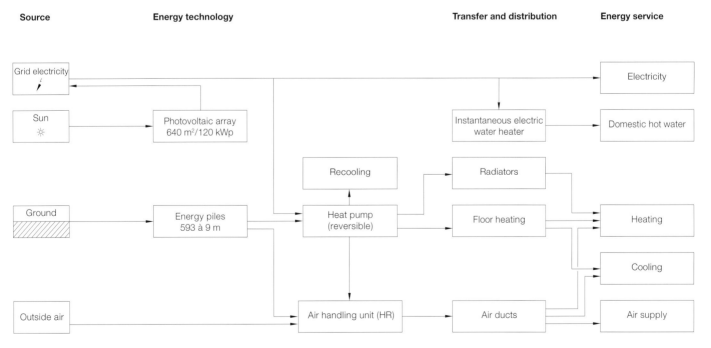

Source	Energy technology		Transfer and distribution	Energy service
Grid electricity				Electricity
Sun	Photovoltaic array 640 m²/120 kWp		Instantaneous electric water heater	Domestic hot water
		Recooling	Radiators	
Ground	Energy piles 593 à 9 m	Heat pump (reversible)	Floor heating	Heating
				Cooling
Outside air		Air handling unit (HR)	Air ducts	Air supply

4.32

Office building

Cologne, D 2008

Client: Hiba Grundbesitz, Cologne
Architects: Benthem Crouwel Architects,
Amsterdam/Aachen
Energy planning: Ecofys, Cologne
Building services: Zeiler + Partner,
Frechen
Building simulation/certification: ifes
GmbH, Frechen
Building physics: ISRW Dr.-Ing. Klapdor,
Düsseldorf

4.3

The three-storey office building, with a usable floor area of 3752 m² , offers space for 150 work places. An atrium is placed at the centre of the compact, square structure. The building was awarded the gold certificate by the German Sustainable Building Council (DGNB) and the building envelope meets all the requirements of a Passive House. This enabled efficient thermal conditioning of the building based solely on the ventilation system.
Groundwater wells in combination with heat pumps serve as a heat or cold source. They are connected to heat exchangers in the centralised air handling unit located in the basement. The warm or cold air is fed into the building via the ventilation system, a water-bearing system is not required.
The air handling unit with heat recovery supplies the individual offices with fresh air. A pipe system embedded in the concrete floor slabs is used to distribute the air which has the effect of activating the corresponding building component. The waste air is drawn out of the offices and into the atrium through flood vents. In summer, the air is removed directly via louvers in the roof area. In winter, the air is channelled to the ventilation plant via a centralised duct in order to recover the heat. A solar thermal system is installed on the roof to heat drinking water.
The presence of the atrium, which is provided with solar glazing, gives the offices access to daylight from two directions. Blinds, automatically controlled via solar radiation sensors, are fitted to the windows in the exterior facades. The photovoltaic array installed on the roof with a capacity of 32.4 kW$_p$ generates approximately 30000 kWh of electricity per year, covering around 20 % of the total power demand.

4.3

4.3

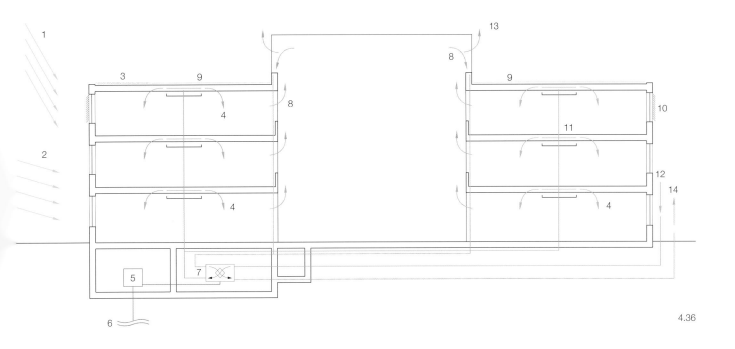

4.36

Source	Energy technology		Transfer and distribution	Energy service

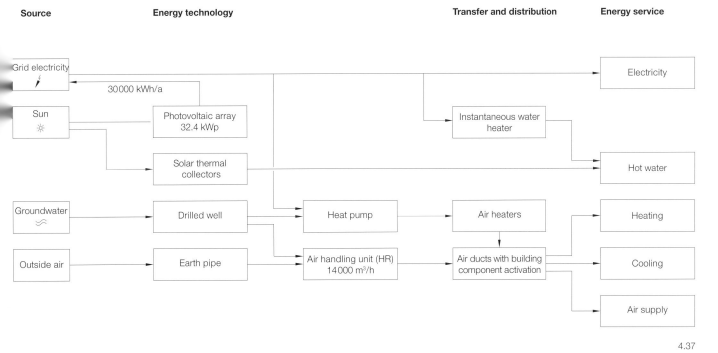

4.37

4.38

4.39

4.33 Exterior view
4.34 Second floor plan, scale 1:500
4.35 Ground floor plan, scale 1:500
4.36 Section with energy and ventilation concept
scale 1:250
1 Summer sun
2 Winter sun
3 Solar thermal collector
4 Supply air
5 Heat pump
6 Drilled well
7 Air handling unit with heat recovery
8 Exhaust air (discharge of air via atrium)
9 Photovoltaics
10 Exterior sun protection blinds
11 Building component activation via supply air
12 Outside air
13 Exhaust air (summer)
14 Exhaust air (winter)
4.37 Technical concept
4.38 Installation of pipe system for building
component activation
4.39 Solar thermal device on roof for provision of hot water

Office building

Winterthur, CH 2007

Client: Marché Restaurants Schweiz, Kemptthal
Architects: Beat Kämpfen, Büro für Architektur, Zurich
Energy engineer: Naef Energietechnik, Zurich
Building physics and acoustics: Amstein & Walthert AG, Zurich
Sanitary planning: Gerber Haustechnik, Schwerzenbach

The office building is in the immediate vicinity of the Marché Restaurant at the motorway service area, Kemptthal. Allowing a flexible arrangement of group offices, it offers space for 50 staff members on three levels. Apart from the two staircase cores made of reinforced concrete, the entire building was designed as a timber construction. A basement was not developed for ecological reasons; the plant room is therefore located on top of the main staircase. Approximately half of the south facing facade consists of opaque glazing filled with salt hydrates. Their function is to absorb solar radiation and discharge the heat to the offices in a time-delayed mode. Continuous balconies and fabric blinds as exterior shading devices prevent overheating in summer. Due to its efficient building envelope, the building was awarded the Swiss Minergie-P-Eco certificate.

Two 180 m deep ground probes are responsible for heating the building. A heat pump generates the necessary forward-flow temperature and the heat is then distributed via a floor heating system. The low ground temperatures, also provide an effective means of passive cooling in summer. The central air hand-ling unit draws fresh air in via a ground loop placed below the building, which is then fed into the rooms at floor level. The warm air rises and is removed at ceiling level. Green walls, also known as vertical planting systems, function as natural room humidifiers. A 485 m² large photovoltaic array, which at the same time functions as the roof covering, was installed on the south-facing single-pitch roof. The capacity of 44.6 kW$_p$ generates approximately 40000 kWh of electricity per year which, in an annual balance, is sufficient to cover the total demand of the building services as well as the user's power demand.

Detail Green 01/2009

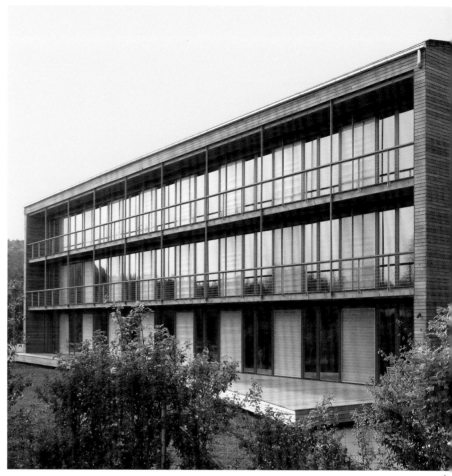

4.

4.

4.

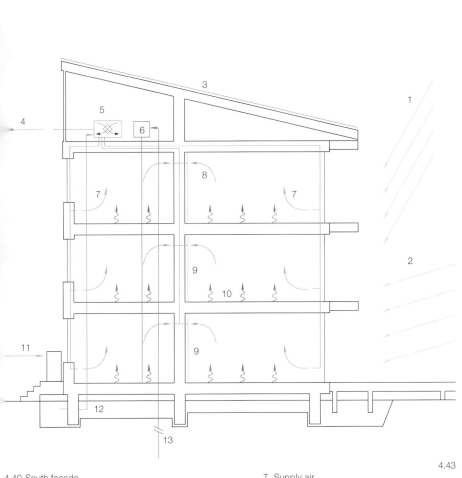

4.44

4.43

4.45

4.40 South facade
4.41 First floor plan, scale 1:500
4.42 Ground floor plan, scale 1:500
4.43 Section with energy and ventilation concept
 scale 1:150
 1 Summer sun
 2 Winter sun
 3 Photovoltaics
 4 Exhaust air
 5 Air handling unit
 6 Heat pump

 7 Supply air
 8 Waste air
 9 Humidification with green wall
 10 Floor heating/cooling
 11 Outside air
 12 Earth pipe
 13 Ground probes
4.44 Photovoltaic array as roof covering
4.45 Green wall as humidifier
4.46 Technical concept

Source	Energy technology		Transfer and distribution	Energy service
Grid electricity				Electricity 40000 kWh/a
	40000 kWh/a			
Sun	Photovoltaic array 485 m² / 44.6 kWp	Domestic hot water storage tank 500 l		Hot water
Ground	Ground probes 2 x 180 m	Heat pump	Floor heating	Heating
				Cooling
Outside air	Earth pipe	Air handling unit (HR)	Air ducts	Air supply
Biomass	Green wall			Humidity

4.46

European Investment Bank

Luxembourg, 2008

Client:
European Investment Bank, Luxembourg
Architects:
Ingenhoven Architekten, Düsseldorf
Facade planning and building physics:
DS-Plan, Stuttgart
Building services:
HL-Technik, Munich (design) / IC-Consult,
Frankfurt a. M. / pbe-Beljuli, Pulheim /
S & E Consult, Luxembourg

The ten-storey building of the European Investment Bank (EIB) in Luxembourg accommodates offices, restaurants with kitchens as well as an underground car park. The almost 170 m long and 50 m wide building is characterised by the three north-facing conservatories and the three south-facing atriums with their large curved glass facades. During the heating season, these form a buffer to the cold outside air. To prevent overheating in summer, large, automatically controlled apertures are integrated in the envelope. The building is connected to the municipal district heating network, which generates heat in a combined heat and power process. Building component activation of the mainly unclad concrete floor slabs covers the base load during the heating period. The remaining heat is provided by using floor-mounted induction units with heating coils. They are connected to the ventilation system via ducts laid within the cavity floor.

In summer, the same systems are used to cool the building. The cold air is generated by a desiccant evaporative cooling system (DEC) which makes use of the excess summer heat from the district heating network. The low night-time temperatures are directly used to cool the thermal storage mass via cooling towers. In addition, electrical compression cooling machines supply the server rooms, conference rooms and kitchens with cold air. The offices can be ventilated naturally via the atriums during 75 % of the year. The induction units are used only in rooms without windows and during peak temperature periods in winter and summer. This system enables individual control of the air supply, heating and cooling functions in each room.

📖 Detail Green 01/2009

4.47

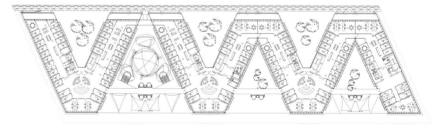

4.48

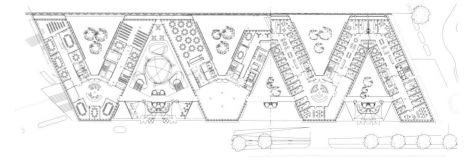

4.49

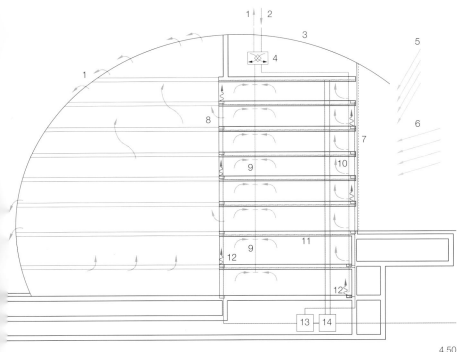

4.50

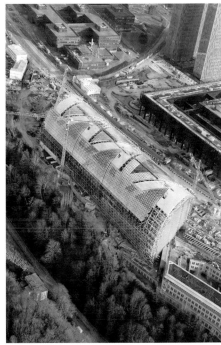

4.51

4.47 View of atrium
4.48 First floor plan, scale 1:1750
4.49 Ground floor plan, scale 1:1750
4.50 Section with energy and ventilation concept
 scale 1:500
 1 Exhaust air
 2 Outside air
 3 Sun protection glazing
 4 Air handling unit with heat recovery
 5 Summer sun
 6 Winter sun

 7 Exterior sun protection
 8 Window ventilation via atrium
 9 Waste air
 10 Supply air
 11 Building component activation
 12 Floor-mounted induction units
 13 Desiccant evaporative cooling (DEC)
 14 District heating substation
4.51 Aerial view during the construction phase
4.52 Air circulation diagram
4.53 Technical concept

4.52

Source	Energy technology	Transfer and distribution	Energy service

4.53

Office building

Vienna, A 2008

Client: WWFF, Wiener Wirtschafts-
förderungsfonds, Vienna
Architects: POS Architekten ZT KG, Vienna
Electrical planning/building services: KWI
Consultants & Engineers, Vienna/St. Pölten
Building physics: IBO – Austrian Institute
for Healthy and Ecological Building, Vienna
Green buffer planning: Radtke Biotechnik,
Veitshöchheim

The Competence Centre for Renewable Energies offers space for up to 20 companies on a usable floor area of around 7500 m². All the materials were tested according to their environmental compatibility and their chemical properties in order to guarantee a high quality of inside air. The building envelope, made of a light timber construction clad with fibre cement panels, meets Passive House standards. A groundwater heat pump and the 27 m-deep drilled wells supply approximately 320 kW of thermal energy. The heating is supported by solar thermal collectors covering a roof area of 285 m². Both systems feed into a central storage tank with a capacity of 15 000 litres; heat distribution is by means of building component activation. Decentralised instantaneous electric water heaters cover the low demand for hot water.

Due to the specially folded south-facing facade, the sun reaches far into the rooms in winter. In summer, photovoltaic elements fitted to the upward facing facade areas protect the interior from direct sunlight and therefore reduce the thermal load. In addition, perforated blinds are fitted inside. For these reasons, it is possible to cool the building passively by using only groundwater. In addition, the solar cooling concept provides for evaporative cooling of the inflowing air. In the southern facade, there is an air space between the panes of glass and the floor slabs. The warmed air flows up through this void, is drawn off and channelled into the heat recovery system. A total of 110 m² of planting has been installed in four open conservatories to humidify the air. Approximately 400 m² of photovoltaic modules generate around 37 000 kWh of electricity per year with a capacity of $46 kW_p$. This is sufficient to cover approximately 20 % of the electrical energy demand.

 DBZ 01/2009

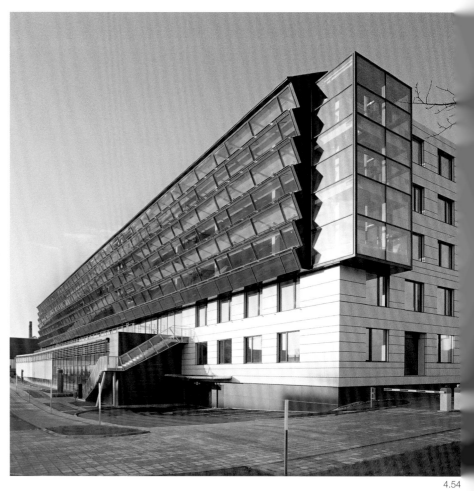

4.54

4.55

4.56

4.54 South elevation
4.55 Fourth floor plan, scale 1:1000
4.56 Ground floor plan, scale 1:1000

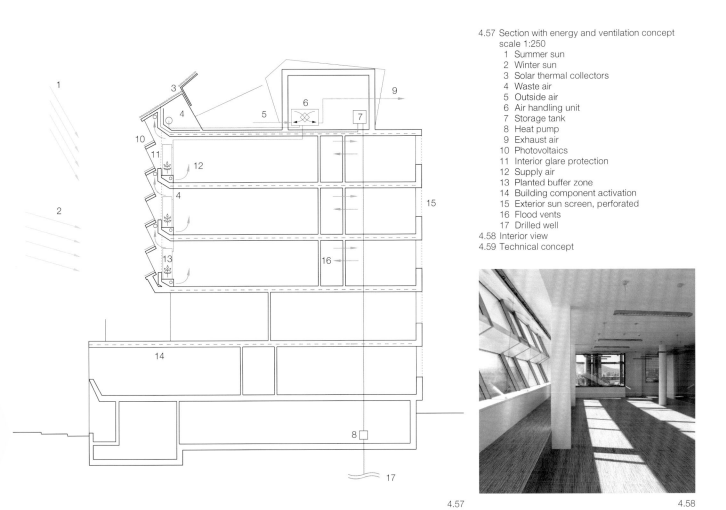

4.57 Section with energy and ventilation concept
 scale 1:250
 1 Summer sun
 2 Winter sun
 3 Solar thermal collectors
 4 Waste air
 5 Outside air
 6 Air handling unit
 7 Storage tank
 8 Heat pump
 9 Exhaust air
 10 Photovoltaics
 11 Interior glare protection
 12 Supply air
 13 Planted buffer zone
 14 Building component activation
 15 Exterior sun screen, perforated
 16 Flood vents
 17 Drilled well
4.58 Interior view
4.59 Technical concept

4.57

4.58

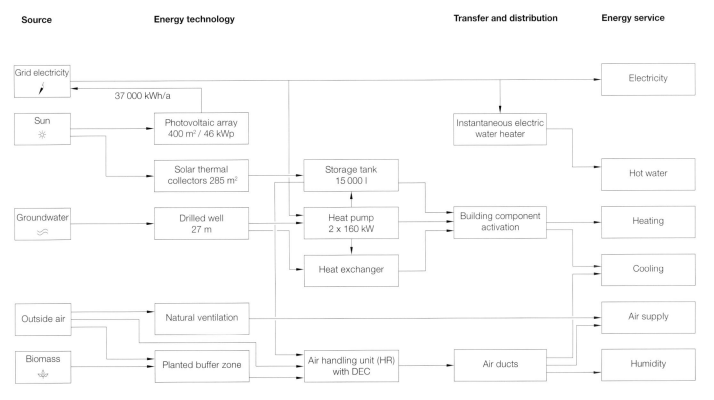

Source	Energy technology	Transfer and distribution	Energy service

4.59

Office building

Berlin, D 2007

Client:
Heinrich-Böll-Stiftung e.V., Berlin
Architects:
E2A Eckert Eckert Architekten, Zurich
Building services:
Basler & Hoffmann, Zurich

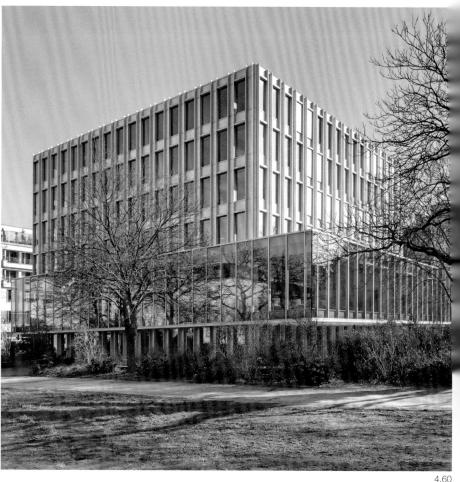

4.60

The new headquarters of the Heinrich-Böll-Stiftung is located in the centre of Berlin immediately bordering a park. The cube-shaped building has a floor area of approximately 7000 m² and accommodates offices that, in the main, have been left in bare concrete. The fully-glazed bel-étage used for conferences is very distinctive in the way it protrudes on three sides. The energy consumption of the newbuild undercuts the legally prescribed levels by 50 %. The heating is covered mainly by the waste heat from the servers. They are positioned in so-called cool racks, special cooling cabinets, which are thermally integrated into the building services concept enabling immediate use of the waste heat. The remaining heat is provided by a district heating line. Parapet air handling units with high-performance heat exchangers and a low forward-flow temperature of only 28 °C emit heat to the work spaces. These parapet units are also responsible for cooling in summer. An adiabatic recooler, which is sprayed with tap water, provides the necessary cold water (20 °C).
Like the temperature, the air supply can also be controlled individually by the occupants. All windows in the offices can be opened to the interior courtyard. They can therefore be supplied with fresh air in a cross ventilation mode. In the summer months, the atrium is opened up and the warm air is easily removed through apertures in the roof area. In winter, the horizontal ventilation flaps remain closed. An air handling unit with a heat recovery system supplies the atrium with fresh air during the heating period. The offices are then also supplied with air from the atrium. A grid-connected photovoltaic array positioned on the building's roof generates approximately 53 000 kWh of electricity per year.

DBZ 01/2009

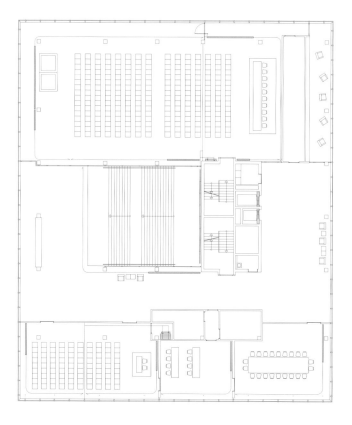

4.61

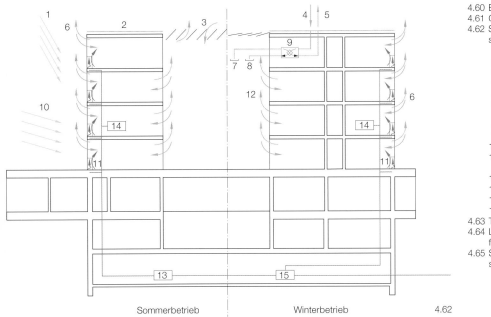

4.60 Exterior view
4.61 Ground floor plan, scale 1:400
4.62 Section with energy and ventilation concept
scale 1:400
1 Summer sun
2 Photovoltaic array
3 Atrium air in and outlet in summer
4 Outside air (winter operation)
5 Exhaust air (winter operation)
6 Individual window ventilation
7 Waste air (winter operation)
8 Supply air (winter operation)
9 Air handling unit with heat recovery
10 Winter sun
11 Parapet unit (heating and cooling)
two-wire connection
12 Window ventilation via atrium
13 Adiabatic recooler
14 Cool racks
15 District heating substation
4.63 Technical concept
4.64 Lecture halls in the open-plan layout of the
first floor
4.65 Schematic diagram: Adiabatic recooler in
summer

Sommerbetrieb Winterbetrieb 4.62

Source	Energy technology	Transfer and distribution	Energy service

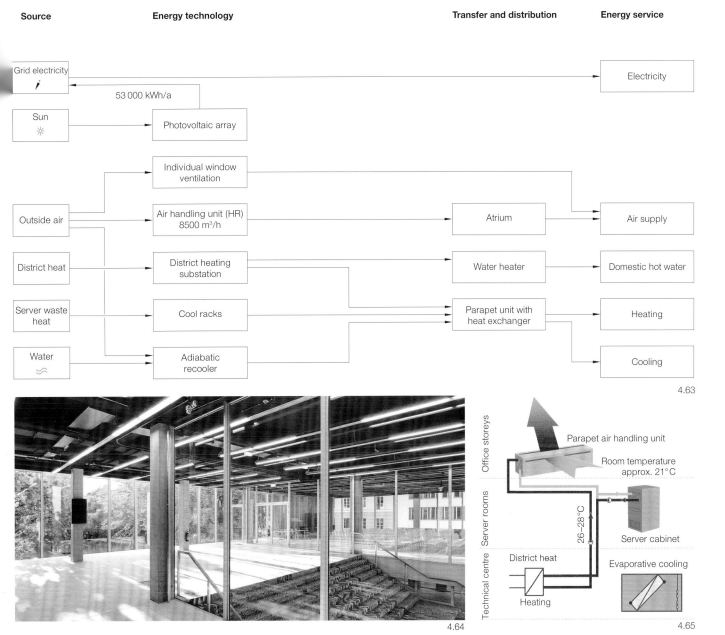

4.63

4.64

4.65

105

Office building

Konstanz, D 2007

Client: Nycomed, Konstanz
Architects: Petzinka Pink Architekten,
Düsseldorf
Building physics and facade planning:
DS-Plan, Mülheim a. d. Ruhr
Building services: DS-Plan, Cologne

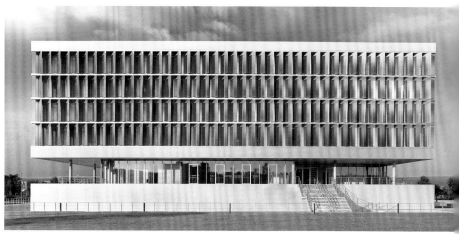

4.66

The headquarters of the pharmaceutical
company Nycomed is located on the out-
skirts of Konstanz. The building with its
square floor plan provides space for 500
members of staff on an area measuring
19500 m². Four congruent building ele-
ments enclose a central atrium in a wind-
mill-like fashion. The building services and
storage space is located in the basement, a
cafe and a restaurant on the level forming
the base of the building. Immediately
above, the reception area with an informa-
tion and conference centre surrounds the
naturally ventilated courtyard. Offices and
meeting areas arranged along double-load-
ed corridors are located on the four upper
storeys.

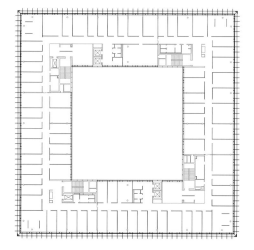

4.67

Due to the very well insulated exterior fa-
cade and the triple glazing, the building
has a primary energy demand of
80 kWh/m²a. A wood pellet heating system
installed in an adjacent boiler house gener-
ates the necessary heat, which is distribut-
ed via building component activation on all
levels as well as via the ventilation system.
Within the layout, there are certain differ-
ences in the way areas are treated: a cen-
tral air handling unit supplies and removes
air in the offices surrounding the atrium; fa-
cade elements with integrated decentral-
ised air handling units have been installed
in the outward-facing rooms. As well as the
air exchange, these are also responsible for
heating and cooling. The vertical, storey-
high glass louvres are printed to 60%. De-
spite their high transparency, they are able
to achieve a sun protection factor of <0.2.
As a radiation-dependent, solar tracking
screening system, they automatically con-
trol the amount of daylight penetration. The
interior glare protection elements can be
controlled individually allowing the occu-
pants to select their own lighting conditions.

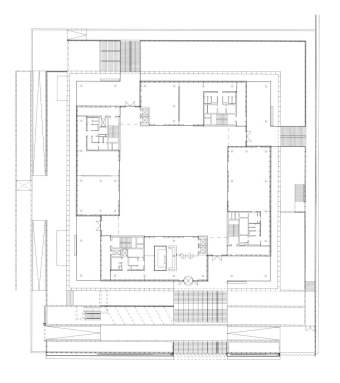

4.68

DBZ 01/2009

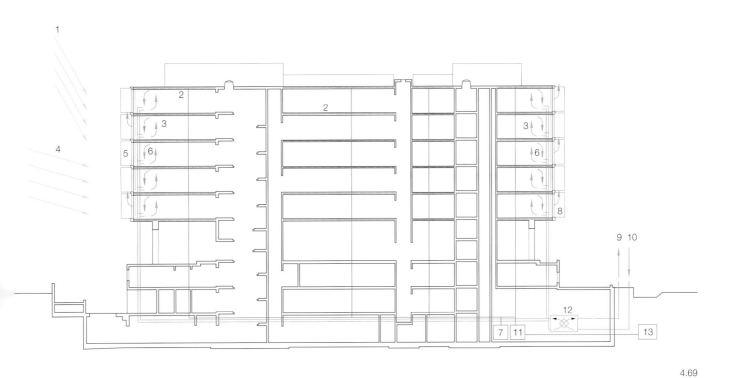

4.69

Source	Energy technology		Transfer and distribution	Energy service

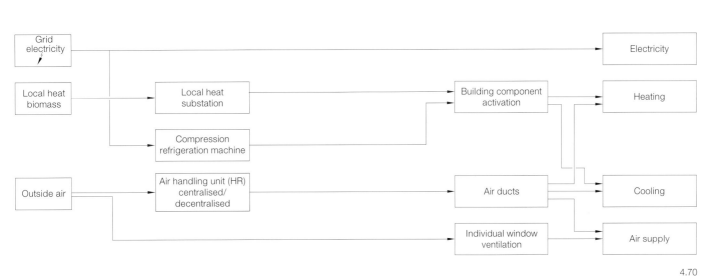

4.70

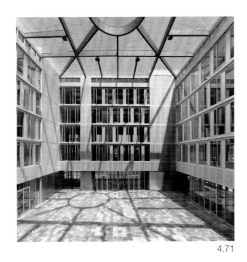

4.71

4.72

4.66 Outside view
4.67 Second floor plan, scale 1:1000
4.68 Ground floor plan, scale 1:1000
4.69 Section with energy and ventilation concept
 scale 1:500
 1 Summer sun
 2 Building component activation
 3 Supply air
 4 Winter sun
 5 Glass louvres
 6 Waste air
 7 Refrigeration machine
 8 Individual window ventilation
 9 Exhaust air
 10 Outside air
 11 Local heat transfer station
 12 Air handling unit with heat recovery
 13 Local heat generated with biomass
4.70 Technical concept
4.71 View into atrium
4.72 Gap in double facade

Institute and administration building

Aachen, D 2008

Client: Bau- und Liegenschaftsbetrieb
NRW, Niederlassung Aachen
Architects:
ARGE Fritzer + Pape, Aachen/Graz
(design), Pape Architekturbüro, Aachen/
Cologne (execution)
Building services, facade:
ARUP Deutschland, Berlin
Building physics, acoustics:
Graner & Partner, Bergisch-Gladbach

RWTH's Student Service Centre is located in the heart of Aachen's city centre. The C-shaped building with its 17 m-cantilevered roof storey 20 m above the ground accommodates a cafeteria, an events hall, offices and conference rooms. The protruding element protects the south facade from direct sunlight in summer. In addition, interior solar shades are fitted. The two openings in the roof storey provide a visual link between the building's forecourt and the conference rooms.

Within the framework of an EU project, a deep geothermal bore hole was completed. This is the first use of this method to supply a new build with energy for heating and cooling. During the heating period, the 2500 m deep ground probe, with a return-flow temperature of approximately 70 °C, supplies the building with heat. This is distributed to the rooms via building component activation, convection heaters and, in the roof storey, via ceiling heaters. In the case of cooling, the high temperature of the ground is used as energy to power an adsorption refrigeration machine. Due to the building component activation, a cold water temperature of 17 °C is sufficient to provide a good room climate. The work places are ventilated naturally. Only the assembly areas need to be supplied with fresh air from an air-conditioning plant. Sorption rotors are installed to dehumidify the supply air. The necessary regeneration heat is also supplied by the ground probe. Due to the experimental character of this concept, a redundant connection to the district heating network was established and an electrically powered compression cooling machine was installed. If the ground probe system were to fail, these precautionary measures would guarantee smooth operation of the building services.

▢ xia intelligente architektur 04-06/2009

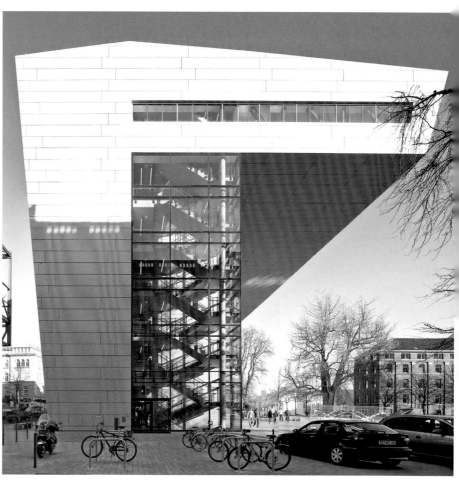

4.73

4.74

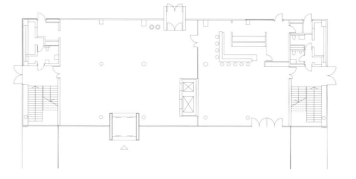

4.75

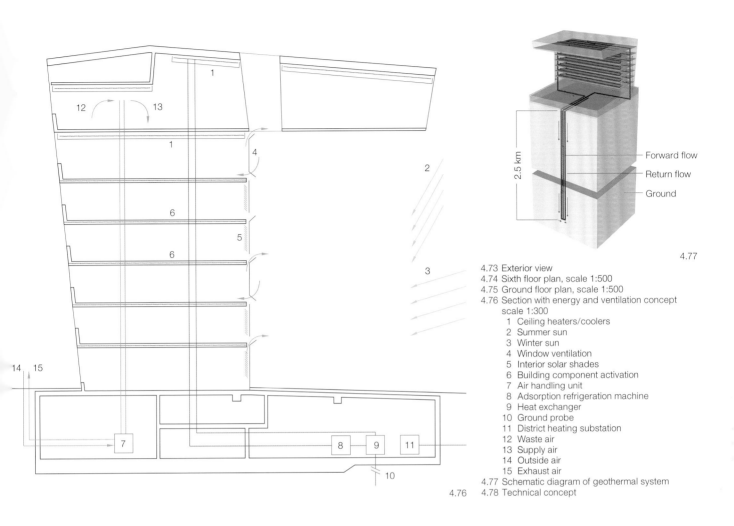

4.73 Exterior view
4.74 Sixth floor plan, scale 1:500
4.75 Ground floor plan, scale 1:500
4.76 Section with energy and ventilation concept
scale 1:300
 1 Ceiling heaters/coolers
 2 Summer sun
 3 Winter sun
 4 Window ventilation
 5 Interior solar shades
 6 Building component activation
 7 Air handling unit
 8 Adsorption refrigeration machine
 9 Heat exchanger
10 Ground probe
11 District heating substation
12 Waste air
13 Supply air
14 Outside air
15 Exhaust air
4.77 Schematic diagram of geothermal system
4.78 Technical concept

2.5 km

Forward flow
Return flow
Ground

4.77

4.76

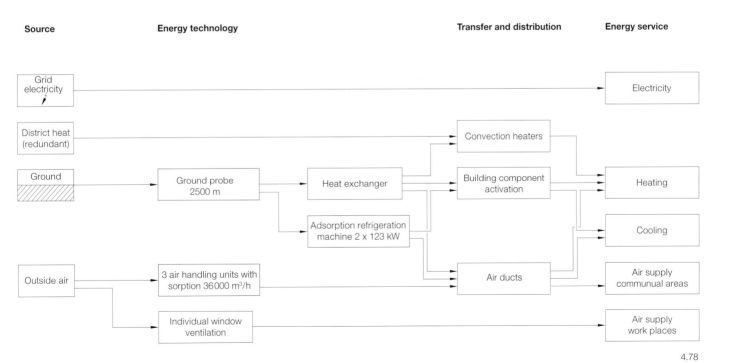

Source	Energy technology		Transfer and distribution	Energy service
Grid electricity				Electricity
District heat (redundant)			Convection heaters	
Ground	Ground probe 2500 m	Heat exchanger	Building component activation	Heating
		Adsorption refrigeration machine 2 x 123 kW		Cooling
Outside air	3 air handling units with sorption 36 000 m³/h		Air ducts	Air supply communual areas
	Individual window ventilation			Air supply work places

4.78

109

Production building

Kassel, D 2009

Client: SMA Technologie,
Niestetal-Sandershausen
Architects: HHS Planer + Architekten,
Kassel
Energy design: EGS-plan, Stuttgart
General contractor of building services:
Imtech, Kassel

The production hall with a total floor area of 2.5 hectares was developed by the inverter manufacturer on its company premises close to Kassel. In addition to the production areas, the long building includes a testing area, storage space, a staff canteen and the energy centre, which supplies the entire building with carbon-neutral heat, cold and electricity. The heat is primarily generated by a BTTP station which is operated by a biogas plant erected close by purely for this purpose. A gas condensing boiler is added as a back-up system. The remaining heat is drawn off an existing district heating network fed by a waste incinerator which is operated as a combined heat and power plant. Furthermore, the waste heat from the compressed air generators is used. All three heat supplying facilities feed into one central storage tank, which in turn supplies the ceiling heaters/coolers, the air handling units and the domestic water users with heat. For cooling purposes, an absorption refrigeration machine is operated with the waste heat from the BTTP. In peak times, an electrically driven compression refrigeration machine supports this combined cooling, heat and power (CCHP) system. A further storage tank is tied into the cooling network; the waste heat from the rooms is extracted through the ceiling heaters/coolers as well as the air handling units. Ten large-scale glass roof elements provide the interior with daylight. Photovoltaic cells integrated in these skylights are also used to provide solar screening. Photovoltaic modules with a total of 1.1 MW_p are also installed into the opaque areas of the flat roof. This power yield is supplemented by the power generated in the biogas BTTP. The remaining demand for electrical energy (including all production operations) is taken off the grid in the form of green electricity.

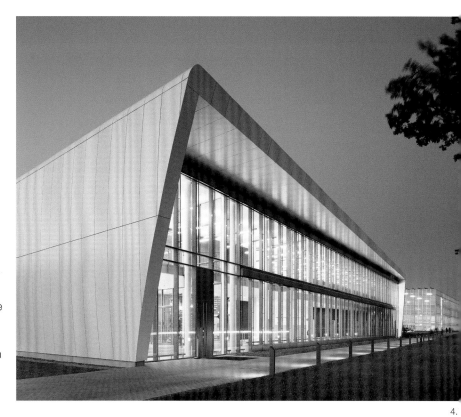

4.

4.

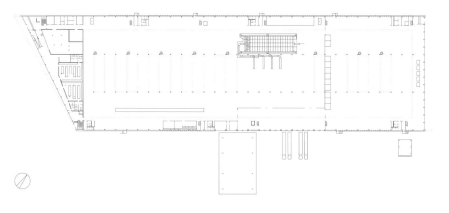

4.

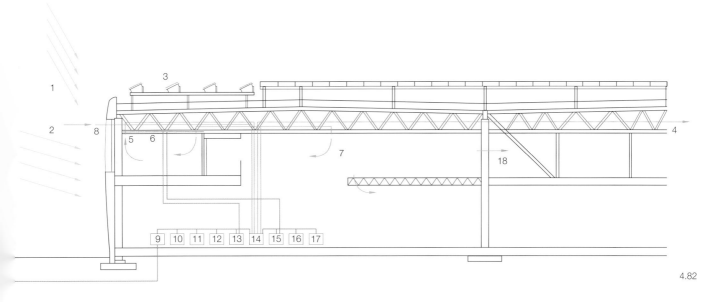

4.82

Source	Energy technology	Transfer and distribution	Energy service	
Grid electricity			Electricity	
Sun ☼	Photovoltaic array 1.1 MWp			
	CHP unit	Compression refrigeration machine	Cold store	Cooling
Biogas ♨	Condensing boiler (redundant)	Absorption refrigeration machine	Compressed air generator	Air pressure
District heat	District heating substation	Heat store		Heating
Outside air	Air handling unit (HR) approx. 170000 m³/h		Air ducts	Air supply

4.83

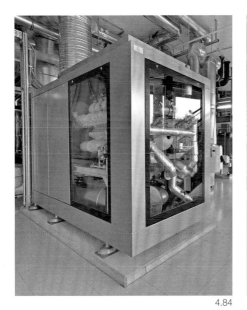

4.84

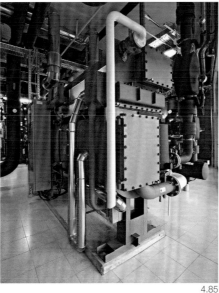

4.85

4.79 Exterior view
4.80 Section, scale 1:400
4.81 Ground floor plan, scale 1:2500
4.82 Section with energy and ventilation concept
 scale 1:250
 1 Summer sun
 2 Winter sun
 3 Photovoltaics
 4 Air exhaust through exhaust air duct
 5 Air exhaust through shadow gap
 6 Ceiling heater/cooler
 7 Supply air
 8 Outside air inlet on northwest facade
 9 District heating substation
 10 BTTP unit
 11 Condensing boiler
 12 Compressed air generator
 13 Heat store
 14 Air handling unit with heat recovery
 15 Cold store
 16 Compression refrigeration machine
 17 Absorption refrigeration machine
 18 Production exhaust air outlet in southeast
 facade
4.83 Technical concept
4.84 Biogas BTTP
4.85 Absorption refrigeration machine

Community centre

Ludesch, Vorarlberg, A 2006

Client: Gemeinde Ludesch
Immobilienverwaltungs GmbH & Co KEG,
Ludesch
Architect: Hermann Kaufmann,
Schwarzach
Energy concept: Synergy, Dornbirn
PV planning: Ertex Solar, Amstetten
Building biology: IBO, Karl Torghele,
Dornbirn

The community centre is located in the centre of the small town of Ludesch in Vorarlberg. It is a U-shaped building made up of three structural elements enclosing a covered forecourt. Public facilities, such as a post office, a café, a library and a crèche are located on the ground floor. Offices, seminar rooms and the town archive are on the first floor. Apart from the basement in reinforced concrete, the community centre is completed as a timber structure. The interior surfaces and the facade have been finished in white pine. In order to protect the natural facades from the impact of weather, both levels have been fitted with protruding roofs.

The building constructed with biologically sound building materials meets Passive House standards. The heat is supplied by using groundwater in combination with a heat pump to preheat air. A local heat supply system, which is fed by an existing woodchip plant, covers the remaining heat demand. The groundwater is also used in summer to passively cool the building. In combination with a latent heat store, solar thermal collectors covering a roof area of 30 m² warm the drinking water required.

The building is divided into four individual ventilation zones. An air handling unit with a heat recovery system and an integrated humidifier distributes the warm or cold air throughout the building. The foyer, the corridors and one rental space in the basement are also equipped with floor heating. The glass roof that protects the central forecourt from rain features transluscent solar cells. 120 modules with a capacity of 18 kW$_p$ and covering an area of 350 m², generate approximately 16000 kWh of electricity per year.

📖 Detail Praxis Photovoltaik

4.86

4.87

4.88

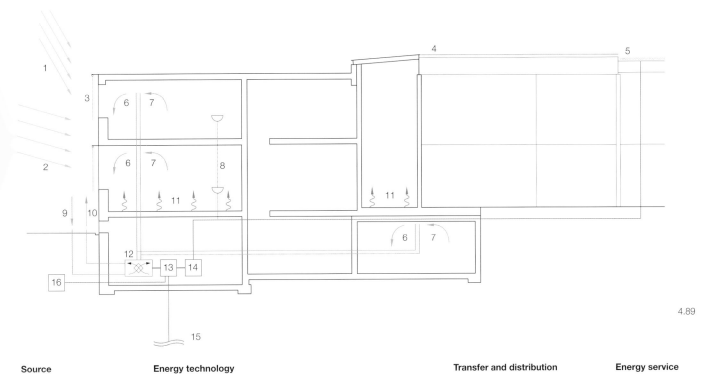

4.89

Source	Energy technology		Transfer and distribution	Energy service

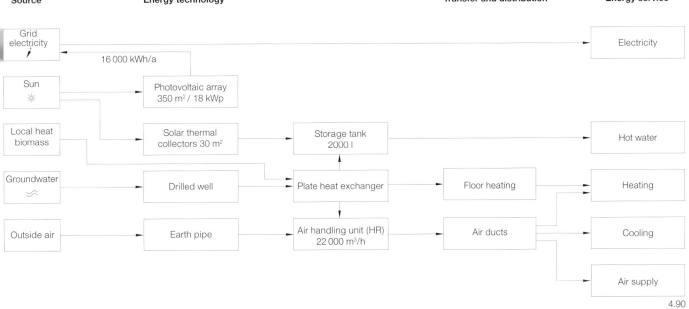

4.90

4.86 Exterior view
4.87 First floor plan, scale 1:800
4.88 Ground floor plan, scale 1:800
4.89 Section with energy and ventilation concept
scale 1:200
 1 Summer sun
 2 Winter sun
 3 Exterior sun screening
 4 Photovoltaics
 5 Solar thermal collectors
 6 Supply air
 7 Waste air
 8 Domestic hot water
 9 Outside air
 10 Exhaust air
 11 Floor heating
 12 Air handling unit with heat recovery
 13 Plate heat exchanger
 14 Storage tank
 15 Drilled well
 16 Local heat generation with woodchip
4.90 Technical concept
4.91 Entrance situation and covered forecourt
4.92 Forecourt roof covering with transluscent solar
cells

4.91

4.92

Military dining and leisure facility

Donaueschingen, D 2007

Client: Bundesrepublik Deutschland/
Staatliches Hochbauamt Freiburg
Architects: hotz + architekten, Freiburg
Energy concept, building physics,
acoustics: Stahl + Weiß, Büro für
SonnenEnergie, Freiburg
Building services: Rentschler +
Riedesser, Filderstadt

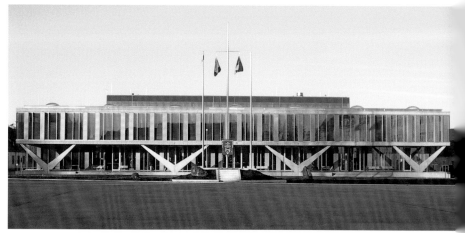

4.93

A new building with dining rooms and rooms for the soldiers' leisure activities has been developed on the grounds of the Foch Barracks, which is part of the German-French Brigade, in Donaueschingen. The construction comprises a reinforced concrete core with technical and functional rooms, composite columns and a curtain wall. Triple glazing, with a U-value of $0.6 \, W/m^2K$, has been used for the fixed facade elements. Together with well-insulated opaque panels, the facade has an average transmission heat loss of only $0.42 \, W/m^2K$. The required heat is channelled to the building via an existing district heating line and distributed by using facade-integrated convection heaters, as well as by thermally activating the reinforced concrete floor slabs. In summer the slabs are also used to remove heat. Large glass facade elements provide natural light to the mainly used zones. Specially designed light tubes were fitted to guide diffuse daylight into the centre of the ground floor. The entire building is naturally ventilated: In winter the outside air is channelled into the rooms through the facade panels fitted with integrated ventilation flaps and heating coils. The supply air is heated using convection heaters. In the summer months, the air rises through solar chimneys and is discharged to the outside via ventilation flaps. For this purpose, the south facade of the plant room on top of the roof has been fully glazed and fitted with a black absorber wall. In the case of solar irradiance, the heat is removed through thermal buoyancy and without energy intensive fans. Only the kitchen has been fitted with a mechanical air handling unit. By means of a composite cycle system, the exhaust air and waste heat from the cooling equipment are used to heat the domestic hot water.

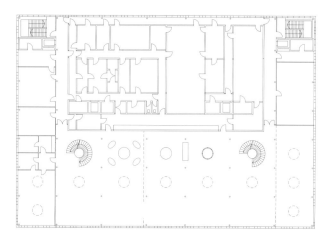

4.94

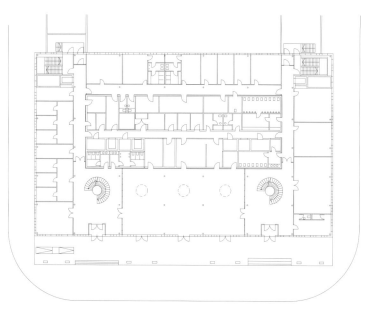

4.95

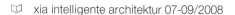 xia intelligente architektur 07-09/2008

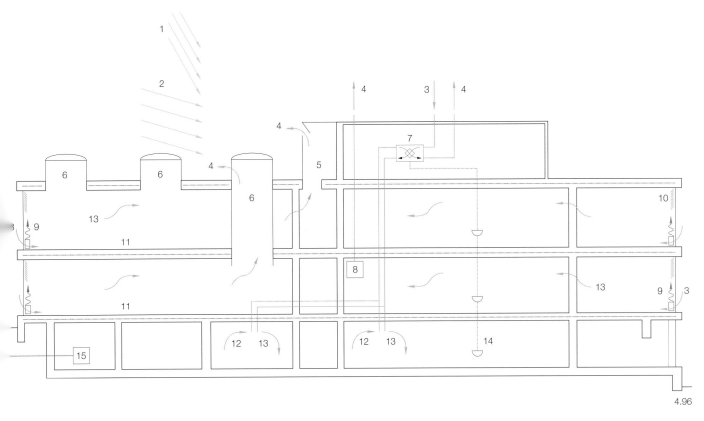

4.96

Source	Energy technology		Transfer and distribution	Energy service

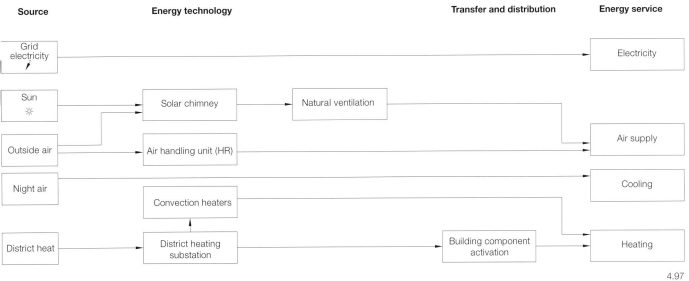

4.97

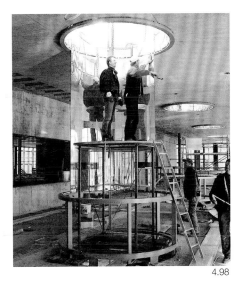

4.98

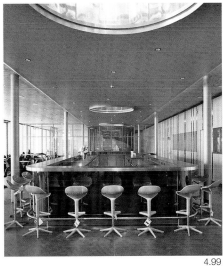

4.99

4.93 Exterior view
4.94 First floor plan, scale 1:500
4.95 Ground floor plan, scale 1:500
4.96 Section with energy and ventilation concept
 scale 1:250
 1 Summer sun
 2 Winter sun
 3 Outside air
 4 Exhaust air
 5 Solar chimney
 6 Light tube
 7 Air handling unit with heat recovery
 8 Exhaust air fan (kitchen)
 9 Convection heaters
 10 Interior sun screening
 11 Building component activation
 12 Waste air
 13 Supply air
 14 Domestic hot water
 15 District heating substation
4.97 Technical concept
4.98 Fitting of light tube
4.99 Dining room with light tubes

Mountain restaurant

Zermatt, CH 2007

Client: Zermatt Bergbahnen, Zermatt
Architects: Peak Architekten, Zurich
Energy planning: Lauber IWISA, Naters

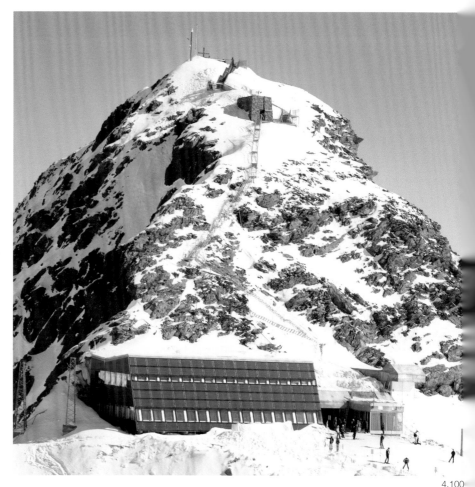

4.100

The tourist centre, Matterhorn Glacier Paradise, is located on the Klein Matterhorn above Zermatt at a height of 3883 metres. The new building is immediately next to the old mountain restaurant which continues to be used as a garage and a workshop for the cable car. The ground floor of the newbuild houses a shop and a restaurant for 120 persons, the first floor a dining hall with seating for 50 as well as sleeping accommodation for 40. The building services rooms are located in the basement.

For structural reasons, the base of the building has been executed in reinforced concrete, the rest is made up of prefabricated timber elements. The building gains most of its heat through the south-facing, 70 degrees inclined, facade. The outside air is drawn in through the facade elements, heated and distributed in the restaurant and the guest rooms by means of two air handling units. Heat pumps recover most of the heat contained in the waste air and reintroduce it into the building's heating cycle. A 190 m^2 photovoltaic array in the south facade with a capacity of 22.75 kW$_p$ covers the energy demand of the heat pumps and the fans for the ventilation. The rear-ventilated facade also provides cooling for the photovoltaic modules. The effect of the clear, cold air and reflected ambient radiation is that the modules are 80% more efficient than comparable plants at low altitudes. As a building without exterior sanitary infrastructure, the building has its own microbiological sewage treatment plant. The wastewater from the kitchen and bathrooms is purified and fed into the natural water of the environment. Greywater is used to flush the toilets.

4.101

4.102

📖 Detail Green 02/2009

4.103

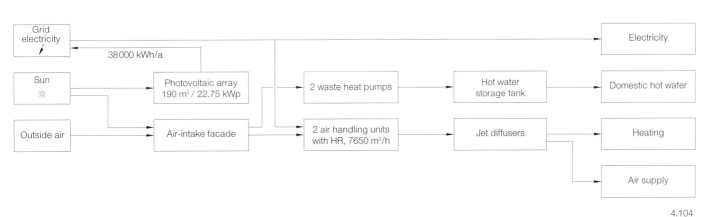

Source	Energy technology		Transfer and distribution	Energy service
Grid electricity				Electricity
	38000 kWh/a			
Sun	Photovoltaic array 190 m² / 22.75 kWp	2 waste heat pumps	Hot water storage tank	Domestic hot water
Outside air	Air-intake facade	2 air handling units with HR, 7650 m³/h	Jet diffusers	Heating
				Air supply

4.104

4.105

4.106

Protecting existing stock and refurbishing systems

During the course of planned refurbishment work, it is necessary to check whether there are plant components which, in any event, need replacing independent of the planned measures. Generally every existing piece of technical equipment is worth protecting if it was executed according to the technical standards prevailing at the time of its construction. However, if alterations to the building stock or additions are required, these should then be performed according to the most recent technical standards. The desire to retain existing technical equipment may be superseded by statutory regulations requiring that changes be made independent of redevelopment measures.

Apart from setting standards for new builds, the EnEV, which has been in force since 2002 and last updated in 2009, now also requests minimum energy standards for refurbishments.

Prior to performing modernisation measures, a detailed documentary report of the existing stock has to be drawn up. Special attention should be paid to the condition of the building envelope and the existing building services. A thorough analysis not only provides a complete overview of the situation but also helps to identify potential improvements and effectively compare the various options. In the case of a high heat demand, the first step should be to insulate the building envelope before optimising the plant technology. The lowest possible heat demand can only be obtained with a perfectly insulated building envelope and, as a result, provide the ideal conditions for integrating sustainable building services.

It makes no sense to replace old windows without also optimising the remaining building envelope. Apart from reducing the transmission heat loss, this solution would lead to a considerable reduction of air leakage. Of course, it is generally desirable to minimise heat loss through air infiltration and exfiltration. However, by solely exchanging the windows and at the same time not changing behaviour regarding ventilation, the relative humidity in the room air increases, causing water vapour to condense on the inside of uninsulated, cold exterior walls. This can very quickly lead to the formation of mould in corners or behind furniture.

Once the building envelope has been optimised in terms of energy efficiency, modernisation or improvement measures including sustainable building services should follow.

Before replacing the components of the building services, it is necessary to establish the age and condition of the individual pieces of equipment. By making comparisons with the average service life, the remaining life expectancy can be determined (Fig. 5.1). If several separate components forming one assembly unit have almost reached their estimated service life, the replacement of the entire unit should be considered. If the expected service life has not yet been reached, it is worthwhile performing a comparison of performance factors and efficiency before exchanging the component concerned. Based on these findings, a conclusion can be made regarding future savings in operation costs in relation to necessary investments for new plant.

Building ventilation

It is not unusual for ventilation problems to occur after energy-efficient modernisation measures have been made to the building envelope. The changes often have the effect of making the building more airtight and consequently preventing the natural air exchange through joints. The installation of modern, tightly-closing windows without insulating the exterior walls at the same time, is especially problematic. Due to the improved airtightness of windows but with the same low surface temperatures of the exterior walls, the formation of mould cannot be avoided if the attitude towards ventilation does not change considerably. The increased airtightness calls for controlled ventilation provided either by opening windows at regular intervals or retrofitting a mechanical ventilation system.

Ventilation plants
It is really possible to retrofit ductwork for channelling supply and exhaust air only if extensive refurbishment work is to be carried out. The complex and branched structure of the supply air ducts, in particular, can frequently be integrated only at great expense. Sometimes disused chimney flues can be used to integrate the vertical ducts; the horizontal distribution of supply air can be performed in corridors. The supply air inlets, in this case jet outlets are most appropriate, are ideally placed above the door lintels of the individual rooms. The exhaust air outlets should be placed in a way that no structural components are affected by the extracted air. In winter, condensation could form on the components affected by the outward flow of warm air and cause damage. Air outlets also have an impact on the appearance of the building. By dividing the volume of exhaust air into several smaller flow volumes, ventilation tiles could be used to remove the air. The

ffect on the building's appearance is hereby minimised. It is important to make sure that there is sufficient distance between the air intake and the exhaust air outlet.

n contrast to new builds, in the case of refurbishments it is necessary to examine whether the retrofitting of a controlled supply and discharge of air can be integrated into the building services concept in an ecologically and economically feasible way. It is generally not possible to optimise an existing building in such a way that it will meet passive house standards. The advantage of a passive house, which includes distributing the required heat entirely via the ventilation system, is therefore not applicable. The alternative is therefore to install an air exhaust system or a local ventilation system. If the situation only allows the integration of an air exhaust system, it is necessary to make sure that the air inlets are positioned immediately above the radiators. This method of installation heats the supply air as it is drawn in and prevents draughts. The exhaust air duct is ideally placed in a disused chimney flue.

If the refurbishment measures only include optimising the building envelope in terms of energy efficiency, retrofitting a local ventilation system is a possible option (see Air supply, p. 57). This system includes at least two ventilation units operating in an alternating push-pull mode. Each unit basically consists of a wall opening with an integrated fan and a recuperative heat exchanger for heat recovery purposes. The system's fans are controlled so that they draw in and remove air in alternating cycles. When air is being removed, the heat exchanger absorbs a proportion of the heat contained and uses it to heat the supply air.

For energy reasons, local ventilation units should not be placed immediately above radiators. Furthermore, it is necessary to observe, at an early planning stage, that each fan has to be connected to the electric power supply network. In comparison to natural ventilation, local ventilation systems reduce ventilation heat loss in winter and ventilation heat gain in summer, at the same time improving thermal comfort. However, since the energy saved from reducing the ventilation heat loss has to be compared with the energy consumption of the fans, local ventilation units are usually able to achieve only a small to medium gain in the total energy efficiency when compared to natural ventilation (Fig. 5.3).

Ventilation ductwork
If ductwork is to be retrofitted, it is particularly important to determine the exact dimensions and keep ductwork lengths to a minimum. Despite the often limited installation space in existing buildings, sharp bends should be avoided. Two 45° bends are, for example, better than a single 90° bend. Insufficient duct sections, sharp bends and excessive lengths cause high pressure loss and correspondingly high operation costs for the fans.

If ductwork crossings cannot be avoided, special fittings should be used to create smooth transitions from round to flat ducts. Flexible plastic ducting is not suitable. If ductwork has to be added to buildings with a very low installation height, several ducts can be connected in parallel. It is also possible, with low pressure loss, to integrate ducts into the floor structure. Typical flat duct heights for systems with floor integration are approximately 55 mm (Fig. 5.4).

Heating system	Service life [1]
Low-temperature boiler [2]	20–25 years
Condensing boiler [2, 3]	10–15 years
Burner [2]	10–15 years
Pumps	10–15 years
Pipes (heating) [4, 5]	20–40 years
Radiators [6]	25–35 years
Underfloor heating [3, 4]	25–35 years
Solar collectors [3]	20–25 years

Mechanical ventilation systems/service life [1] Cooling and air-conditioning plants	
Ductwork [2]	30–40 years
Air outlets [2]	20–30 years
Fans [2, 6]	5–15 years
Heat exchangers (air-to-air) [6]	15–25 years

[1] Average values according to information received from trade associations, guilds and manufacturers
[2] If inspected, serviced and cleaned regularly
[3] There are no longer terms of experience for common systems currently on the market
[4] Service life according approval tests of pipelines is 50 years
[5] Highly dependent on temperature, water quality and material
[6] Dependent on construction type

5.1

5.2

System option	Installation time and effort	Investment costs	Potential savings	Comfort gain	Time of retrofit
Local ventilation system	low	low	low to medium	low	any time
Central exhaust system	low	low	high	medium	when changing windows
Air supply and exhaust ventilation system	high	high	low, however, without leak test	high	when performing extensive refurbishment work

5.3

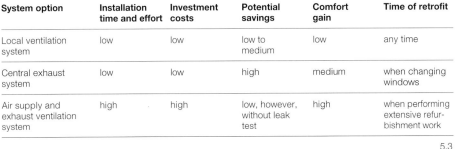

5.4

5.1 Service life of building services
5.2 When fitting flat ducts, it is important to consider the axis of bends. Variant A causes greater pressure loss than Variant B.
5.3 Possibilities concerning the retrofitting of ventilation systems in existing buildings and their main features
5.4 When installing air ducts, it is possible to choose between circular or rectangular sections. The sections shown all cause approximately the same pressure loss.

119

Apart from the proportions, it is also worth considering the type of bend when using rectangular ducts. The pressure loss caused by a vertical bend in a vertically installed rectangular duct is, in the most extreme scenario, almost twice as high as that in a horizontally installed rectangular duct with the same proportions (Fig. 5.2, p. 119). If sound attenuators are needed in the air duct system, the use of insertable sound attenuators should be avoided, despite the limited installation space, since they usually give rise to high pressure loss.

Heat and enthalpy exchanger
It is generally advisable to incorporate a heat exchanger. In residential buildings, the removal of exhaust air without heat recovery leads to an annual ventilation heat loss of approximately 50 kWh/m²a. An enthalpy exchanger is an alternative to a heat exchanger. These systems operate with moisture recovery and should therefore be used in rooms with low humidity levels. The humidity level is dependent on the material of the walls and the room's intensity of use. Low relative humidity can theoretically also occur by opening windows and doors. However, for reasons of thermal comfort, the air exchange in the case of natural ventilation is generally so low that the relative humidity does not change noticeably.

In order to increase the effect, the enthalpy exchanger absorbs a proportion of the moisture contained in the exhaust air and transfers it to the inflowing supply air. This is achieved by using a hygroscopic material (usually salts) which adsorbs the water vapour contained in the exhaust air. Once released and transferred through a membrane, the moisture is then used to humidify the inflowing air. This process is based on osmotic pressure. The structure of the membrane prevents the growth of microbes. The transfer of odours is also blocked. The thermal efficiency of an enthalpy exchanger is slightly lower than that of a normal heat exchanger.

A rotary heat exchanger that operates with a sorption agent is an alternative to an enthalpy exchanger. However, in contrast to the above-mentioned device, mixing of the supply and exhaust air volume is not quite as effective.

If an electrically heated humidifier is integrated in the existing ventilation system, it should be replaced by an enthalpy exchanger during the course of the refurbishment work.

Heat transfer systems
There are different methods of transferring heat to the building interior. In the context of refurbishment work, the question that arises in this case is whether the current system is to be reused or replaced (Fig. 5.5).

Radiators
Due to the high heat loads in older buildings, fin-type radiators were usually used. After completing energy refurbishment measures to the building envelope, the decision has to be made whether these radiators are to be reused or replaced by smaller ones (Fig. 5.6). By reducing the heat demand, existing radiators can usually be reused although lower forward-flow temperatures should be applied. However, due to the large quantity of water contained within the system as well as the frequently unlagged pipe network, the operation of low-temperature heating in combination with old fin-type radiators can be expected to be fairly sluggish. These conditions should be improved and energy loss should be minimised by insulating all the existing pipes and fittings. Prefabricated insulation elements are available for newer models.

Panel heating
Systems with heat emitting surfaces have the clear advantage of large heat transferring areas which can be operated with very low and highly efficient forward-flow temperatures. Low forward-flow temperatures are, for example, a prerequisite for the efficient operation of heat pumps. Capillary tube mats are particularly suitable for retrofitting wall surface heating. These systems consist of water-bearing plastic tube mats, which are, for example, fixed to the bare wall and then plastered (Fig. 5.7). Due to the small distances between the capillary tubes, the temperature distribution is very even contributing towards a high level of thermal comfort. Capillary tube systems are extremely slim which means they are also suitable for retrofits in buildings with very low ceiling heights.

If the mats are added during the course of refurbishment work in office buildings, they can be fitted to correspond with the grid dimensions of the windows. This approach maintains the flexibility of moving partition walls to meet future needs.

If underfloor heating is fitted in the existing building, it is necessary to establish which material was used. In the case of plastic tubes that are not fully diffusion-proof, there is a danger that oxygen has entered the system over the years and caused corrosion to the metal parts. Dry-lay floor heating systems are especially suited for retrofitting. Due to their low weight per unit area, the low structural height and the dry construction method, dry screed systems are particularly suitable. Alternatively, special refurbishment systems can be applied which utilise bubble foil and small-bore plastic tubing (Fig. 5.8). Including the floor covering but without impact sound insulation, the construction height is usually below 50 mm. When laying the plastic tubing, it is absolutely necessary to observe the minimum distance between the tubes so as to avoid thermal short-circuits within the system. As to the proportions of the heating circuit area, length to width ratio should be no more than 2:1.

Smoke vents
A precondition for the modernisation or replacement of a heating plant is, in most

5.5

5.6

ases, the refurbishment of the chimney flue. Typical examples of damage are tar and soot build-up as well as the penetration of moisture. Tar build-up causes damage to the chimney structure and occurs when the water vapour contained in the exhaust gas condenses in the chimney flue and mixes with oxygen. Yellowy brown discolourations on the outside of the chimney surface are typical indications of this damage. In the case of wood-fires, if the dewpoint is underrun, the result may be the incomplete combustion of the fuel and an excessive build-up of carbon matter in the chimney flue, so called sooting. Since gaseous fuels contain much larger quantities of water in comparison to other fuels, the chimney flue frequently suffers from moisture penetration. When the exhaust gas condenses in the chimney, the flue walls absorb a large amount of the water resulting in the penetration of moisture into the chimney. Systems with stainless steel are therefore frequently used for chimney refurbishment.

Heat pumps

Low forward-flow temperatures of the heating plant are required for the efficient operation of a heat pump. Low temperatures can, however, only be applied once the building envelope has undergone a refurbishment. If the current system is to be replaced by a heat pump, it is necessary to check whether the existing radiators can be reused. Because the radiators in existing buildings are frequently over-dimensioned and additional insulation measures lead to a significant reduction of the necessary heating load, it is usually possible to reuse them. If new heat distribution systems are to be integrated, systems with large surface areas, such as floor or wall heating systems, are recommended because they can be operated with minimum forward-flow temperatures. The heat pump's performance factor is directly influenced by the forward-flow temperature. For this reason, it is absolutely necessary to avoid temperatures above 55 °C.
Heat pumps using outside air as their heat source are not recommended since, especially in winter, they are not able to reach performance factors above three. From a primary energy point of view, these systems would then have to be considered less favourable than a gas condensing boiler.

Large buildings, in particular, are often faced with situations requiring that some areas be cooled while others, at the same time, be heated. If a heat pump system is to be retrofitted, the scenario of linking several internal heat pumps to one water circuit and equipping it with an additional central external heat pump should be considered (Fig. 5.9). This type of system is often referred to as "water loop". The connected heat pumps use the water loop as both a heat source and a heat sink, so that it is possible to provide different temperatures: a heat pump removes the heat from a room requiring cooling and transfers it to the water circuit. This in turn functions as a heat source for the operation of a heat pump in a room requiring a higher temperature. In order to ensure perfect system operation, a defined temperature level must be maintained in the water loop. If this level is overrun or undercut, the difference has to be balanced by the external heat pump. The run time of the external heat pump can be reduced by integrating an additional buffer storage tank. The external heat pump is ideally operated with waste heat available from production processes, such as a server room.

Optimising and adjusting systems

The primary energy consumption of a technical building system is defined as the amount of primary energy necessary for the generation of heat, hot water and, if applicable, the operation of a ventilation plant. It is possible to evaluate the plant technology in terms of primary energy consumption (hot water, ventilation and heating) by applying the plant efficiency factor. Taking a heating system as an example, this value indicates the relationship between consumed primary energy and the generated useful heat for heating purposes. The lower the plant efficiency factor, the more efficient the system is.
Apart from applying efficient plant technology, low annual primary energy consumption can also be achieved by using a large proportion of renewable energy systems.

Heating plant

When evaluating the efficiency of a heating system, apart from the boiler itself, it is also important to consider all of the other components such as storage facil-

5.7

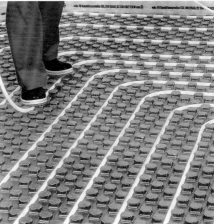

5.8

5.9

5.5 Data plate of an old oil heating system with indication of the forward flow temperature (110 °C)
5.6 Old fin-type radiator
5.7 Capillary tube mats as wall heating
5.8 Floor heating laid in prefabricated plastic bubble panels
5.9 Exemplary integration of heat pumps in a "water loop" system

ity, distribution, heat transfer and, not to be forgotten, the plant control (Fig. 5.11 and 5.12). The plant efficiency can be evaluated according to the current efficiency coefficient and the annual fuel utilisation efficiency. The efficiency coefficient describes the efficiency of the system in ideal conditions, which usually means in full-load operation. The annual fuel utilisation efficiency describes the relation between the actual amount of useful energy delivered during a one year period, here as useful heat, and the amount of energy that must be supplied as fuel. The difference between the two amounts of energy results from plant loss. Based on the annual fuel utilisation efficiency, it is possible to make a clear statement about the actual plant efficiency: the higher the determined value is, the better the efficiency. Decisive factors for high fuel utilisation efficiency are, in particular, a low forward-flow temperature and perfect boiler and storage tank dimensions.

The heating systems integrated in older buildings usually operate with high forward-flow temperatures and, due to poor standards of insulation and dated control engineering, display very low annual fuel use efficiencies. One way to improve the performance is to reduce the forward-flow temperature. However, in order to reduce the temperature, it is normally necessary to insulate the building envelope. If energy optimisation work is carried out on the facade, the existing heating system can be operated with lower forward-flow temperatures, the aim being to reduce

the system's heating curve. The flatter the heating curve, the lower the forward-flow temperatures are in relation to the outside temperatures.

Apart from the forward-flow temperature, the size of the storage tank is also of great importance. Combi boilers, frequently found in older buildings, usually include an integrated hot water storage tank with a fairly small capacity. Small storage tanks, however, require the system to perform shorter cycles, which leads to significant deterioration of the efficiency ratio.

If the heating system is to be replaced, the minimum standard is the installation of a condensing boiler. The use of condensing technology normally requires a chimney refurbishment and provision of a condensate drain. It is necessary to use a suitable material for the drain in order to prevent damage.

The overall aim of optimisation measures should, however, be the integration of sustainable plant technology based on the use of renewable energies (Fig. 5.10). Extending an existing system with sustainable building technology can also be a sensible solution. Approaches following this principle are particularly appropriate if the aim is to make use of the system's remaining service life. In this case, a bivalent system is used combining two different heat generation systems. It is, for example, possible to install a new pellet boiler to cover the required base load. The building's existing condensing boiler is then switched on only to cover peak loads.

For the practical integration of solar technology, a low forward-flow temperature less than 55°C is required. Apart from being used to heat domestic hot water, solar energy can also be applied to support heating. However this only makes sense economically if the solar coverage rate is clearly higher than ten per cent. Before installing a new heating system, it is absolutely necessary to refurbish the building envelope. Poor insulation is frequently the cause for high transmission heat loss, and the size of the new heating system has to match these needs. Undertaking insulation measures after installing a new heating system results in the heating plant having greater capacity than that required to meet the reduced heat load. Apart from causing unnecessary costs, this situation leads to the system performing short cycling. The efficiency coefficient, in this case, is significantly lower and increased wear and tear is the result.

Cleaning the heating system
Older plants that are to be reused should be rinsed in order to remove impurities and sedimentation. If more than one heating circuit is installed, they should be rinsed separately. However, significant increases in efficiency cannot be expected from this simple maintenance measure.

Hydraulic balancing
It is also necessary to check whether the individual radiators have been hydraulically balanced. If the difference between the forward-flow and the return-flow temperature is only slight and if, despite the pump operating, all of the radiators are not equally hot, it can be assumed that the system has not been hydraulically balanced. Hydraulic balancing is the prerequisite for ensuring that a heating system is not operated at unnecessarily high temperatures and that all radiators are supplied with the quantity of hot water essential to meet the desired room temperature. Without hydraulic balancing the rooms closest to the heating plant are supplied with too much heat, the rooms further away with too little (Fig. 5.13). Moreover, the hydraulic balancing of individual radiators ensures the optimisation of pump cycles due to lower volume flows, perfect pressure conditions and an even distribution of heat according to needs.

Main features	Natural gas	Liquid gas	Heating oil EL	Wood pellets	Woodchip	Electricity mix	District heat	Solar radiation	Ambient heat²
Renewable				•	•		○	•	•
Pipeline dependent	•					•	•		
Pipeline independent		•	•	•	•			•	•
Utility dependent	○	○				○	•		
Storage room necessary		•	•	•	•				
Condensing mode	•	•	•	○	○				
Simple recording of consumption	•					•	•	○	○
Accumulated energy use¹ (kWh$_{Prim}$/kWh$_{End}$)	1.14	1.11	1.11	1.16	1.07	2.99	0.77–1.85		
Greenhouse gases CO_2 equivalent¹ (g/kWh$_{End}$)	249	263	303	42	35	647	217–408		
Primary energy factor according to EnEV 2009, Enclosure 1	1.1	1.1	1.1	0.2	0.2	2.6	0.0–1.3		

¹ According to data from the computer programme GEMIS
² Energy from the ground, groundwater or ambient air, which is turned into useful heat by utilising a heat pump

5.10

122

Heating curve

Another aspect that needs to be considered is whether the heating curve is too steep. The steeper the curve, the higher the forward-flow temperature of the heating system is in comparison to the outside temperature. If the setting of the heating curve is unnecessarily high, the forward-flow temperature, on the one hand, is too high and the heat flow, on the other hand, is too low at the time of the heat output, since the radiator's thermostatic valve is open only marginally. The possibility of reducing the heating curve and therefore also the forward-flow temperature is definitely worth considering (Fig 5.14). Furthermore, it is necessary to identify which parameters the heating curve is based on and whether the positioning of the temperature sensors is appropriate.

Control mechanism

A heating system that is controlled only via an inside temperature sensor should be supplemented by an outside temperature sensor. This so-called »weather-based heating system« is in line with the current state of technology. If a heating system in an existing building is controlled only via an outside temperature sensor, the course of the heating curve is determined without taking solar or internal heat gains into consideration. In such a case, in the event of heat gains through solar radiation and internal heat loads, rooms become overheated. However, reducing the heating curve in this situation, involves the risk of not being able to permanently ensure adequate room temperatures. Optimal and energy-efficient plant operation is therefore only possible if an outside as well as an inside temperature sensor is provided.

If the main rooms are not all facing in the same direction, the outside temperature sensor should be placed on the north or northwest facade. In this case, the inside room temperature is balanced by using thermostatic radiator valves.

If all main rooms are facing the same way, the sensor should be positioned on the outside wall of these rooms. The outside temperature sensor should generally be placed in the wind, not in direct sunlight and at least 2.5 m above the ground. Furthermore, it is important to make sure that, in the morning, the sensor is not affected by the sun or any other heat source, such as a warm airflow from the

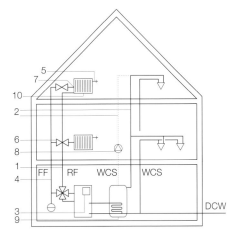

1 Lagging of pipelines in unheated areas
2 Lagging of DHW and WCS pipelines
3 Improving control of heating
4 Adjusting the pump performance
5 Bleeding the system
6 Fitting of thermostatic radiator valves (with low control gradient)
7 Hydraulic balancing (valve setting)
8 Time control of the circulation pump
9 Insulation of the water storage tank
10 Cleaning of all components to improve the flow of water
FF Forward flow
RF Return flow
DHW Domestic hot water
DCW Domestic cold water
WCS Water circulation system

5.11

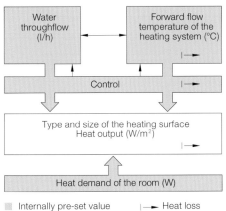

5.12

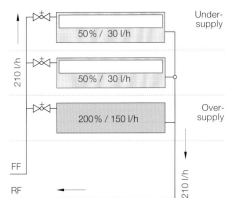

a

5.13

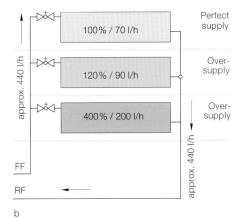

b

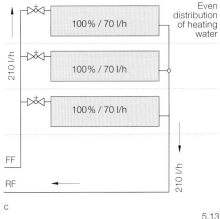

c

5.10 Comparison of different energy mediums for room heating
5.11 Optimisation potentials of a heating system in an existing building
5.12 Influencing factors for the type and dimensions of heating surfaces
5.13 Perfect hydraulic balancing of the heating system is necessary to optimise the pump run time and to ensure an adequate heat transfer of all radiators.
 a Heating system without hydraulic balancing: non-uniform heat distribution
 b Inaccurately controlled heating system caused by increasing the pump capacity
 c Heating system with good hydraulic balancing: uniform heat distribution
5.14 Exemplary illustration of different heating curves. They present the temperature level of the forward flow in relation to the outside temperature.

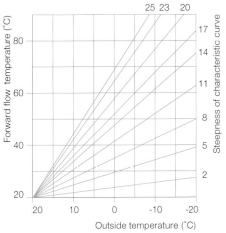

5.14

123

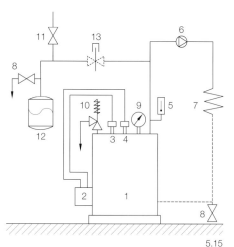

5.15

Installation of cold water pipes	Insulation thickness [1] (mm)
Open installation, in non-heated room In a duct, without hot water pipes In wall chase, rising main, on concrete floor slab	4
Open installation, in heated room	9
In duct or wall chase, next to hot water pipes	13

[1] Based on λ = 0.040 W/mK

Internal diameter (DN) of hot water pipe (mm)	Insulation thickness [1] (mm)
≤ 22	20
> 22 and ≤ 35	30
> 35 and ≤ 100	DN
> 100	100
Pipes and fittings: • in wall and slab penetrations • at crossings, at connection points • at central pipe manifolds	50 % of the above-mentioned requirements

[1] Based on λ = 0,035 W/mK

5.16

entrance door. In this context, the EnEV requires that all heating systems are equipped with an automatic system, which regulates the heat input according to a single reference value.

In buildings with different utilisation zones, it should be checked whether individual room control might be able to improve the system. This addition would enable the different utilisation zones to be controlled independently in terms of location and timing.

Thermostatic radiator valves (TRVs)
In principle, all radiators should be equipped with thermostatic radiator valves, since these control the water flow according to the room temperature (Fig. 5.17). Enclosing the valves with wall linings or positioning pieces of furniture in front of them causes problems in regulating the heat output. According to the EnEV, since 2002, old valves without thermostatic control mechanisms must be replaced.

Pipe insulation
Existing pipes should be checked for sufficient insulation. In older buildings, in particular, there is often a lack of insulation in areas of branch connections and shut-off valves and this should be rectified. If the refurbishment is being carried out according to EnEV, all accessible heating pipes and fittings must be insulated (Fig. 5.21). Furthermore, when inspecting the pipes, it is necessary to make sure that there is sufficient distance between the forward and return-flow pipes. If the pipes have been placed too close, the heat transmission taking place between the pipes has a detrimental impact on the system. If the pipes are to be replaced, it is important to ensure short and straight laying as well as perfect pipe diameters. Short and accurately sized pipes with as few corners as possible are condition for low pressure loss. This also has a direct impact on the power consumption of the circulation pump.

Three-way valve
It is also necessary to check whether the forward and return-flow pipes are connected via a three-way mixing valve. The use of a so-called »modular heating circuit« is currently state-of-the-art.

Their retrofitting in existing plants is compulsory.

Hot-water storage tanks
With regard to the hot-water storage tank, tests should be carried out to check whether the supply temperature of the hot water is set too high and therefore causing unnecessary heat loss. The supply temperature (the temperature that the water in the hot-water storage tank reaches through heating) should be no higher than 65 °C. By lowering the temperature, the energy consumption of the heating system can be reduced.

Also relevant for the energy consumption is the difference between the hot water supply temperature and the lowest temperature that the tank water may drop to after withdrawal of water without additional heating. If the temperature difference is small, the boiler will short cycle and operation of the plant becomes extremely inefficient. Another relevant aspect is whether limescale has built up in the hot water storage tank. A limescale layer of only one millimetre increases the energy expenditure for heating the water by approximately ten per cent.

5.17

5.18

5.19

Membrane expansion vessel
In cool conditions, the membrane expansion vessel (MEG) should not contain any water. This can be checked by simply tapping the vessel. The MEG is responsible for supplying a balanced system pressure (Fig. 5.18). If the pressure fluctuations cannot be controlled adequately by the MEG, short cycling and therefore higher energy consumption of the heating system may be the result.

Recirculation pump
Optimising the recirculation pump can also contribute towards much greater efficiency in operating the plant. Frequently the run times of the pump and the demand profile are not correctly matched. Permanent pump operation leads to unnecessary consumption of electricity and to higher heat loss. In existing buildings, circulation and recirculation pumps are often larger than required; these are generally inefficient, multistage pumps (Fig. 5.19).
If the pump is to be exchanged, it should be replaced by a high efficiency device with a synchronous motor. In contrast to less complicated systems, these pumps do not supply a predefined water volume but ensure that, dependent on the water flow through the radiators, a constant pressure is maintained in the pipes. Due to the clearly reduced electricity consumption, the slightly higher initial costs amortise after only a few years.
Decentralised pumps are an alternative to a central heating pump. They are installed on each radiator and replace the existing thermostatic valves as well as the central pump. By using this system, a so-called »supply-oriented heating system« can be converted into a »demand-oriented heating system«, since the decen-

tralised pump is in operation only when heat is actually demanded. Improved energy consumption derives from the shorter transient times and the more precise temperature control.

Hot water production
In existing buildings, the hot water is usually either heated by an instantaneous water heater or by the heating system. Instantaneous water heaters are recommended only in situations where there is limited demand for hot water and there are long pipelines.

Circulator pumps
In order to be able to provide instant hot water at all times, it is necessary to lay a circulation pipe in addition to the hot water pipes. A pump circulates the hot water in a cycle consisting of a hot water line, a circulation line and a heat exchanger. The aim is to avoid stagnation in the pipeline and therefore prevent the water from cooling down. Hot water circulation therefore only makes sense when there is a demand for hot water. Frequently there are systems in existing properties that lack any adjustment between the pump cycles and the user profile within the building (Fig. 5.22). Unnecessary water circulation causes unnecessary amounts of energy to be consumed by the pump as well as greater heat loss. For this reason, it is advisable to check the building's usage profile as well as the pump's cycle profile. If a circulation system is currently fitted without a pump and works on the principle of gravity, it is essential to retrofit a circulator pump. When installing a new pump, care should be taken to use an energy-efficient, variable speed system. Multistage systems are no longer considered state-of-the-art.

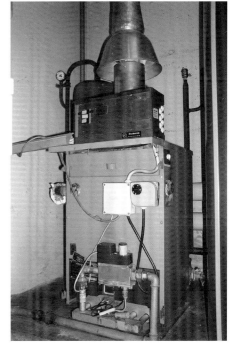

5.20

5.21

5.15 Closed hot water heating (schematic diagram)
 1 Boiler
 2 Burner
 3 Thermostat
 4 Temperature monitor
 5 Thermometer
 6 Recirculation pump
 7 Radiators or other heat distributing system
 8 Drain cock
 9 Pressure gauge
 10 Safety valve
 11 Air vent valve
 12 Membrane expansion vessel
 13 Shut-off valve
5.16 Pipe insulation for domestic cold water pipes
5.17 Old control valve without thermostat
5.18 Membrane expansion vessel
5.19 Old multistage recirculation pump
5.20 Gas heating in existing building
5.21 Heating pipes with insulation
5.22 Typical utilisation periods of heating systems

Residential building

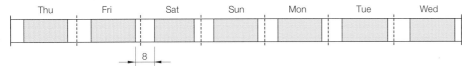

8

Non-use time per week: 56 h = 33 %

Office building

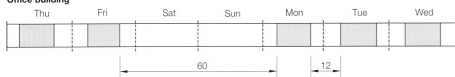

60 12

Non-use time per week: 108 h = 64 %

5.22

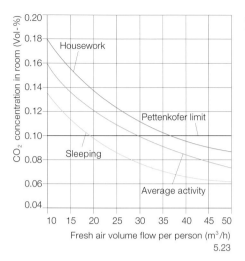

5.23

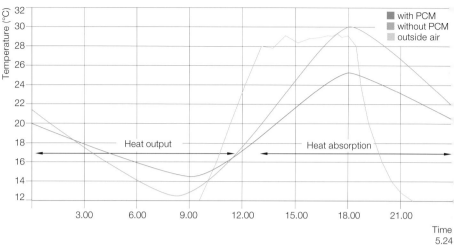

5.24

Fresh hot water system

If the hot water is produced by the heating system, the hot water is stored in a tank. To avoid excessive growth of legionella inside the storage tank, the water must be heated to at least 65°C for short periods at regular intervals. The significant heating of the water occurs independent of demand and is associated with a high consumption of energy.

As an alternative to the demand independent provision of hot water, it is possible to retrofit a domestic hot water system which provides hot water as and when needed. The difference to a conventional system is that the domestic hot water is not stored in a tank. Instead the stored hot water heats the cold fresh water in a flow through mode (Fig. 5.25). A heat exchanger fitted outside the storage tank takes care of the heating process. In this system, the stored water and the domestic hot water are hygienically and thermally separated. Since a stagnation of domestic hot water cannot occur in this case, there is no danger of legionella growth within the drinking water pipes. The regular heating of the water in the storage tank to 65°C is no longer necessary and the energy consumed for heating the domestic hot water is reduced significantly since it is no longer dependent on the storage temperature.

Utilisation of wastewater heat

The retrofitting of a decentralised wastewater heat exchanger should be considered, in particular, in buildings where large quantities of wastewater are produced, for example in large-scale catering establishments. These systems transfer a considerable amount of heat contained in the wastewater to the cold water. In the case of a high demand for hot water, large amounts of energy are saved (Fig. 5.26). Alternatively, the energy contained in the wastewater can be used as a heat source to power a heat pump.

Ventilation plants

As a general rule, the ventilation system in an existing building should be checked to ensure it is well aligned with the usage. Due to the low heat storage capacity of air, high heating or cooling loads should not be covered by the ventilation plant. The channelling of recirculated air should be avoided unless it is required to condition the room air.

Variable air volume control

It is generally possible to optimise ventilation heat loss and the energy consumption of fans, by varying the volume flow according to, for example, the number of occupants (variable air volume control). The volume flow can either be time or sensor controlled. Sensors can, for example, measure the current CO_2 concentration in a habitable room, the content of water vapour in kitchen air or the quantity of volatile organic compounds (VOC) in room air. The concentration level is then the determinant for the required air volume flow (Fig. 5.23). It is also possible to operate a sensor-controlled system with a combination of a basic, constant ventilation system and a demand controlled ventilation system.

In the case of a CO_2 controlled operation, the CO_2 reference value should ideally be variable and dependent on the outside temperature. When the outside air temperatures are very low, the system allows for a higher CO_2 content, when the outside temperatures are high, the permissible CO_2 content is much lower. A demand controlled volume flow is subject to retrofitting air quality sensors. In this case, it is very important to consider the location of the air quality monitors. Exhaust air ducts are not ideal since these provide a value of an air mixture extracted from different rooms. An ideal adjustment of the volume flows can only be made if measurements are taken in different zones.

In order to avoid pressure differences within the building, not only the volume flow of supply air but also that of exhaust air must be controlled when using a variable air volume system. Ideally this is done with a so-called cascade control: the supply air control device functions as the primary control device (master), the exhaust air control device as the secondary control device (slave). In contrast to the more simple parallel mode, in which both control devices operate independently of one another and are set to produce constant volume flows, this control method also caters for varying supply air volume flows without producing differences between the supply and exhaust air volume. Identical volume flows of supply and exhaust air are important to avoid uncontrolled exfiltration (outflow) of room air from the inside to the outside of the building or infiltration (inflow) of outside air into the building.

Uncontrolled exfiltration can, for example, lead to condensation build-up inside the building envelope and be the cause for extensive structural damage. Infiltration of outside air can cause draughts.

It is generally necessary to also consider the air distribution ductwork when introducing a demand-controlled ventilation system since the reduction of single air volume flows can lead to changes in the

hydraulic conditions. Individual areas may, in this case, no longer be supplied with a sufficiently high volume flow of fresh air. However, it is possible to correct this problem by installing additional volume flow regulators.

Heat recovery
If existing ventilation plants are not equipped with a heat recovery system, it is important to check whether it is possible to integrate a suitable device. If the supply and exhaust air ducts are spatially separated, heat exchangers based on a closed loop system can be retrofitted. In this system, the waste heat is transferred to a liquid in a heat exchanger. It is then transported to the supply air system via a well insulated pipe circuit and transferred to the supply air by using a second heat exchanger. The preheated supply air is finally channelled back into the interior space.

Dual duct system
If a dual-duct air-conditioning system is fitted in the building, the possibility of replacing it by a single-duct system should be considered. Dual-duct systems are operated with cold and warm air ducts that run in parallel throughout the building. Mixing boxes mix the hot and cold air to meet the desired temperature. In contrast to target-oriented temperature control, dual-duct systems consume significantly higher amounts of energy since, in the worst case, outside air is partially heated and partially cooled at the same time. Because these systems are usually designed to cover heating and cooling needs, they tend to channel far too much air, which, in turn, increases the energy consumption of the fans.

Thermal storage mass
Sufficient thermal storage mass is necessary to balance temperature fluctuations within the building and therefore provide a stable thermal climate. Whether or not the internal surfaces can contribute towards a comfortable thermal climate depends especially on the material's unit weight, its specific thermal capacity as well as its heat penetration coefficient. It is particularly important to provide sufficient thermal mass, if the thermal loads are not discharged immediately but stored in the building during the day and removed at night by means of night-time ventilation. In this case, cold air is

channelled into and through the building during the night-time hours. Good thermal storage components are, for example, uncladded concrete ceilings, which can store approximately 180 Wh/m²K of heat.
In order to avoid using active building services, optimisation measures should include uncovering structural elements that could function as thermally activated components and, if applicable, removing suspended ceilings. To meet the requirements concerning room acoustics, individually hung ceiling sails can be installed in place of suspended ceilings. If a lightweight structure cannot provide sufficient storage mass, it is possible to optimise the storage capacity by, for example, retrofitting phase change materials (PCM) (Fig 5.24). Phase change materials that are appropriate for integration in buildings usually consist of paraffin or salt hydrates. They are available in micro and macro encapsulated formats. Micro-encapsulated PCMs can be used as an aggregate in plaster or in the form of gypsum plaster boards.
In macro-encapsulated format, the PCMs can, for example, be sealed in plastic foil bags and integrated into the building. Ceiling systems with integrated macro-encapsulated PCMs based on salt hydrates are nowadays available (Fig. 5.27).
Phase change materials store heat isothermally, which means that the temperature of the material does not change. Instead the PCM changes its physical state in the case of heat absorption (latent heat storage). The advantage of this process in contrast to sensible heat absorption is that more energy can be stored without causing an increase of the material's temperature. Micro-encapsulated components, in particular, are beneficial since they can be worked on site. Gypsum plaster boards with PCM additive can be worked and installed in the same way as plaster boards without the additive. By retrofitting PCMs, it is pos-sible to passively reduce the peak temperatures in a building and improve the thermal comfort without increasing energy use. Since the thermal energy is only stored and not discharged, an opportunity to remove the heat must be provided at a later time during the day. Night-time ventilation is a perfect way to discharge thermal loads.

5.25

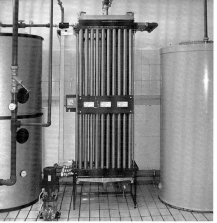

5.26

5.27

5.23 CO_2 concentrations in room air dependent on activity and volume flow of fresh air
5.24 Typical development of air temperature in rooms with and without latent heat store (PCM)
5.25 Fresh water unit
5.26 Wastewater heat exchanger
5.27 System ceiling element with integrated latent heat store based on salt hydrate

Building management

The building management of a property includes all services that are necessary to operate and manage buildings (including all structural and technical plant). The aim of building management is the maintenance of the building and the continuous optimisation of operating conditions.

All services can be assigned to one of the three categories, technical, infrastructural and commercial building management. In addition, there are interfaces to floor-space management and facility management.

The aim of quality management is the continual analysis and improvement of the quality, security and availability of all service processes as well as their environmental compatibility (see GEFMA 700). The task of optimising the running costs of all services by reducing the processing costs is also amongst the responsibilities (see GEFMA 200, DIN 18960).

Building automation

Building automation and control (BAC) in compliance with DIN 276 and DIN 18386, plays a key role in relation to the economy of the building's operation as well as issues concerning the conservation of the environment and resources. The term building automation and control covers all installations and services concerned with automatic control. These systems facilitate the monitoring and optimisation of building services as well as their management for a more energy-efficient and safe operation. In buildings with complex building services concepts, BAC is the essential tool for technical building management (TBM) during the building's useful life. With the support of TBM, the building infrastructure, such as energy supply and communications, can be monitored. The building services, heating, cooling,

ventilation and air conditioning, power systems, sanitary matters, and information technology as well as building automation, are subject to constant change. The developments in information technology are naturally having the largest impact. Once included in building monitoring and control engineering, building automation and control is now regarded as a separate trade in the construction industry (DIN 276, Cost group 480). This fact has also been recognised in the update of the HOAI 2009.

The technical calculations and data from the planning and construction phase serve as the basis for operating the building and its plant. It follows that building automation systems can ensure effective management of the technical installations thus leading to high energy efficiency. Integrated energy saving functions and programmes can be compiled based on the actual use of a building. This approach prevents unnecessary amounts of energy being wasted and CO_2 emissions causing harm.

It is possible to forward information from the building automation and control system, for example energy consumption data, to the commercial and infrastructural building management as a basis for budgets and cost sheets. Data and information required for integrated building management purposes in the context of life cycle planning should be captured and then processed by this central planning, control and information system. The functions of technical building management also include supplying information regarding the maintenance of plant or building. Furthermore, through continuous measurements and the corresponding documentary evidence, it is possible to detect malfunctions in plant operation and to forecast trends concerning energy consumption. These additional supportive measures, which include taking measure-

ments, making corrections and taking precautions to improve the energy efficiency of the building are referred to as energy management.

The effects that building automation and control systems and building management have on the energy efficiency of the building can be determined according to DIN EN 15232 either by using a detailed procedure or the BAC efficiency factor process (Fig. 6.1). With the help of the latter, more simple procedure, it is possible to quickly evaluate the efficiency of the BAC system and the technical building management. This procedure applies BAC efficiency factors that relate to the annual energy use of a building (heating, cooling, air supply and lighting equipment).

The BAC efficiency factors have been established for different building types according to DIN EN 15217. This was achieved by characterising every type of building with a standardised user profile (number of occupants and internal heat gain). The defined BAC efficiency classes A, B, C and D are categorised according to different levels of automation accuracy and quality. In this case, the effects the different climate conditions have on the BAC factors are neglected.

Building automation and control efficiency classes

Figures 6.2 and 6.3 display how the individual functions are assigned and the effect they have on the energy efficiency of the building. They are divided into three groups: functions for automatic control, functions for home and building automation systems and functions for technical building management.

The four different BAC efficiency classes (A, B, C, D) are defined for non-residential buildings and residential buildings as follows:

Efficiency class D applies to BAC systems that are not energy efficient. Buildings with such systems need to be refurbished. New buildings may not be built with systems of this type.
Efficiency class C applies to standard BAC systems.
Efficiency class B applies to advanced BAC systems and some particular TBM functions.
Efficiency class A applies to highly energy-efficient BAC systems and TBM.

By using higher building automation and control efficiency classes, i.e. better and more precise control functions, energy savings can be achieved within the overall system. The potential savings can be determined by applying the BAC efficiency factors. The possible potential savings for non-residential buildings are listed in Figures 6.4 and 6.5 (p. 130). If, for example, BAC systems with the efficiency class A are used in place of efficiency class C, the savings potential for thermal energy ranges between 14 % (hospital) and 50 % (lecture hall) (Fig. 6.4). In the case of electrical energy, the savings range between 4 % and 14 % (Fig. 6.5).

Functions, operation and maintenance of building automation systems
Fully or partially automatic operation modes are suitable for professional building management systems, especially those aimed at safe management strategies. Criteria to decide on the type of operation could, for example, be economic cost comparisons but also the maximum acceptable time period between identification of a fault in the operating sequence and having it resolved.
Software solutions, which are a compilation of standard modules selected according to the requirements of the owner or the type of operation, support the building operation. The BAC functions (input and output functions, monitoring, controlling, regulating, optimising, etc.) are described in detail in VDI 3814, Page 1. The plant specific functions can be recorded in schematic automation diagrams, in control diagrams or the BAC function list, preferably in form of an estimating table suitable for further data processing. Further functions of technical building management are supported and provided through BAC systems.
For the safe and economical functioning of the building services systems, depending

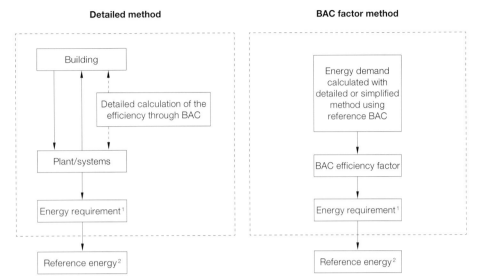

Detailed method **BAC factor method**

[1] Energy requirement for heating, cooling, ventilation, domestic hot water supply or lighting
[2] Reference energy is the total amount of energy, specified for each energy medium (gas, oil, electricity, etc.)

6.1

| | Definition of efficiency classes | | | | | | | |
| Ventilation and climate control | Residential building | | | | Non-residential building | | | |
	D	C	B	A	D	C	B	A
Controlling the airflow at room level								
0 No control								
1 Manual control								
2 Time dependent control								
3 Presence dependent control								
4 Demand dependent control								
Controlling the airflow at air handling plant level								
0 No control								
1 Time dependent on/off control								
2 Automatic flow or pressure control with or without pressure reset								
Defrosting control of the heat transfer medium								
0 No control of defrost processes								
1 Control of defrost processes								
Overheating control of the heat transfer medium								
0 No control of overheating								
1 Control of overheating								
Free mechanical cooling								
0 No control								
1 Night-time cooling								
2 Free cooling								
3 hx assisted control[1]								
Control of forward flow temperature								
0 No control								
1 Uniform reference value								
2 Variable reference value with adjustment according to outside temperature								
3 Variable reference value with adjustment according to heat load								
Control of air humidity								
0 No control								
1 Limits to humidity level of supply air								
2 Control of humidity level of supply air								
3 Control of humidity level of room or waste air								

[1] hx = Enthalpy humidity reference value, with h = enthalpy and x = (absolute) humidity

6.2

6.1 Detailed method and BAC factor method to calculate the impact of automation systems on the energy efficiency.
The arrows merely illustrate the calculation process and do not represent the energy flow and/or mass flow.
6.2 Funtional list and assignment to the BAC energy efficiency classes according to DIN EN 15232

| Lighting control | Definition of efficiency classes | | | | | | | |
| | Residential buildings | | | | Non-residential buildings | | | |
	D	C	B	A	D	C	B	A
Control according to lighting level								
0 Manual on/off switch								
1 Manual on/off switch + additional auto off signal								
2 Automatic detection Auto on/dimmed								
3 Automatic detection Auto on/off								
4 Automatic detection Manual on/dimmed								
5 Automatic detection Manual on/auto off								
Daylight control								
0 Manual								
1 Auto								
Sun protection control								
0 Manual operation								
1 Motorised operation with manual control of lamella								
2 Motorised operation with automatic control								
3 Combined control of lighting/anti-dazzle/heating, ventilation and air condition plant								
House automation system/building automation system								
0 No house automation/no building automation								
1 Centralised adjustment of the house automation system/building automation system according to the requirements of the occupants: e.g. time schedule, reference values, etc.								
2 Centralised optimisation of the house and building automation system: e.g. coordination of the controlling device, reference values, etc.								
Technical house and building management								
Detection of faults in the house/building's technical facilities and support of trouble shooting procedures								
0 No								
1 Yes								
Information on energy consumption, room conditions and possibilities for improvements								
0 No								
1 Yes								

6.3

| Non-residential buildings | BAC efficiency factors, thermal | | | |
| | D | C | B | A |
	Not energy efficient	Standard (reference value)	Increased energy efficiency	High energy efficiency
Offices	1.51	1.00	0.80	0.70
Lecture halls	1.24	1.00	0.75	0.5[1]
Educational institutions	1.20	1.00	0.88	0.80
Hospitals	1.31	1.00	0.91	0.86
Hotels	1.31	1.00	0.85	0.68
Restaurants	1.23	1.00	0.77	0.68
Buildings for wholesale and retail	1.56	1.00	0.73	0.6[1]
Further types (sport facilities, warehouses, industrial institutions, etc.)		1.00		

[1] These values are extremely dependent on the heating/cooling demand for the ventilation

6.4

| Non-residential buildings | BAC efficiency factors, electrical | | | |
| | D | C | B | A |
	Not energy efficient	Standard (reference value)	Increased energy efficiency	High energy efficiency
Offices	1.10	1.00	0.93	0.87
Lecture halls	1.06	1.00	0.94	0.89
Educational institutions	1.07	1.00	0.93	0.86
Hospitals	1.05	1.00	0.98	0.96
Hotels	1.07	1.00	0.95	0.90
Restaurants	1.04	1.00	0.96	0.92
Buildings for wholesale and retail	1.08	1.00	0.95	0.91
Further types (sport facilities, warehouses, industrial institutions, etc.)		1.00		

6.5

on the degree of automation, a BAC system is required that is accessible, functional and trouble-free in operation. The functionality of all components can be impaired due to age, wear and tear or damage. For this reason, it is necessary to service and maintain all components, assembly groups and systems. The following criteria are fundamental for the cost optimisation of a building management system:

- Clear definition of services between the development and the operation phase by defining and allocating the services and interfaces in an unambigious way.
- Detailed tendering and commissioning the services concerned with the commissioning, acceptance and documentation work as separate items or units.
- Extensive and fault-free acceptance and taking over of the plant according to components, systems, quality of workmanship and the functions after the execution and commissioning of the plant.
- The necessary maintenance and servicing work is to be determined by the owners, users and occupants in consideration of the demands concerning quality and availability.
- The extent and intervals of services are be planned individually according to VDMA 24 186.

The term "operation" includes all services that are necessary for and during the utilisation of a building. They are generally described in an operation manual which determines the requirements placed on superior tools such as CAFM (Computer Aided Facility Management) systems. The resulting definitions of the project targets with the corresponding interfaces should be implemented practically during the execution phase of the project.

The operation of the building's technical facilities requires instructed, trained and qualified staff. From an organisational viewpoint, it is necessary to distinguish between:

- Operation with own staff (owner-operated)
- Operation with external staff (externally operated)
- Combinations of owner operated and externally operated

6.3 Funtional list and assignment of the BAC energy efficiency classes according to DIN EN 15232
6.4 BAC/TBM efficiency factors, thermal (non-residential buildings) acc. to DIN EN 1523
6.5 BAC/TBM efficiency factors, electrical (non-residential buildings) acc. to DIN EN 1523

Interface concepts, documentation
The interface between the installed technology, the building structure and the organisational processes is fundamental for the operation of the technical facilities with regard to the wellbeing of the user and concerning economic aspects. Interface concepts must consider the built structures and the technical systems in equal measure. The structural interfaces, for example, have effects on the performance specifications in the tenders. The more complex the relations are between the interfaces (also regarding shipment and performance specifications), the more important it is to designate a single individual amongst the project participants to be responsible to manage the specific task. In order to have a properly structured and efficient work flow, it is necessary to provide constantly updated documents regarding all technical facilities. These documents are needed to run the technical equipment and must be accessible for the technical maintenance service team at all times. In order to ensure good integration of the automation functions into the superior coordinating level, it is important that the data point addresses (see VDI 3814) are standardised. The performance of maintenance and servicing work should always be recorded and documented accordingly.

Computer-Aided Facility Management (CAFM)

The focus of facility management is, amongst other things, the holistic approach to buildings throughout their entire life cycle. From the building's utilisation phase onwards, the CAFM system takes on central functions, which are depicted in modular applications. The aim should be to link the information from all systems that are part of the building services (air supply technology, building automation, mechanical conveying and handling, security technology, etc.) in one single management system. The information is exchanged amongst the various systems via interfaces or integrations. Prior to the introduction of a CAFM system, the planner must come to an agreement with the user regarding all the desired and required features and operation sequences. The development of these objectives should then be coordinated in consultation with the company's existing organisational units (EDP, construction, technology, controlling, etc.). In this context, it is important to make sure that the

CAFM processes and modules are described clearly. The following are examples of modules that have an important link to building automation:

Maintenance management
The module "maintenance management" is generally used to prepare and administer job orders as well as to plan, control and monitor maintenance work. The BAC system generates static or dynamic intervals for the timing of inspection, servicing or maintenance work. The administration of the spare parts inventory and material release orders can also be a part of this module.

Energy management
The module »energy management« supports the operator to control and regulate the overall energy consumption and costs. In this case, the consumption of all mediums is considered, provided that appropriate metering devices were planned at an early stage and installed accordingly. The energy management system is a continuous cycle which includes taking measurements, analysing the actual situation, recommending possible measures, their implementation and performance reviews. The aim is to achieve continuous improvement in the efficiency of energy use and thereby secure energy savings. Furthermore, negotiations with energy suppliers can help to reduce supply costs.

Fault management
The module "fault management" includes the central administration of faults, warnings and trouble reports. It is possible to introduce different escalation levels for eliminating faults. The processing stage can be monitored and traced at all times by generating job orders with corresponding feedback mechanisms. In addition, there is an assignment to the appropriate cost centre.

Energy savings potential in buildings operation

The acceptance and taking over of technical work sections by the client or the operator are important phases within a construction project which must be considered carefully during the planning or contracting phase.

Commissioning, acceptance
VOB Part C (DIN 18386-3) usually forms

the basis for all work performed by the contractors of different work sections. With the acceptance of the work, the legal responsibility shifts to the operator. Each work section prepares its own inspection documents and as-built drawings to demonstrate that the requested functions have been fulfilled. However, these are generally only considered separately for each individual work section. An overall examination or acceptance, as would be appreciated by the planner and the client, does not usually occur. The company that, for example, installed the chilled ceiling with the appropriate hydraulics and control valves understands the work as being complete when the installation work is finished and a flushing report is issued together with the hydraulic calculation. The link between the different work sections, the BAC system with single room control, is the last element to be installed in the sequence of construction work.
However, only a comprehensive, trade integrating functional demonstration of all installations, including the interaction of electricity, air-conditioning and ventilation plant, refrigeration machines, chilled ceilings, sun protection devices, lighting and room automation, really shows whether the interfaces of the work sections have been properly carried out. A comprehensive, trade integrating acceptance test is not explicitly mentioned in the VOB. For this reason, it is important to already consider one in the tendering phase to avoid disputes on completion. Since comprehensive, trade integrating acceptance tests can only be performed after the completion of the building automation systems, the acceptance tests of all other work sections should be carried out as partial acceptance tests.
Taking the outside climate as an example, it is important to bear in mind that not all conditions occurring during the course of a year can be presented at a single time. For this reason, it is recommended to establish agreements for longer acceptance test periods (e.g. an operating year of the plant). Apart from individual checks (e.g. hydraulic balancing, measuring records, etc.), comprehensive functional performance tests should be carried out. These should include the examination of control mechanisms and control circuits based on the plant description and the defined plant parameters. For example, the smoke exhaust function of a mechanical air-handling plant can only be demon-

Optimising building operations

Room automation functions (according to LonMark)		Relevant for lighting energy	Relevant for heating/cooling energy
Lighting functions	Automatic lighting	▪	
	Daylight control switch	▪	
	Constant lighting control	▪	
Sun protection functions	Automatic thermal adjustment		▪
	Automatic sun protection	▪	
	Lamella adjustment	▪	
Room climate functions	Time programme for selection of energy level		▪
	Post occupancy evaluation		▪
	Window monitoring		▪
	Natural night-time cooling		▪
	Summer compensation		▪
	Load optimisation		▪

6.6

Room automation function	Savings[1]	Positive influential factors
Constant light control (incl. post occupancy evaluation)	35–50%	• good daylighting • high illuminance (> 300 lx) • particularly efficient with lamella adjustment
Automatic light (incl. post occupancy evaluation)	25–45%	• good daylighting • high illuminance
Automatic sun protection	5–8%	• good daylighting
Lamella adjustment	10–13%	• good daylighting • particularly efficient with artificial light control
Automatic lighting or staircase lighting	n/s	• low occupancy (e.g. in corridors)

a

Room automation function	Savings[1]	Positive influential factors
Timer programme for energy level	5–10%	• long operation periods for heating • low thermal mass
Post occupancy evaluation	5–10%	• longer absence periods when operating heating
Window monitoring	5–10%	• low thermal mass
Natural night-time cooling	n/s	• possible circulation of outside air
Summer compensation	n/s	• possible for all cooling systems
Load optimisation	n/s	• possible for all heating and cooling systems
Automatic thermal adjustment	5%	• good daylighting • exterior sun protection device
Time programme for sun protection	n/s	• reduces cooling period in night hours

[1] Savings potential in comparison to reference building according to DIN V 18599 or DIN EN 15232

b

6.7

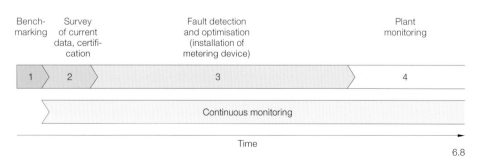

6.8

6.6 Energy relevant room automation functions
6.7 Room automation functions
 a to save energy used for lighting
 b to save energy used for heating/cooling
6.8 General method for energy monitoring
6.9 Annual energy demand of an office building with and without room automation

strated if a signal from the fire-alarm centre is triggered and connected, and the servomotor of the ventilation flap in the facade allows for an inflow of supply air. The documents must be presented on the acceptance date and, it goes without saying, a few random checks should also be performed.

Works acceptance by the operator
If the plant is to be accepted by the operator, the operator's staff should be briefed and, if necessary, given advance training. In this case, the following aspects should be considered:
• The complexity of the building automation defines the extent of the necessary briefing or training sessions.
• The as-built drawings, the functional descriptions and the minutes from the acceptance tests should have been completed and handed over.
• In the case of new plant, the briefing and training of staff should be accounted for in the tender
• If several different automation systems are being used, for example EIB and LON, it might not be possible to control the BACS in a comprehensive and uniform way. In this case, the briefing or training of staff should be performed in accordance with the operator's concept.

Energy savings potential during operation
Potentials for energy saving can, amongst other things, derive from the control options offered by technical systems, as are presented in Figures 6.2 and 6.3. Figure 6.6 shows the systems which, according to LonMark Deutschland [1], are defined functions of room automation and have an influence on the energy efficiency. The individual room automation functions can be divided into two groups according to their effect (Fig. 6.7):
• Functions that primarily reduce the demand for electrical energy used for lighting.
• Functions that reduce the energy demand for heating or cooling.

Room and building automation systems employing bus technology can, through consistent application of efficiency increasing control strategies, achieve a much greater effect than other measures. And because they are so cost effective, the systems are particularly suitable not only in new builds but also in existing buildings as a modernisation measure.

y applying a room automation system, it s possible to reduce the energy consumption in an individual room, i.e. at the place of the energy transfer, by linking the functions room climate control, lighting control and sun protection.

This provides the facility to adapt the energy input to the actual use (number of occupants) and the user behaviour (e.g. window ventilation). The next level is to control the primary systems. Due to the optimised demand situation concerning the room automation, the task here is to reduce loss during the generation and distribution.

An optimised control system can halve the primary energy demand of a building (Fig. 6.9). Model calculations prove [1] that an efficient room automation system for an office building promises to be extremely cost effective from the commissioning onwards, despite the higher investment costs in comparison to those of a reference building.

The investment costs for such an automation system are around 500 to 700 Euro more per office than those for a conventional installation. For an amortisation period of ten years and an interest rate of, for example, five per cent, the investor faces additional financing costs of approximately 70 to 100 Euro per year. On the other hand, by installing an automation system, the energy costs for heating, cooling and lighting can be reduced by approximately 140 Euro per office and year (from approx. 330 Euro in a non-automated building to approx. 190 Euro). The overall result is an annual saving of 40 to 70 Euro per office. A conventional office building built according to the current low-energy standards (as of 2009) was used to perform the model calculations. The energy input was merely reduced by installing an optimised room automation system. The savings were then determined according to DIN V 18599 as well as DIN EN 15232. They are allocated as follows:

- 60 % of the lighting energy can be saved by integrating sun protection devices with lamella adjustment, constant lighting control as well as post-occupancy evaluation which automatically switches off lights in rooms no longer occupied.
- 25 % of the energy for heating and 40 % of the energy for cooling can be saved by adjusting the set values according to time and number of occupants, shut-

ting down the energy flow when opening windows and supporting the heating or cooling processes by using the sun protection devices in unoccupied rooms. In this case, the impact of constant lighting control on the energy demand for heating and cooling has been considered.

Energy monitoring

Energy monitoring is the basis for controlling and optimising energy consumption in buildings and properties. It is the most fundamental tool for systematically and permanently anchoring the control and optimisation of energy consumption in building operations.

The monitoring starts with the planning concept for the installation of meters and, apart from involving regular evaluations of the measuring results, the compilation of consumption records and energy reports, also includes controlling at a management level (Fig. 6.8).

The basis for energy management is a survey and analysis of the current situation and the energy consumption in order to identify weak points and sources of loss within the technical systems and to pinpoint areas with savings potential.

Amongst other things, the amounts of energy consumed as recorded by internal metering equipment are very important. These figures make it easy to ascertain the causes for large consumption and, at the same time, identify long-term consumption trends. When developing an energy monitoring system, the specific framework conditions of the building must be considered, for example the organisational structure of the consumers and the individual cost items. The consumption data is collected at regular intervals, documented and, finally, evaluated according to technical and commercial aspects. In order to determine targets and to evaluate the results, it is advisable to define characteristic figures and reference values (benchmarks). These values allow comparisons to be made with other buildings. Finally, based on the data collection and the defined targets, specific measures for a more energy efficient operation can be developed. Energy controlling ensures the systematic and continuous evaluation of the regularly measured energy consumption and, at the same time, the monitoring of the set targets. It facilitates the assignment of a specific energy consumption to the indi-

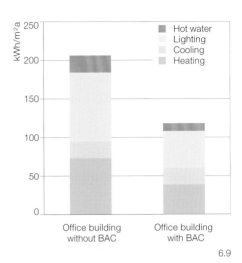

6.9

vidual cost unit and the identification of deviations from the predetermined values. The efficiency of the developed measures can be checked immediately and new measures can be developed and implemented in order to reduce the energy consumption and resulting costs even further. Due to the recording and evaluation of, for example, the outside air temperature, the energy consumption values that are immediately dependent on this outside temperature (i.e. heat load) can be adjusted within the system. This procedure facilitates direct comparisons with, for example, the building data from other heating periods. Deviations in the energy consumption can be singled out immediately and at short notice. Energy budgets for certain consumers can therefore be determined well in advance.

Automated energy controlling requires special metering devices. Bus systems for remote meter reading are advantageous since they have lower error rates in comparison to pulse counters. Software that is installed on the computer of the service provider appointed with the energy monitoring, collects all the meter data remotely via networking technology and evaluates the received information. The results are finally issued in tables and in graphical form.

Due to the complexity of monitoring systems and the relatively high investment costs, automatic energy controlling is currently only used in large buildings or properties. It goes without saying that monitoring systems already provided should be integrated in the building automation and control system.

Notes

[1] LonMark Deutschland e.V. (ed.):
 Energieeffizienz automatisieren. Aachen 2009

In recent years, there has been a continual increase in the demands made on buildings' technical installations and systems. The population growth in many regions around the world, together with the resulting scarceness of resources and the consequences this has regarding the climate, also have an impact on construction processes. In future, buildings will have to be planned and operated to more sustainable standards. These developments pose new challenges for the planning of technical facilities and particularly for their interaction with architecture.

A thorough analysis of the environmental factors and the proposed utilisation is absolutely essential for the optimisation of today's building services systems. Site specific factors such as solar radiation, shading, thermal and ventilating features can already be checked during the planning process by using simulation tools. These planning tools will become more and more important in the building industry in the coming years. It is already possible today, with just limited technical input, to develop and operate energy autarchic buildings (zero energy houses), while, at the same time, satisfying all requirements regarding comfort. This is achieved by having an overall concept which links the building envelope, the plant technology and a means to optimise operations. For this purpose, the joint development of an energy concept is an important planning and communication tool.

There have been significant developments in energy saving strategies and the efficient use of energy in recent years. Despite this, there remains great potential for further advancements to reduce emissions during the construction and operation phases of buildings. The standard for the future development of buildings, apart from a minimised energy demand, will be a zero-emission operation, as well as the total recyclability of the building.

Despite the increasing efficiency of buildings, heat supply will continue to play a key role in building services in years to come. Alternative energies such as ground and ambient heat, solar energy and biomass will replace fossil mediums, which still form the basis of most supply systems today. Careful consideration needs to be given to the pros and cons of competing technical systems and individual comparative analysis is necessary if these are not readily apparent. Low-temperature heating systems (additive and component integrated solutions) should be used with heat generators suited to the plant. A storage concept must be developed if the periods of heat generation and heat consumption do not coincide. Mini heat generators, such as a fuel cell, that supply a single-family home, could in future be linked with other decentralised heat generators to form a virtual power station. For the future energy and heat market, it will be of significant value to compile up-to-date forecasts concerning heat generation and load distribution as a basis to control the corresponding systems.

In order to implement perfect cooling strategies, methods to minimise cooling loads need to be considered during the planning phase of the building. Ideally, natural heat sinks should be used to remove heat. In the near future, cooling concepts will focus on a greater use of phase change materials. PCMs offer the possibility of storing heat at great density for an interim period without actually increasing the temperature of the heat store. This interim storage facility permits the efficient use of natural heat sinks, such as low outside air temperatures during the night. Against the backdrop of increasing global warming, future research programmes will soon start to focus more on solar cooling systems. For example, sorption refrigeration plants based on solar energy are not suitable for hot-dry regions since they must be recooled. This recooling is currently still being performed by evaporation of the scarce water resources. Future systems will not consume water, even when the outside temperatures are high. Furthermore, small solar cooling systems for decentralised applications will become available on the market. From an ecological viewpoint, these will be a sustainable alternative to electrically powered compression cooling systems.

The controlled supply and discharge of air is an important technical component, especially in buildings with high energy efficiency. The use of multi-gas detectors in office buildings with demand-controlled ventilation systems will increase over the next few years. Apart from measuring the quantities of pollutants, future research institutes will focus their attention on the perceived room air quality. Air quality sensors will also be available to measure and monitor the air of decentralised air-handling plants in residential buildings. Furthermore, the importance of combining ventilation and heat storage will increase. The application of PCMs to store heat produced during the day will play a key role in raising the efficiency of night-time ventilation concepts.

In the future, electrical energy will in all probability advance to be the most important form of energy. Electrical energy is flexible in the ways that it can be used. Furthermore, it can be generated from different renewable energy sources (wind, water, geothermal energy, photovoltaics, combined heat and power generation based on biomass) by using a number of different technologies. However, in the direct context of building planning, the number of relevant systems reduces to combined heat and power generation and photovoltaics. Given the impact in terms of design, the latter imposes special challenges on the interdisciplinary planning process.

In the meantime, the provision of clean drinking water has become a real challenge in many regions. It goes without saying that drinking water should always be used sparingly. The possibility of installing water-saving fittings should be examined carefully. It is also necessary to consider the sewage system and reduce the quantity of wastewater. Even if today greywater and rainwater utilisation plants can be used economically only in very rare cases, these systems will nevertheless in the future become important components of sustainable concepts in building services.

Analyses of completed projects show that it is necessary to adapt the energy concept and its technical features to the building and its individual characteristics to a greater degree than has been the case up until now. Numerous systems using heat pumps, solar technology and biomass heating systems have proven successful in practical applications. Heat recovery, in the case of air handling units,

is a standard feature nowadays. In years to come, technical concepts will be influenced less by technological innovation, instead the focus will be on the effective linking of existing systems and their alignment with the building's usage.

When optimising existing technical facilities, the first aim should be to adapt the system to reflect the current state of technology. Pipelines should be flushed, hydraulically balanced as well as insulated. The legally required retrofitting of thermostatic valves should be performed and inefficient system components should be replaced. With a view to further optimisation, additional components can be integrated into the overall concept as a next step. The possibilities include, for example, the retrofitting of a wastewater heat exchanger or the utilisation of available hot wastewater to operate a heat pump. The integration of a fresh hot water system is also an interesting aspect in the case of refurbishments. It is often necessary to make extensive alterations to an existing building, when the objective is to create the right conditions for the future integration of highly efficient technical components. The use of innovative, efficient technologies, such as zeolite heating units, which will be available on the market in due course, only makes sense if the existing building services have been perfectly planned and installed, and are therefore highly efficient.

It is possible today, within the scope of the generally accepted planning criteria, to minimise technical plant and reduce operating costs. In terms of conservation of resources and the environment as well as profitability, building automation is gaining importance. A holistic automation

concept is an indispensable ingredient for the functionality and operability of technical building systems covering heating, cooling, air supply, electricity and sanitary installations. At the same time, it is a tool for the technical building management and monitors facilities that form part of the building infrastructure, such as the energy provision, communication and security. Further measures concerning energy optimisation will emerge as soon as it is possible to integrate weather forecasts into the controlling strategies of heating and cooling systems and connect them with the automation of the specific technical building facility. However, in the future it is not just the equipment within a building that will be networked. Buildings will also communicate with other buildings within the same district. The aim will be to control existing plant in an optimal way by means of autonomous IT systems and, as a result, to use resources efficiently over a range of different buildings.

Glossary

Absorption
Bonding of atoms, ions or molecules within an enclosed volume of an absorbent material.

Accumulator
Rechargeable, usually electrochemical, storage device for electrical energy.

Adsorption
Accumulation of a gas or a liquid to the surface of a solid material.

Air extraction system
Device that actively extracts exhaust air out of the building's interior with the support of an air handling unit. Supply air is drawn in passively due to the negative pressure created.

Air supply and discharge system
A system which actively removes waste air out of the building and actively draws fresh air into the building.

Air volume flow (m³/s or m³/h)
A volume of air transported within a defined unit of time.

Amorphous silica (a-Si)
Non-crystalline silica with non-aligned structure of atoms for the manufacture of thin-film solar cells.

Annual performance factor β (–)
To evaluate the energy efficiency of heat pumps the annual performance factor is used. It describes the ratio between the supplied heating or cooling capacity (heat) and the necessary energy input to drive the heat pump (e.g. electrical energy) during the course of a year. The annual performance factor is therefore a value to describe the overall efficiency of a heat pump over a year.

Base load
Minimum consumption of energy which is not undercut during a defined time period. If the base consumption level is exceeded, peak load supply systems are used to cover the additional requirements.

Building automation and control (BAC)
All systems used to control, regulate, monitor and optimise the building automatically with regard to all building services aspects. BAC is an important component of technical facility management.

Carnot process
The Carnot process is a theoretical, thermodynamic cycle. The Carnot efficiency, derived from the working temperature, defines the maximum proportion of thermal energy that can be converted into mechanical work.

CFD simulations
Computational Fluid Dynamics (CFD) is a method used to simulate airflows inside and outside buildings.

Coefficient of Performance (COP)
Similar to the efficiency level, the COP is an indicator used to evaluate the efficiency of energy conversion. It is used in particular for heat pumps and refrigeration machines. Regarding heat pumps, the coefficient describes the ratio between the output of useful heat and the input of (e.g. electrical) energy including ancillary energy under standard conditions. A COP of 2.0 means that twice as much energy is generated as is invested to drive the heat pump. It is only a value to understand the efficiency of the device. The COP does not give an indication of the system's overall efficiency.

Colour solar cells
Nanostructured solar cells based on the semiconductor titanium dioxide and an organic colourant.

Combined heat and power (CHP)
Simultaneous generation of electricity and heat. Usually by applying a motor driven generator which also makes use of the waste heat by installing a heat exchanger.

Combined heat, cooling and power (CHCP)
Simultaneous generation of electricity, heating and cooling. In most cases, this is a system to generate heat and power with an added component to generate cold by making use of the waste heat.

Computer Aided Facility Management (CAFM)
Software support for facility management. Information from databanks is provided and processed for the different facilities.

Cooling load
The heat load that must be removed from interior space to maintain or achieve a defined condition. The cooling load is a mixture of internal and external heat loads.

Copper indium diselenide, copper indium disulfide (CIS)
Semiconductor material for thin film solar cells; optionally gallium can be used as an alloy.

Desorption/desorb
Separation of substances after successful absorption or adsorption as a part of a thermodynamical process. An input of energy (e.g. thermal energy) is generally required for this process.

Diffuse solar radiation
Proportion of non-directional solar radiation which is scattered in the atmosphere before reaching the Earth's surface.

Direct solar radiation
Proportion of direct solar radiation which reaches the Earth's surface directly without being scattered in the atmosphere and casts hard shadows.

Downstream heater coil
Air heating in the air inlet of a ventilation plant, which ensures an adequate temperature of the supply air, even at low outside temperatures.

EC motor
Electronically commutated, brushless DC motor. In comparison to other motors, this one is advantageous in terms of its service life, controllability and economic efficiency.

Eco efficiency
A still fairly undefined unit for the relation between the economic useful value of a product and the impact it has on the environment due to the manufacturing process.

Efficiency ratio (%)
The efficiency ratio describes the relation of the useful output (use) to the total input (expenditure) under standard conditions. Theoretically efficiency ratios must be below 100%, however, in the case of, for example, condensing boilers, the efficiency ratio is often stated to be above 100%. The energy input refers to the net calorific value of the fuel; in addition, the condensation heat of the waste airflow (gross calorific value) is used in the conversion process.

Energy
A physical factor describing the stored work of a system. Energy can neither be generated nor consumed, merely stored, transported or converted from one physical state, e.g. electrical or radiant energy, into another. The benefit value can deteriorate due to transformation or transportation processes, since the conversion does not work in all directions. Apart from the base value joule (J), the value kilowatt-hour (kWh) is often used in energy supply.

Energy medium/energy source
In the truest sense, these are resources found in nature, which can be used to generate energy due to the convertibility of their chemically or nuclear-stored energy (biomass, fossil or nuclear fuels). However, in general linguistic usage, energy sources such as solar energy, geothermal energy, wind or water power are included, despite them being a physical medium of thermal, potential or kinetic energy.

Energy payback time, energy amortisation period
Period required for an energy generating system to harvest the same quantity of energy as was invested in its production. On conclusion of the energy payback time, a system holds a positive energy balance.

Feed-in tariff
The payment plant operators receive from grid utilities for feeding generated electricity into the public grid. In Germany, the minimum rates are determined by the Renewable Energy Sources Act (EEG).

Final energy (J)
The quantity of energy that can be provided to the end consumer at the place of consumption after subtracting the loss through conversion and distribution, e.g. in the form of electricity, wood pellets, heating oil or long-distance heat. The final energy usually serves as a basis for energy cost calculations.

Final energy consumption (kWh/a)
In contrast to the final energy demand Q_e, the final energy consumption is the actual amount of energy consumed according to measurements taken in the building. It considers, for example, the occupier's behaviour and climatic fluctuations. Physically, however, this term is not correct. According to the energy conservation law, energy cannot be consumed in a closed system, but only converted from one state of energy to another.

Final energy demand Q_e (kWh/a)
Amount of energy required to provide useful energy (e.g. heating, domestic hot water, lighting, etc.) in a building. The final energy demand Q_e is a value which has been determined according to the EnEV. It considers the occurrence of loss due to transfer, distribution, storage and conversion. The value is for standardised conditions (e.g. defined user behaviour, inside temperature, etc.) but differentiated according to the applied energy medium. It is set according to the specific building's system limit.

Flood vents
Openings in walls or doors that, in the case of a controlled building ventilation system, function as a connector between air supply and air discharge zones

Forward flow
Temperature level of the heat transfer medium (usually water) in the circulation system after leaving the heat generator (see return flow).

Global radiation
The total of direct, diffuse and reflected radiation received on horizontal ground of the Earth's surface.

Global Warming Potential – GWP 100 (kg CO_2-eq)
The increasing concentration of greenhouse gases in the troposphere, due to a higher reflection of infrared radiation, is the cause of global warming. The global warming potential considers all greenhouse gases in relation to the effect of CO_2. Since the harmful gases remain in the troposphere for different periods of time, the considered time span must be stated. A time horizon of 100 years is commonly used.

Heat demand Q_H (kWh/a)
The calculated quantity of energy necessary to cover the heat loss at a defined inside temperature during the heating period of a building. It is calculated in accordance with the transmission and ventilation heat loss Q_v less the solar and internal heat gains.

Heat load ϕ_{hl} (kW)
The amount of heat required to maintain the defined inside temperature specific to the building under the most unfavourable conditions. The heating load calculation is usually performed for each individual room of the building. For this reason, it is necessary to determine the heat transfer requirement (loss through the building envelope) and the ventilation heat requirement. Internal and solar heat gains are not considered in the calculation. The heat load is the basis for dimensioning radiators and the heating system.

Heat recovery factor
Value to define the efficiency of a heat recovery system. It is generally applicable for heat exchangers in ventilation plants.

Inverter
Electrical device used to convert solar-generated direct current into conventional alternating current.

Kilowatt hour (kWh)
Unit for work and energy.
1 kWh = 3600 Ws = 3600 J.

Mesoclimatic site factors
Compilation of different site specific climatic factors. The area of a mesoclimate ranges between several hundred metres and a few hundred kilometres.

Metabolic equivalent (MET)
Unit that compares the energy consumed when performing different physical activities.

Microcrystalline silicon (µc-Si)
Silicon with very fine crystalline structure for thin film solar cells.

Micromorph silicon (a-Si/µc-Si)
Combination of amorphous and microcrystalline silicon in thin film solar cells.

Monitoring
Includes all types of activities concerned with the systematic recording of data, observation or monitoring of a procedure or process by means of technical device or other observation systems.

Monocrystalline silicon
In contrast to polycrystalline silicon, a homogeneous, silicon consisting of one single high-quality crystal used to manufacture wafers as a basis for solar cells.

Nano solar cells
Solar cell type based on nano-structured semiconductors that can be manufactured quickly and with low energy expenditure by using an inexpensive printing procedure, e.g. coloured, organic or CIS nano cells.

Net calorific value (J/kg or J/m³)
A measured unit for the amount of heat released by a substance during combustion. In this case, only the useful amount of heat is considered, i.e. the heat of vaporisation of the produced water vapour is subtracted. To make comparisons between the calorific values of different building materials, the following values of different fuels may be found useful: wood 7–16 MJ/kg, lignitic coal 29.9 MJ/kg, crude oil (at 25°C) 42.8 MJ/kg and natural gas (at 25°C) 35–45 MJ/m³. The gross calorific value includes the heat of vaporisation.

Olfactory comfort
Criterion for the quality of room air with regard to unpleasant smells.
(olf = unit to measure the strength of air pollution)

Organic solar cells
Nano solar cells based on semiconducting plastics or polymers.

Peak load
Required heating or cooling output for extreme boundary conditions (see base load).

Performance Ratio
Evaluation criterion defining the quality of a device generally independent of the location, orientation, module efficiency and size of the generator. The value refers to the ratio between the actual and the theoretical yield under standard test conditions.

Pettenkofer limit
Describes a CO_2 content of 1000 ppm (0.1 volume per cent). It is named after Max Josef von Pettenkofer who, in the 19th century, set up standards to evaluate building interiors from a hygiene viewpoint.

Photovoltaics (PV)
Immediate transformation of light into electrical energy by means of solar cells.

Plant efficiency factor e_p (-)
Characteristic value for the overall efficiency of technical building installations (e.g. heating system). It defines the ratio of useful energy to invested primary energy. Since renewable energies with their corresponding primary energy factors are also included in the calculation, the plant efficiency factor can fall below 1.

Power output
The power output defines the transformed energy during a period of time. To be precise, this is the performed work during a certain time span with the formula symbol P and the unit watt (W). Electric power is the product of voltage and current. In photovoltaics, the provided instantaneous power output is usually below the maximum possible nominal output.

Power-to-heat ratio
The percentage of electrical energy generated per kilowatt hour of heat in a combined heat and power system.

Primary energy (J)
The energy contained in energy media that are found in nature. These energy media include fossil fuels, such as coal, crude oil and natural gas, or minerals, such as uranium ore, as well as regenerative energy media, such as solar energy, wind, water, biomass or geothermal energy. Due to the transformation of primary energy into useful energy, which is eventually required by the consumer, loss occurs through the conversion or transformation processes.

Primary energy demand Q_p (kWh/a)
Before calculating the primary energy demand of a building according to EnEV, it is necessary to determine the energy demand. Loss through conversion is considered in the primary energy factor f_p. The relationship between final energy demand Q_e, primary energy demand Q_p and primary energy factor f_p is $Q_p = Q_e \times f_p$

Primary energy factor f_p (–)
Expresses the ratio between the invested non-renewable primary energy (including the losses through generation, distribution and storage) and the generated final energy. Typical primary energy factors are, for example, 1.1 for heating oil and natural gas, 2.7 for electricity or 0.2 for wood. The lower the primary energy factor, the more efficient the generation of energy is based on the corresponding primary energy medium.

Primary energy intensity PEI (MJ)
The primary energy intensity, also referred to as grey energy, includes the energy expenditure required for the production and utilisation of a product. All the quantities of energy that are required for the manufacture, transportation and storage (including all preliminary products) are considered. The smaller the value, the better the material as regards ecological aspects. The PEI is broken down according to the energy sources used for the production, i.e. into renewable and non-renewable energy media.

PV module
Packaged unit of several interconnected solar cells, which, according to the design, consist of a top layer, a compound material, solar cells, a back layer, a frame and an electrical connection.

Radon
Radioactive isotope, which diffuses from the ground when uranium and thorium, of which small amounts are contained in the ground, decay.
The concentration of radon is generally higher in South Germany than in North Germany.

Recuperative heat exchanger
In contrast to regenerative heat exchangers, which alternately channel hot and cold media, recuperative heat exchangers, e.g. plate heat exchangers, are provided with separate ducts for both media.

Reflection
In optics, reflection occurs when light is thrown back by the surfaces of two close media with different optical density. Angle of incidence, surface quality, wave length, polarisation and material property influence the degree and type of reflection.

Return flow
Temperate level of the heat transfer medium (usually water) in the circulation system before reaching the heat generator (see forward flow).

Room automation
An area of building automation which is responsible for the comprehensive control of all automated functions and tasks within the rooms of a building.

Secondary energy (J)
Secondary energy is the energy remaining after the conversion of primary energy into so-called useful

energy mediums such as electricity, heating oil, long-distance heat or wood pellets. It refers to the location where the useful energy medium is generated.

Semiconductor
Material whose electrical conductivity is intermediate at room temperature between that of a metal and a non-conductive insulator.

Solar constant
A unit for the, during the course of a year, practically constant intensity of solar irradiance reaching the ground perpendicularly at the edge of the earth's atmosphere. The mean value is defined as $1367\,W/m^2$.

Solar coverage rate
The percentage of the building's demand for thermal energy covered by the useful energy supplied by the solar system.

Sorbent
The function of a sorbent is to take up a substance within a phase (absorption) or at a contact area (adsorption). The sorbent material is either referred to as a sorbent or a sorption agent.

Sorption cooling machine
Refrigeration machine that in contrast to a (electrically driven) compression cooling machine is driven by thermal energy. Solar energy or waste heat from coupling processes can be used as the energy to drive the machine.

Specific transmission heat loss H_t (W/K)
Transmission heat loss occurs due to the thermal conductivity of all the space-enclosing surfaces of heated rooms (roofs, exterior walls, windows, doors and ground slab) and due to thermal bridges. The value therefore determines the quality of the building envelope in terms of energy. The geometry of the structure and the U values of the components influence the level of transmission heat loss considerably.

Stand-alone power system
Autarchic power supply system without connection to the grid in contrast to a grid-connected system.

Storage tank
Storage tanks are used in heating and cooling technology and are responsible for storing energy temporarily. The result is that the generation and consumption of energy can take place in a time-delayed mode.

Stratified storage system
This is a special type of storage tank. The input and output of water as the heat transfer medium is carried out according to temperature (warm water at the top, cold water at the bottom). This has the effect that large temperature differences can occur within the storage tank. Different heat sources (e.g. boiler, solar thermal collectors) can therefore feed into a stratified storage tank and different heating circuits can be connected (e.g. floor heating, domestic hot water).

Thermal labyrinth
Length of pipe required to precondition large volumes of supply air and usually installed below the ground slab. Due to the temperatures in the thermal labyrinth, air is precooled during summer and preheated during winter.

Thin-film technology
Manufacturing process of applying thin solar cells measuring only a few micrometers by using amorphous, micro-crystalline or micromorph silicon, cadmium telluride or copper indium diselenide/disulfide to panes of glass or flexible substrates (transparent or opaque foils) utilising different coating procedures.

Transformer
An electrical device that is used in technical building installations to increase or reduce alternating currents. Transformers are indispensable in power supply since electrical energy can only be transported economically over large distances by using high voltages. Electrical devices, however, can only be operated at low voltage.

Transmission
Permeability of a medium regarding the transmission of heat, light or sound.

Useful energy (J)
The energy finally used by the end consumer. In this case, the final energy is usually converted at a loss. The different types of useful energy include heat, cold, light, movement or sound waves. The useful energy is the basis for the calculation of the primary energy demand according to EnEV.

Ventilation heat loss Q_v (kWh/a)
Ventilation heat loss occurs when warm room air is replaced by cold outside air. For hygienic reasons, this air exchange is necessary to replace used air. In addition, uncontrolled ventilation heat loss, due to untight component joints, can increase the energy demand for heating considerably. Controlled ventilation and heat recovery systems can reduce ventilation heat loss.

Venturi effect
The velocity of an incompressible fluid flowing through a pipe is inversely proportional to the changing pipe section. The speed of flow is therefore greatest at the most constricted section of pipe. This so called Venturi effect can be used for ventilation purposes.

Watt-peak (W_p)
Watt-peak is a measure for the peak output at the maximum power point (MPP) and is usually determined under standard test conditions.

Wind shear
A difference in wind speed or wind direction between two defined points.

Yield
Yield defines the electrical energy provided and used by a PV array within a certain period of time. In the case of grid-connected systems which feed all of the generated energy into the grid, the yield corresponds to the value measured by the feed-in monitor. It is frequently referred to as the specific annual yield in reference to the nominal output and specified in kWh/kW_p.

Standards and guidelines

Comfort and building services
DIN EN 15251 Indoor environmental input parameters for design and assessment of energy performance of buildings addressing indoor air quality, thermal environment, lighting and acoustics. 2007
DIN EN ISO 7730 Ergonomics of the thermal environment – Analytical determination and interpretation of thermal comfort using calculation of the PMV and PPD indices and local thermal comfort criteria. 2006

Building services within the energy concept
DIN V 18599 Energy efficiency of buildings – Calculation of the net, final and primary energy demand for heating, cooling, ventilation, domestic hot water and lighting. 2005 and 2007
DIN EN 832 Calculation of energy use for heating, residential buildings. 2003
DIN EN ISO 13370 Draft Thermal performance of buildings – Heat transfer via the ground – Calculation methods. 2005
DIN EN ISO 13790 Draft Energy performance of buildings – Calculation of energy use for space heating and cooling. 2005
DIN EN 15217 Energy performance of buildings – Methods for expressing energy performance and for energy certification of buildings. 2007
DIN EN 15251 Indoor environmental input parameters for design and assessment of energy performance of buildings addressing indoor air quality, thermal environment, lighting and acoustics. 2007

VDI 3807 Part 4 Characteristic values of energy and water consumption of buildings – Characteristic values for electrical energy. 2008
VDI 3810 Operation of technical heating installations. 1997
VDI 6007 Part 1 Calculation of transient thermal response of rooms and buildings – Modelling of rooms. 2007

Costs and economic efficiency
DIN 276 Building costs. 2008
DIN 277 Part 1 Areas and volumes of buildings. 2005
DIN 18960 User costs of buildings. 2008

VDI 2067 Part 1 Economic efficiency of building installations – Fundamentals and economic calculation. 2000
VDI 2067 Part 2 Cost calculation of the heat supply plant – Room heating. 1993
VDI 2067 Part 4 Cost calculation of the heat supply plant – Domestic hot water supply. 1982
VDI 2067 Part 5 Cost calculation of the heat supply plant – Amount of steam in laundries, large kitchens and hospitals. 1982
VDI 2067 Part 6 Cost calculation of the heat supply plant – Heat pumps. 1989
VDI 2067 Part 7 Cost calculation of the heat supply plant – Block-type thermal power station. 1988
VDI 2067 Part 10 Draft Economic efficiency of building installations – Energy requirements for heated and air-conditioned buildings. 1998
VDI 2067 Part 11 Draft Economic efficiency of building installations – Method to calculate the energy demand of heated and air-conditioned buildings. 1998
VDI 2067 Part 12 Economic efficiency of building installations – Effective energy requirements for heating service water. 2000
VDI 2067 Part 21 Economic efficiency of building installations – Energy effort of benefit transfer – HVAC systems. 2003
VDI 2067 Part 22 Economic efficiency of building installations – Energy effort of benefit transfer for heating service water. 2005

Building services systems – Fundamentals
DIN V 4701 Part 10 Energy efficiency of heating and ventilation systems in buildings – Part 10: Heating, domestic hot water supply, ventilation. 2003

DIN V 4701 Part 12 Evaluation of heating and ventilation systems in terms of energy efficiency in existing buildings – Part 12: Heat generation and domestic hot water generation. 2004

DIN EN 15255 Energy performance of buildings – Sensible room cooling load calculation – General criteria and validation procedures. 2007

DIN EN 15265 Draft Energy performance of buildings – Calculation of energy needs for space heating and cooling using dynamic methods – General criteria and validation procedures. 2005

DIN 18379 German construction contract procedures (VOB) – Part C: General technical specifications in construction contracts (ATV) – Installation of air conditioning systems. 2006

DIN 18380 German construction contract procedures (VOB) – Part C: General technical specifications in construction contracts (ATV) – Installation of central heating systems and hot water supply systems. 2006

DIN 18381 German construction contract procedures (VOB) – Part C: General technical specifications in construction contracts (ATV) – Installation of gas, water and drainage pipework inside buildings. 2006

DIN 18382 German construction contract procedures (VOB) – Part C: General technical specifications in construction contracts (ATV) – Electrical supply systems rated for voltages up to 36 kV. 2002

DIN 18385 German construction contract procedures (VOB) – Part C: General technical specifications in construction contracts (ATV) – Installation of lifts, escalators, passenger conveyors and materials handling equipment. 2002

DIN 18386 German construction contract procedures (VOB) – Part C: General technical specifications in construction contracts (ATV) – Building automation and control systems. 2006

VDI 2050 Part 1 Requirements for technical centres – Technical bases for planning and execution. 2006

VDI 6026 Draft Planning, construction, operation – Contents and format of planning, execution and revision documents concerning technical building installations. 2007

VDI 6026 Documentation in the building services – Contents and format of planning, execution and review documents. 2008

VDI 6028 Part 1 Assessment criteria for building services – Fundamental principles. 2002

VDI 3985 Principles for the design, construction and acceptance of combined heat and power plants with internal combustion engines. 2004

VDI 4608 Energy systems – Combined heat and power – Terms, definitions, examples. 2005

Heating

DIN EN 15377 Part 1 Draft Heating systems in buildings – Design of embedded water based surface heating and cooling systems – Part 1: Determination of the design heating and cooling capacity. 2006

DIN EN 15377 Part 2 Draft Heating systems in buildings – Design of embedded water based surface heating and cooling systems – Part 2: Planning, dimensioning and installation. 2006

DIN EN 15377 Part 3 Draft Heating systems in buildings – Design of embedded water based surface heating and cooling systems – Part 3: Optimisation for use of renewable energy sources. 2006

DIN EN 12170 Heating systems in buildings – Procedure for the preparation of documents in respect of operation, maintenance and use – Heating systems requiring a trained operator. 2002

DIN EN 12828 Heating systems in buildings – Design of water-based heating systems. 2003

DIN EN 12831 Heating systems in buildings – Method for calculating the design heat load. 2003

DIN EN 12831 Technical companion sheet 1 Heating systems in buildings – Method for calculating the design heat load – National Annex NA. 2008

DIN EN 12975 Part 1 Draft Thermal solar systems and components – Solar collectors – Part 1: General requirements. 2004

DIN EN 12976 Part 1 Draft Thermal solar systems and components – Factory made systems – Part 1: General requirements. 2004

DIN EN 14336 Heating systems in buildings – Installation and commissioning of water based heating systems. 2005

DIN EN 15377-1 Draft Heating systems in buildings – Design of embedded water based surface heating and cooling systems – Part 1: Determination of the design heating and cooling capacity. 2006

DIN EN 15377 Part 2 Draft Heating systems in buildings – Design of embedded water based surface heating and cooling systems – Part 2: Planning, dimensioning and installation. 2006

DIN EN 15377 Part 3 Draft Heating systems in buildings – Design of embedded water based surface heating and cooling systems – Part 3: Optimisation for use of renewable energy sources. 2006

DIN EN 15450 Heating systems in buildings – Design of heat pump heating systems. 2007

VDI 2050 Supplement Central heating plants – Acts, ordinances, technical rules. 1996

VDI 2050 Part 2 Central heating plants – Acts, ordinances, technical rules. 1995

VDI 3810 Operation of heating systems. 1997

VDI 6012 Part 1 Local energy systems in buildings – Fundamentals and energy storage systems. 2003

VDI 6012 Part 3 Local energy systems in buildings – Fuel cells. 2002

VDI 6028 Part 3 Assessment criteria for building services – Requirement profiles and valuation criteria for heating technology. 2002

VDI 4640 Part 1 Draft Thermal use of the underground – Fundamentals, approvals, environmental aspects. 2008

VDI 4640 Part 2 Thermal use of the underground – Ground source heat pump systems. 2001

VDI 4640 Part 3 Utilisation of the subsurface for thermal purposes – Underground thermal energy storage. 2001

VDI 4640 Part 4 Thermal use of the underground – Direct uses. 2004

VDI 4650 Part 1 Calculation of heat pumps – Simplified method for the calculation of the seasonal performance factor of heat pumps – Electric heat pumps for space heating and domestic hot water. 2003

VDI 6003 Water heating systems – Comfort criteria and performance levels for planning, evaluation and implementation. 2004

Cooling

DIN EN 15255 Draft Energy performance of buildings – Sensible room cooling load calculation – General criteria and validation procedures. 2005

DIN 8930 Part 2 Refrigerating systems and heat pumps – Terminology – Fundamentals. 2005

DIN 8930 Part 5 Refrigerating systems and heat pumps – Terminology – Contracting. 2003

VDI 6028 Part 4.2 Assessment criteria for building services – Requirement profiles and valuation criteria for refrigeration plants. 2005

VDI 2078 Cooling load calculation of air-conditioned rooms (VDI cooling load regulations). 1996

VDI 2078 Part 1 Cooling load calculation of air-conditioned buildings with room-conditioning using cooled walls and ceilings. 2003

Air supply

DIN EN 12792 Ventilation of buildings – Symbols, terminology and graphical symbols. 2004

DIN EN 13779 Ventilation of non-residential buildings – Performance requirements for ventilation and room-conditioning systems. 2007

VDI 4706 Part 1 Draft Planning and dimensioning of the indoor climate (VDI ventilation code of practice). 2009

VDI 6028 Part 4.1 Assessment criteria for building services – Requirement profiles and valuation criteria for ventilation and air conditioning. 2004

VDI 2071 Heat recovery in heating, ventilation and air conditioning plants. 1997

VDI 3525 Automation and control of air-conditioning systems – Examples. 2007

VDI 3801 Operation of air-conditioning systems. 2000

VDI 3803 Air-conditioning systems – Structural and technical principles (VDI ventilation code of practice). 2002

VDI 3804 Air-conditioning systems – Office buildings. 2009

VDI 6022 Part 1 Hygienic requirements for ventilating and air-conditioning systems and air-handling units. 2006

VDI 6022 Part 2 Hygienic requirements for ventilation and air-conditioning systems – Measurement procedures and examinations in hygiene check-ups and hygiene inspections. 2007

VDI 6022 Part 3 Hygienic requirements for ventilation and air-conditioning systems in commercial and industrial buildings. 2002

VDI 6035 Ventilation and air-conditioning technology – Decentralised ventilation systems – Wall-mounted air-conditioners. 2009

Power supply

VDI 2050 Part 5 Draft Requirements in technical equipment rooms – Electrical engineering. 2007

VDI 6012 Part 2 Decentralised energy systems in buildings – Photovoltaics. 2002

VDI 6012 Part 4 Decentralised energy systems in buildings – Small wind power plant. 2002

Water supply

DIN 1986 Part 100 Drainage systems on private ground – Part 100: Specifications in relation to DIN EN 752 and DIN EN 12056. 2008

DIN 1989 Part 1–4 Rainwater harvesting systems. 2002–2005

DIN 2000 Central drinking water supply – Guidelines regarding requirements for drinking water, planning, construction, operation and maintenance of plants. 2000

DIN EN 12056 Part 1–5 Gravity drainage systems inside buildings. 2001

VDI 6028 Part 2 Assessment criteria for building services – Requirement profiles and valuation criteria for sanitary engineering. 2004

VDI 6002 Part 1 Solar heating of domestic water – General principles, system technology and use in residential building. 2004

VDI 6002 Part 2 Solar heating for domestic water – Application in student accommodation, senior citizens residences, hospitals, swimming pools and camp sites. 2009

VDI 6003 Water heating systems – Comfort criteria and performance levels for planning, evaluation and implementation. 2004

VDI 6023 Hygiene for drinking water supply systems – Requirements for planning, design, operation and maintenance. 2006

VDI 6023 Part 1 Draft Hygienic awareness concerning drinking water supply systems – Requirements for planning, design, operation and maintenance. 2005

VDI 6023 Part 2 Hygiene-aware planning, installation, operation and maintenance of drinking water supply systems – Requirements for hygiene training. 2005

VDI 6024 Saving of water in drinking-water installations. 2003

Optimising existing buildings

DIN EN 15232 Energy performance of buildings – Impact of Building Automation, Controls and Building Management. 2007

GEFMA 200 Costs in facility management; cost classification structure. 2004

GEFMA 700 Quality orientation in FM. 2005

VDMA 24186 0 Program of services for the maintenance of technical systems and equipment in buildings. 2007

VDI 3810 Operation of technical heating plant. 1997

VDI 6009 Part 1 Facility Management – Building management in practice. 2002

VDI 6009 Part 2 Facility Management – Introduction of building management in several properties – Examples. 2003

VDI 6009 Part 3 Facility Management – Introduction of Computer Aided Facility Management System (CAFM). 2003

VDI 6028 Part 6 Assessment criteria for building services – Requirement profiles and valuation criteria for building automation. 2004

VDI 3814 Part 1 Building automation and control systems (BACS) – System basics. 2005

VDI 3814 Part 2 Building Automation and Control Systems (BACS) – Legislation, technical rules. 2005

VDI 3814 Part 3 Building Automation and Control System (BACS) – Advice for technical building management – Planning, operation and maintenance. 2006

VDI 3814 Part 4 Building Automation and Control System (BACS) – data point lists and functions – Examples. 2003

VDI 3814 Part 5 Building Automation and Control System (BACS) – Advice for system integration with communication protocols. 2000

Picture credits

The authors and the publisher would like to thank everybody who has helped to create this book by providing their pictures, by granting permission to reproduce them and supplying information. All diagrams in this book were specifically developed for this purpose. Photographs without credits are taken by architects, are photos of projects or are from DETAIL's archives. Despite intense efforts, it was not possible to identify the copyright owners of some of the photographs, their copyright, however, is not affected. In this case, please contact us.
The numbers refer to the figures in the text.

Architecture and technology
1.1 AG Energiebilanzen e.V., Berlin
1.2 NEST Architekten, Unterhaching, and own additions
1.3 Schütz, Peter: Ökologische Gebäudeausrüstung. Vienna 2002, p. 11
1.4 DIN EN 15251. Berlin 2007
1.5 DIN EN 15251. Berlin 2007
1.6 Swiss Federal Office of Public Health (BAG), see: www.bag.admin.ch/themen/chemikalien/00238/01355/01359/index.html?lang=de
1.7 VDI E-4607 Page 1:2009-08 Criteria for indoor room climate (VDI ventilation guidelines). Berlin 2009
1.8 Seppänen, Olli; Fisk, William J.: Association of Ventilation – Type with SBS Symptoms in Office Workers, International Journal of Indoor Air Quality and Climate, 2002
1.9 according to EN ISO 7730-2005 (D)

Building services in the energy concept
2.7 German Federal Ministry for the Environment, Nature Conservation and Nuclear Safety (BMU)/AGEE-Stat. Berlin 2009
2.9 Schreiber Ingenieure, Ulm
2.10 Schreiber Ingenieure, Ulm
2.11 VDI 3807 Part 4 Characteristic values of energy and water consumption for buildings – Characteristic values for electrical energy. Berlin 2008
2.12 VDI 2067 Part 1: 2000-09 Economic efficiency of building installations – Fundamentals and economic calculation. Berlin 2000
2.14 Wolff, Dieter: Optimierung von Heizanlagen. OPTIMUS-Studie 2006. Cologne 2006, p. 7

Building services systems
Heating
3.1 Alois Schärfl
3.2 Schulze Darup, Burkhart: Energieeffiziente Wohngebäude, FIZ Karlsruhe, BINE Informationsdienst. Bonn (pub.) Berlin 2009
3.4 Vaillant Deutschland GmbH & Co. KG, Remscheid
3.6a Rennergy Systems AG. Buchenberg 2007
3.6b ÖkoFEN. Bühl 2007
3.7 with reference to Fachagentur Nachwachsende Rohstoffe e.V. (pub.): Leitfaden Bioenergie, Planung, Betrieb und Wirtschaftlichkeit von Bioenergieanlagen. Gülzow 2000
3.8 Watter, Holger: Nachhaltige Energiesysteme. Wiesbaden 2009
3.9 with reference to BINE Informationsdienst (pub.): Basis Energie 1: Holz – Energie aus Biomasse. Bonn 2001, p. 2
3.10 VDI 4640 Part 2. Berlin 2001
3.12 Viessmann Werke GmbH, Allendorf (Eder)
3.14 BINE Informationsdienst: Zeolith-Heizgerät, Projektinfo 02/05, Fachinformationszentrum. Karlsruhe/Bonn 2005
3.15–3.17 with reference to BINE Informationsdienst (pub.): Basis Energie 21: Kraft und Wärme koppeln. Bonn 2006, p. 2–3
3.18 SenerTec GmbH, Schweinfurt
3.19–3.21 Viessmann Werke GmbH, Allendorf (Eder)
3.22 Entwicklungs- und Vertriebsgesellschaft Brennstoffzelle mbH (EBZ). Dresden 2007
3.23 see 3.8

3.24 Watter, Holger: Nachhaltige Energiesysteme. Wiesbaden 2009
3.26 www.energiewelten.de: Fachverband für Energie-Marketing und -Anwendung (HEA) e.V at VDEW, Frankfurt am Main/Verband der Elektrizitätswirtschaft – VDEW – e.V., Berlin
3.28 Pistohl, Wolfram: Handbuch der Gebäudetechnik. Planungsgrundlagen und Beispiele. Volume 1 and 2. Düsseldorf 2009
3.29 Fisch, Manfred Norbert: Scripture for the lecture Solar technology I, ITW Stuttgart University. Stuttgart 2007
3.30 Roland Siemon, www.dpi-solar.de
3.31 Grammer Solar GmbH, Amberg
3.32 SikoSolar Vertriebs GmbH, Jenbach (A)
3.33 Viessmann Werke GmbH, Allendorf (Eder)
3.34 Siemens-Pressebild, Siemens AG, Munich/Berlin
3.35 SikoSolar Vertriebs GmbH, Jenbach (A)
3.36 grab architekten ag, Altendorf (CH)
3.37 Beat Kämpfen, Zurich (CH)
3.38 Sunways AG, Konstanz
3.42 according to Consolar Solare Energiesysteme, Frankfurt/Main
3.44 Paradigma Deutschland GmbH, Karlsbad
3.45 Rheinzink GmbH, Datteln
3.46 http://www.aee.at/publikationen/zeitung/2008-04/images/08_2.gif
3.47 AEE intec, Institut für Nachhaltige Technologien, Gleisdorf (A)
3.48 Sonnenhaus-Institut e.V., Straubing
3.49 Hausladen, Gerhard et al.: ClimaDesign – Lösungen für Gebäude, die mit weniger Technik mehr können. Munich 2005, p. 25
3.50 with reference to Lutz, Hans-Peter: Solaranlagen zur Warmwasserbereitung und Heizungsunterstützung im Eigenheim. Stuttgart 2003, p. 12
3.51 BINE Informationsdienst (pub.): Profi-Info Langzeit-Wärmespeicher und solare Nahwärme, 1/2001. Bonn 2001
3.52 grab architekten ag, Altendorf (CH)
3.53 Solites – Steinbeis Forschungsinstitut für solare und zukunftsfähige thermische Energiesysteme, Stuttgart
3.54 Wilo AG, Dortmund
3.55, 3.56 Hausladen, Gerhard et al.: Einführung in die Bauklimatik. Klima- und Energiekonzepte für Gebäude. Berlin 2003, p. 92 and 104
3.57 BINE Informationsdienst (pub.): Dezentrale Heizungspumpe, Projektinfo 13/06. Karlsruhe/Bonn 2006
3.58 Hausladen, Gerhard et al: Einführung in die Bauklimatik. Klima- und Energiekonzepte für Gebäude. Berlin 2003, p. 92 and 104
3.59 Wilo AG, Dortmund
3.60 Vasco GmbH, Rheine
3.61 Möhlenhoff Wärmetechnik GmbH, Salzgitter
3.62 Uponor GmbH, Haßfurt

Cooling
3.66, 3.69, 3.71 Zimmermann, Mark: Handbuch der passiven Kühlung. Stuttgart 2003
3.72 Silvio Klenner, www.Erdwärme-Zeitung.de
3.73 REHAU AG + Co, Rehau
3.74 Schnauer Energie-, Solar- und Umwelttechnik GmbH & Co. KG, Krems
3.76 according to Munters GmbH, Hamburg
3.78, 3.79 Arbeitskreis kostengünstige Passivhäuser – Energieeffiziente Raumkühlung, PHI Protokollband 31. Passivhaus Institut. Darmstadt 2005
3.80 Rheinzink GmbH, Datteln
3.81 see 3.78
3.82 IP-5 Ingenieurpartnerschaft Karlsruhe
3.87 IP-5 Ingenieurpartnerschaft Karlsruhe
3.92 BINE Informationsdienst, Henning, Hans-Martin et al: Kühlen und Klimatisieren mit Wärme. Karlsruhe/Bonn 2009, p. 23
3.94 see 3.92, p. 81
3.97 Verlagsgruppe Hüthig Jehle Rehm GmbH, Heidelberg
3.98 VIKA Ingenieur GmbH, Aachen
3.100 BINE Informationsdienst (pub.): Thermoaktive Bauteilsysteme, Themeninfo 1 – 2007. Bonn 2007, p. 7
3.102 Cook + Fox Architects, New York
3.103 ILKAZELL Isoliertechnik GmbH, Zwickau

3.104 isocal Heizkühlsysteme GmbH, Friedrichs-
hafen
3.105 Cook + Fox Architects, New York
3.106 Anthermo GmbH, Dortmund

Air supply
3.107 Tagungsband 10. Internationale Passivhaus-
tagung 2006, Passivhaus Institut. Darmstadt
2006, p. 448
3.108 DIN EN 13779: 2007 Ventilation for non-
residential buildings. 2007
3.109 see 3.108
3.110 see 3.108
3.111 according to data from TU Darmstadt, subject
design and energy-efficient building
3.112 König, Holger: Wege zum gesunden Bauen,
Ökobuch. Staufen bei Freiburg 1998, p. 15
3.113 Allard, Francis: Natural Ventilation in Buildings,
A Design Handbook. London 1998
3.116 Denis Gilbert/VIEW/artur, Essen
3.117 Barthélémy – Griño Architectes, Bernhard
Lenz, Paris
3.118a Hufton + Crow Photography, London
3.118b Arup Associates, London
3.119 Caroline Sohie, London
3.120 Aschoff, Carsten; Grotjan, Hartmut:
Frischlufttechnik im Wohnungsbau. Stuttgart
2004
3.127 Wolf GmbH, Mainburg
3.131 according to VDI 3803 Air-conditioning –
Central air-conditioning systems – Structural
and technical principles. 2002
3.132 see 3.131
3.135 Zimmermann, Mark: Handbuch der passiven
Kühlung. Stuttgart 2003, p. 57
3.136 see 3.135, p. 53
3.139 see 3.135, p.188
3.140 Bavarian Ministry for Environment, Public
Health and Consumer Protection, Bavarian
Ministry of Economic Affairs, Infrastructure,
Transport and Technology (pub.):
Oberflächennahe Geothermie, Heizen und
Kühlen mit Energie aus dem Untergrund.
Munich 2007
3.141 see 3.135, p. 188
3.142 Zimmermann, Mark: Handbuch der passiven
Kühlung. Stuttgart 2003, p. 87
3.143 Voss, Karsten; Löhnert, Günter: Bürogebäude
mit Zukunft, Konzepte, Analysen, Erfahrungen.
Cologne 2005, p. 110
3.144-3.146 Kiefer Luft- und Klimatechnik, Stuttgart

Power supply
3.150 AG Energiebilanzen e.V. (AGEB), Deutsches
Institut für Wirtschaftsforschung, Berlin
3.151 Federal Ministry for the Environment, Nature
Conservation and Nuclear Safety: Was Strom
aus erneuerbaren Energien wirklich kostet. 2nd
edition. Wuppertal 2005.
3.152 according to: Schultke, Hans; Werner, Michael:
ABC der Elektroinstallation. Frankfurt 2005,
p. 190
3.155 DIN EN 13779: 2007-09, table 6 Ventilation for
non-residential buildings – Performance
requirements for ventilation and room-
conditioning systems. Berlin 2007
3.156 see 3.155
3.157 Pistohl, Wolfram: Handbuch der
Gebäudetechnik. Planungsgrundlagen und
Beispiele. Volume 1 and 2. Düsseldorf 2007
3.158 Nimbus Group GmbH, Stuttgart
3.159 according to KONE GmbH, R-Serie, Hanover
3.162 Bundesverband Kraft-Wärme-Kopplung, Berlin
3.163 Buderus/Bosch Thermotechnik GmbH,
Wetzlar
3.164 Sunmachine GmbH, Wildpoldsried
3.165 Löhnert, Günter et al: Bürogebäude mit
Zukunft. Konzepte, Analysen, Erfahrungen.
Cologne 2005
3.166 our own exemplary calculations in reference to
www.bhkw-infozentrum.de
3.167 Wolfgang Suttor, Mengkofen
3.168 Wolfgang Suttor, Mengkofen
3.169 Stark, Thomas: Untersuchungen zur aktiven
Nutzung erneuerbarer Energie am Beispiel
eines Wohn- und eines Bürogebäudes.
Stuttgart 2004, p. 198
3.172 Michael Voit, Munich

3.173 Tobias Grau GmbH, Rellingen
3.175 Stark, Thomas; Baden-Württemberg Ministry of
Finance (pub.): Architektonische Integration
von Photovoltaik-Anlagen. Stuttgart 2005, p. 21
3.176 Lüling, Claudia (ed.): Energizing Architecture.
Berlin 2009, p. 108
3.180 ENERTRAG AG, Dauerthal/
our own additions

Water supply
3.181 Aloys F. Dornbracht GmbH & Co. KG, Iserlohn
3.182 German Association of Energy and Water
Industries, BDEW, Berlin 2009
3.187–3.190 Hansgrohe AG, Schiltach/
Pontos GmbH, Offenburg
3.192 Federal Association of the German Gas and
Water Industries, BGW, Berlin
3.193 Verband kommunaler Unternehmen e.V. (VKU),
Holländer: VKU-Gutachten. 2009
3.194 INTEWA GmbH, Aachen
3.195 Fachvereinigung Betriebs- und
Regenwassernutzung e.V. (fbr), Darmstadt
3.196 grab architekten ag, Altendorf
3.197 Keramag AG, Ratingen

Technical concepts
4.2, 4.7 Christine Blaser, Bern
4.8 Peter Schürch, Bern
4.9 Christof Lackner/Neue Heimat Tirol,
Innsbruck (A)
4.12, 4.13 Christof Lackner/Neue Heimat Tirol,
Innsbruck (A)
4.15 grab architekten ag, Altendorf
4.19, 4.20 grab architekten ag, Altendorf
4.22 Christian Theny, Feldkirchen
4.27 Paul Ott, Graz
4.28 GAP Architekten Generalplaner, Berlin
4.31 Martin Duckek, Ulm
4.33 Manos Meisen, Düsseldorf
4.38, 4.39 Manos Meisen, Düsseldorf
4.40 Willi Kracher, Zurich
4.44 Beat Kämpfen, Zurich
4.45 Hilde Kari Nylund, Norsk VVS
4.47 H.G. Esch, Hennef
4.48 ingenhoven architects, Düsseldorf
4.54 Hertha Hurnaus, Vienna
4.58 WWFF, Wiener Wirtschaftsförderungsfonds,
Vienna
4.60, 4.64 Jan Bitter, Berlin
4.66, 4.71 Taufik Kenan, Berlin
4.72 Stefan Postius, Konstanz
4.73 Tomas Riehle/arturimages.com
4.79–4.85 SMA Solar Technology AG, Niestetal
4.86, 4.91 Bruno Klomfar, Vienna
4.92 ERTL GLAS AG/ertex-solar, Amstetten
4.93 Gerd Kaltenbach, Staatliches Hochbauamt
Freiburg, Freiburg
4.98 Wolfram Janzer, Stuttgart
4.99 Helmut Knecht, Staatliches Hochbauamt
Freiburg, Freiburg
4.100, 4.101 Zermatt Tourismus, Zermatt/
Bruno Helbling Fotografie, Zurich
4.102 Peak Architekten, Zermatt/Zurich

Optimising existing buildings
5.2 Feist, Wolfgang (ed.): Lüftung bei
Bestandssanierung: Lösungsvarianten,
volume 30 of Arbeitskreis kostengünstige
Passivhäuser Phase III, Passivhaus Institut.
Darmstadt 2004
5.3 Aschoff, Carsten; Grotjan, Hartmut:
Frischlufttechnik im Wohnungsbau, p. 39.
Stuttgart 2004
5.4 see 5.2
5.7 Clina Heiz- und Kühlelemente GmbH, Berlin
5.8 Uponor GmbH, Haßfurt
5.9 Sanner, Burkhard. Lahnau 2009
5.10 according to data from Deutsche Energie
Agentur (dena) (pub.): Leitfaden
Energieausweis – Energiebedarfsausweis für
Wohngebäude - Modernisierungs-
empfehlungen. Part 2. Berlin 2007
5.11–5.13 according to data from TU Darmstadt,
subject design and energy-efficient building
5.15 Volger, Karl: Haustechnik. Grundlagen,
Planung, Ausführung. Stuttgart 1971, p. 381

5.16 according to data from Pistohl, Wolfram:
Handbuch der Gebäudetechnik.
Planungsgrundlagen und Beispiele. Volume 1.
Düsseldorf 2007
5.18–5.21 Heinrich Schoof, Karlsruhe
5.22 Schmid, Christoph: Heizungs- und
Lüftungstechnik. Bau und Energie. Wiesbaden
1993, p. 83
5.23 Aschoff, Carsten; Grotjan, Hartmut:
Frischlufttechnik im Wohnungsbau. Stuttgart
2004, p. 12
5.24 Dörken GmbH & Co. KG, Herdecke
5.25 Thermotechnik Strasshofer GmbH, Geretsried
5.26 LiGAS GmbH, Liebenau Gebäude- und
Anlagenservice, Meckenbeuren
5.27 Dörken GmbH & Co. KG, Herdecke

Optimising building operations
6.1–6.5 DIN EN 15232: 2007-11 Energy
performance of buildings – Impact of Building
Automation, Controls and Building
Management. Berlin 2007
6.6–6.7 LonMark Deutschland e.V. (ed.): Energie-
effizienz automatisieren. Aachen 2009
6.8 www.buildingeq.eu: Guidelines for the Evalu-
ation of Building Performance. 2009
6.9 LonMark Deutschland e.V. (pub.): Energie-
effizienz automatisieren. Aachen 2009

Literature (selection)

Principles

Bohne, Dirk; Wellpott, Edwin: Technischer Ausbau von Gebäuden. Stuttgart 2006

Daniels, Klaus: Advanced Building Systems. Basel/Boston/Berlin 2003

Daniels, Klaus; Hammann, Ralph E.: Energy Design for Tomorrow. Fellbach 2009

Giebeler, Georg et al: Atlas Sanierung. Munich 2008

Haas-Arndt, Doris; Ranft, Fred: Energieeffiziente Altbauten. Karlsruhe/Bonn 2004

Hausladen, Gerhard et al: Clima Design. Munich 2005

Hausladen, Gerhard et al: Clima Skin. Munich 2006

Hegger, Manfred et al: Energie Atlas. Munich 2007

Laasch, Erhard; Laasch, Thomas: Haustechnik. Wiesbaden 2008

Pistohl, Wolfram: Handbuch der Gebäudetechnik Volume 1 and 2. Munich 2009

Voss, Karstenet al: Bürogebäude mit Zukunft. Cologne 2005

Wüstenrot-Stiftung (pub.): Energieeffiziente Architektur. Stuttgart 2009

Energy concepts

Bührke, Thomas; Wengenmayr, Roland: Erneuerbare Energie – Alternative Energiekonzepte für die Zukunft. Weinheim 2010

Daniels, Klaus; Hamman, Ralph: Energy Design for tomorrow – Energie Design für morgen. Fellbach 2009

Watter, Holger: Nachhaltige Energiesysteme. Wiesbaden 2009

Heating

David, Ruth; de Boer, Jan; Erhorn, Hans ; Reiß, Johann; Rouvel, Lothar; Schiller, Heiko; Weiß, Nina; Wenning, Martin: Heizen, Kühlen, Belüften und Beleuchten. Stuttgart 2009

Schramek, Ernst-Rudolf; Recknagel, Hermann; Sprenger, Eberhard: Taschenbuch für Heizung- und Klimatechnik 2009/10. Munich 2009

Cooling

Henning, Hans Martin et al: Kühlen und Klimatisieren mit Wärme. Karlsruhe/Bonn 2009

Hennig, Martin et al: Solar-Assisted Air-Conditioning in Buildings. Vienna/New York 2007

Pech, Anton; Klaus, Jens: Heizung und Kühlung. Vienna/New York 2007

Trogisch, Günther: Planungshilfen bauteilintegrierte Heizung und Kühlung. Heidelberg 2008

Zimmermann, Mark: Handbuch der passiven Kühlung. Stuttgart 2003

Passivhaus Institut (pub.): Arbeitskreis kostengünstige Passivhäuser – Phase III: Energieeffiziente Raumkühlung. Darmstadt 2005

Hindenburg, Carsten, IHK Südlicher Oberrhein (pub.): Sorptionsgestütztes Klimatisierungssystem mit 100 m² Solarluftkollektoren – vier Jahre Betriebserfahrungen mit Sonnenenergie als einzige Wärmequelle im Sommer. Freiburg 2008

Air supply

Trogisch, Achim: Planungshilfen Lüftungstechnik. Heidelberg 2009

Aschoff, Carsten; Grotjan, Hartmut: Frischlufttechnik im Wohnungsbau. Stuttgart 2004

Schütz, Peter: Ökologische Gebäudeausrüstung. Vienna/New York 2002

Wirth, Stefan M.: Gebäudetechnische Systemlösungen für Niedrigenergiehäuser. Berlin 2003

Eicker, Ursula: Klimatisierung und sommerlicher Wärmeschutz von Passiv-Verwaltungsgebäuden. ZAEF – Stuttgart University. Stuttgart 2009

Power supply

Lüling, Claudia (ed.): Energizing Architecture. Hamburg 2009

DETAIL Praxis: Photovoltaik. Munich 2009

Hagemann, Ingo: Gebäudeintegrierte Photovoltaik. Cologne 2002

Water supply

Feurich, Hugo: Grundlagen der Sanitärtechnik. Düsseldorf 2010

Karger, Rosemarie; Cord-Landwehr, Klaus; Hoffmann, Frank: Wasserversorgung. Wiesbaden 2008

Optimising existing buildings

Passivhaus Institut (pub.): Arbeitskreis kostengünstige Passivhäuser – Phase III: Lüftung bei Bestandssanierung. Darmstadt 2005

BAKA Bundesarbeitskreis Altbauerneuerung: Kompetenz Bauen im Bestand. Stuttgart 2009

Hartmann, Frank; Siegele, Klaus: Heizungsmodernisierung in Wohngebäuden – Anlagentechnik für Architekten. Stuttgart 2009

Pfeiffer, Martin: Energetische Gebäudesanierung. Institut für Bauforschung e.V. Stuttgart 2008

Reuther, Stefan; Weber, Christian: Energetische Modernisierung von Gebäuden. Darmstadt 2008

Optimising building operations

Krimmling, Jörn: Facility Management – Strukturen und methodische Instrumente. Stuttgart 2005

Neddermann, Rolf: Energetische Gebäudemodernisierung. Cologne 2009

Authors

Bernhard Lenz

1968 Born in Frankfurt am Main
1991–1995 Studied interior design in Mainz
1995–1999 Studied architecture in Cologne
1999–2003 Postgraduate masters course in sustainable technologies for the Tropics
2000–2002 Employed in the architects' practices Renzo Piano Building Workshop, Paris, and Dominique Perrault Architecture, Paris
2003–2005 Employed and project manager in the architects' practice Barthélémy – Griňo Architectes, Paris
since 2005 Employed as an associate in the architects' practice Rethink: Be, architecture and urban design, Paris
2005–2009 Research assistant at TU Darmstadt, faculty of architecture, for the subjects design and building technology
2005–2009 Lecturer at TU Darmstadt, faculty of architecture, in the subjects design and building technology
since 2007 Free-lance energy consultant
2008 Lecturer at TU Munich, masters course, ClimaDesign
2009 Doctorate at TU Darmstadt in innovative solar-thermal heating and cooling systems to improve thermal comfort in building in the hot arid zone
2009–2010 Stand-in professor at Karlsruhe Institute of Technology (KIT)/Karlsruhe University, for the subjects building physics and technical installations

Member of the Chamber of Architects and Town Planners in Hessen. Author and co-author of various publications, e.g. Atlas Sanierung and Energie Atlas. Selected fields of research: solar heating and cooling, sorption-supported seasonal latent heat stores

Jürgen Schreiber

1959 Born in Ulm
1978–1984 Studied mechanical engineering (energy technology) at Stuttgart University
1984–1986 Project engineer in industry
1986–1991 Project manager in an engineering practice
1991 Founded engineering practice
since 2000 Managing director of the firm of consulting engineers Schreiber Ingenieure GmbH in Ulm
2001–2004 Lecturer at Biberach University of Applied Sciences in building technology and building air conditioning
since 2004 Professor for building technology, Stuttgart University, Faculty 1 Architecture and Urban Planning, Institute of Building Products, Building Physics and Design (IBBTE)

Member of the Chamber of Engineers in Baden-Württemberg, Association of German Engineers (VDI), IG Passivhaus and in Energiewirtschaftliches Projektrat, UNW Ulm. Futher fields: surveyor for EnEV and Ingenieurkammer BW as well as cooperation partner of the ENA (European Network Architecture)

Thomas Stark

1970 Born in Waiblingen
1990–1993 Apprenticeship as bank clerk
1993–1999 Studied architecture at Stuttgart University
1999 Thesis on structural integration of photovoltaics
2000–2005 Research assistant at Stuttgart University, institute for building construction
2003 Doctorate in utilisation of renewable energies in buildings
2005 Founded ee-plan Energiekonzepte in Stuttgart
2005–2008 Research assistant at TU Darmstadt for design and energy-efficient building
since 2008 Professor for energy-efficient building at the HTWG Konstanz
since 2009 Managing partner of the ee concept GmbH in Darmstadt/Stuttgart

Member of the German Sustainable Building Council (DGNB), author of various publications. Selected fields of research: solar building, energy concepts, certification of sustainabililty